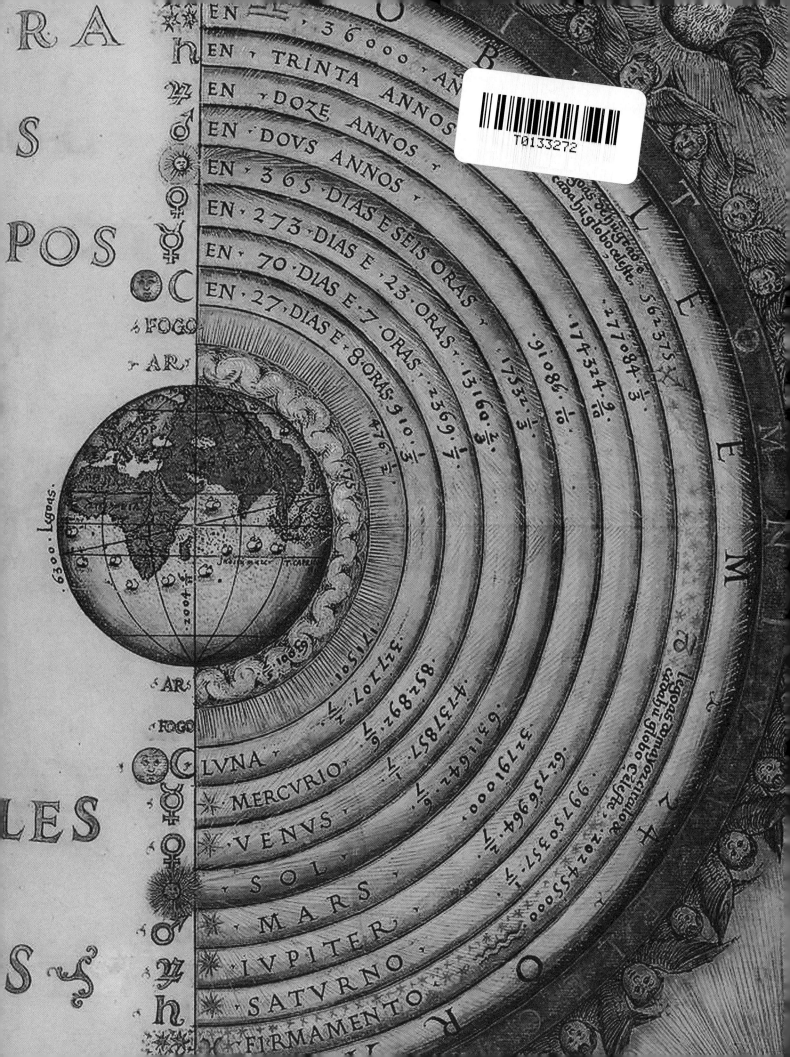

COSMOS

COSMOS

The Art and Science of the Universe

Roberta J. M. Olson and Jay M. Pasachoff

Published by Reaktion Books Ltd
Unit 32, Waterside
44–48 Wharf Road
London N1 7UX, UK
www.reaktionbooks.co.uk

First published 2019

Copyright © Roberta J. M. Olson and Jay M. Pasachoff 2019

All rights reserved

No part of this publication may be reproduced, stored in
a retrieval system, or transmitted, in any form or by any
means, electronic, mechanical, photocopying, recording or
otherwise, without the prior permission of the publishers

Printed and bound in China
by 1010 Printing International Ltd

A catalogue record for this book is available
from the British Library

ISBN 978 1 78914 054 5

Contents

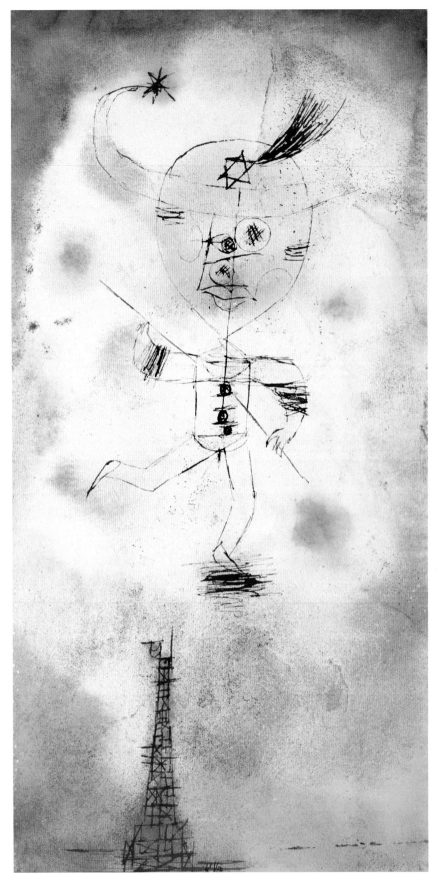

1 Paul Klee, *The Comet of Paris*, 1918, black ink, watercolour and gouache on paper, 20.8 × 10.6 cm.

Introduction

This visually provocative volume charts the human love affair with the heavens in art and astronomy. We have written the book based on exciting science, art and cultural history, for a general but intellectually acute audience interested in the compelling story of the discovery of how the universe is arranged and how it functions.

We have worked together since 1985, brought together by Halley's Comet returning to the inner solar system to become the first comet to be observed by a spacecraft. Since then, we have pioneered the interdisciplinary study of astronomical phenomena in art. We are gratified that our work seems to have sparked much enthusiasm in many new areas of exploration, including a highly regarded international series of conferences entitled 'The Inspiration of Astronomical Phenomena'. Our unique collaboration as individuals from separate but extremely visual professions – an astronomer who is a renowned expert on solar eclipses (and collects rare astronomical books) and an award-winning art historian – has produced cutting-edge approaches and innovative perspectives that appeal to a wide spectrum of readers across disciplines. For over three decades we have been accumulating material for this book, resulting in an archive of thousands of candidates for its illustrations.

The original catalyst for our collaboration was Olson's article in *Scientific American* (1979) advancing her now widely accepted idea that the Star of Bethlehem which Giotto di Bondone painted in his *Adoration of the Magi* scene (*c.* 1304–6) in the Scrovegni Chapel, Padua, was actually a portrait of Halley's Comet during its 1301 apparition. This article prompted the European Space Agency to ask Olson's permission to name their satellite that flew past the comet in 1985–6 'Giotto' and to invite her subsequently to join them for their presentation of the spacecraft's results to the Italian government and to the Pope. One of our most recent articles, 'Out of the Shadows: Art of the Eclipse' published in 2014, holds the distinction of being the first story from the 'Books and Arts' section to have an illustration grace the cover of the magazine *Nature*.

Our visual approach in *Cosmos* is more ambitious than our past publications and showcases the most extraordinary representations of the superstars of the firmament and universe. Illustrations and the book's running narrative interweave developments in astronomy and art chronologically in topical chapters that create a rich tapestry. They suggest, as the nineteenth-century German polymath Alexander von Humboldt believed and wrote about in his *Kosmos*, that every aspect of the universe is connected in a web of life, on Earth and in the heavens. While some of our chapters are more historical than others, the book is intended for a diverse audience, but one passionate or curious about astronomy, art, history and culture, as well as about preserving the environment for future generations. Interspersed with the works of art are photographic images of the celestial phenomena, while the final chapter charts the development of astronomical photography from its infancy in the nineteenth and twentieth centuries on Earth to the celestial photography of the Hubble Space Telescope and other spacecraft. Although our focus is on Western art, where the tradition of representing astronomical phenomena has been more prevalent, we allude to works in other cultures as well. As humans we all belong to the cosmos, and we are literally made of stardust.

2 Rufino Tamayo, *El hombre (Man)*, 1953, vinyl with pigment on panel, 5.5 × 3.2 m.

1 Astronomy:
The Personification and the Practice

Astronomy compels the soul to look upwards
and leads us from this world to another.
Plato, *The Republic*, 1, 342

Speaking as a committed skygazer, the early nineteenth-century English landscape painter John Constable claimed 'the sky is the chief organ of sentiment'. But for millennia before Constable, the heavens had mesmerized both Western and Eastern cultures, which worshipped them and examined their denizens for explanations about the cosmos, as embodied in a timeless evocation by the Mexican painter Rufino Tamayo (illus. 2). With electric light pollution, it is difficult for twenty-first-century individuals to understand the impact that the night sky – with all its majesty and mystery – had on prehistoric civilizations. For them, heavenly bodies and celestial phenomena embodied their deities or carried divine messages from them. Nevertheless, ancient peoples tried to penetrate the mysteries of the heavens and searched to find answers, either in their mythologies or in more proto-scientific approaches that involved observations of physical phenomena.

An ancient device, the Antikythera mechanism, found in Greek waters a hundred years ago, intrigues us (illus. 3).

Often called the first analogue computer, this scientific wonder of the ancient world was discovered in 1901 by sponge divers in a shipwreck dating from 70–60 BC, in the treacherous waters of the Aegean Sea near Crete. Submerged for over two thousand years off the island of Antikythera, its three flat, misshapen, green-patinated pieces of bronze have intrigued researchers ever since. Additional pieces surfaced in the 1970s and in 2005, but others may still rest on the bottom of the sea. Only after X-rays were taken in the 1970s and 1990s was the function of the device determined: it replicated the motions of the heavens. By holding it in your hands you could track the motion of the Sun, Moon and planets with amazing accuracy. Its internal, heavily corroded 82 parts and 37 gear wheels with teeth are sophisticated and seem modern, and nothing like it is known again for more than a thousand years. Archaeologists and scientists believe that the device was part of a complicated astronomical clock, with knobs for turning, that functioned like an orrery, a mechanical model of the solar system. Instead of hours and minutes, its hands displayed the celestial time of the Sun, Moon and each of the five planets visible to the naked eye. On the back were two dials: one was a calendar and the other showed the timings of lunar and

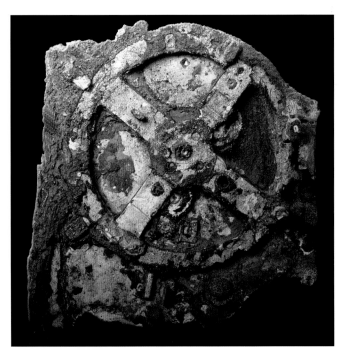

3 Antikythera Mechanism, one of its 82 parts, *c.* 205–100 BC, bronze, 15 cm diameter.

the heavens, which they did by constructing their famous ziggurats, in present-day Iraq. Believing that these structures connected them to the divine order of the heavens, they used them as observing platforms that enabled them to develop an unrivalled, naked-eye knowledge of the sky. Without any known devices, the Babylonians predicted the movements of the Sun, Moon and planets, sometimes more accurately than scientists until the twentieth century. Since the Babylonians, like many early cultures, worshipped sky divinities, their observations were connected to their religion, and they interpreted astronomical phenomena as portents of future events. By the time of Alexander the Great's invasion in the fourth century BC, the Babylonians had developed sophisticated measurements of solar eclipses, made with the aid of a water clock. Today, their accurate eclipse records are preserved as cuneiform inscriptions on clay tablets and remain invaluable to astrophysicists. The Babylonians also recorded other celestial phenomena, such as comets, and predicted with mathematical precision the movements of the Moon, whose waxing and waning set their calendar.

For us, the Babylonian skywatchers are important because their highly precise predictions based on observation lie at the base of Western science, even though their mathematical astronomy only dates from 400–300 BC. Other Near Eastern cultures, such as that of the Assyrians, also preserved fragmentary Babylonian records that would inspire the earliest great figures of the Western scientific tradition after the conquests of Alexander, among them the Graeco-Roman astronomers and mathematicians Hipparchus of Nicaea and Ptolemy. Despite their important contributions, Near Eastern civilizations made no attempt to visualize the sky and its bodies in terms of orbits and geometrical concepts, though they did engrave images of their sky gods and the Sun, Moon and stars on cylinder seals and steles.

By contrast, the Greeks not only recorded celestial events but also asked why the planets and other celestial bodies followed a certain motion. Unlike the Babylonians, they began to speculate and use

solar eclipses, accompanied by inscriptions about stars and when they rose and set. Archaeologists believe from preserved wood fragments that it was probably housed in a wooden case. While the apparatus demonstrates that the Greeks thought that nature and the universe operated on mechanical, pre-established principles based on mathematics, it also incorporated ideas from earlier Near Eastern cultures, among them the zodiac – the twelve signs in astrology and early astronomy corresponding to the constellations Aries, Taurus, Gemini, Cancer, Leo, Virgo, Libra, Scorpio, Sagittarius, Capricorn, Aquarius and Pisces – of the Babylonians and other influences from the Egyptians.

Earlier, in the Near East and Mesopotamia, the Akkadian ruler Naram-Sin revealed his reverence for the heavens by having himself sculpted on his victory stele (*c.* 2150 BC; Musée du Louvre, Paris) as a god of the universe conquering his smaller enemies and looking at the Sun and a gigantic star. The Babylonians, however, were among the earliest cultures to systematically study

mathematics to prove or disprove theories. Their loose political organization – unlike the rigid, bureaucratic frameworks of the earthly and divine authorities of ancient Babylon, Egypt and China – created a fertile environment for the inception of the scientific attitude, while their development of geometry led to the investigation of celestial mechanics. Geometry also freed the Greeks from a narrow preoccupation with numbers and projected their thinking into three-dimensional space. The crucial step occurred around 150 BC with the astronomer Hipparchus, whose work survives mainly through Ptolemy's treatise the *Almagest*. Hipparchus created a plausible simulation of what he observed in the sky and proved it through trigonometry. The Greeks' systematic need to prove and project into the future marked the birth of scientific method. Their skill can be glimpsed in the Antikythera mechanism, which reveals that Greek astronomy was more advanced than was previously thought. It was designed to predict the positions and motions of the Sun and Moon and their respective eclipses, as well as those of stars and the five visible planets, for calendric and astrological purposes and to calculate the four-year cycle of athletic games.

The changing appearances and movements of the Sun, Moon, stars and planets provided a complex pattern that begged to be understood by ancient cultures. Once mastered, this knowledge of celestial bodies provided a sense of control and predictability over not only the physical and spiritual worlds but also the immense void of the cosmos. It offered a rhythm for the annual cycle of hunting and planting and suggested the existence of sky gods, who were associated with priests and rulers on Earth. Each ancient culture formed a distinctive ordering of the cosmos – a cosmology – based on the changing celestial fixtures in the firmament interwoven with the forces of nature.

A pale echo of these attitudes – embraced in civilizations from the ancient Chinese to the Egyptian, Babylonian and Mayan cultures – is found in the mild horoscopic astrology that is still popular today and that depends on the twelve signs of the zodiac invented by the Babylonians. In Babylonian culture, astronomy and astrology developed side by side as interrelated skills. The increasing use of mathematical techniques affected both activities and led to the development of horoscopes around 400 BC, or at least around the time of Alexander's conquest of Egypt in 332 BC. By the beginning of the Christian era, a distinction seems to have crept in between astronomers and astrologers, as was noted by the Greek historian and geographer Strabo. Ptolemy distinguished the two practices in his *Tetrabiblos*, stating that it is sometimes possible to read human fate in the stars, whereas the forecasts of the heavens themselves are sure and effective. Nevertheless, since astronomy – the natural science dealing with celestial bodies, space and the physical universe outside Earth's atmosphere – and astrology – the belief system that claims human affairs are governed by celestial objects – both derive from the Greek word for star (*aster* or *astron*), their association would continue.

The personification of Astronomy and the origin of the discipline astronomy are inextricably linked to the history and fate of the personification Urania (in Greek, *Ourania*), meaning 'heavenly'. In Greek mythology and the Platonic tradition, Urania is the eldest daughter of Zeus and one of the nine Muses, or goddesses of inspiration. Presiding over astronomy and astrology, she was worshipped in Alexandria, Egypt, at the Mouseion (source of the word 'museum') and appears in Graeco-Roman sculpture with her sisters and their attributes, either in relief on sarcophagi or as a three-dimensional seated or standing figure. The Muses were considered attendants of Apollo, god of reason and poetry, and were frequently depicted with him. The Romans accepted these Greek goddesses into their pantheon and their sculptors copied earlier Greek originals, such as a statue of Urania that once belonged to a monumental group of Muses (illus. 4). Similar to another Urania from an earlier, celebrated set of Muses found at Hadrian's Villa outside Rome and today housed in Madrid's Museo del Prado, this Urania holds her attributes: a celestial globe and an instrument for observation – a pair of calipers, a

wand or a compass – to point out stars, as she purportedly could foretell the future by their arrangement.

By the early Renaissance and the dawn of the modern age in the fourteenth century, serious observations of celestial phenomena in centres like Padua and Florence caused Urania to be displaced by the representation of a practising astronomer in the act of observing the heavens.

A noteworthy example embellishes the campanile of Florence Cathedral, designed by Giotto in the 1330s, as one of a series of reliefs celebrating the diversity of human creative and productive endeavours that enabled this commercial republic to thrive (illus. 5). This astronomer is frequently identified as Gionitus, who according to Brunetto Latini, Italian philosopher and guardian of

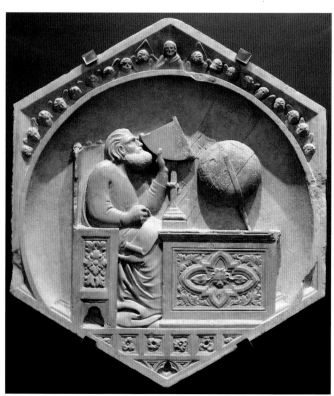

5 Andrea Pisano and assistants, *Gionitus, the Inventor of Astronomy*, from the south side of the Campanile, Florence, *c.* 1343–8, marble.

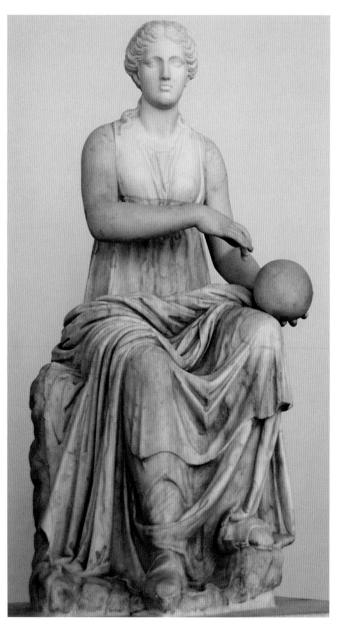

4 Unidentified sculptor, Urania Ludovisi, Muse of Astronomy, Roman copy of a Hellenistic original, 1st century AD, marble.

the poet Dante Alighieri, in his *Li Livres dou trésor* (Book of Treasures, 1284), was the fourth son of Noah and the inventor of astonomy. Alternatively, the figure has been identified as Ptolemy or just 'the Astronomer'. What is significant is that the sculpted vignette features a bearded astronomer-scholar who is seated in his study measuring the heavens with a quadrant. On his desk rests a celestial globe embellished with the zodiacal band that resembles many extant ancient marble examples (see illus. 19). Although damaged, three zodiacal signs carved on it are clear: Cancer, Gemini and Taurus. The secular elements in this Christian context are balanced by an unusual abbreviation of the Christianized Ptolemaic system of the nested spheres of heaven, consisting of a single concave sphere with the zodiacal band (with the signs of Pisces, Aquarius and Capricorn in relief) enveloping the astronomer. At the apex of this celestial sphere is God the Father, flanked by nine angels on each side representing the nine orders of angelic beings in the Ptolemaic conception of the cosmos. It cannot be coincidental that the relief above it on the Campanile, which the Italian sculptor Andrea Pisano planned in a rhomboid format, represents Faith. Higher up on the same facade is another set of reliefs, enclosed in rhombuses, representing the seven liberal arts of antiquity; the reliefs include Astronomia, the female personification of astronomy, who holds her emblematic celestial globe with its ecliptic. Unlike the other liberal arts, who sit on benches and rest their feet on architectonic stools, she perches on clouds and her feet are supported by an arch-shaped footstool, representing the dome of heaven, that encloses a swirling cosmos. These two representations of Astronomy testify to the importance accorded to the personification in fourteenth-century Florence, while also suggesting that our discussion of Astronomia is far from simple.

The Muse Urania appears on one of the so-called *tarocchi*, the fifty famous fifteenth-century woodcut cards by an anonymous engraver from Ferrara, Italy, that aim to show the order of the universe (illus. 6). Dressed in a classicizing garment and holding a compass and a plain

globe, she functions, together with her sisters and Apollo, as a mediator between human beings and universal knowledge. One would think that with the Italian iconographer Cesare Ripa's description of Urania in his *Iconologia* (published in 1593, with an enlarged edition appearing in 1603) her representation in Western art would have been established, but that is not the case as,

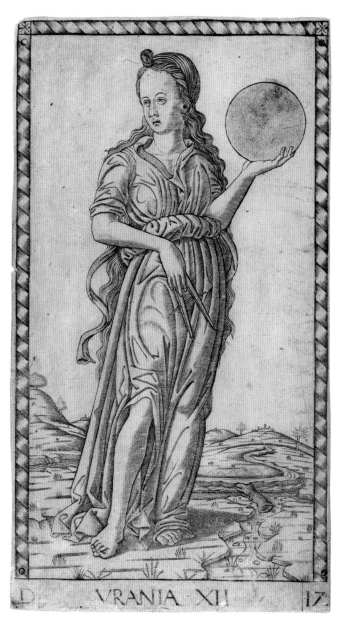

6 Master of the E-Series Tarocchi, *Urania*, c. 1465, hand-coloured woodcut, 17.8 × 10 cm.

tellingly, he includes four descriptions of the Muse, each with different attributes. Adding to the confusion, in his second description Ripa writes that she holds a sphere 'because she is linked to Astrologia'. Since no early edition of Ripa's highly influential tome contained illustrations of Urania, there was more room for artistic licence. Besides, not all painters or their patrons depended on Ripa's descriptions for their imagery.

Beginning with Renaissance humanists' zeal for rediscovering the knowledge of the ancient world, and with their interest in exploring new intellectual and scientific territories in mathematics and geometry, a large wedge began to divide astrology from astronomy. It would eventually cause a split, albeit not a neat or linear one, between the two disciplines in the seventeenth century, with one path eventually leading to a more scientific approach. The Renaissance link to ancient astronomy is graphically illustrated in a woodcut in the German mathematician and astronomer Regiomontanus' publication of Ptolemy's *Almagest*, a task begun by his teacher Georg von Peuerbach (illus. 7). It shows Ptolemy and Regiomontanus (born Johannes Müller von Königsberg) discussing the Platonic-Ptolemaic structure of the universe, depicted as a huge armillary. Most importantly, it is the contemporary Regiomontanus who takes the active role, instructively pointing with his right arm to the sphere, while Ptolemy passively studies his book.

Astronomical instruments, like the armillary sphere – a model of the celestial spheres consisting of a framework of rings around the Earth (in the Ptolemaic conception) and later the Sun (in the Copernican view) – could also symbolize the discipline of astronomy, as the woodcut featuring Regiomontanus intimates. Another case in point is the larger armillary sphere that Bernardino di Betto, called Pinturicchio, frescoed as hovering over astronomers and/or astrologers (both considered philosophers), who are discussing the heavens in the Borgia Apartments of the Vatican (illus. 8). It is one vignette of the decorative cycle in the Sala delle Sibille (Room of the Sibyls), in the suite of rooms decorated for the notorious Pope Alexander VI (Borgia). Since sibyls were pagan

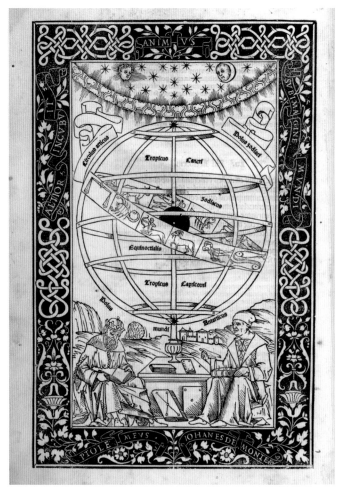

7 Johannes Müller (Regiomontanus) and Georg von Peuerbach, frontispiece of *Epytoma in Almagestum Ptolemaei* (Venice, 1496), woodcut.

seers whom humanists of the time viewed as precursors to the Old Testament prophets, the programme's adviser arguably envisaged the scene as representing an allegory of astrology rather than astronomy – especially because seven similarly shaped compartments contain the planets. Rather than being featured in miniature, jewel-like manuscript illuminations, as was typical in medieval times, these celestial symbols have ascended to a monumental scale, with their prestigious location underscoring their importance. Moreover, the adjacent Sala delle Arti Liberali (Room of Liberal Arts), which may have been the Pope's study and library, is embellished with

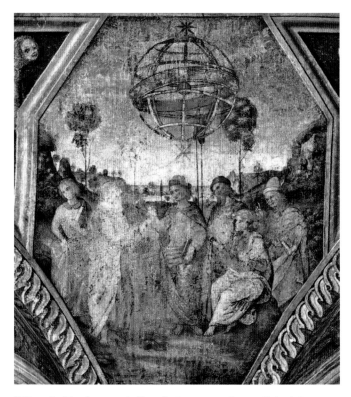

8 Pinturicchio, *Astronomia/Astrologia*, 1492–4, fresco, Sala delle Sibille, Vatican, Rome.

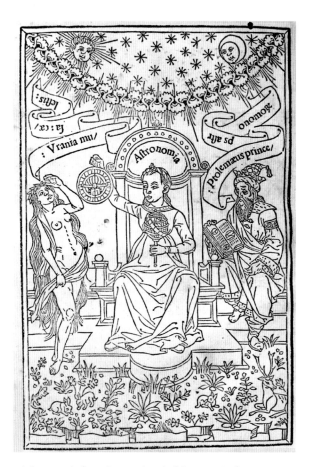

9 Johannes de Sacrobosco, detail of *Astronomia*, frontispiece from *De sphaera mundi* (Venice, 1488), woodcut.

large scenes featuring the female personifications of the liberal arts enthroned, surrounded by their attendants. Astronomy occupies the largest compartment, indicating her important status, and has pride of place in a lunette above a window, linking her to the natural light and the macrocosm of the heavens. In her right hand she brandishes an armillary sphere, as though showing it to both the personages in the frescoed space and the Pope's visitors in the room. This representation might also explain why Pinturicchio's supposed allegory in the Sala delle Sibille seems more grounded and geared towards the astronomical side of the spectrum in an age where astronomy and astrology were still linked; its six scholars engage in a discussion below the huge gold armillary sphere of the cosmos, which hovers above like a UFO. For Pinturicchio's contemporaries, the armillary sphere – consisting of metal bands representing the equator, the ecliptic, meridians and parallels – was the primary scientific instrument that astronomers and navigators employed to study the celestial positions and movements of the stars around Earth before the advent of the telescope in the seventeenth century. Hipparchus credited the Greek astronomer Eratosthenes with its invention. Many late fifteenth-century representations of astronomers from antiquity – such as Ptolemy, whose *Cosmographia* was popular at the time – are represented holding armillary spheres, as is Astronomia in an illustration from the 1488 edition of Johannes de Sacrobosco's *De sphaera mundi* (illus. 9). At the very least, Pinturicchio's two images of Astrology and/or

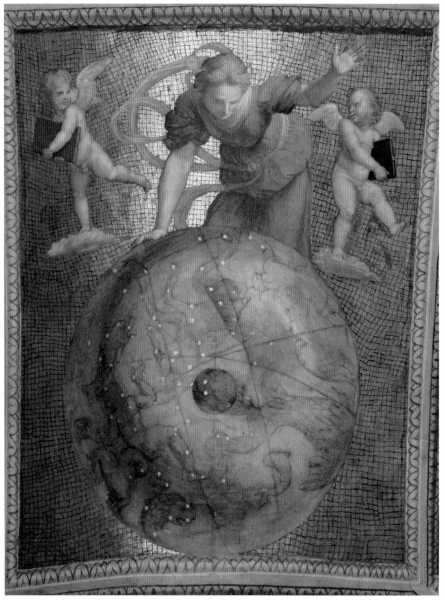

10 Raphael, *Astronomia*, 1509–10, fresco, Stanza della Segnatura, Vatican, Rome.

Astronomy in the Borgia Apartments sparked a debate about astronomy versus astrology.

Reinforcing this conclusion is the slightly later representation of Astronomia in the vault of the nearby Stanza della Segnatura, the library of the Borgia Pope's successor, Pope Julius II (della Rovere), by Raphael Sanzio, Pinturicchio's heir as Vatican decorator (illus. 10).

Pinturicchio's fresco was Raphael's prototype, not only for his figure of Astronomia, which Raphael originally planned with an armillary sphere instead of a celestial globe, as revealed in a preparatory drawing, but also for his most famous scene, the monumental *School of Athens* on the wall below. Its Hellenic philosophers include the ancient astronomers Strabo and Ptolemy holding

celestial and terrestrial globes. Recent discoveries in the New World had expanded the geographic horizon, and Julius II, the warrior Pope who hosted Leonardo da Vinci as an extended house guest in the Vatican, was keenly interested in both navigation and astronomy as tools to extend his domain.

The figure Raphael represented in his fresco is Astronomia or Astronomy. Since her attributes overlap with those of Urania and Astrologia, some ambiguity has surrounded her identity because she was painted in the early sixteenth century. As we have noted, astronomy and astrology were frequently considered one and the same, even in scientific circles, until the end of the sixteenth century, when astrology remained associated with divination, while astronomy became identified with the scientific study of the heavens. Regardless of the fact that sixteenth-century artist Giorgio Vasari, considered the father of art history, in his *Lives of the Most Excellent Painters, Sculptors and Architects* (1550; 1568), called Raphael's personification 'Astrologia' and others identified her as 'Urania', stressing her role as a Muse, we believe that both patron and artist intended her to be Astronomia, the personification of that liberal art. She stands poised above and behind a transparent celestial globe, whose upper crystalline sphere of the firmament in the Ptolemaic system and its gold fixed stars are seen from outside in the empyrean heaven. Raphael further embellished the globe with the outlines of several Ptolemaic constellations – among them Delphinus, Pegasus, Draco, Capricorn (perhaps also alluding to Julius' restoration of the city of Rome to the splendour of the Roman Emperor Augustus, born under this sign), Aquarius, the southern fish of Pisces, Pisces Austrinus (prior to the twentieth-century Pisces Notius), Cetus and either Andromeda or Cepheus. These constellations were in the autumnal sky when Julius II was elected to the papacy on 31 October 1503 (11 November of the Gregorian calendar). Although Raphael did not represent all the constellations correctly, he manipulated them in order to view the terrestrial sphere of Earth embedded at the centre of the celestial sphere. The

artist also etched the globe with the celestial equator, or equinoctial circle, the ecliptic and a pair of lines marking the two colures – the meridians that pass through the northern and southern celestial poles that derive from ancient astronomy and cosmology. Lacking a zodiacal band, the image stresses astronomy over astrology.

The figure's placement in Raphael's tightly knit humanist programme – between the roundel with Philosophy, above the *School of Athens*, and that of Poetry, above *Parnassus* with Apollo and the Muses, including Urania – cinches the argument that she is Astronomia. Her classicizing drapery underlines her allegorical status, as do the two flanking putti who move towards the adjacent roundels, implying that poetry and philosophy are essential to the working of the universe. Astronomia's gesture suggests that she is setting the universe in motion, while her placement at the apex of a triangle – formed at the left by Urania in the *Parnassus* and at the right by Ptolemy in the *School of Athens* – is identical to the figures in the woodcut from Sacrobosco's *Sphaera mundi*, where the central enthroned woman, identified by an inscription as Astronomia, sits between a nude Urania and Ptolemy (see illus. 9). It is not surprising that representations of both Astronomia and Astrologia in many fifteenth-century prints can be distinguished only by their inscriptions.

Raphael's amazingly forward-looking, semi-transparent globe must have had a model – probably the same one on which the later celestial globe by Giovanni Antonio Vanosino da Varese was patterned (see illus. 32). To create a convincing visual metaphor of the *caelum cristallinum* (the crystalline heaven) as a three-dimensional object, he rearranged the cartographical demarcations of the ecliptic, equator and colures so suavely that the final effect is as convincing as his *trompe l'œil* painting of the gold mosaic tesserae surrounding his stellar image. It is testament to Raphael's consummate skill as an artist that he was able to sustain these technically challenging illusions in paint. In planning the image he was assisted by the astronomer, cartographer and painter Johannes Ruysch (Giovanni Ruisch), who

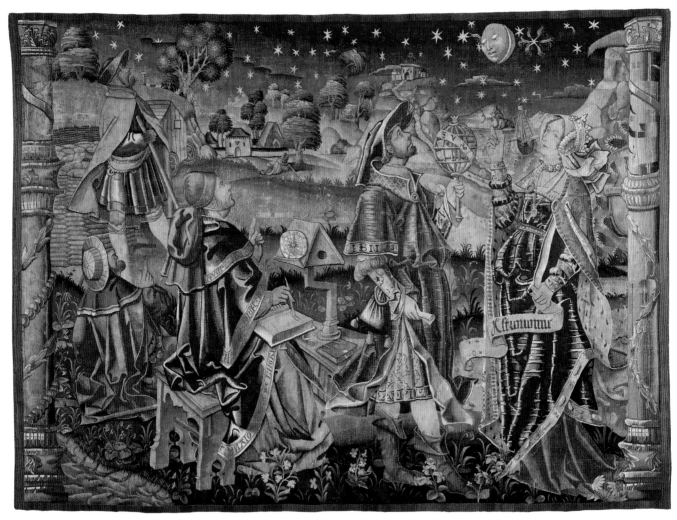

11 French (Gobelin?) manufactory, *Astronomy*, c. 1515, wool and silk, 2.3 × 3.3 m.

was involved with astronomy and navigation in the New World. Even before Raphael began this Stanza, Nicolaus Copernicus, partially educated in Italy, was beginning to doubt the Ptolemaic system that Raphael depicted, circulating his first treatise on the heliocentric system in manuscript form as early as 1507.

To gauge the level of continuing confusion between Astrologia and Astronomia, Ripa includes in the 1603 edition of his *Iconologia* three separate descriptions of Astrologia, together with a statement linking her to the Muse Urania. In all three he describes her wearing a pair of wings and a sky-blue dress but accompanied by various attributes, among them a sphere or globe, an armillary sphere, astrolabe, quadrant and other astrological instruments, as well as a 'book with stars and astronomical figures' and a star chart. Tellingly, in the 1625 edition, a wingless Astronomia makes her appearance, marking the moment when the two personifications appear in print together as distinct. Eventually, Astronomy is the victor.

During the Renaissance, Urania could also be represented as a nude, as we have seen in the Sacrobosco woodcut (see illus. 9), because in antiquity she was occasionally associated with Aphrodite, goddess of

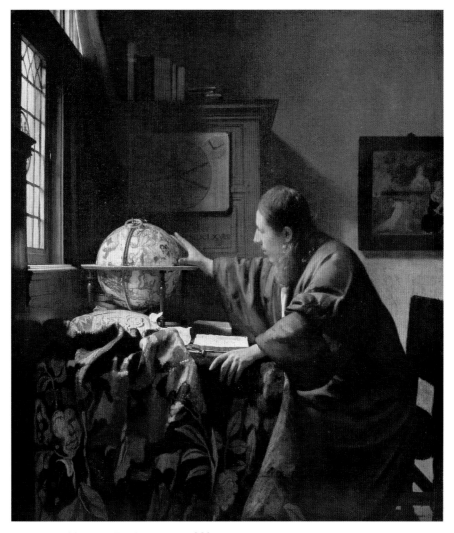

12 Johannes Vermeer, *The Astronomer*, 1668, oil on canvas, 51 × 45 cm.

love, in her cosmic nature. Albrecht Dürer, a German artist well versed in astronomical matters, represented Urania nude in three prints. One of them, a woodcut in the *Prognosticon ad annos MDIII–IIII* of Johannes Stabius, published in Nuremberg about 1502, allies the Muse ambiguously with astrology and prognostications.

While depictions of generic astronomers and astrologers wielding all manner of instruments – sextants, astrolabes, quadrants and armillary spheres – and charts grace illuminated manuscripts from medieval times, beginning in the sixteenth century, portrayals of astronomers involved in the act of observing began to increase.

As one might expect, they appear most frequently in small-scale manuscript illuminations and prints. The ascendance of astronomy over astrology, however, is undeniable in a large tapestry of circa 1515 (illus. 11), in which an astronomer holding an armillary sphere gazes at the heavens while being guided by Astronomia (inscribed in French *Astronomie*), who points to the Sun and a strangely configured star. By the next century, the very act of observing – as in the Beauvais tapestry 'The Astronomers' from the series *The History of the Emperor of China* (c. 1697–1705) – largely displaces the personification of Astronomy/Astronomia.

During the seventeenth century, intimate portrait-like oil paintings representing astronomers engaged in observation had become popular. For example, Johannes Vermeer portrayed an astronomer (illus. 12) studying a celestial globe in such a down-to-earth manner that he seems to be the painter's neighbour; nevertheless, with its juxtaposition of window and globe, the painting is not without symbolic allusions to the macrocosm and microcosm. Other depictions of astronomers feature secondary philosophical themes, such as Gerrit Dou's dramatic nocturne *Astronomer by Candlelight* (late 1650s; J. Paul Getty Museum), in which an hourglass introduces a *vanitas* gloss about the temporality of life into the painting. Even more specific are the portraits of historical individuals, such as the occupational portrait of Italian astronomer and cartographer Giovanni Antonio Magini by an unidentified artist (1620, unlocated). The painter portrayed Magini as a scholar engaged in celestial calculations with an armillary sphere and other instruments; outside the window of his study are figures involved in observational activities. In the century of Galileo Galilei, which was still digesting Copernicus' ideas, it is not surprising that astronomical subjects were highly topical and that depictions of groups of astronomers in animated discussions – such as Niccolò Tornioli's *The Astronomers* (1645; Palazzo Spada, Rome) – were not uncommon. Nevertheless, Giovanni Francesco Barbieri (known as Guercino) and other artists painted or delineated for patrons many half-length portrayals of astronomers, astrologers or 'cosmographers' that continued the conversation about astrology versus astronomy (illus. 13).

In fact, depictions of Astrologia enjoyed a long after-life, probably for more conservatively minded patrons. A case in point is a painting by Guercino (1650–55;

13 Guercino, *'Cosmographer' with a Celestial Globe and Compass*, 1630s, brown ink on paper, 16.3 × 26.9 cm.

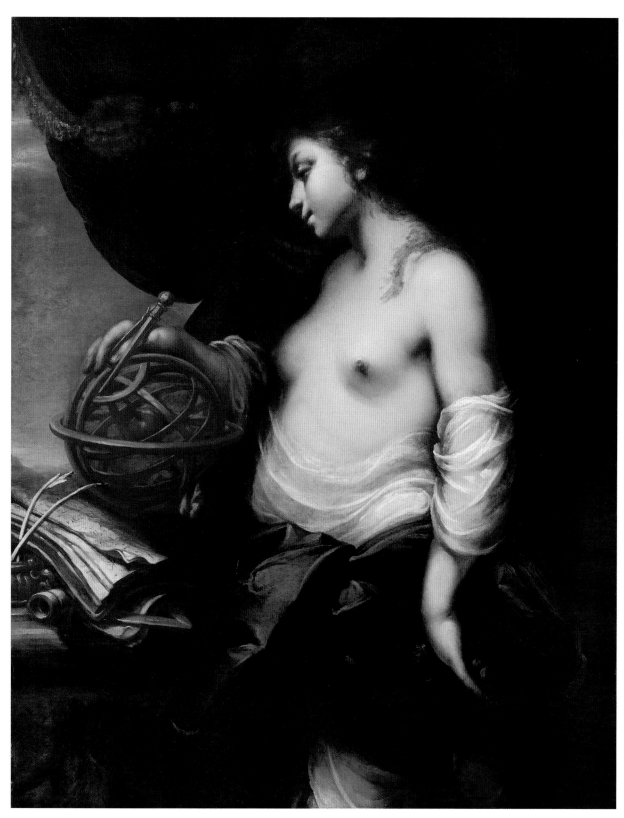

14 Vincenzo Mannozzi, *Astrologia/Astronomia*, c. 1650, oil on canvas, 129.5 × 98 cm.

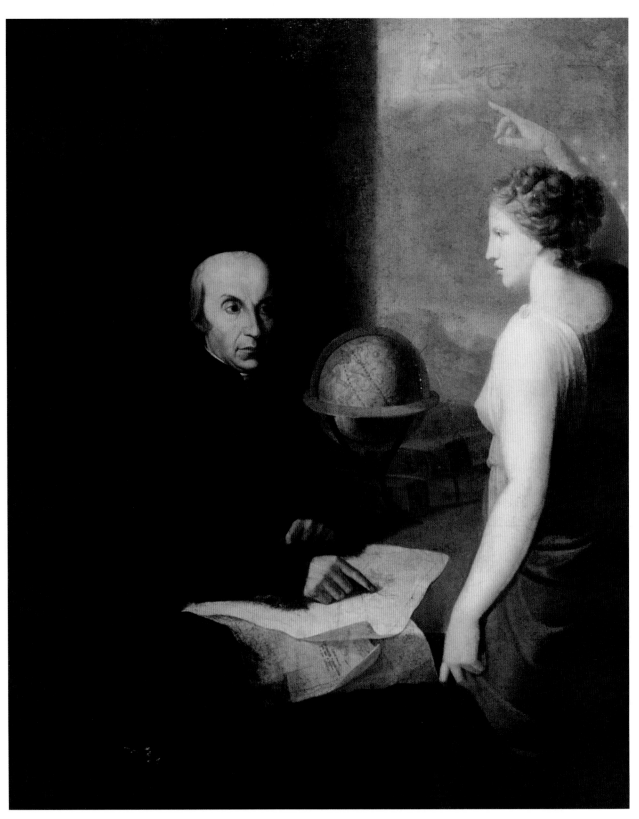

15 Francesco La Farina, *Giuseppe Piazzi with Urania Who Points out Ceres*, 1808, oil on canvas, 150 × 125 cm.

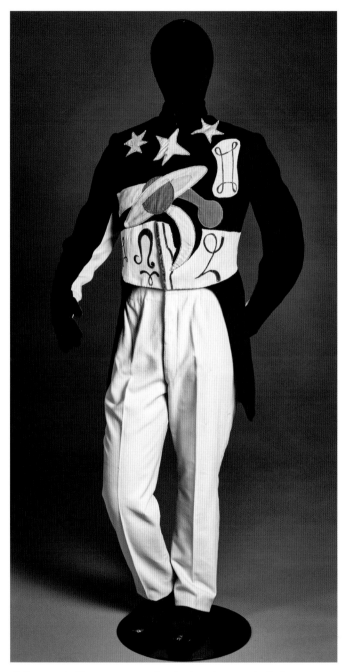

16 Giorgio de Chirico, costume for the Astrologer in the ballet *Le Bal*, 1929, white and black wool flannel, silk appliqués and paint.

Blanton Museum of Art, Austin, Texas) in which Astrologia holds an armillary sphere to connote her older associations and to add a veneer of gravitas and allegory. Many of these examples have more than a whiff of ambiguity and, like the Guercino, could also be interpreted as Astronomia. Another example is Vincenzo Mannozzi's *Astrology* or *Astronomy* (illus. 14), in which the partially nude figure, her sensuous body and falling blue drapery symbolizing the sky and meant to titillate, holds a compass or pair of callipers and leans on an armillary sphere. Perhaps the identity of the personification was made intentionally ambiguous in order to spark a discussion about her nature? The work's three-quarter-length format suggests that it was a cabinet picture intended for intellectual discussion and enjoyment by scholars and connoisseurs. An equivocal Astronomia also graces the frontispiece of the Italian astronomer and Catholic priest Giovanni Battista Riccioli's *Almagestum novum* (1651), where she holds an anachronistic armillary sphere and a scale that weighs the Copernican heliocentric system against Riccioli's own geocentric one (based on that of the Danish astronomer Tycho Brahe). Dressed in a garment embellished with stars and an ecliptic belt, she is assisted by an astronomer who holds a telescope and whose skin is decorated with eyes like those of Argus, the hundred-eyed giant of Greek mythology.

Later examples featuring representations of Urania usually convey the antiquity of a person or an idea, as is the case with the Swiss artist Henry Fuseli's design featuring the ancient Greek poet Aratus, famous for his verse about celestial phenomena, and the star-crowned Muse engraved by John Keyse Sherwin for the frontispiece of John Bonnycastle's *Introduction to Astronomy* (1786). In other contexts, the presence of Urania aggrandizes a person or event, such as the portrait of *Giuseppe Piazzi with Urania Who Points out Ceres* (illus. 15), which the Italian astronomer's friends commissioned to commemorate his 1801 discovery of Ceres, the first known asteroid and dwarf planet. It was this sensational discovery – more than Piazzi's catalogue of 7,646 stars, which was in itself a milestone in nineteenth-century astronomy – that made

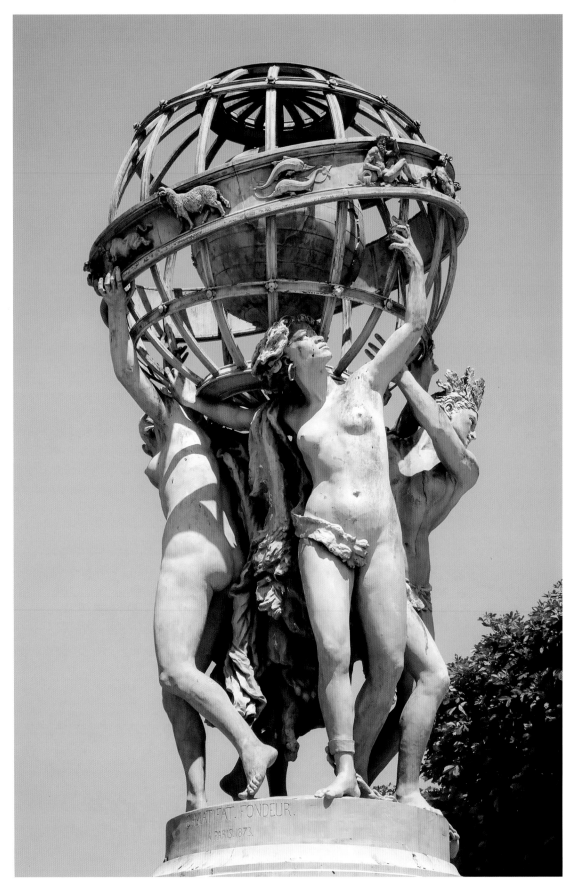

17 Jean-Baptiste Carpeaux, fountain of the observatoire de Paris, 1874, bronze and marble base, Observatory Gardens, Paris.

him famous. Here, Urania's presence as a Muse stresses inspiration over observation and allows science to take a poetic bow to the liberal arts.

Moreover, during the Renaissance Urania had become the Muse of poets, especially those who were concerned with philosophy or the heavens, linking science and art. She was usually shown gazing upwards because she was supposed to inspire imagination and lift men's souls to heavenly heights. Among the poets and authors of scientific treatises who continued to invoke Urania were Johann Bayer in *Uranometria* (1603) and John Milton in *Paradise Lost* (1667), as well as Johann Bode in *Uranographia* (1801). She was also the namesake for many observatories from Berlin to Zurich, such as Tycho Brahe's Uraniborg on the island of Hven (1580), and her image decorates some of them, such as a stained-glass window of over 2.7 metres (9 ft) high, *Urania* by Mary Elizabeth Tillinghast (1903), at Allegheny Observatory in Pittsburgh, Pennsylvania. On 22 July 1854, the British astronomer John Russell Hind discovered a large main-belt asteroid and named it 30 Urania, assuring the Muse of astronomy a place in the heavens, as well as in the history of astronomy.

During the past several centuries, astrology and astrologers have been relegated to popular culture and to the realm of amusement – as in the Italian Surrealist artist Giorgio de Chirico's costume for the Astrologer in the ballet *Le Bal* (illus. 16), performed by Sergei Diaghilev's avant-garde Ballets Russes, the most influential ballet company of the early twentieth century. George Balanchine choreographed this production about deception and ambiguity before he emigrated to the United States.

Although in the nineteenth and twentieth centuries astronomy has triumphed in achieving feats in space exploration that previously had been considered fantastical or unimaginable, traditional conventions in the visual arts persist as a gloss on the past. A case in point is the fountain of the Paris Observatory by the French sculptor Jean-Baptiste Carpeaux and three other sculptors, which features an armillary sphere held up by the Four Continents and playfully looks backward to pre-Copernican ideas (illus. 17). For this civic commission Carpeaux was given free rein in the decorative design, with a single caveat: not to obstruct the view of either the Luxembourg Palace or the Paris Observatory. Concomitantly, astronomers have transitioned from court appointments to distinguished research and academic positions with the potential of becoming media darlings, such as, in the twentieth century, Isaac Asimov and Carl Sagan.

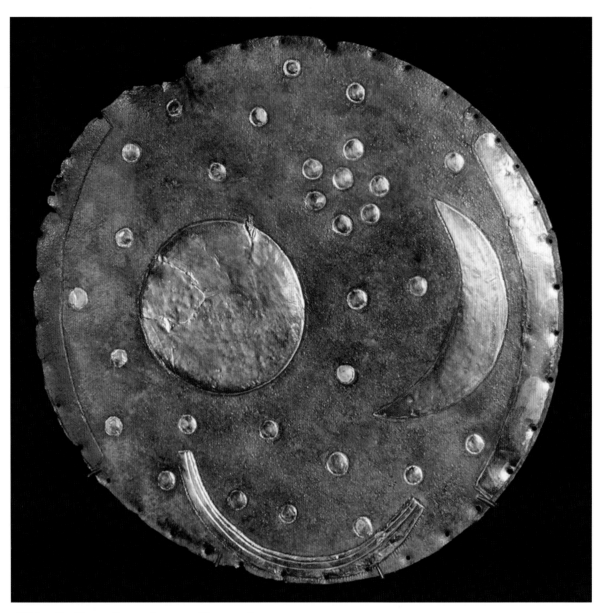

18 Nebra Sky Disc, c. 1600 BC, bronze, gold, 30 cm diameter.

2 The Mechanics of the Cosmos:
Star Maps, Constellations and Globes

Doubt thou the stars are fire;
Doubt that the sun doth move;
Doubt truth to be a liar;
But never doubt I love.
William Shakespeare, *Hamlet*, Act II, Scene 2

Star maps mirror the beauty of the sky and can provide a flattened twin to the celestial sphere or globe. Attempts at diagramming and understanding the universe date from ancient Near Eastern and Babylonian, Egyptian and European Neolithic times – for example the Nebra Sky Disc of around 1600 BC (illus. 18). Around two thousand years ago a Roman sculptor chiselled in marble Atlas, a Titan of Greek myth, carrying a celestial sphere on his shoulders, a sculpture today known as the *Farnese Atlas* (illus. 19). There are also contemporary Aboriginal Australian examples that demonstrate attempts to understand the structure and forces of the cosmos. One such example (illus. 20) was used in 2017 to illustrate the release of 217 official star names by the Working Group on Star Names of the International Astronomical Union, which only recently has begun the practice, codifying names that have been in use for centuries as well as expanding to a set of names chosen from a wide

variety of civilizations around the world, with a goal of diversity.

One can draw the view of the skies on a concave surface as people see it, looking up, or from 'God's view', looking down. Among the former is the fifteenth-century fresco on the dome of the Old Sacristy in San Lorenzo, Florence. The astronomer Paolo dal Pozzo Toscanelli probably plotted its celestial cartography for the unidentified artists who painted it (illus. 21; see also illus. 103).

For more than 1,500 years, Western civilization embraced the geocentric design of the Aristotelian-Ptolemaic system, with its nested celestial spheres (illus. 22–4), as the prevailing cosmology. The astronomical system in use for many centuries employed Ptolemy's mathematical calculations from his second-century *Almagest*, and while this could predict some heavenly events, it did not explain all celestial phenomena. Although its Earth-centred orientation was mistaken, the Florentine artist Sandro Botticelli drew it beautifully in an illustration of Dante's *Paradiso* (illus. 25), where, standing in the sphere of the Moon, Beatrice explains the nature of the heavens to Dante. Soon after the turn of the sixteenth century, the Venetian painter Giorgione included the zodiac at its proper angle relative to Earth's

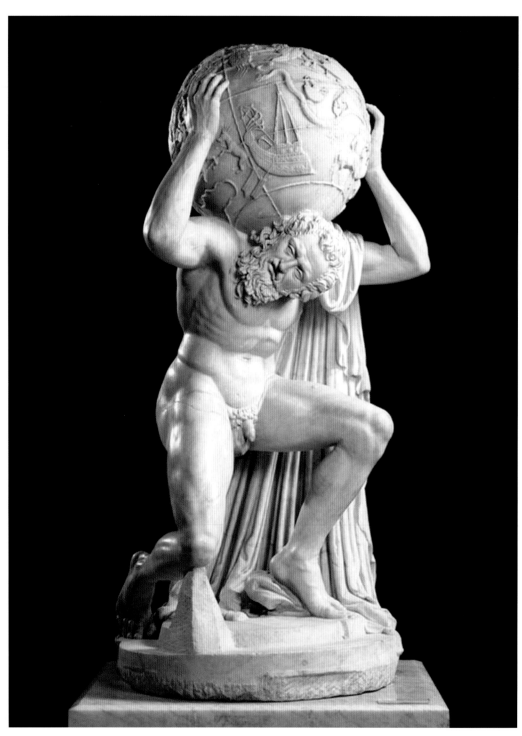

19 *Farnese Atlas*, 2nd century AD, marble, 2.13 m height, globe 65 cm diameter.

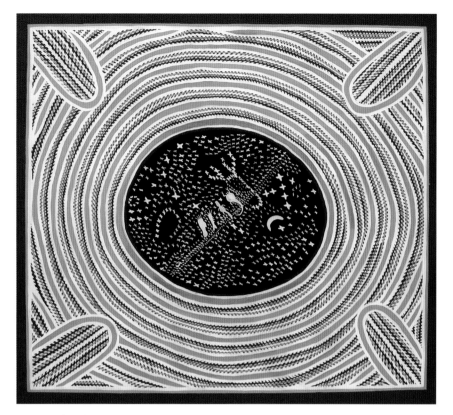

20 Bill Yidumduma Harney, Aboriginal Milky Way star map, c. 2000, bush ochre and charcoal on canvas.

21 Unknown artists with Paolo dal Pozzo Toscanelli, dome over the altar with the Moon in Taurus, after 1442, fresco, Old Sacristy, San Lorenzo, Florence.

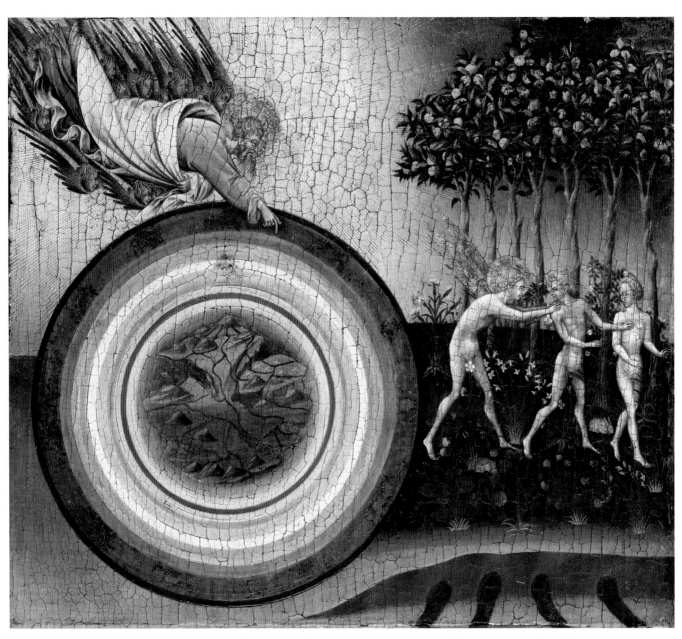

22 Giovanni di Paolo, *The Creation of the World and Expulsion from Paradise*, 1445, tempera and gold on canvas, transferred from wood, 46.4 × 52.1 cm.

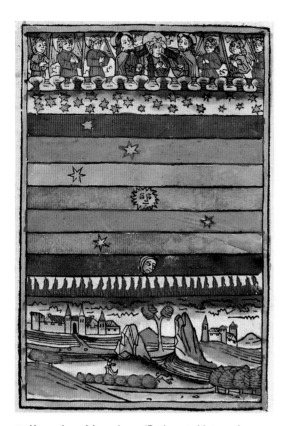

23 Konrad von Megenberg, 'Ptolomaic Universe',
folio 20v (67) from *Buch der Natur* (Augsburg, 1481),
hand-coloured woodcut.

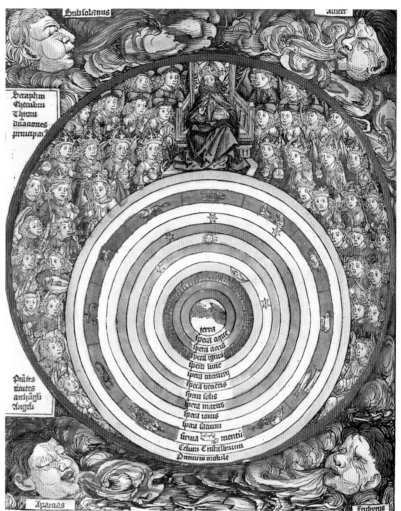

24 Michael Wolgemut and Wilhelm Pleydenwurff, 'Sphera planetarum et orbium',
folio 5v from Hartmann Schedel, *Liber chronicarum* (Nuremberg Chronicle;
Nuremberg, 1493), hand-coloured woodcut.

25 Sandro Botticelli, *Canto II* from Dante's *Paradiso*, c. 1490, silver point and ink on parchment, 32.2 × 47 cm, Kupferstichkabinett, Staatliche Museen, Berlin.

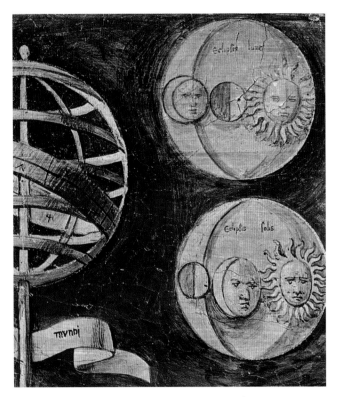

26 Giorgione, detail of a frieze of the Liberal Arts (based on Sacrobosco), c. 1502(?), fresco, Casa Barbarella, Castelfranco.

27 Michael Ostendorfer, eclipse calculator, plate G III from Peter Apian, *Astronomicum Caesareum* (Ingolstadt, 1540), hand-coloured woodcut.

poles in a frescoed frieze about the liberal arts that decorates the Casa Barbarella in Castelfranco (illus. 26), basing his work no doubt on one of the many editions of Sacrobosco's *Sphericum opusculum* (1485).

In this chapter, we discuss the complex Ptolemaic system and its effects on art and science, which Nicolaus Copernicus overturned in 1543 with his heliocentric theory, published as *De revolutionibus orbium coelestium*. Before Copernicus, Petrus Apianus (Peter Apian), in his *Astronomicum Caesarium* of 1540, published not only beautiful celestial images but also nested discs that rotated with respect to each other, so-called volvelles, to use in the calculation of celestial events (illus. 27; see also illus. 109).

Of course, people have long looked at the stars, as we know from Palaeolithic images in the Lascaux caves in the Dordogne in southwestern France, painted around 17,000 years ago, that are thought to be astronomical. Later civilizations read designs in their arrangement, organizing them into constellations, though unfortunately the origins of the 48 known to the ancient Babylonians and Greeks are lost. Imagining connections between the stars evolved images of the constellations that have in turn been associated with stories. The European identifications of constellations and their related narratives that we mainly follow in the Western world are linked to the Greek gods and myths. A case in point is Orion, the mighty hunter, seen holding up his shield to ward off Taurus, the bull. Scorpius, the scorpion, was sent by Apollo to kill Orion by stinging him, because Orion was spending too much time with Apollo's sister Artemis, distracting her from her job of guiding the Moon across the sky. Zeus, the king of the gods, put Orion and Scorpius in opposite sides of the sky so that they were never visible from Earth at the same time of year. Orion had been thwarted in his pursuit of the Pleiades, or 'seven sisters', who were saved by Zeus, who turned them into doves. They escaped into the sky to live safely, perpetually ahead of the constellation Orion.

Each year, the Sun goes through the boundaries of thirteen constellations. Twelve of them have long been considered part of the 'zodiac', a term that derives from a Latinized form of an ancient Greek word for 'circle of little animals', referring to constellations like Leo (the lion), Taurus (the bull), Cancer (the crab), Aries (the ram), Scorpius (the scorpion; Scorpio in astrology), Capricorn (the sea-goat) and Pisces (the fish). Descriptions of the zodiac can be traced back at least 2,500 years to Babylonian astronomers, who divided the path of the Sun over its annual motion into a dozen equal parts. In his *Almagest*, Ptolemy wrote about the zodiac in more modern terms, including them in his 48 constellations. Later astrologers, through those who practise today, peddled their pseudoscience using that archaic system. Because Earth wobbles on its axis – a phenomenon known as the precession of the equinoxes – the Sun no longer passes through the constellations and positions that match the astrological prognosticators' predictions.

Most of the current 'official' constellation names derive from the Greek myths, whose stories were based on Babylonian, Egyptian and Assyrian tales. Since Ptolemy's *Almagest* recorded only 48 of the current 88 constellations, when explorers from Europe went south of the equator they named the southernmost of our current constellations. Their nomenclature often reflected the modern era's astronomical instruments: a telescope, a divider-compass and an octant, for example. Many of the newer constellation names appeared in Johann Bayer's star atlas of 1603 (see illus. 33, 34), with others being devised by Johannes Hevelius in his 1690 star atlas (both are discussed below). The French astronomer Nicolas Louis de Lacaille devised additional new constellations in 1763.

Other civilizations have diverse nomenclatures for constellations and different stories about stars. The Chinese organize their star groupings by 'Mansions' and other, smaller divisions. An indigenous American story about the Big Dipper (an asterism) relates that the colour that pours out of it when it is turned in the sky after each summer falls onto the leaves to make spectacular autumn foliage.

In 1928 the International Astronomical Union – formed nine years earlier – divided the sky into 88 'regions', the

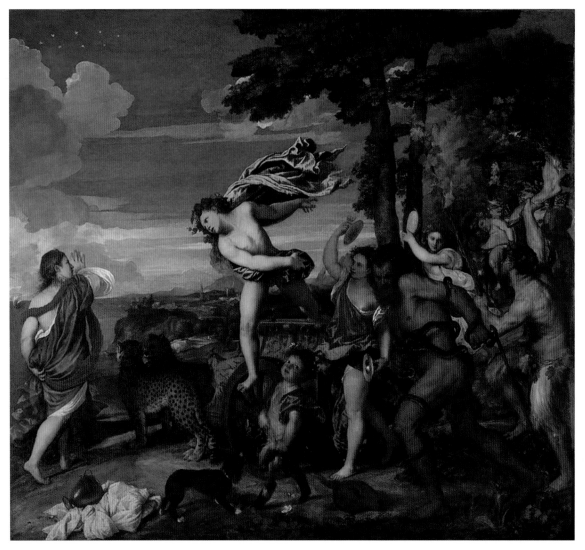

28 Titian, *Bacchus and Ariadne*, 1520–23, oil on canvas, 176.5 × 191 cm.

current definition of constellations, whose names had been approved in 1922. Nineteen of the 88 represent people and 42 represent animals. One of the organization's missions was to provide definitive regions for the names of the variable stars that were being discovered, each identified after the constellation in which it appeared.

During the sixteenth century, Italian painters occasionally represented constellation-related myths in frescoes or easel paintings. For example, the Venetian artists Titian and Jacopo Tintoretto both painted representations of the classical myth of Bacchus and Ariadne,

in which the god of wine leaves his mortal love but rewards her by turning her into the Corona Borealis, one of the constellations mentioned by Ptolemy and whose nomenclature remains to this day (illus. 28). Soon after, in 1540, a book by Alessandro Piccolomini, *Delle stelle fisse* (On the Fixed Stars) appeared (illus. 29). It features tables and charts that illustrate all but one of the constellations known to Ptolemy, as well as that of the Southern Cross, with letters marking the most notable stars in each constellation. It is considered the first in a series of modern star atlases and a precursor to the

29 Alessandro Piccolomini, Cygnus and Cassiopeia, figures IX and X from *Delle stelle fisse* (Venice, 1540), engraving.

beautifully illustrated ones that followed. In his *La sfera del mondo* (On the Globe of the World), Piccolomini discussed the cosmological knowledge of the time.

In *De revolutionibus orbium coelestium* Copernicus had purposely held back from publishing his iconoclastic idea that the Sun rather than the Earth was at the centre of the universe (illus. 30): it was not necessarily the most honourable place to be, because detritus could theoretically collect at such a centre. It took a visit by the Austrian scholar Georg Joachim Rheticus to Copernicus at Frauenborg (now Frombork in northeastern Poland) to pry the book out of him. Its publication was delayed until the year of his death because of the cataclysmic implications that it contained for Church doctrine. To protect Copernicus from prospective punishment, the clergyman Andreas Osiander – who was monitoring the publication with the printer at a city remote from the author – added an apparently unauthorized preface indicating that heliocentricity was useful for celestial calculations, which was not actually true. Osiander even added the words *orbium coelestium* ('of the celestial spheres') to Copernicus' simple *De revolutionibus* (On the Revolutions) – part of the scheme to avoid the wrath of the Church. Further, Copernicus intentionally dedicated his tome to Pope Paul III to

avoid papal criticism. In fact, Copernicus' model was so revolutionary that scepticism towards his ideas persisted for over a century.

Before Copernicus' ideas were widely accepted, Francisco de Hollanda, court painter to the Portuguese king, produced visionary illustrations of the geocentric system in a hallucinatory mixture of Neoplatonism, the Kabbala and Christianity (illus. 31). In contrast, Giordano Bruno, an early convert to the Copernican view, expanded this iconoclastic theory out into the universe and to infinity, claiming that there was an infinity of worlds. His heretical ideas about cosmology, pantheism and transmigration of the soul led to his death by burning at the stake in 1600; the site can be visited in the Campo de' Fiori in Rome, where a statue of him was erected 130 years ago showing his belated rehabilitation.

The three-dimensional universe was not relegated to mere flat surfaces for painting or drawing. An early deluxe example is Giovanni Antonio Vanosino da Varese's brightly painted celestial globe from 1567, held in the Vatican museum (illus. 32). A century later, the most famous globe maker of the time was Vincenzo Coronelli, an Italian working in France who made huge globes for the French kings starting in 1683. Examples of his craftsmanship are found in collections worldwide, for example at the Bibliothèque nationale de France (moved from the Palace of Versailles in 2006), the Bibliothèque Sainte-Geneviève and the University of Paris, as well as at Yale University in New Haven, Connecticut. Most celestial and terrestrial globes, including Coronelli's, are made of flat gores printed on paper that are cut and then moulded and pasted onto a spherical shape. Coronelli's largest globe was an impressive 4 metres (13 ft) across.

The first true modern star atlas that featured the figures and star-lettering scheme we still use today was charted by Johann Bayer in his *Uranometria* of 1603 (illus. 33, 34). Its 51 bifolium (or double-spread) charts were engraved by Alexander Mair, based on drawings by Jacob de Gheyn III. Illustration 33 shows Taurus as a muscular bull charging the ecliptic region (the grey area where the Sun, Moon and planets appear), with the

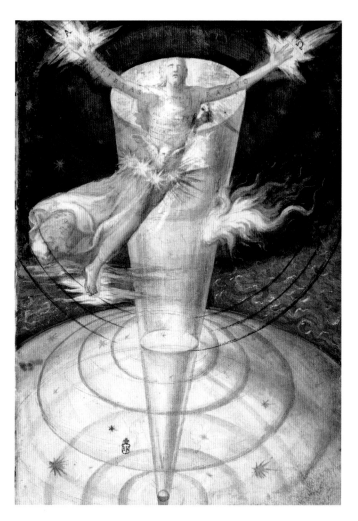

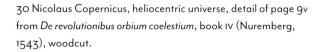

30 Nicolaus Copernicus, heliocentric universe, detail of page 9v from *De revolutionibus orbium coelestium*, book IV (Nuremberg, 1543), woodcut.

31 Francisco de Hollanda, geocentric universe, from *De aetatibus mundi imagines*, 1545–73, tempera and ink on parchment. MS, DIB/14/26, folio 7, Biblioteca Nacional de España, Madrid.

two stars Alpha and Beta Tauri. Illustration 34 features a hand-coloured plate of the sea monster Cetus from Greek mythology, today sometimes called 'the whale', located near other water-related constellations such as Aquarius, Pisces and Eridanus. Bayer used constellation names largely from Ptolemy and modified Piccolomini's system of letters to identify individual stars, assigning Greek letters to the brightest stars in each constellation, usually in order of brightness (though for the Big Dipper asterism in the constellation Ursa Major he followed the shape of the Dipper with Alpha, Beta, Gamma and Delta

as the bowl, and Epsilon, Zeta and Theta marking the attached handle). When he had exhausted Greek letters for a given constellation, Bayer used Roman letters.

Bayer's *Uranometria* was cutting-edge astronomy before the fantastic discoveries of Galileo, which we will discuss later. Once Galileo heard about a device that had been invented in Holland for surveying and magnifying celestial objects, he used the concept to make his own telescope (then called a *perspicillum*), and soon turned it towards the sky. He observed many more stars than had been seen before in Orion and the Milky Way. Still,

even within a few years of Galileo's epochal discoveries, Robert Fludd, in his illustrated treatise *Utriusque cosmi maioris . . .* (1617–18), could still maintain an archaic idea of the cosmos, using a celestial dove in an engraving as part of his fantastic diagrams of the universe.

In the painting *Allegory of Sight* (illus. 35), Peter Paul Rubens and Jan Brueghel the Elder depicted sophisticated astronomical instruments, including telescopes, only seven years after Galileo's first astronomical use of the telescope (his results were published in 1610 in *Sidereus nuncius* (Starry Messenger)). In the canvas, Brueghel, who was court painter to the Habsburg Archduke of Austria Albert VII, represented one of the first images of a telescope (the very first is thought to have been the frontispiece of the German astronomer Simon Marius's *Mundus Iovialis* of 1614), suggesting that he may have seen the early spyglasses (pre-Galileo) of Hans Lipperhey or Zacharias Janssen in Holland. (As part of a set of names generated through an international call to ordinary citizens for suggestions, two extra-solar planet-like objects – orbiting a star other than the Sun – were named in 2015 by the International Astronomical Union: exoplanets Lipperhey and Janssen, orbiting the star newly named Copernicus.)

Allegory of Sight is one of a series of paintings about the five senses that Rubens and Brueghel, who were friends, painted in 1617–18 for Albert VII and his wife, Isabella, governors of the Spanish Netherlands. It belongs to a genre characteristic of Antwerp at the time but shows the importance of astronomical instruments and mathematics in a complicated dialogue with the arts. The ability to identify scientific instruments in this painting was as important as being able to identify the subjects and artists of the paintings (including one representing Christ healing the blind man) and to decode their symbolism. The work includes both large- and small-scale objects; its landscape alludes to the macrocosm, while the study/gallery that refers to the microcosm includes the intellectual scholar and connoisseur. The work's theme, therefore, is that both art and science lead to a delight in and understanding of the cosmos through sight. Painted at the time when Galileo was arguing for the Copernican theory (he was summoned to Rome by the Inquisition in 1616), *Allegory of Sight* also raises the topical issue of heliocentrism versus geocentrism. Reportedly, Rubens, who was a Neo-Stoic, had an interest in the Copernican debate. He had probably met Galileo in Mantua in 1602, and again in 1604, and included him in a group portrait, now in the Wallraf-Richartz Museum in Cologne.

Many astronomers and mathematicians who were also celestial cartographers were involved in this radical rethinking of the universe and its structure. They masterminded sumptuous, hand-coloured works, most notably that of Andrea Cellarius (illus. 36, 37), which not only illustrated the Copernican system of the universe but also simultaneously showed the geocentric model, in a lavish volume that included sophisticated celestial diagrams, star maps and volvelles (*Harmonia macrocosmica*, 1661).

Johannes Hevelius used his family's brewery wealth, supplemented by a royal pension, to build a series of

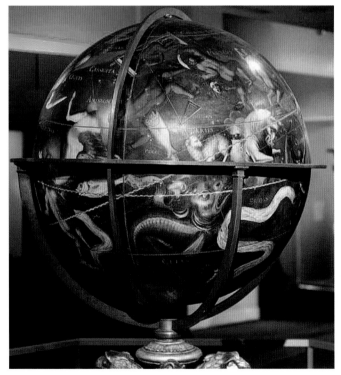

32 Giovanni Antonio Vanosino, celestial globe, 1567, brass, paint, gold, 195 cm diameter.

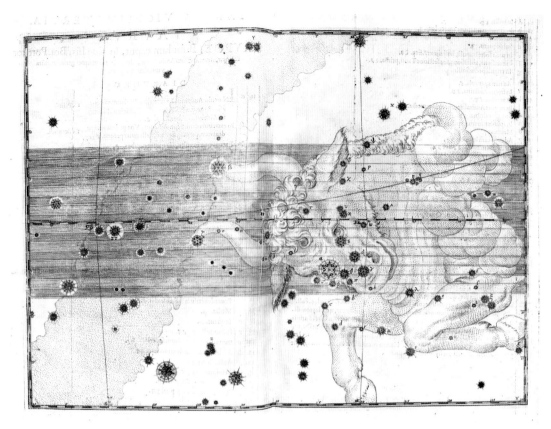

33 Johann Bayer, *Taurus*, page 23v from *Uranometria* (Augsburg, 1603), engraving.

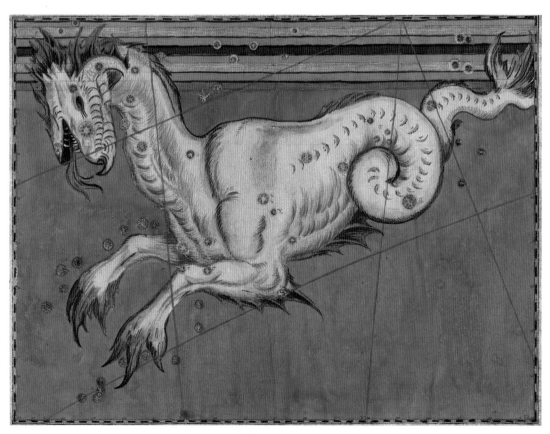

34 Johann Bayer, *Cetus*, page 34v from *Uranometria* (Augsburg, 1603), hand-coloured engraving.

35 Peter Paul Rubens and Jan Brueghel the Elder, *Allegory of Sight*, 1617, oil on canvas, 64.7 × 109.5 cm.

telescopes of increasing quality at his private observatory, Sternenberg, in Poland. These allowed the astronomer to assemble a magnificent star atlas, *Firmamentum Sobiescianum, sive Uranographia*, published in 1690. It was named in honour of Giovanni III Sobieski, King of Poland. Its constellation charts were engraved with more vigour than those in Bayer's earlier atlas. A few decades later, the English Astronomer Royal, John Flamsteed, after compiling an accurate star catalogue for the northern sky, created his own large-scale *Atlas coelestis*, published posthumously in 1729 by his widow and friends.

Johann Gabriel Doppelmayr, professor of mathematics at Nuremberg, produced his own *Atlas coelestis* in 1742. It was much more than a star atlas, however, featuring many double-page spreads illustrating terrestrial and Copernican world systems and phenomena such as transits and eclipses. The individual plates were published over a 35-year period, but its star maps did not share the beauty or lavishness of the Bayer, Hevelius or Flamsteed atlases.

A step towards improved accuracy in the calculation of star positions led the physician John Bevis (discoverer of the Crab Nebula, the first so-called Messier Object, or M1, discussed in later chapters) to produce a particularly beautiful star atlas, *Uranographia Britannica* (illus. 38). Unfortunately, his publisher went bankrupt after the plates were engraved in 1747–9, but before publication. Nevertheless, a few bound volumes became available in 1786 when the publishing house changed hands; they were released (perhaps at auction) under the title *Atlas celeste*, to a limited distribution. Only two dozen copies of the *Atlas celeste* are known. Moreover, Bevis was one of only two people in England known to have observed the 1759 return of Halley's Comet, as predicted by Halley only a few decades earlier.

36 Andrea Cellarius, plate 3 from *Harmonia macrocosmica* (Amsterdam, 1661), hand-coloured engraving.

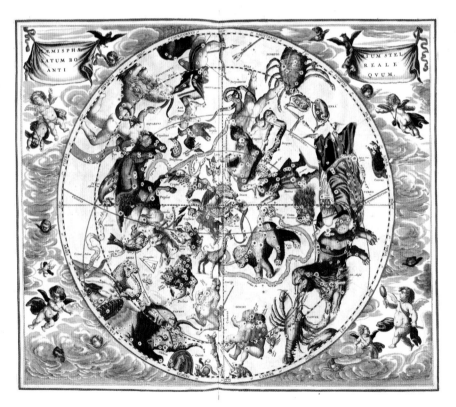

37 Andrea Cellarius, plate 25 from *Harmonia macrocosmica* (Amsterdam, 1661), hand-coloured engraving.

38 John Bevis, Cygnus, plate 9 from *Uranographia Britannica* (or *Atlas celeste*) (London, 1747–9, published 1786), engraving.

Flamsteed's *Atlas* proved so popular that a French edition appeared in 1776, followed by a third edition in 1795. These reduced-format publications retained the star and constellation configurations, and in some cases improved their design – Flamsteed's original fold-out single Hydra plate was divided into two plates, increasing the total number of plates by one – but did not match the lavishness of the original publication.

Orreries – named after the Earl of Orrery who owned an elegant one from around 1704 that is one of the first preserved – are models of the solar system with balls for the planets revolving around a central Sun. They showcase the elegant heliocentric system three-dimensionally and became important didactic tools to demonstrate the new harmony of the spheres. Many types were produced from the early eighteenth century onwards, ranging from very luxurious instruments to more utilitarian examples. During the eighteenth century, when astronomy was extremely popular and science became a form of entertainment, itinerant lecturers as well as scientists

employed orreries in homes and institutions to instruct the public. The famous painting *A Philosopher Lecturing on the Orrery* (1766) by Joseph Wright of Derby (illus. 39) captures the tenor of this popular, intimate type of lecture. Further investigations of the expanding view of the universe will be found in Chapter Seven in discussions of nebulae, galaxies and the Big Bang.

Perhaps the most magnificent orrery ever made is the so-called Pope Orrery, made by Joseph Pope with the American patriot silversmith Paul Revere (illus. 40). Long displayed in a stairwell at the Houghton Library of Rare Books at Harvard University, it is now in the Collection of Historical Scientific Instruments at the Harvard Science Center in Cambridge, Massachusetts. A much more modest orrery by the eighteenth-century London instrument-maker Benjamin Martin, and an accompanying book on the topic, includes some ivory planets and moons around Jupiter, and Saturn with its rings, orbiting a brass Sun (illus. 41).

The depictions of the constellations are of ancient origin, as seen on the globe of the *Farnese Atlas* of two thousand years ago. Later Renaissance examples – such as the dome of the Old Sacristy in San Lorenzo, based on Toscanelli's design; the mapping of the constellation Crux in the southern sky by Amerigo Vespucci; and even star charts engraved by Albrecht Dürer in 1515 – all extended that knowledge of the constellations. Star maps and atlases became increasingly accurate in the following centuries. Even more precise was the star catalogue compiled by Caroline Herschel from observations by Flamsteed, with an introduction and remarks by her 'Brother' (as she always referred to him), William Herschel, published in 1798. This was a precursor of the *General Catalogue* of non-stellar objects by the Herschels, which in turn led to the nineteenth-century *New General Catalogue* by William's son and Caroline's nephew, John Herschel. The publication introduced the NGC numbers for non-stellar objects that we still use today. Caroline also kept records of her nocturnal studies of the sky in her 'Book of Observations', with illustrations of the fixed stars and comets (illus. 42). She

discovered nine comets and later became the first woman to be awarded the Gold Medal of the Royal Astronomical Society and to be paid for her astronomical research.

Perhaps the pinnacle of gloriously engraved star atlases was the giant *Uranographia* of 1801 (illus. 43) by Johann Elert Bode, the long-time director of the Berlin Academy of Sciences. His magnificent atlas, still unsurpassed, contains 99 constellations – not all their nomenclature survives to this day – with 17,240 stars, some ten times more than were in Bayer's atlas.

The mapping of stars was about to become seemingly outmoded, although astronomers were not aware of the fact that it would be replaced by the discovery of spectroscopy. It took another hundred years for the realization to sink in, and the release of a billion star positions in 2018 by the European Space Agency's *Gaia* spacecraft restored astrometry to a place of honour. An early peak was the spectroscopic atlas of the dark 'spectral lines' absorbing the rainbow of light from the Sun, with over five hundred lines carefully measured and drawn by the German optician Joseph Fraunhofer in 1814 and published three years later (illus. 44). When Fraunhofer was knighted by the King of Bavaria, he gained an ennobling 'von' to his name, showing his stature as elevated above that of his birth.

Other star atlases continued to be published. When in 1832–3 Elijah Burritt produced a popular atlas in the United States, with many didactic charts, the printing and format fell far short of the artistic quality of the engraved star atlases of the past. Modern sets of accurate star maps are the descendants of the Piccolomini, Bayer, Hevelius and Bode star atlases, especially those of contemporary celestial cartographer Wil Tirion – albeit that these no longer show the traditional constellation figures. Rather, the 88 constellations are areas of the sky with boundaries approved by the International Astronomical Union in 1928.

The stars and constellations remained so popular with the general public, however, that we find them ubiquitously, sometimes used with creative licence. A case in point is Karl Schinkel's starry vault design for a

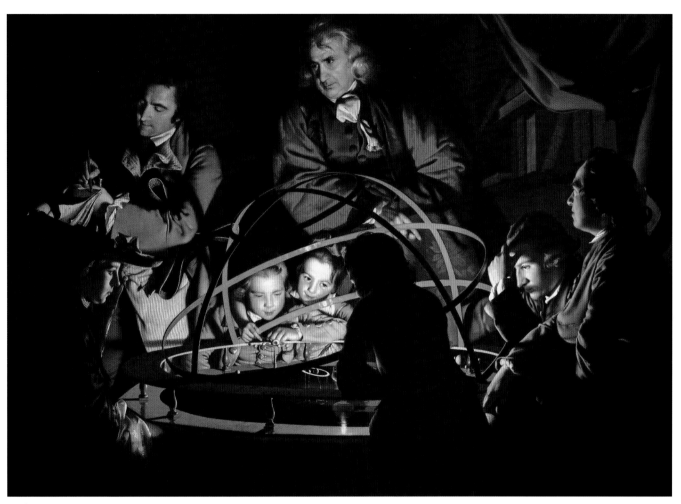

39 Joseph Wright of Derby, *A Philosopher Lecturing on the Orrery*, 1766, oil on canvas, 147 × 203 cm.

production of Mozart's opera *The Magic Flute* in 1847–9 (illus. 45). The generations of star maps, and eventually astronomical photography (see Chapter Ten), opened the door for artistic licence to thrive in the twentieth century. Pablo Picasso drew schematic dot-and-line *Constellations* in India ink that resemble musical notes (1925; Musée Picasso, Paris). We can admire the inventive, suggestive ponderings about the cosmos which appear in Joan Miró's suite of gouache and oil paintings *Constellations* (1940–41), named by the French poet André Breton and considered one of the crowning achievements of Miró's career. His long-time friend the American sculptor Alexander Calder also constructed a sculpture series

titled *Constellations* (in the 1940s), which includes stationary works as well as kinetic mobiles (illus. 46). More recently, the American artist Kiki Smith has constructed out of glass, bronze and handmade paper a three-dimensional constellation star chart (1996, Corning Museum of Glass, Corning, New York).

In later chapters we will provide still further examples of the overlap of art and astronomy. Such cross-disciplinary collaborations have led to the computer-art conceptions of the merging of giant black holes that in 2015 accompanied the biggest advance in astronomy since Galileo turned his telescope to the heavens in 1609: the measurement of gravitational waves from

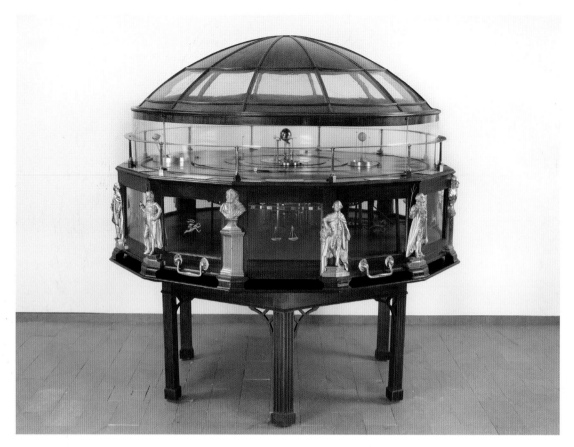

40 Joseph Pope and Paul Revere, Grand Orrery, 1776–87, mahogany, brass, bronze, reverse-painted glass and ivory, with dome perhaps added later, 163 cm height, 171.4 cm diameter. Collection of Historical Scientific Instruments, Harvard University, Cambridge, Massachusetts.

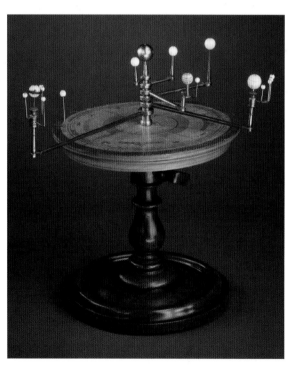

41 Benjamin Martin, orrery, 1781, wood, brass, ivory, 29.5 cm height.

I saw no luminous spot in the dark part of the moon.

C.H. 4th Comet. Apr. 17, 1790. See Sep. 4. 1791
I saw nothing luminous in the dark part of the ☽

16h 24' Sid. Time. I made Fig 1. But by a Mem. made at 17h 16, it appears that the angle should have been more obtuse than I have marked it.

17h 16 I think the angle which the two stars c & d make with the comet now, is more acute than otherwise; and by memory, I think I should have made it more obtuse in Fig. 1. than I have done.
Day light is too strong for seeing any longer.
I have added by memory, the stars passing from a to C thro' the Telescope.

Eye draught Comet α Andromeda
δ Androm.

Cor. −6' 46",6 Apr. 18, 1790
16h 5' I see the comet. It has moved from the place where it was last night; but it is too low yet to see the small stars.
16h 30' For 2 observation see Apr. 17 Fig. 2.
16h 52' The comet follows the star a 1' :: perhaps 1" ± in time.
16 52 I made the star a pass along the parallel wire, and when the comet came to the perpendicular, it was about its own diameter above the parallel wire.
Mem. I remember that I made use of a circle of cart, and a thread fixed for the parallel, & another at rectangles to it for the perpendicular; this being a clumsy contrivance made it uncertain to 1" ± in the obs. 16h 52'
The star a & comet being twice in the Fig. means, that I repeated the obs. as soon as I the star in the center.

42 Caroline Herschel, observation notes, 16–18 April 1790, brown ink on paper. MS RAS C. I/I.2, Royal Astronomical Society, London.

43 Johann Elert Bode, polar constellations, plate 3 from *Uranographia* (Berlin, 1801), engraving.

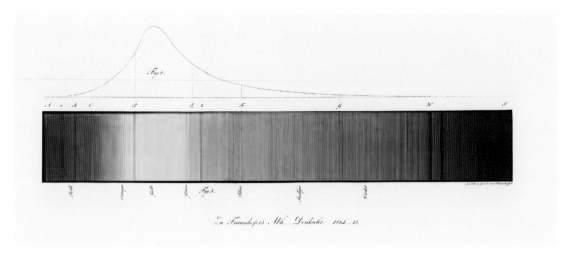

44 Joseph Fraunhofer, *Bestimmung des Brechungs- und Farbenzerstreuungs-Vermögens verschiedener Glasarten* (Munich, 1817), hand-coloured etching.

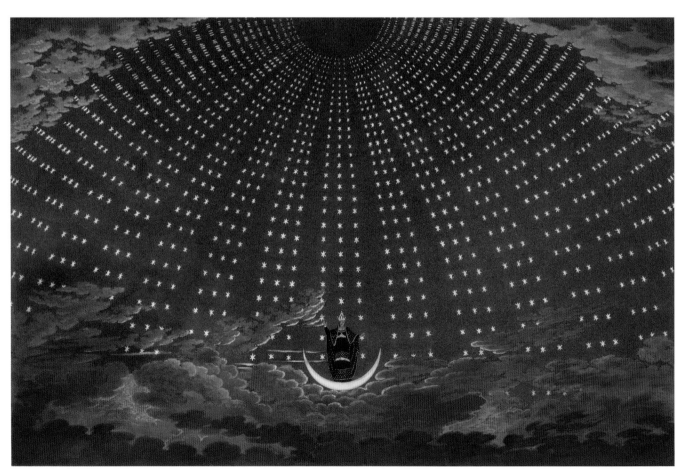

45 Karl Friedrich Schinkel, *Starry Vault of the Palace of the Queen of the Night, Act I, Scene 6 of Mozart's 'The Magic Flute'*, 1847–9, aquatint printed in colour and hand-coloured, 22.8 × 35 cm image.

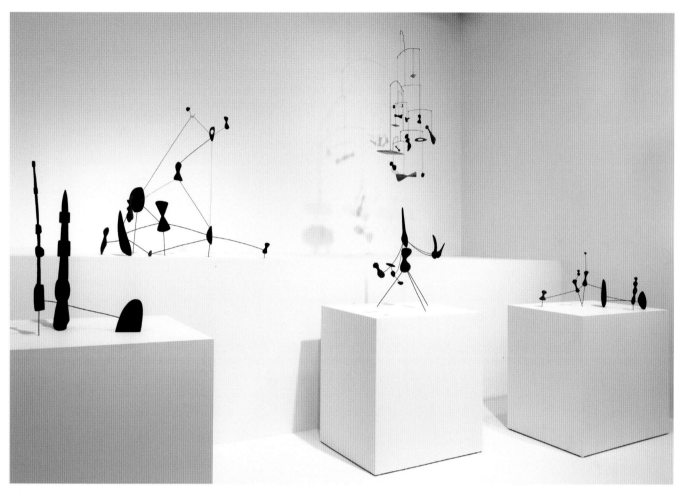

46 Alexander Calder, works from the *Constellations* series installed at Pace Gallery, New York, in an exhibition of 20 April–20 June 2017. From left: *Constellation*, 1943; *Constellation*, 1943; *Constellation*, c. 1943; *Constellation Mobile*, 1943; *Constellation*, 1943.

the Laser Interferometer Gravitational-wave Observatory (LIGO). For this discovery the project's principal scientists, Kip Thorne, Barry Barish (replacing the deceased Ron Drever) and Rainer Weiss, were awarded the 2017 Nobel Prize in Physics; their names will go down in history with Galileo's. The discovery, however, had already relegated all astronomical observations with 'photons' (that is, almost everything up to then: gamma rays, X-rays, ultraviolet, visible light, infrared, radio waves) to being merely one of three types of astronomy. A recent description of astronomy given by NASA lists the three objects of observation as 'photons, particles, and gravitational waves', apparently attributing comparable importance to each.

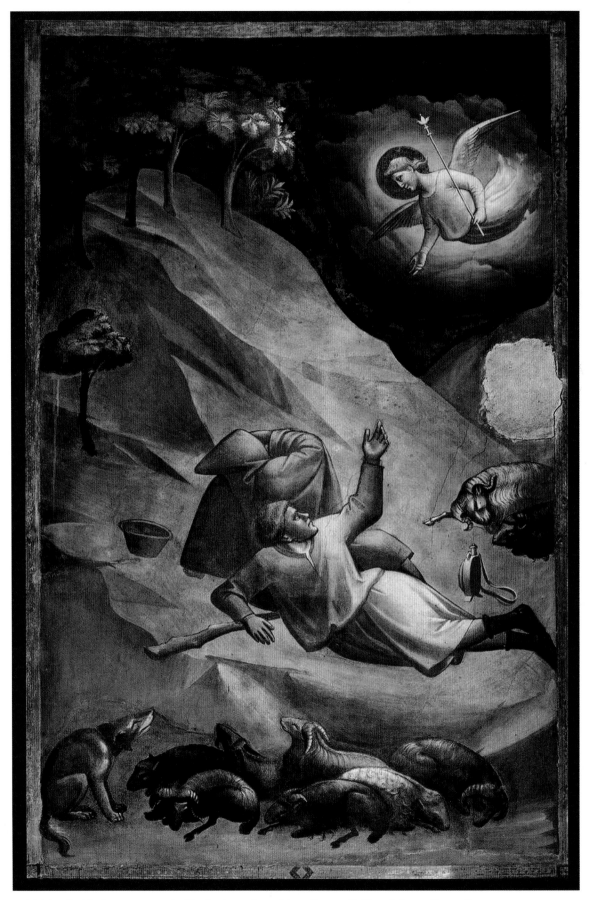

47 Taddeo Gaddi, *Annunciation to the Shepherds*, 1328–32, fresco, Baroncelli Chapel, Santa Croce, Florence.

3 The Sun and Solar Eclipses

Not all the beauty of astronomy takes place at night-time. The Sun, which lights up our sky during the day, has a beauty of its own. And the glory of a total solar eclipse makes millions cheer when they are fortunate enough to be in its narrow path.

Of all the objects in the sky, the Sun is not only the brightest but, because of its overwhelming presence, also one of the most difficult to observe in detail. Usually the Sun is too bright for scientists to see anything in its immediate vicinity. Only during eclipses does its radiant halo, the corona, become visible. Even today's images of solar eclipses reveal the difficulty in observing the everyday Sun, when open-lens camera images that include the Sun do not show its disc, merely blurring out its region in the sky. The composite image shown here incorporates several individual photos that reveal the solar corona, with streamers and polar plumes held in place by the Sun's magnetic field, imaged during the total solar eclipse of 21 August 2017, whose path of totality crossed the United States (illus. 48).

The Sun has been significant to humans since ancient times. The Greeks personified the Sun with their god Helios, and later Graeco-Roman culture had Apollo (who had superseded Sol, an older Sun god from the days of the Republic). These deities were often represented in the arts and we have derived from their names a number of current scientific terms, such as 'heliophysics', formerly known as 'solar physics'.

For centuries, astronomers have turned to eclipses to explain fundamental physics. The second-century BC Greek astronomer and mathematician Hipparchus used a solar eclipse to solve a celestial geometry problem. Watchers, artists and scientists distinguish between the everyday visible Sun and the normally hidden parts that are revealed to the eye during total solar eclipses. Both the visible and the hidden Sun have been featured in art over the millennia. Scientists now use Greek names for the parts of the Sun. The everyday solar surface, from which we get light, is known as the photosphere (from the Greek *phos*, 'light'). When that photosphere is cut off from our view by the Moon's silhouette, creating a total solar eclipse, we briefly see a reddish colour at the leading edge of the Moon, revealing the solar chromosphere (a term scientists started using in the nineteenth century, from the Greek *chromos*, colour). We see the chromosphere again when it appears on the trailing side of the lunar limb. In between, we see the beautiful halo that makes up the

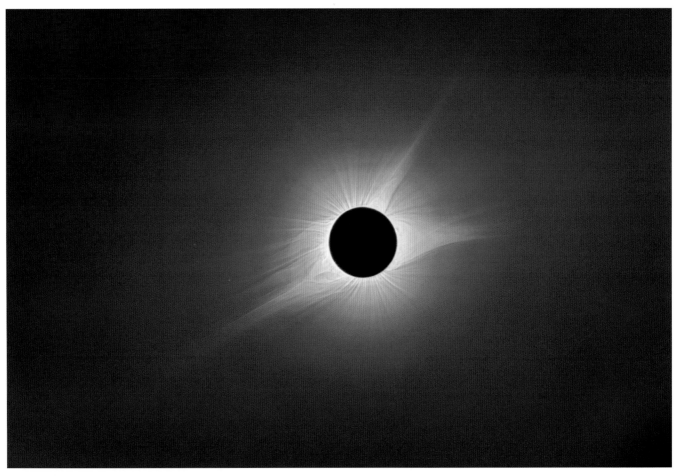

48 Williams College Expedition, total eclipse of the Sun, 2017, digital composite.

Sun's outermost atmosphere, for which we use the Latin word *corona*, meaning crown.

The solar photosphere is too bright to look at safely with the naked eye. Taddeo Gaddi's *Annunciation to the Shepherds* (illus. 47) invokes such an overwhelming solar intensity in a religious context that it conflates actual astronomical light with mystical light. The artist portrayed the light with great authenticity because he had witnessed a solar eclipse – probably the total solar eclipse of 16 July 1330 – and confessed in a letter to being partially blinded by it. He expressed that trauma in this nocturnal scene, where one shepherd shields his eyes from the unearthly light. In William Blake's frontispiece illustration to his 1795 epic, prophetic poem *The Song of Los* (illus. 49),

a Sun-like object in eclipse expresses a different kind of highly personal and arcane mysticism: here, Los (an anagram of Sol), the divine aspect of the imagination, kneels in veneration before an altar or his smithy.

The disc of the Sun can, however, be viewed safely without any filtering when there is sufficient haze in the sky or when the Sun is viewed near sunrise or sunset through sufficient atmosphere. Even Claude Monet's painting *Impression, Sunrise* (1872; Musée Marmottan, Paris) – the work which led art critic Louis Leroy, in a review in *Le Charivari*, to coin the term 'Impressionism' for the movement of the same name – shows the Sun visible through low-altitude haze (as well as the Sun's reflection in the water of the harbour of Le Havre, France).

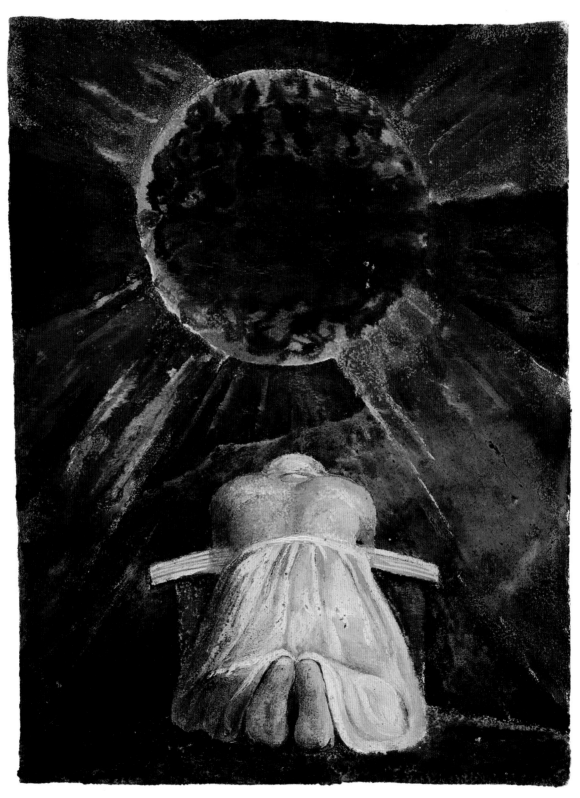

49 William Blake, frontispiece from *The Song of Los*, 1795, watercolour, gouache and ink on paper. Bentley copy E, The Huntington Library, San Marino, California.

By contrast, Van Gogh's *Willows at Sunset* (1888; Kröller-Müller Museum, Otterlo) has a low-sunset reveal, with the artist amplifying the power of the Sun and landscape elements through exaggeration and use of saturated colour, even drawing in what are supposed rays of light, for expressive effects. In daytime scenes, Van Gogh frequently represented the power of the Sun, which fascinated him – as well as other celestial bodies in many of his works – to express his strong emotional response to nature. He used bold colours and broken brushstrokes to communicate their dynamic, pulsing power and creative force, seen also in *The Starry Night* (see illus. 246).

The Sun, of course, gives off light from every bit of its surface, so when artists of all ages draw rays coming out of the Sun, they are merely illustrating that the Sun shines. Such figurative solar rays have been employed by numerous artists, such as the literal and amusing form lent to it by the Surrealist Giorgio de Chirico in his *Sun on the Easel* (1973; Fondazione Giorgio e Isa de Chirico, Rome). In his bronze *Day* (illus. 50), the American Art Deco sculptor Paul Manship employed similar solar rays in a highly decorative, stylized fashion.

Telescopic study of the Sun can be traced – as can so many telescopic discoveries – to Galileo Galilei in the early seventeenth century. Galileo's ink drawings of the Sun from 1612 show the solarspots on which he elaborated in his book *Istoria e dimostrazioni intorno alle macchie solari* (Letters on Sunspots) of 1613. Galileo's dozens of almost daily drawings, engraved by Matthaeus Greuter, demonstrated the rotation of the Sun (illus. 51).

Donato Creti's canvas *Sun* (illus. 52), dating from a hundred years later, features a telescope of the time being used to project a solar image, since a projection onto a dull (not very reflective) surface is safe to look at, even when the Sun is too bright to look at safely without special filtering. This extraordinary painting was part of

50 Paul Manship, *Day*, 1938, bronze, 34.3 × 66.7 cm.

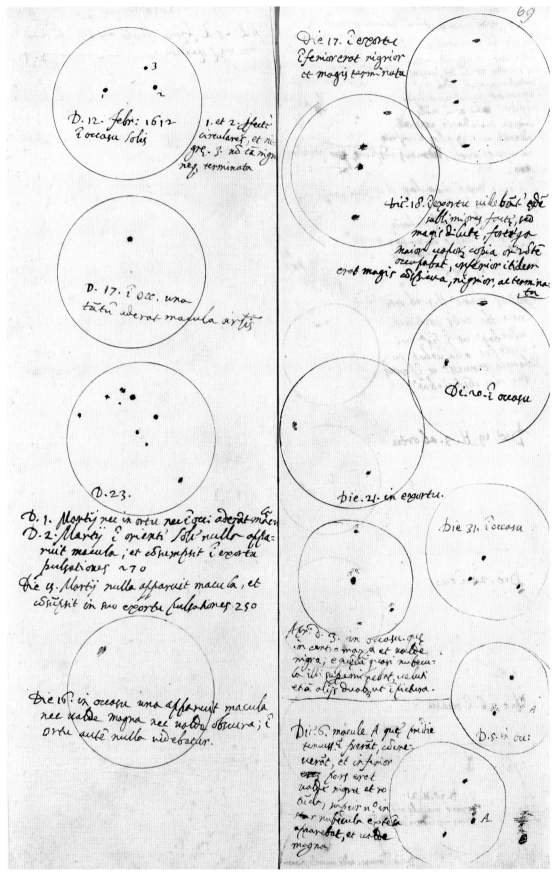

51 Galileo Galilei, sunspots, observed from 12 February to 1 May 1612, brown ink on paper. MS GAL 57, folio 69r,
Biblioteca nazionale centrale, Florence.

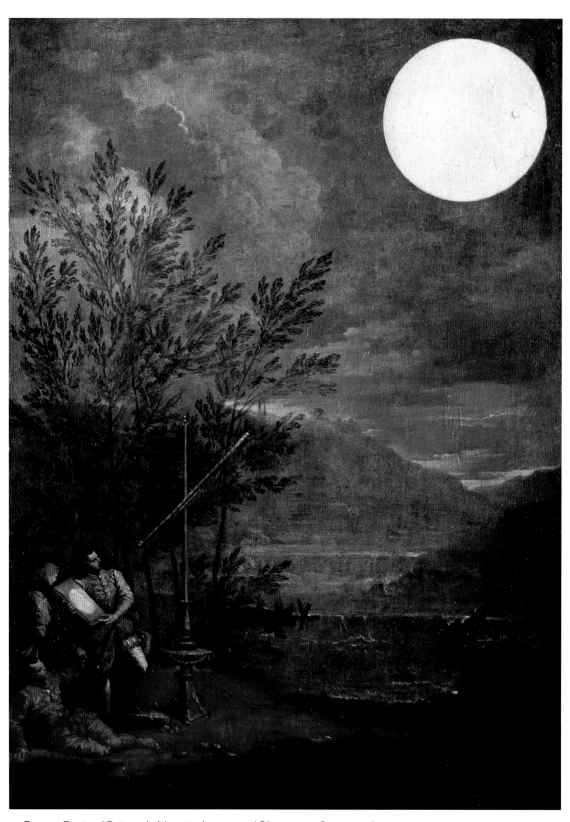

52 Donato Creti and Raimondo Manzini, *Astronomical Observations: Sun*, 1711, oil on canvas, 51 × 35 cm.

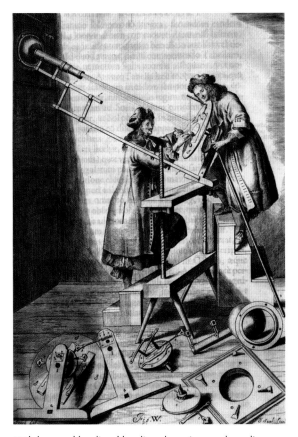

53 Johannes Hevelius, *Hevelius observing a solar eclipse by projection into a darkened room*, from *Machina coelestis* (Danzig, 1673), engraving.

54 Gossuin de Metz, solar eclipse, detail from *Image du monde*, 1320, watercolour on parchment. MS Français 574, folio 103r, Bibliothèque nationale de France, Paris.

a series of astronomical observations commissioned by Count Luigi Ferdinando Marsili, a soldier, passionate naturalist and amateur astronomer who hoped to use them to convince Pope Clement XI to support the construction of an observatory in Bologna to house his instruments (see also illus. 116). It was this method of projection that was no doubt used by Galileo as well, and by Jeremiah Horrocks in 1639 to view the transit of Venus across the face of the Sun, the subject of a mural in Manchester City Hall from a later century. Johannes Hevelius, in his *Machina coelestis* (1673–9), illustrated in the first volume another projection method used to view a solar eclipse (illus. 53).

The relation of the Sun and the Moon that creates a solar eclipse has been understood since the time of

Stonehenge's earliest epoch, perhaps as early as 2500 BC, or even before. We now know that the Sun's measurements equal over 100 Earths or 400 Moons across, and that the Sun is also 400 times further away from the Earth than is the Moon. Thus, the Sun and the Moon appear to subtend the same angle in the sky, about half a degree of arc. The angular sizes agree to within about 10 per cent because of the elliptical orbits of the Moon around Earth and of Earth around the Sun. When the Moon entirely covers the bright solar disc, we have a total eclipse. When the Moon's angular size is a little too small to cover the entire bright solar disc, an annulus or ring of everyday bright sunlight remains, resulting in an annular eclipse.

The cause of a solar eclipse was accurately diagrammed on parchment during the fourteenth century

55 Beatus de Liébana and S. Hieronymus, solar and lunar eclipses, from *Commentarius in Apocalypsin* (Apocalypse of Saint-Sever), 11th century, watercolour on parchment. MS Latin 8878, folio 141r, Bibliothèque nationale de France, Paris.

56 Taddeo Gaddi, wing of a triptych: *The Crucifixion*, c. 1330–34, tempera and gold leaf on panel, 39.5 × 13.9 cm.

57 Giovanni di Paolo, eclipse, from Dante's *Divina Commedia*, c. 1444–50, watercolour on parchment. Yates Thompson MS 36, folio 132, British Library, London.

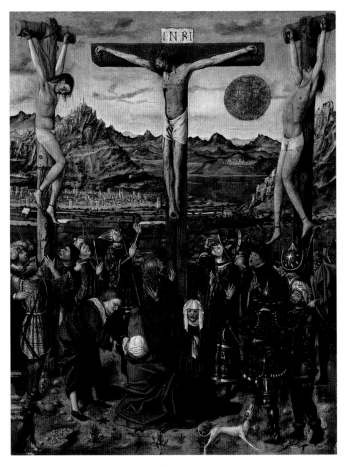

58 Anonymous Valencian artist, *The Crucifixion, c.* 1450–60, oil on panel, 44.8 × 34 cm.

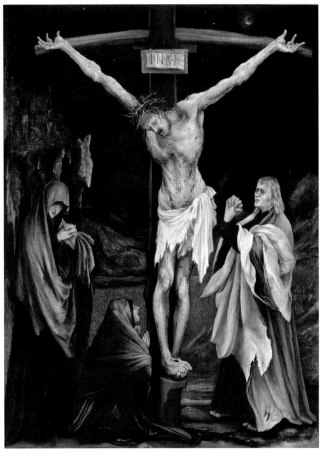

59 Matthias Grünewald, *The Small Crucifixion, c.* 1511–20, oil on panel, 61.3 × 46 cm.

by Gossuin de Metz in his *Image du monde* manuscript illumination (illus. 54). Gossuin depicted the syzygy – a lining up of three celestial objects – that causes a solar eclipse. It represents a considerable improvement on the more figurative and less scientifically aligned depictions of solar and lunar eclipses in the eleventh-century manuscript illumination *Apocalypse of Saint-Sever* (illus. 55). Four centuries later, Giovanni di Paolo depicted a solar eclipse in a manuscript illumination for Dante Alighieri's *Divina Commedia* (illus. 57).

Over the centuries, some Christians have believed that a solar eclipse occurred at the time of Jesus's crucifixion, though despite centuries of research and traditional planetarium Christmas shows, there may well not have

been an actual astronomical event at that historical time. It was common practice to invoke a celestial event to mark a terrestrial one, even if there was no actual correspondence. In the mid-fourteenth century Taddeo Gaddi painted a powerful scene of *The Crucifixion* on the interior of the right shutter of a devotional triptych (illus. 56); this rare portrayal of a solar eclipse captures the daytime darkness which the Gospels of Mark, Matthew and Luke describe as occurring during that event. At the summit of the pointed gable, instead of applying gold ground, Gaddi painted a dark blue lapis lazuli wedge with a border of silver – now oxidized, but which would once have been electric – to simulate the moment of totality. We know that the artist was temporarily blinded

by a solar eclipse, and he translated his experience of totality in this revolutionary way. His depiction of the eclipse, which symbolizes the cosmos in chaos, also reveals the nascent interest in observing natural phenomena that was emerging during the early Italian Renaissance.

In subsequent centuries, the tradition of including a solar eclipse or a single Sun without the Moon at the Crucifixion continued (illus. 58). In the sixteenth century, we find Matthias Grünewald's *The Small Crucifixion* (illus. 59) showing the time just before the emergence of the ordinary solar disc from totality, as shown by the brightening at lower left of the lunar silhouette. Peter Paul Rubens painted a prominent solar eclipse in his

major triptych altarpiece for Antwerp Cathedral, the *Raising of the Cross* (illus. 60), as well as in his *Coup de lance* (1619–20; Koninklijk Museum voor Schone Kunsten, Antwerp). Other artists followed suit, among them Philippe de Champaigne, who included a partial solar eclipse in his *Crucifixion* (1655; Musée Grenoble), Mathieu Le Nain (1635–40; private collection) and Jusepe de Ribera (1643; Museo Diocesano de Arte Sacro, Vitoria, Alava, Spain).

Often a Sun-Moon-Earth syzygy is not perfectly aligned, resulting in only a partial eclipse being seen from Earth, as happened on three occasions in 2018. Further, viewers situated off the central line of a total or annular eclipse experience only a partial eclipse.

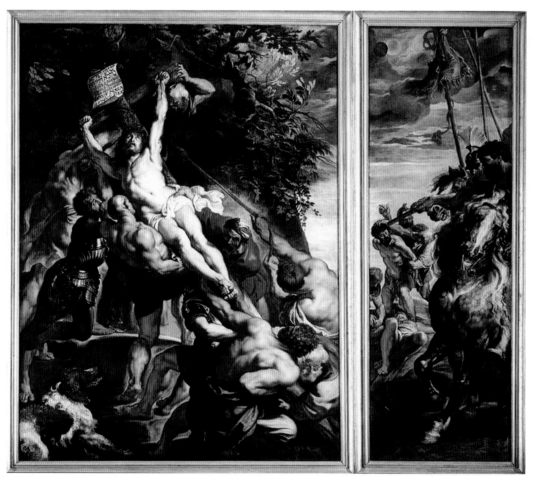

60 Peter Paul Rubens, *Raising of the Cross* (two panels of a triptych), 1611, oil on panel, 4.6 × 3.4 m centre, 4.6 × 1.5 m wing. Vrouwekathedraal, Antwerp.

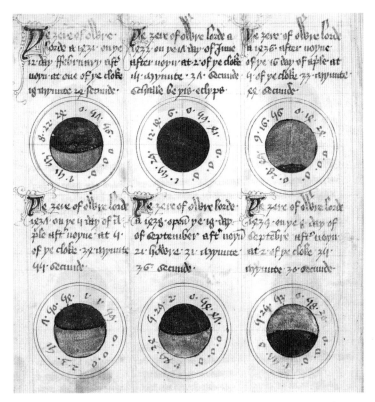

61 Solar eclipse from a physician's folding almanac, 1430–31, watercolour and ink on parchment. MS Harley 937, folio 8r, British Library, London.

62 Christianus Prolianus, *tabulae eclipsium*, part 5 from Joachinus de Gigantibus, *Astronomia*, 1478, watercolour on parchment. Latin MS 53, folio 71r, Ryland Medieval Collections, University of Manchester.

63 Jakob Pflaum, solar eclipses from *Calendarium* (Ulm, 1478), woodcut.

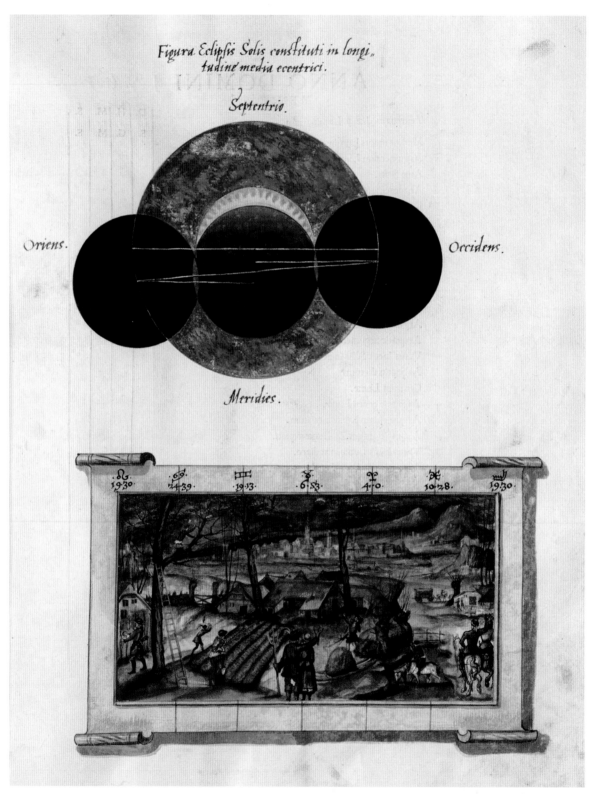

64 Cyprián Karásek Lvovický, predicted partial solar eclipse on 8 April 1567, from *Eclipses luminarium*, 1555, watercolour on parchment. MS Cod. icon. 181 (HSS), folio 21r, Bayerische Staatsbibliothek, Munich.

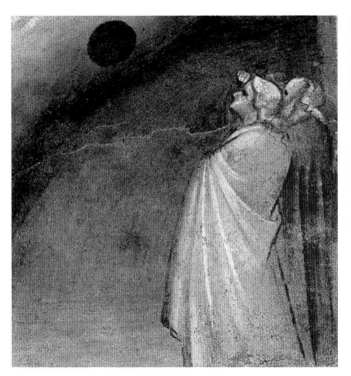

66 Raphael and workshop, *Isaac and Rebecca Spied upon by Abimelech*, 1518, fresco, Loggia of Leo x, Vatican, Rome.

65 Andrea di Cione (Orcagna), fragment of *The Triumph of Death*, showing a solar eclipse, *c.* 1350, fresco, Museo dell'Opera, Santa Croce, Florence.

Examples of such off-axis diagrams of eclipses include a fifteenth-century image in a physician's almanac (illus. 61) and woodcuts from the German astronomer Regiomontanus' *Calendarium* (1476), which – among eclipses of the time – also included a lunar eclipse from thirty years later. From about the same time, Christianus Prolianus' diagrams (illus. 62) and Jakob Pflaum's *Calendarium* (illus. 63) provided series of images of partial solar eclipses.

In the sixteenth century, the Bohemian astonomer Cyprián Lvovický's *Eclipses luminarium* showed the lunar silhouette moving across the Sun to make an eclipse (illus. 64), using a style akin to modern computer compounding of several images. As previously noted, Petrus Apianus' massive *Astronomicum Caesareum* from 1540 includes eclipse calculators with volvelles (see illus. 27).

Probably the most successful early depiction of a total solar eclipse appears in a fragment of the decorative border that once framed the now damaged *Triumph of Death* (illus. 65) by Andrea di Cione, better known as Orcagna. It was painted after the decimating Black Death of 1348 and reflects both the apocalyptic tenor of the times and the early Renaissance interest in observation that Gaddi had earlier preserved in his two eclipse portrayals, as discussed above. Moreover, Orcagna included two men shielding their eyes to gaze at the unearthly light. Almost two hundred years later, Raphael frescoed a small scene depicting *Isaac and Rebecca Spied upon by Abimelech* that features a solar eclipse with a silhouetted Moon and a coronal glow around it (illus. 66). It is probably based on an annular eclipse that the artist observed on 8 June 1518, and that he 'corrected' to show totality and the Sun's corona, the pearly halo circling the Sun that appears around the lunar silhouette at a total eclipse. As we have argued in earlier publications, Raphael's interpretation of Genesis 26:7–8

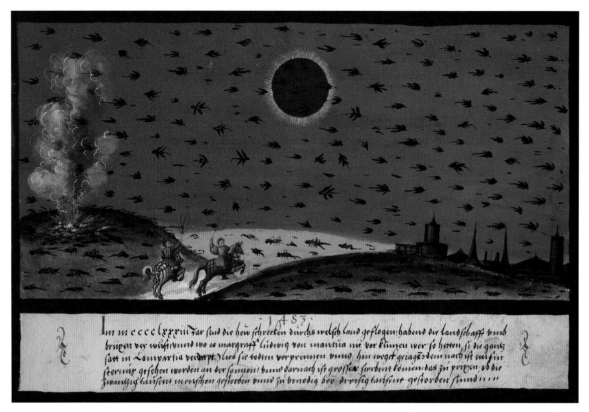

67 Unidentified artist, solar eclipse of 1483, folio 87 from the *Augsburg Book of Miracles* (*Augsburger Wunderzeichenbuch*), c. 1550, watercolour, gouache and black ink on paper. The Cartin Collection.

shows Isaac and Rebecca exploiting the temporary darkness of a solar eclipse to conceal their amorous assignation, which Abimelech nevertheless observed. Another eclipse, by an anonymous artist from 1550 in a German Book of Miracles, purports to show the solar eclipse recorded in 1483 (illus. 67). Although it contains the white solar corona surrounding the Moon, as seen at all total solar eclipses, its illustrator also included other reported portentous events: the plague of locusts seen in Lombardy the same year, followed by a 'great dying' of 50,000 people. Johannes Kepler, in his treatise *Optics* of 1604, seems to have been the first person to comment on this corona.

The French Mannerist artist Antoine Caron included an unorthodox solar eclipse (or possibly another celestial phenomenon) in his enigmatic painting *Astronomers Studying an Eclipse* (illus. 68). The real solar corona

is not yellowish as Caron represented it, and the painting's sky and clouds seem stylized. Nevertheless, aside from the colour, the shape of the Sun and its surround resembles the solar corona during totality that photographs show today. Did Caron – court painter to Queen Catherine de' Medici of France – make a leap and depict actual astronomers observing a solar eclipse? Even though his subject involves ancient Greeks, Caron's painting reveals that he may have witnessed the total eclipse of 25 January 1571. In the foreground, a philosopher looks at the sky and points to an armillary sphere. Next to him, Dionysius the Areopagite, who preaches Christianity, points to the sky and looks at the celestial globe carried by another figure, suggesting that Caron was portraying an astronomical event. A statue of Urania, the Muse of astronomy (see Chapter One), stands on a twisted column in the background. Note the telling

68 Antoine Caron, *Astronomers Studying an Eclipse (Dionysius the Areopagite Converting the Pagan Philosophers)*, c. 1570–80, oil on panel, 92.7 × 72.1 cm.

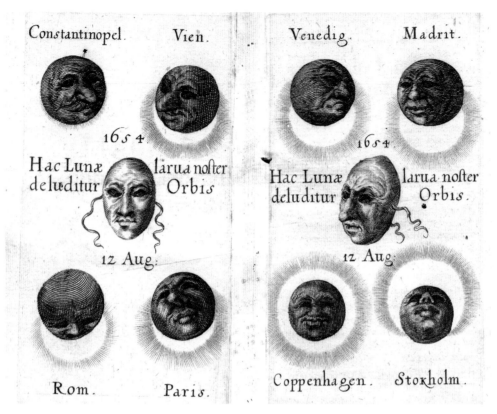

69 Jakob Balde, solar eclipse of 12 August 1654, from *De eclipsi solari . . . libri duo* (Munich, 1662), engraving.

absence of a telescope, an apparatus not invented for another 25 years or so.

With the advent of the more scientifically geared seventeenth century, a wider variety of eclipse images was produced, among them Jakob Balde's series of eclipses, some partial and at least one total showing a corona (illus. 69). Astronomer Johannes Hevelius, noted for discovering the details of Saturn's rings, painted a watercolour vignette showing himself observing a partial eclipse using a small telescope, also described in his accompanying letter (illus. 70). Though another illustration (see illus. 53) shows a projection device for safely observing eclipses, no specific mention of eye protection appears, since such a projected image is safe to look at without a special filter.

The watershed for eclipse observation came with Astronomer Royal Edmond Halley's broadside publication predicting the path of the May 1715 eclipse

(illus. 71). It marked the first time that the lunar umbra's path across the Earth's surface was shown. In the text below the illustration, Halley asked for what we now call 'citizen science': he requested that people send their actual observations to him. His predictions were off by only about 30 kilometres (20 mi.) and four minutes, but he produced a sequel with a map that corrected the path of the 1715 eclipse and showed that of the 1724 eclipse, which passed across England to continental Europe. With twenty-first-century, three-dimensional topographic mapping of the lunar surface from the Japan Aerospace Exploration Agency's *Kaguya* (SELENE) satellite and NASA's *Lunar Reconnaissance Orbiter*, astronomers have drastically improved on Halley's accuracy. They can now predict the time of an eclipse – including the appearance of Baily's beads, the last bits of everyday sunlight shining through the deepest valleys on the lunar limb during annular or total eclipses of the Sun and the

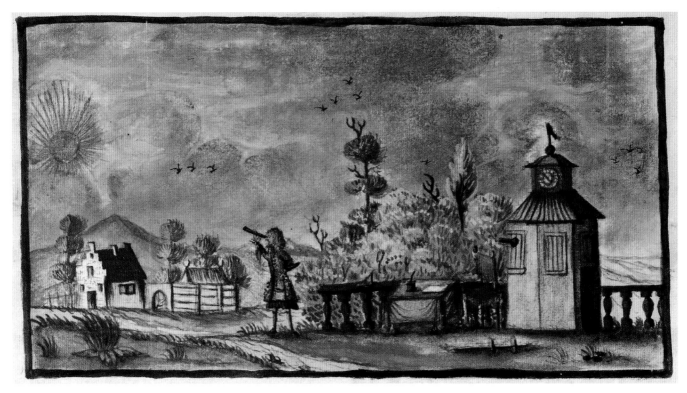

70 Johannes Hevelius, detail of a letter with Hevelius observing a partial solar eclipse, 29 April 1676, watercolour and ink on paper, Bibliothéque de l'Observatoire de Paris.

diamond-ring effect that arises from the alignment of valleys on the lunar edge – to a tenth of a second.

That same 1715 eclipse that Halley observed was portrayed by an unidentified artist in a canvas that includes the Paris observatory building in the background and fervid observers in the foreground (illus. 72). Previously, the painting had been misidentified as showing the 1724 eclipse, which passed near Paris, but the time of day in the painting matches the earlier event.

Most eclipse images up to this time were not convincing, especially those purporting to show totality. Only with the German Baroque altarpiece *Vision of St Benedict* by Cosmas Damian Asam from 1735, in a Bavarian church in Weltenburg (illus. 74), with its dazzling ray coming (slightly inaccurately) from the lunar disc, do we find an artist convincingly rendering totality followed by the diamond-ring effect (illus. 73). As we have demonstrated in several articles, Asam viewed a

number of solar eclipses (in 1706, 1724 and 1733), recording them in a series of works, some with St Benedict, with increasing accuracy. He may have also known the eclipse maps of Halley and others. Asam, who often worked with his brother, the sculptor Egid Quirin Asam, harnessed his eclipse observations to visualize St Benedict's heavenly vision of the divine light as described in the sixth-century *Dialogues* of St Gregory the Great.

During the eighteenth century, the fascination with solar eclipses continued. The astronomer and mathematician Johann Gabriel Doppelmayr's *Atlas Coelestis* was published posthumously in 1742. Beginning in 1707, his ideas on eclipses were published earlier by others, such as Carel Allard (illus. 76). James Ferguson's 'Eclipsareon', which is preserved in an etching, was a mechanical device that could duplicate the circumstance of an eclipse syzygy (illus. 75). It was intended to allow lecturing astronomers to demonstrate the mechanics of eclipses

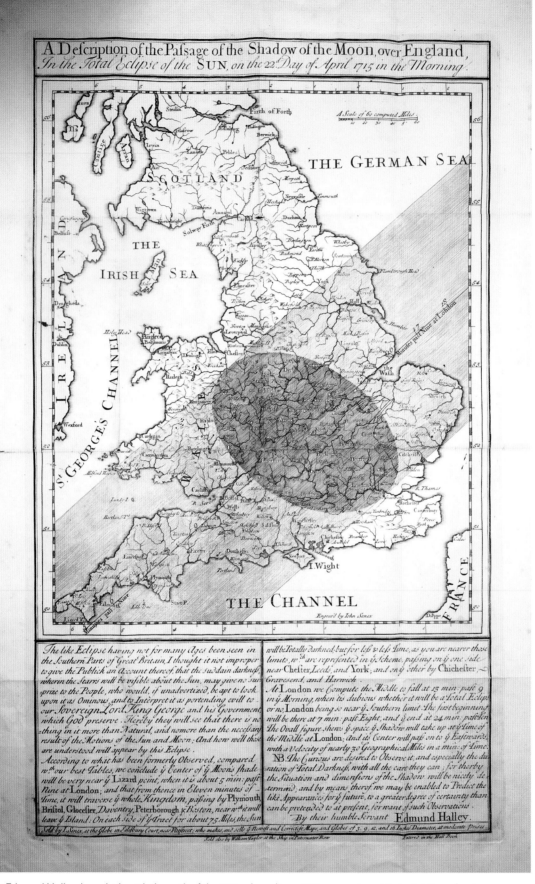

71 Edmond Halley, broadside with the path of the 1715 solar eclipse, 1715, engraving, 40.4 × 24.7 cm sheet.

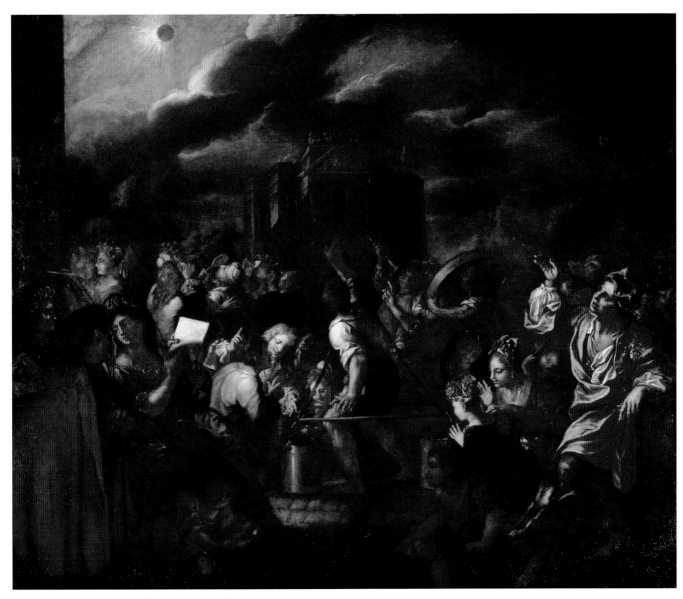

72 Unidentified artist, *Solar Eclipse of 1715 with Paris Observatory*, c. 1715, oil on canvas, 155 × 180 cm.

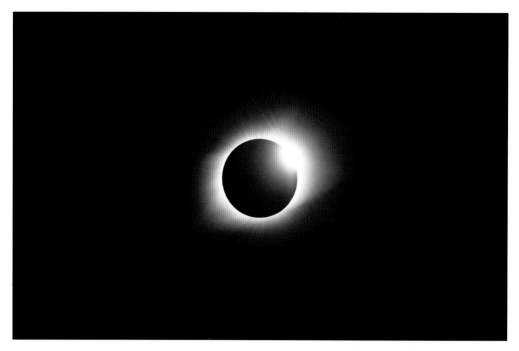

73 Williams College Expedition, solar eclipse with diamond-ring effect, showing a bit of reddish chromosphere.

74 Cosmas Damian Asam, *Vision of St Benedict*, 1735, oil on canvas, 2.71 × 1.33 m. Benediktiner-Kloster-und Pfarrkirche Sankt Georg und Sankt Martin, Weltenburg, Germany.

75 James Ferguson, 'The Eclipsareon', plate XIII from Ferguson and Jeremiah Horrocks, *Astronomy Explained upon Sir Isaac Newton's Principles, and Made Easy to Those Who Have Not Studied Mathematics . . .* (London, 1790), engraving.

76 Carel Allard (after Doppelmayr), detail of celestial map
showing the path of totality of the solar eclipse of 12 May 1706,
from *Planisphaerii coelestis hemisphaerium*, print mounted on cloth.

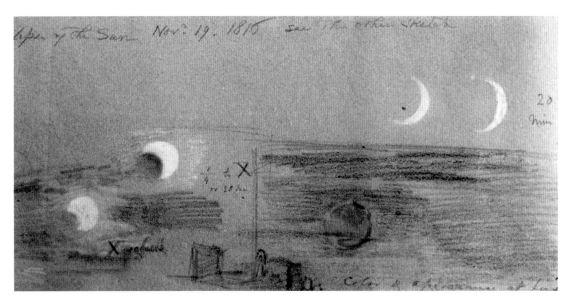

77 John Linnell, *Studies of the Solar Eclipse of 19 November 1816*, 1816, coloured chalks on paper, 13.2 × 27 cm irregular.

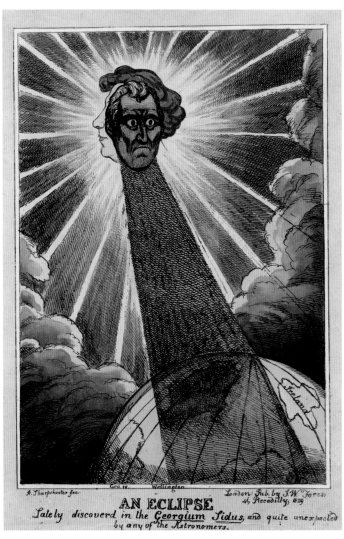

78 Unidentified artist, *An Eclipse Lately Discovered in the 'Georgium Sidus'*, c. 1830, hand-coloured engraving, 35.3 × 24.7 cm.

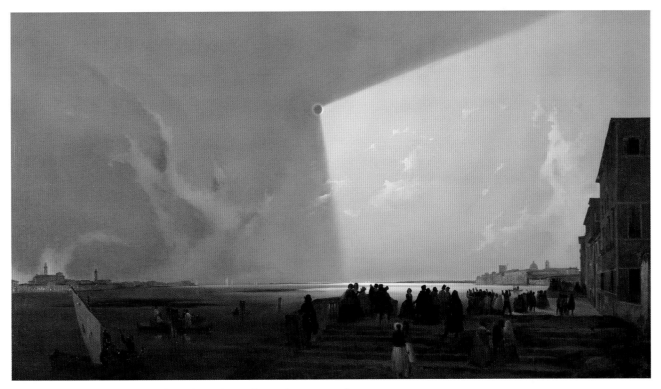

79 Ippolito Caffi, *Solar Eclipse of 8 July 1842, Venice*, 1842, oil on canvas, 84 × 152 cm.

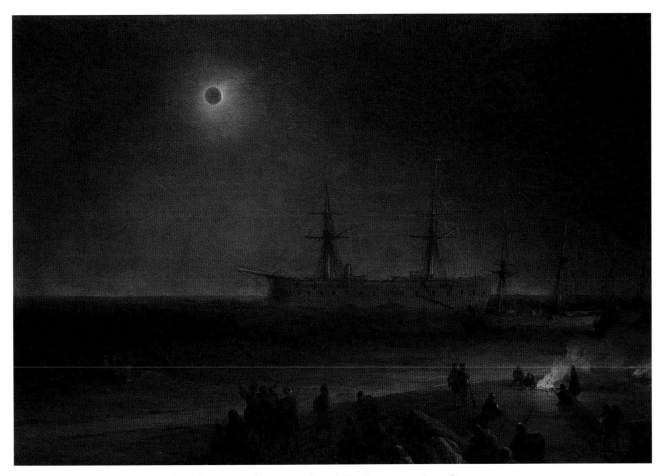

80 Ivan Konstantinovich Aivazovsky, *Solar Eclipse in Feodosia in 1851*, 1876, oil on canvas, 81 × 118 cm.

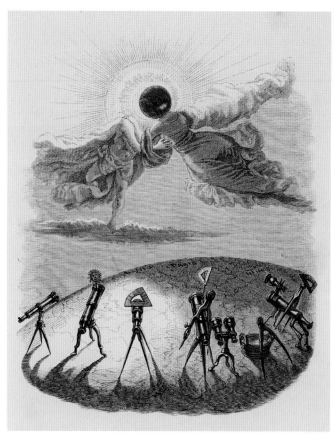

81 J. J. Grandville, 'Une éclipse conjugale', from *Un autre monde* (Paris, 1844), wood engraving.

82 Étienne Léopold Trouvelot, *Solar Protuberances* [prominences, in modern terminology], observed on 5 May 1873, plate II from *The Trouvelot Astronomical Drawings Manual* (New York, 1881), chromolithograph, 94 × 71 cm.

to a public that was keen to learn about astronomy and the new discoveries in the field.

The era of scientific understanding of the Sun dawned with the nineteenth century and its transition from recording astronomical phenomena via draughtsmanship to photography. Early in the century, the noted English landscape painter John Linnell drew images of the partial solar eclipse of 1816, which he viewed from London near sunrise, in coloured chalk (illus. 77). We know from the second of this group of three drawings of the same eclipse, held in the British Museum, that he drew it from No. 2 Streatham Street, Bloomsbury. Totality for that eclipse passed through Scandinavia and Eastern Europe.

An anonymous artist with the pseudonym 'sharpshooter' created an amusing political satire employing eclipse imagery in around 1830 (illus. 78). The hand-coloured print is entitled *An Eclipse Lately Discovered in the 'Georgium Sidus'*, this last the name originally used by the astronomer William Herschel forty years earlier for the planet he discovered: what we now call Uranus. The image shows the Duke of Wellington, a highly popular figure, eclipsing King George IV.

The total eclipse of 8 July 1842 precipitated realistic paintings of the Sun with its corona, among them a dramatic view by Leander Russ (private collection). For dramatic effect, the Italian artist Ippolito Caffi emphasized and sharpened the difference in the sky between

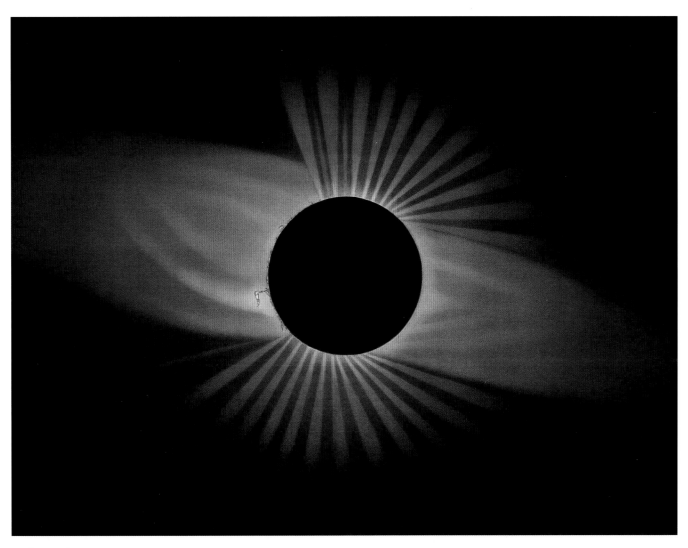

83 Étienne Léopold Trouvelot, *Total Eclipse of the Sun*, observed 29 July 1878 at Creston, Wyoming Territory, plate III from *The Trouvelot Astronomical Drawings Manual* (New York, 1881), chromolithograph, 71 × 94 cm.

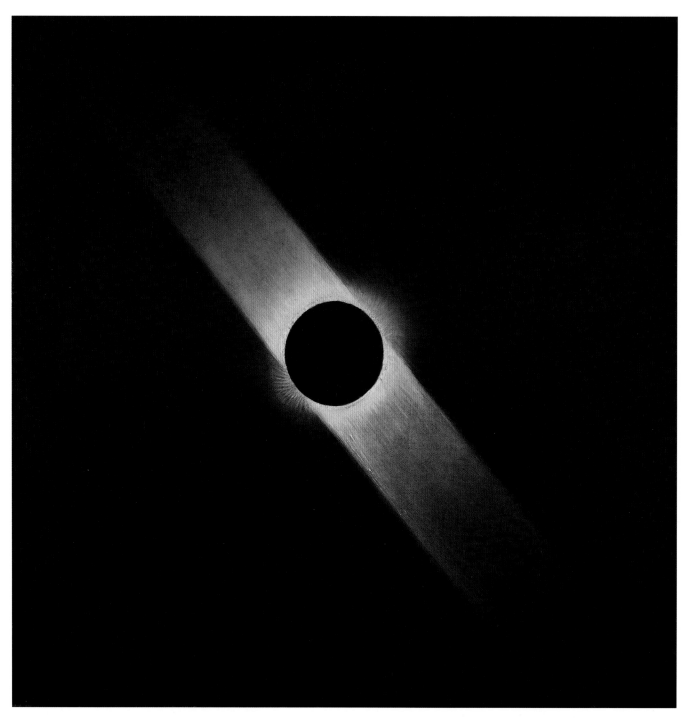

84 Henry Harrison, *Annular Eclipse with Equatorial Streamers, 29 September 1875, from Jersey City, NJ*, oil on canvas, 63.5 × 63.5 cm.

85, 86 Diego Rivera, *Portrait of Ramón Gómez de la Serna*, 1915, oil on canvas, 109.6 × 90.2 cm.
Above: detail of the eye.

the umbral shadow and the relative brightness of the penumbra in his *veduta* of the eclipse over Venice (illus. 79), while about 25 years after the total solar eclipse of 8 July 1851 in Feodosia, the Crimea, Ivan Konstantinovich Aivazovsky painted the event during totality, probably basing it on sketches he had made at the time (illus. 80). The French illustrator J. J. Grandville's 'A Conjugal Eclipse', from his imaginative masterpiece *Un autre monde* (Another World) of 1844, sounds a lighter note, amusingly portraying an eclipse as a love affair (illus. 81).

One of the most notorious stories linked to astronomy is that of the scientist and artist Étienne Léopold Trouvelot, whose family fled to the United States following the 1851 coup d'état in France. In the 1860s Trouvelot was experimenting on gypsy moths and some escaped, leading to the horrible situation of gypsy-moth infestations that Americans continue to suffer yearly, over 150 years later, in large parts of the United States. Distraught over this serious error, Trouvelot turned away from biology to astronomical art, producing a wonderful set of pastels of celestial phenomena that were replicated in a series of high-quality chromolithographs. He created them using a grid embedded in his telescope, which enabled him to accurately transfer the image he was viewing to his gridded paper. Trouvelot's series of fifteen astronomical phenomena was published by Charles Scribner's Sons in 1881, just as astronomical photography was beginning to take hold. In 1873 he used a spectograph for his observations that showed only the red light of hydrogen, allowing him to draw what we call 'solar prominences' (sometimes wrongly called 'solar protuberances') extending some 160 kilometres (100 mi.) high over the solar limb. He represented a small area of the Sun's edge with prominences observed on 5 May 1873 (illus. 82). The prominences are shaped and held in place suspended above the Sun by the magnetic field. He also depicted a solar eclipse with wide streamers at the Sun's equator and plumes at the solar poles (illus. 83), all held in place by the coronal magnetic field. His image was based on the American eclipse of 29 July 1878 as observed from Creston, Wyoming Territory (later the state of Wyoming).

The 160-kilometre-wide path of the total eclipse of December 1870 passed through Gibraltar and North Africa. Paul Jacob Naftel, from Guernsey, painted a watercolour of *Solar Eclipse and Old Glory* (Royal Astronomical Society, London), from which an engraving was made. In the foreground a group of people with telescopes observe totality through a clouded sky.

The title of Henry Harrison's painting *Annular Eclipse with Equatorial Streamers, 29 September 1875, from Jersey City, NJ*, cannot be correct, since it depicts a total eclipse (illus. 84). The two closest American total eclipses – the only type with coronal streamers – were in 1869 and 1878. There was, however, an annular eclipse of that date that went through Albany, New York, but not Jersey City. Harrison must have copied his totality image from another source, possibly thinking, mistakenly, that though his 90 per cent coverage of the solar diameter wouldn't show the solar corona, annularity would.

There are also fascinating 'eclipse comets', that is, comets discovered when totality darkens the sky. One is preserved in a photograph by Arthur Schuster showing the solar corona from Egypt in 1882 (see illus. 293). This eclipse comet looks like a genuine comet, though others have turned out to be 'coronal mass ejections', the occurrence of which was only properly appreciated using data from a U.S. Naval Research Laboratory coronagraph mounted on the Solar and Heliospheric Observatory, launched by the European Space Agency in 1995.

In 1915 the Mexican artist Diego Rivera painted a portrait of Ramón Gómez de la Serna, a well-known Spanish dramatist and writer (illus. 85, 86). The glint in the sitter's eye assumes the shape of the corona during totality at a solar eclipse. Indeed, Gómez de la Serna had mentioned an eclipse in one of his 'Greguerías', or aphoristic poems: 'After the eclipse, the Moon washes its face to clean up the soot.' Subsequently, Rivera himself became an eclipse aficionado. On 31 August 1932, when he was painting murals for the Detroit Institute of Art, Rivera, with his wife Frida Kahlo and others, rushed

87 George Grosz, *Eclipse of the Sun*, 1926, oil on canvas, 207.3 × 182.5 cm.

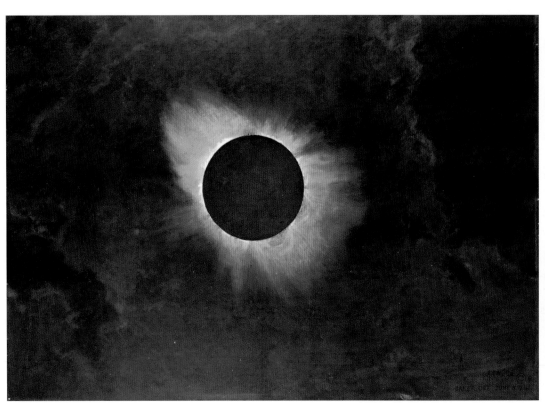

88 Howard Russell Butler, *Triptych: Solar Eclipses of 1918, 1923, 1925*, 1926, oil on canvas; left panel: 173 × 248 cm; centre panel: 241 × 170 cm; right panel: 165 × 234 cm. American Museum of Natural History, New York.

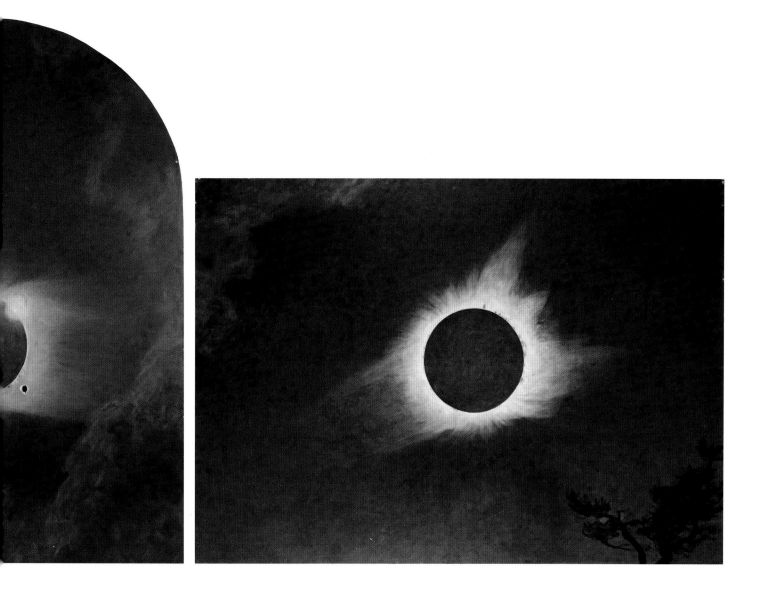

89 Nicholas Roerich, *Prince Igor's Campaign*, 1942, tempera on canvas, 91.4 × 127 cm.

out to the roof to observe the solar eclipse; they would have seen only partial phases from Michigan, when totality went through Maine. Until that time the artist seems not to have been in the paths of any total or annular eclipses, but he was attracted to their symbolic and literary concepts.

Many artists in the early twentieth century used eclipse images as symbols. For example, the Swiss-German artist Paul Klee, who was fascinated by astronomical imagery, painted a watercolour depicting totality and explosions that echo the battles of the First World War: *Solar Eclipse* (1918; private collection). Klee could have travelled not too far from his home in Munich to see the 21 August 1914 total solar eclipse, which occurred soon after the war erupted. Totality was visible from Scandinavia and what are now Belarus and Ukraine, though it was cloudy in Crimea, along with the war preventing a crucial test of the new 'general relativity' theory of Albert Einstein. When the German Expressionist artist George Grosz rendered his nightmarish *Eclipse of the*

Sun in 1926, he used the event as a potent iconographical metaphor about the evil that can happen when the light of truth is obscured (illus. 87). There was no total eclipse whose path of totality went near Germany, so Grosz harnessed eclipse symbolism for its dramatic impact in this bizarre and socially critical work that portrays the warmongering of arms manufacturers.

The American Howard Russell Butler, who had a physics degree from Princeton, retrained as an artist with the landscape painter Frederic Edwin Church in Mexico. Butler was invited to join the U.S. Naval Observatory on its eclipse expedition to Oregon in 1918 because he was noted for being able to make quick sketches and later transform them into finished oil paintings, describing his methods in articles. At the time, his methods rendered more precise results than photography, but would eventually bow to the increasing accuracy of the camera. Butler became fascinated with solar eclipses and portrayed others that occurred in 1923 and 1925, creating a triptych that was installed for

90 Paul Nash, *Eclipse of the Sunflower*, 1945, oil on canvas, 71.1 × 91.4 cm.

91 Charles Rain, *The Eclipse*, 1946, oil on board, 45.7 × 61 cm.

92 Robert Delaunay, *Circular Forms, Sun No. 2*, c. 1912–13, acrylic on canvas, 100 × 68.5 cm.

93 Roy Lichtenstein, *Eclipse of the Sun*, 1975, oil and magna on canvas, 101.6 × 177.8 cm.

decades at the entrance to the American Museum of Natural History's Hayden Planetarium in New York City (illus. 88). He also painted half-size versions, of which there are sets at the Buffalo Museum of Science, Princeton University, and the Franklin Institute in Philadelphia, plus a single eclipse canvas at the Staten Island Museum, New York City. Later, Butler also painted the eclipse of 1932 when it passed over his studio on the Maine coast.

Mid-twentieth-century artists continued to find new ways to use eclipse imagery. In 1942 the Russian artist Nicholas Roerich envisioned the military campaign of Prince Igor Svyatoslavich in the twelfth century, with an eclipse prominently embellishing the sky (illus. 89). The story, which is a foundational myth of his country, is widely known in Russia and is important for the opera *Prince Igor* by Aleksandr Borodin, whose prologue is set at the time of an eclipse. Mystically inclined, Roerich

painted various astronomical phenomena throughout his career, such as meteors streaking across the sky, comets and the aurora borealis. In 1943 the American artist Arthur Dove painted an abstract eclipse image, *The Sun* (1943; Smithsonian American Art Museum, Washington, DC), and Paul Nash's 1945 *Eclipse of the Sunflower* is an amusing visual play involving astronomy and botany (illus. 90). Charles Rain's surrealistic painting *The Eclipse* from around the same time includes an eclipse with a diamond-ring effect in the sky as one of several disquieting objects that add to its mysterious, haunting world (illus. 91).

Abstract artists also employed less descriptive circular forms to great effect to invoke solar eclipses, sometimes in series. Among them was the French painter Robert Delaunay – who along with his wife Sonia co-founded Orphism – as seen in his *Circular Forms, Sun No. 2* (illus. 92), and Wassily Kandinsky,

94 Rosemarie Fiore, *Smoke Eclipse #52*, 2015, lit smoke firework residue on Sunray paper, 71.1 × 71.1 cm.

95 Russell Crotty, *Coronagraph*, 2017, mixed media, 51 × 51 cm.

96 Katie Paterson, *Totality*, 2016, mixed media, 83 cm in diameter.

as in his *Several Circles* (1926; Solomon R. Guggenheim Museum, New York). The American Pop artist Roy Lichtenstein executed a solar eclipse series, including *Eclipse of the Sun*, from 1975 (illus. 93). It is possible that he travelled to the totality paths in the u.s. for the 1970 or 1972 eclipses, but his directional forms convey the high-voltage progression of a dramatic solar eclipse punctuated with Ben-Day dots. Following the trend, more recently Rosemarie Fiore executed a stunningly ephemeral eclipse series, including *Smoke Eclipse #52* (illus. 94), using innovative, provocative media – lit smoke firework residue on Sunray paper.

During 2017, the year of the so-called 'Great American Eclipse' whose path of totality traversed the continental United States from coast to coast for the first time since Howard Russell Butler painted his images of the Oregon eclipse 99 years earlier, more artists turned their attention to this topical subject. Russell Crotty designed a new kind of art in metal, acrylic and resin, with an overall eclipse image and other astronomical objects represented in the apparent rays of his *Coronagraph* series (illus. 95). Finally, in a tour de force, Katie Paterson's *Totality* installation of 2016 gathered images of hundreds of total eclipses – from hundred-year-old drawings to photographs – and used all 10,000 images, including stages of eclipses, on a mirrored ball (illus. 96). It makes us realize that modern photography still does not do justice to the dazzling effects experienced during a total eclipse.

97 Worship of the Moon God: impression (below) of the cylinder seal (above) of Hash-hamer, governor of Iskun-Sin (in North Babylonia), c. 2100 BC, greenstone, 5.3 cm height, 2.87 cm diameter.

4 Earth's Moon and Lunar Eclipses

One giant leap for mankind!
Neil Armstrong

When American astronauts Neil Armstrong and Buzz Aldrin Jr landed *Apollo 11* on the Moon on 20 July 1969, they fulfilled the dreams held by some human beings since time immemorial. Just as the Moon has exerted its power on the tides of Earth, so too has it mesmerized cultures – their religious leaders, artists, poets, philosophers, astronomers and anyone enthralled by the beauty of the night sky – possibly because it is the only heavenly body that regularly shows its features to the naked eye. This chronologically organized chapter examines the history of how the Moon has been regarded, illustrated and mapped in Western visual culture by highlighting select examples, a mere sampling from thousands of potential candidates.

Already around 30,000 BC, during the Aurignacian Palaeolithic period, certain hunter-gatherer societies engraved the cycles of the Moon and, later, lunisolar calendars on portable bone plates, using them for timekeeping. Even more ancient is the Lebombo bone, a baboon fibula discovered between South Africa and Swaziland that may be 35,000 years old, whose 29 notches are believed to be a lunar counter – the Moon's average cycle of phases taking 29.5 days.

The Moon is also one of the only objects in the sky not removed from view by the Sun's rising (Venus also remains visible), and it can be seen in the daylight even when it is only a thin crescent. (Amateur astronomers contest how young a Moon can be seen, with the current record being about eleven hours after 'new moon', after the syzygy or conjunction of the Sun and Earth.) For people in the Arctic regions, such as the Inuit, the Moon is more dominant in some ways than the Sun, not least as it provides the strongest light during the long winter months that have little or no daylight; understandably, the Moon is prominent in their cosmologies. Earth's giant natural satellite is the largest moon in our solar system relative to the size of its parent planet (though Charon, the largest of the five satellites belonging to the dwarf planet Pluto, is proportionately larger). Our Moon may have originally been part of Earth, formed from debris dislodged by an impact event. The monthly lunar cycle made it a natural timekeeper on which early calendars were based. Indeed, the very word 'month' is a cognate of 'moon'.

A handful of Western artists prior to the scientific watershed of the seventeenth century actually studied

the Moon and represented it in works of art that preserve their observations and deserve our attention. Their passion for lunar studies arose not from what the English poet John Milton termed 'Moon-struck madness' (*Paradise Lost*, XI, 485), but rather from an abiding curiosity about nature and the visible phenomena of the world. These celestial depictions reveal that certain artists expanded their fascination with observation to include the heavens and the Moon, which has been called 'the first "other world"'. No wonder that Earth's satellite has always cast a spell on the poetic imagination; as early as the Pythagorean tradition of ancient Greece it has been viewed as a place of repose for restless souls.

In even earlier Western cultures – where the heavens were linked to religion, and mundane astrology exerted its influence over the course of history – the Moon was represented but always in a formulaic manner, usually as a crescent. Examples include the cylinder seal of Hash-hamer, governor of Iskun-Sin in North Babylonia, of circa 2100 BC (illus. 97) and the Nebra Sky Disc from around 1600 BC (see illus. 18), thought to be the oldest known celestial diagram or image of the cosmos.

In Graeco-Roman art, depictions of the sky occasionally include a crescent Moon. These images tend to be symbolic and are rarely scientific, although exceptions occur in Hellenic astronomical papyri. Ancient depictions of the Moon usually accompany the fertility goddess of the Moon and of the hunt, Artemis (the Roman equivalent was Diana). Selene (Roman equivalent Luna) was the personification of the Moon itself; it is from her that the study of the Moon, selenography, takes its name. In medieval times Artemis-Diana merged with Luna, as depicted in the illuminated Hildebald manuscript (798–805) held in the Cathedral Library of Cologne (Codex 83). In the pre-Copernican Ptolemaic system, wherein Earth was positioned at the centre of a universe consisting of concentric circles or nested spheres, the lunar phases were shown and the Moon continued to be most frequently depicted as the easily recognizable crescent. Like a profile portrait, a crescent is the simplest

98 Giotto di Bondone, detail of *The Last Judgement*, c. 1301–6, fresco, Scrovegni Chapel, Padua.

likeness to render, necessitating neither foreshortening nor perspective.

At the beginning of the fourteenth century in the Italian university town of Padua – the centre for nascent astronomical studies where Galileo Galilei would later hold a chair – the Florentine artist Giotto included the Moon and the Sun in an unusual manner. In his *Last Judgement* fresco in the private oratory chapel of Enrico Scrovegni, Giotto painted the firmament as an illusionistic scroll rolled back by an angel (illus. 98). Nearby in the painting cycle is the *Adoration of the Magi* scene, which includes the first naturalistic depiction of a comet in Western art – the *stella cometa* today known as

Halley's Comet (see illus. 135). Giotto's *Last Judgement* portrayal of the Moon with a face derives from a type that arose in the ninth century, when the representation of the goddess Luna was eclipsed by the 'Man in the Moon', a type that the Graeco-Roman Platonist Plutarch first commented on in his dialogue *On the Face in the Moon* (after AD 75). Giotto did not simply harness prevailing visual formulae, however. Rather, he painted his waning crescent Moon just past its third quarter, with an unusual frontal Man-in-the-Moon face whose features vaguely suggest the distribution of 'spots' on the rugged lunar surface – three hundred years before Galileo called into question the smoothness of the Moon's surface. (Curiously, this craggy surface, characterized in antiquity by the Roman writer Pliny the Elder in his *Natural History* as 'spottedness', was thought to be merely the result of dirt from the Earth taken up by moisture.) These spots were widely described as the features of Cain, said to be imprisoned in the Moon, which posed a problem that was debated by the poet Dante in several of his works and illustrated in a contemporary illuminated manuscript of the *Commedia*, where the poet and Beatrice regard the Moon and its spots (MS Holkham 514, fol. 49, Holkham Hall, Earls of Leicester Library, Norfolk). Furthermore, the ashen, silvery colour of Giotto's Moon appears naturalistic in its tonality and its chiaroscuro, unlike most other stylized representations, such as the very linear crescent with a Man in the Moon in profile in a woodcut of 1511 by the German artist Albrecht Dürer (see illus. 205).

Pietro Lorenzetti, a Sienese artist working in Giotto's wake, also observed the skies in his native Tuscany and

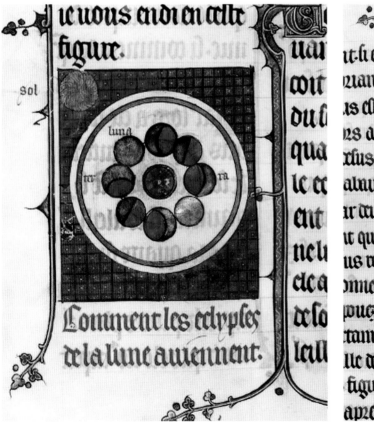
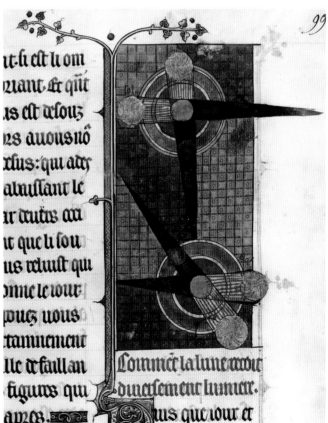

99, 100 Gossuin de Metz, phases of the Moon and orientation of the Moon, details from *Image du monde*, 1320, watercolour on parchment. MS Français 574, folios 99r and 101v, Bibliothèque nationale de France, Paris.

represented realistic meteor showers in two nocturnal scenes – the *Last Supper* and the *Betrayal of Christ* – in his frescoes in the church of San Francesco in Assisi (see illus. 207). In each scene Lorenzetti rendered a crescent Moon (with its horns too long in the *Betrayal*) as a full disc lit by earthshine, but importantly in two different positions that connote the passage of time.

Historians know that at exactly this moment in history scholars were discussing the nature of the Moon; diagrams in illuminated manuscripts from the time show a clear understanding of lunar phases and the Moon's orientation vis-à-vis the Sun (illus. 99, 100). An easy way to understand lunar phase names is to remember four terms: 'crescent', referring to phases where the Moon is less than half illuminated; 'gibbous', for phases where it is more than half illuminated (from the Latin word for 'humpbacked'); 'waning', with the illuminated area diminishing; and 'waxing', with the illuminated area increasing. Didactic illustrations of lunar eclipses at the time, including those mentioned above, also reveal a sophisticated observational knowledge of the Moon.

A lunar eclipse occurs when the Moon passes directly behind Earth and in its shadow (umbra), which happens only when both bodies are aligned with the Sun. There are three types of lunar eclipses: total, partial and penumbral, with the most dramatic being a total lunar eclipse, which occurs when Earth's shadow completely covers the Moon. It transpires only with a full moon and its duration depends on the Moon's location relative to its orbital nodes. Since direct sunlight is completely blocked from reaching the Moon by the Earth's solid silhouette, the only light seen in a total lunar eclipse at totality has been refracted through Earth's atmosphere and, like sunset light, looks dimly reddish. As the white, sunlit area of the Moon is eclipsed, the dark area takes on this red tint, and during totality the whole of the lunar surface appears dimly red in the sky; it is sometimes called a 'blood moon', though never by professional astronomers.

Unlike a solar eclipse, for which totality can be viewed only from a relatively small area of the world, a lunar eclipse may be seen from anywhere on the night side of Earth since it corresponds to an extremely full moon that happens to be in Earth's shadow. A lunar eclipse extends for a few hours and a total lunar eclipse for five hours, with over an hour of totality. By comparison, a total solar eclipse lasts only for a few minutes at a given place along its path, because of the smaller size of the Moon's tapering shadow, with the partial phases lasting perhaps three hours. The partial and total phases of lunar eclipses, unlike the partial phases of their solar cousins, are safe to view without any eye protection. Every year there are at least two and as many as five lunar eclipses, although total lunar eclipses are significantly less common. If one knows the date and time of an eclipse, it is possible to predict the occurrence of others. The Genoese explorer Christopher Columbus notoriously used his mariner's knowledge of eclipses when in March 1504 he fooled the threatening indigenous Arawaks on what is now Jamaica, where he was marooned during his final voyage to the New World. He consulted a copy of Regiomontanus' almanac to predict the lunar eclipse, influencing the Arawaks to capitulate just before the end of totality, giving the Europeans provisions and treating them with respect until a relief vessel rescued them.

Over a century after Lorenzetti, the Early Netherlandish painter Jan van Eyck produced a Crucifixion scene on a devotional diptych which included the first realistic portrayal of the Moon (illus. 101). During the medieval and Renaissance periods many artists depicted the Moon in this context, usually on Christ's left side near the 'bad thief', and balanced on the right by the Sun to signal the cosmic chaos of this apocalyptic moment. Both celestial bodies, which some-times have faces, are highly stylized and occasionally are shown eclipsed and/or red (illus. 102). It has been claimed, but is far from proven, that partial lunar eclipses occurred at Jesus' Crucifixion, which coincided with the Jewish Passover and Sukkot (Feast of the Tabernacle) holidays in AD 32 and 33, the approximate attributed time of the event. But since neither was total, there could not have been a 'blood moon'. Except for its duration,

the darkness at the Crucifixion described in three of the biblical Gospels accords better with a solar eclipse (only one Gospel refers to the darkness as an 'eclipse'). Yet there was no total solar eclipse at that time. We agree with those sceptics who believe that astronomical phenomena are often, but not always, invented to match historical events rather than actually occurring at the claimed times.

In contrast to earlier prototypes, Jan van Eyck depicted a waning gibbous Moon with spotted lunar maria – the large, dark, basaltic plains formed by ancient volcanic eruptions, dubbed *maria* (singular *mare*, Latin for 'sea')

by early astronomers who mistook them for actual seas, although they were not given proper names until later. Van Eyck also represented an irregular terminator, the division between the Moon's illuminated and dark parts. Although he placed the chalk-coloured Moon naturalistically low on the horizon to showcase it, the Moon would not have occupied this position around 3 p.m. when, according to the Bible, the Crucifixion occurred and darkness descended. Rather, the Moon would have been in that position in the morning, before setting at noon. Nevertheless, the astounding naturalism of Van Eyck's

101 Jan van Eyck, detail of *The Crucifixion*, c. 1440–41, oil on canvas, transferred from wood.

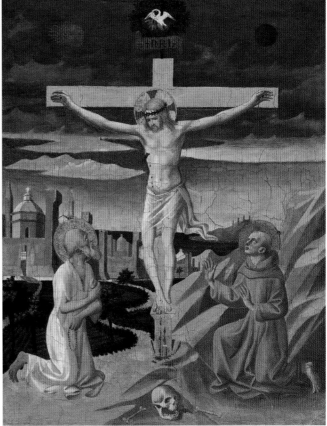

102 Francesco Pesellino, *The Crucifixion with Saint Jerome and Saint Francis*, 1445/50, tempera on panel, 61.5 × 49.1 cm.

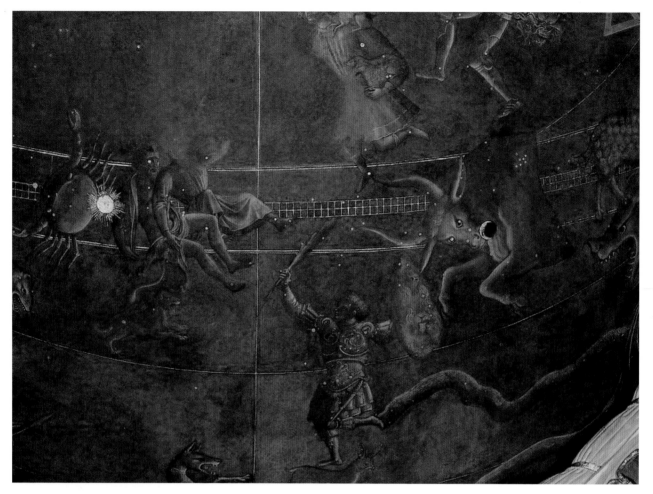

103 Unknown artists with Paolo dal Pozzo Toscanelli, detail of the dome over the altar with the Moon in Taurus, after 1442, fresco, Old Sacristy, San Lorenzo, Florence.

image resulted from the acuity of his observations. Long before Galileo and astronomers had realized this kind of accuracy, Van Eyck superseded the limits of his time. His hand recorded the realities he observed in order to liberate the objects from the stylizations imposed by religious demands and scholastic principles. No doubt he first recorded his observations in a separate study that he consulted, but slightly tilted, when inserting it into his painting.

What is even more significant about Van Eyck's accomplishment is that there are four other portrayals of the Moon in paintings attributed to him, his brother Hubert and their workshop, all set during daylight hours.

The five representations show different lunar phases, suggesting that the artist executed more than one study based on sustained observation over a period of time. These efforts must have been preserved in sketches or in a copybook available for consultation in the workshop, and their execution suggests how important the coordination of the hand and eye would prove to be for pre-photographic astronomy. Not until Leonardo da Vinci does an artist again study the Moon so intensely and yet so dispassionately.

Around the same time, two unidentified artists frescoed a portion of the night sky as an accurate star map, with the constellations, on the dome over the altar in the

Old Sacristy of San Lorenzo, Florence. Their ambitious scheme includes not only the Sun on the ecliptic but also, in the constellation Taurus, a gilded lunar crescent with an irregular terminator and its occluded portion set off by earthshine (illus. 103; see also illus. 21). This fifteenth-century novelty – a *trompe l'œil*, globe-like vision of the heavens – measures 4 metres (13 ft) in diameter, and its programme required advanced perspectival calculations and foreshortenings combined with astrological/astronomical knowledge. The adviser on this fresco, which was painted for the wealthy banker and de facto ruler of Florence, Cosimo de' Medici, is generally thought to have been the astronomer Paolo dal Pozzo Toscanelli (see illus. 137), said by the biographer and bookdealer Vespasiano da Bisticci to have instructed Cosimo in 'astrology'. Not only did Cosimo have a strong interest in astrology and a penchant for symbolism, but he enjoyed visual plays on his name and 'cosmos'. In 1986 the Italian art historian Isabella Lapi Ballerini generated computer-based calculations that pinpoint the date represented on the Old Sacristy dome to 4 or 5 July 1442. She connects the date with a visit to Florence by René of Anjou, King of Naples, Sicily and Jerusalem, amid the growing fervour for the Crusades, a visit that would have supplemented the Old Sacristy's iconographic alliance with the Holy Sepulchre. Other scholars have offered different explanations, among them that the date corresponds to the consecration of the altar on 9 July 1442, although its duplication in the Pazzi Chapel's dome seems to argue against that theory.

Leonardo da Vinci, a legendary polymath who was likewise immersed in perspective and naturalistic explorations, studied the Moon with a scientific attitude and left extensive notes on his observations. Scholars believe that he intended to write a treatise on astronomy but, as with many of his good intentions, it never reached fruition. The foreword of this treatise would have addressed optics, considered at the time to be part of perspective. Judging from his copious notes, Leonardo was far ahead of his time. In his notebooks of around 1510,

in the context of his geological studies and questions about Earth's place in the cosmos, he wrote, 'Il sole nó si muóve' (The sun does not move), a brilliant leap decades in advance of Copernicus and his earthshaking dismissal of geocentrism. Even more impressive were Leonardo's realizations that the Moon does not emit light but reflects that of the Sun, and that a person standing on the Moon would see Earth reflecting light in the same fashion, a phenomenon named 'earthshine'. Nevertheless, he mistakenly believed that stars emit no light of their own.

The largest of Leonardo's lunar drawings still extant are found in the Codex Atlanticus and the Codex Leicester (illus. 104, 105). Two of the drawings feature pre-telescopic mappings of the Moon's surface and reveal that Leonardo viewed lunar markings with a scientific rather than an imaginative eye, referring to them in his notebooks merely as *macchie* ('spots'), without singling out any specific parts. In one passage of his numerous jottings Leonardo remarks that 'the details of the spots of the Moon . . . often show . . . great variations', an observation that he has 'proved by drawing them'. In another passage he argues that, contrary to a prevailing opinion of the time, the Moon cannot be a convex mirror reflecting Earth's continents and seas. At another point he states that 'the spots on the Moon, as they are seen at full-Moon, never vary in the course of its motion over our hemisphere', and he goes on to explain that this phenomenon results from the fact that the Moon always shows the same side to Earth, from which he can conclude that it rotates in the same period as its revolution around the planet.

Significantly, Leonardo argues that the spots are in fact on the Moon itself:

> Others say that the surface of the Moon is smooth and polished and that, like a mirror, it reflects in itself the image of our Earth. This view is also false . . . A second reason is that an object reflected in a convex body takes up but a small portion of that body, as is proved in perspective.

On folio 310r of the Codex Atlanticus, Leonardo drew two thumbnail lunar sketches whose maria suggest a Man in the Moon: on the left a full moon (with the Mare Crisium at the upper right); and on the right the eastern half of the waning Moon as it approaches its third quarter. It is curious that, while the probably dyslexic artist wrote backwards, his lunar images are not reversed.

Unfortunately, only one half of Leonardo's most ambitious lunar drawing remains. Judging from its position on the page, the eastern half was most likely drawn on another page to the left (thus it is either the right half of a full moon or a first-quarter moon). While more elaborately drafted, this sheet is less accurate than Leonardo's earlier, smaller studies. Nevertheless, one can make out his mapping formations, which approximate several maria – such as the Mare Serenitatis adjacent

to the Mare Tranquillitatis, the Mare Foecunditatis and the Mare Nectaris – against the white highlands. To the right and slightly above the large Moon is a smaller, faint sketch of the full moon that at first glance looks like a circle. If it were complete the larger image would have a diameter of around 17.8 centimetres (7 in.) and can be dated stylistically to around 1513–14, suggesting that Leonardo drew it in Rome.

While both sheets feature lunar maria, it is not possible to determine from any of them an accurate libration (the slight wobble of the tilted Moon as it rotates that enables us to see five-eighths of its surface over time from our vantage point on Earth). The lack of references to lunar craters or rays in Leonardo's drawings and writings is probably a result of his never having seen the Moon through what is properly considered a

105 Leonardo da Vinci, waxing crescent Moon with earthshine, brown ink on paper. Codex Leicester, detail of folio 2r, Collection of William H. Gates III.

104 Leonardo da Vinci, sketches of the Moon, 1513–14, charcoal, black chalk and brown ink on paper, 65 × 44 cm. Codex Atlanticus, folio 674v, Biblioteca Ambrosiana, Milan.

telescope, the invention of which occurred around 1608. Yet Leonardo may at the very least have used some form of magnification for viewing the Moon, as Italian scholar and mathematician Girolamo Fracastoro of Verona later would. In his notebooks Leonardo writes to the future reader, as he planned to use the notebooks for publications of written treatises: 'Fa ochiali da vedere la luna grande' (Construct glasses to see the Moon magnified). However, we do not know what he meant by 'glasses' since early telescopes were sometimes termed 'glasses'. To date, no one has satisfactorily explained this apparently significant comment.

Leonardo's third lunar study features a thin crescent Moon (see illus. 105). It shows the *lumen cinereum*, the ash-grey light of earthshine or planetshine, and is the first representation of the phenomenon, also known as the Da Vinci glow – a contribution to astronomy often incorrectly attributed to the German mathematician and astronomer Johannes Kepler and his teacher Michael Mästlin a century later. In this codex (Codex Leicester) Leonardo writes:

> Some have thought that the Moon has a light of its own, but this opinion is false, because they have founded it on that dim light seen between the horns of the new Moon, which looks dark where it is close to the bright part, while against the darkness of the background it looks so light that many have taken it to be a ring of new radiance completing the circle where the tips of the horns illuminated by the sun cease to shine . . . If you want to see how much brighter the shaded portion of the Moon is than the background on which it is seen, conceal the luminous portion of the Moon with your hand or with some other more distant object.

The artist also wrongly speculated that the Moon's surface reflects sunlight on account of being covered by water. He does, however, anticipate Isaac Newton by pointing out the universality of gravitation, discerning it to be a force that acts not only on the Earth but also on the Moon, keeping it in its orbit. To demonstrate why the

Moon appears larger than its true size when it reaches the horizon, Leonardo instructed his reader to take a lens that is highly convex on one surface and concave on the other, and to rest the concave side next to the eye. An object placed beyond the convex surface will now appear distorted in an analogous manner to the Moon apparently enlarged at the horizon.

Apart from this handful of very rough sketches, the other drawings of the Moon mentioned by Leonardo are lost or remain undiscovered. Nevertheless, the available drawings are the earliest to reveal the surface of the Moon, and together with his writings they preserve a scientific study of it. Further, they harmonize with both the artist's profound scientific interests and his reputation as 'il uomo universale' (the universal man). From his notebooks, it is readily apparent that he carefully observed the Moon over a long period of time while developing theoretical explanations for the visual phenomena he recorded. While Leonardo had the courage to criticize Aristotle on some of the latter's views about the Moon, his own ideas were not without flaws. In the end, it is not surprising that Leonardo's lunar studies and his spirit of enquiry left their mark on art and science in Florence. It was there that Galileo would eventually study perspective and chiaroscuro, further demonstrating the connection between practice in Italian Renaissance art and the development of modern experimental science. In addition, Leonardo's scientific interests no doubt accelerated astronomical investigations at the Papal Court during his residence in the Eternal City.

Late in life Leonardo concentrated more on astronomical pursuits, especially after 1513 when on the invitation of the Medici Pope Leo x he lived in Rome and performed his duties as a court celebrity. It may be that Leonardo's presence, together with the humanist inclinations of his patron, helped to accelerate astronomical interests and precipitate significant representations of the Moon by other artists active at the time in the Papal Court, including several by Raphael.

Yet Raphael's interest in astronomical phenomena may have been sparked before Leonardo's arrival in

Rome, as suggested by his *Madonna of Foligno* (see illus. 201). Raphael's fresco in the Stanza della Segnatura, with its personification of Astronomy leaning over a crystalline celestial sphere (see illus. 10), is similarly telling. He was assisted in the frescoes by the artist and cartographer from the Low Countries Johannes Ruysch, who specialized in decorative painting but also made nautical charts and maps and worked as an astronomer.

In the stimulating intellectual environment of the Papal Court, Raphael produced several images of the Moon. While the Moon was a key element of a dramatic solar eclipse he painted in the Vatican's Loggia of Pope Leo x (see illus. 66), he also frescoed a crescent Moon (or a partial lunar eclipse) in the nocturnal scene of the *Liberation of St Peter* in the Stanza d'Eliodoro (illus. 106), a chamber in Leo x's private suite of rooms that showcases Raphael's study of light effects. In this fresco Raphael narrates Peter's miraculous escape from prison aided by an angel who appears surrounded by shining light (Acts 12:1–11). The lunar image intensifies the light effects of the supernatural event within the guise of a natural phenomenon. A lunar eclipse would better fit the narrative of Raphael's portrayal because the Moon dramatically distracts the soldiers while Peter makes his escape in the company of the divine messenger. Moreover, the artist's depiction retains an experimental, visceral feeling that reflects his own lunar observations. Finally, the metaphor of the eclipse brilliantly parallels Peter's stealthy retreat from the prison directly past the guards.

With the new printing technology at the turn of the sixteenth century, prints and illustrated books circulated widely among the intelligentsia of Western Europe, and in such circles already familiar with the mechanics of both lunar and solar eclipses (illus. 107). Works such as Johannes de Sacrobosco's *De sphaera mundi* (illus. 108) were popular, as were paintings for humanistic and domestic settings (see illus. 26). Astronomical mechanical diagrams were also showcased in sumptuous books like the extraordinary *Astronomicum Caesareum* of Peter Apian, cosmographer and court astronomer to Habsburg

Emperor Charles v (to whom Apian dedicated the book), which included turning volvelles (illus. 109).

Leonardo's and Raphael's interest in the Moon was contagious and spread to Sebastiano del Piombo, an artist in the latter's Vatican entourage. His majestic *Pietà* (illus. 110) features figures based on designs by Michelangelo but is dominated by a full moon with lunar maria. Patristic literature reveals that the early Christian Fathers viewed the Moon as a symbol of the Church and a full moon as emblematic of giving birth – not only a reference to the Nativity but also to the birth of the Christian Church following Jesus' death. Sebastiano's careful description of the lunar sphere parallels his studied preparation for painting the corpse of Jesus, based on cadaver studies and anatomical drawings furnished to him by Michelangelo. The resultant, haunting panel shows a desolate landscape that is as dark as the heart of the Madonna. Sebastiano used other complementary visual poetic metaphors in the painting, such as the sunset that colours the sky and signals the death of both daylight and Jesus. The hovering Moon partially obscured by clouds signals that the tragedy of Golgotha will be followed by an epilogue, the light of the Resurrection.

It was in England that studies of the Moon – 384,400 kilometres (238,900 mi.) away from Earth on average, though the distance actually varies, because of its elliptical orbit – reached their modern phase. Around the year 1600, not long before the invention of the telescope, William Gilbert, physicist and physician to Queen Elizabeth i, drew the spotted face of the Moon, adding labels detailing his observations. Unfortunately, Gilbert included his faint pen-and-ink study of the full moon with grid lines, which reflect the current longitudinal lines of the day, in the manuscript of a book. He believed that the bright areas of its surface were water and the darker were land, the exact opposite of the prevailing views of the time. He represented the lunar maria as islands, but we now know that the Moon's surface is mostly dry, devoid of accumulated water, although in August 2018 NASA confirmed that there is water ice on the Moon at its poles.

106 Raphael, *Liberation of St Peter from Prison*, 1512–14, fresco, Stanza d'Eliodoro, Vatican, Rome.

While Gilbert's image is a flattened projection and thus less aesthetically pleasing than Leonardo's drawings, its importance lies in the fact that it is a map, one which uses the system of terrestrial mapping established by Ptolemy.

Gilbert inscribed names for thirteen maria on his map. With the exception of the rather nationalistic 'Britannia' (today identified as Mare Crisium), the names were determined by physical geographic descriptions. Gilbert's drawing is the oldest known map of the Moon made from naked-eye observations and it initiates the trend towards later lunar mapping, the wave of the

future. Nonetheless, the names he gave the maria were not taken up, as by the time his map was published as an engraving in his *De mundo nostro sublunari philosophia nova* (1651), three major nomenclature schemes had already appeared on other maps prepared from telescopic observations. Nevertheless, Gilbert's efforts at lunar mapmaking established him as the first selenographer and signalled that the Moon's surface would soon enter the main currents of astronomical illustration.

Another enterprising Englishman, Thomas Harriot, used a six-power telescope (then called a 'perspective

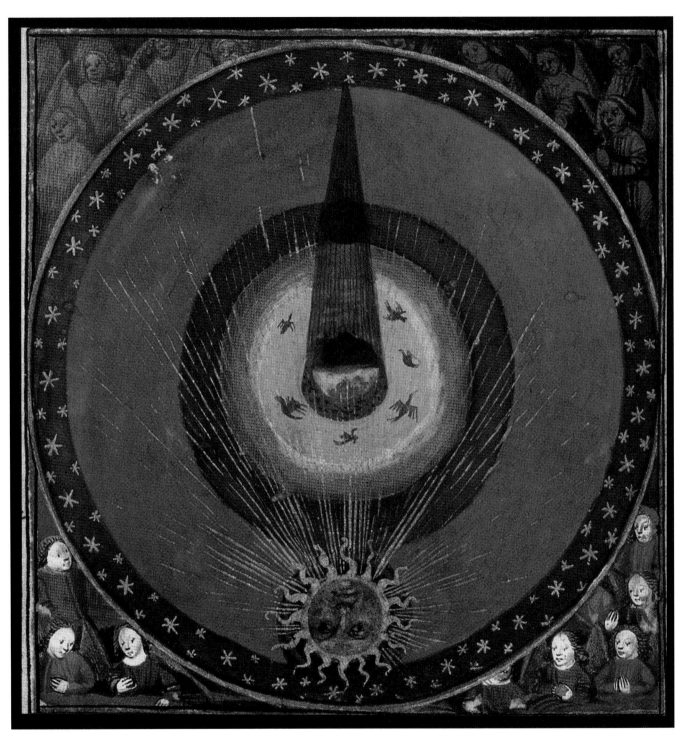

107 Lunar eclipse, detail from *Astrologia judiciara*, 15th century, watercolour on parchment. MS Latin 7432, Bibliothèque nationale de France, Paris.

tube') to make the first known telescopic sketch of the Moon on 26 July 1609 (it is one of several studies in black ink from 1609–11, now in the Egremont Collection, Petworth). Four months later Galileo used a telescope with the same magnifying power to observe the Moon and was immediately credited as being the first person to examine the Moon with magnification of that power. Unfortunately Harriot did not deem his own observations to be important enough to complete – nor did he share Galileo's need for immediate publication – and he did not draw any further images for several months. He resumed his observations simultaneously with Galileo's second and third studies and produced the

first map of the full moon in 1611. While Harriot made an honest attempt at portraying the Moon's main features, he lacked Galileo's artistic training and did not recognize the three-dimensional structure of the lunar mountains, something that Galileo noticed from the spreading of bright spots. Nonetheless, Harriot's impetus to record what he saw through the telescope rather than write about it was a watershed moment: the instrument of enhanced sight, the telescope, revealed images that now had superseded text. It is evident that Harriot's interest in the Moon was rekindled by Galileo's efforts, for he made at least twenty drawings of the Moon in the summer of 1610 that are more like mathematical diagrams. It is

108 Johannes de Sacrobosco, lunar eclipse and solar eclipse, detail from *De sphaera mundi* (Venice, 1488), woodcut.

109 Michael Ostendorfer, lunar eclipse, plate J from Peter Apian, *Astronomicum Caesareum* (Ingolstadt, 1540), hand-coloured woodcut.

110 Sebastiano del Piombo, *Pietà*, 1514–17, oil on panel, 2.7 × 2.25 m.

possible that he and Francis Bacon had seen Gilbert's lunar map, as Harriot names one feature that is also found on Gilbert's map: 'The Caspian'. An astute scientist and mathematician, Harriot is perhaps better known for his description of an expedition with his friend Sir Walter Raleigh to Virginia in 1585 and for the introduction of the 'greater than' (>) and 'less than' (<) signs in mathematics.

Galileo's revolutionary set of brown ink and wash drawings of the Moon from 1609 (illus. 111), of which eleven survive, reveal that the artistic training of his eye enabled him (unlike Harriot) to understand and interpret the raw data of his telescopic observations correctly. His accomplished sheets were eventually engraved and published in the *Sidereus nuncius* (Starry Messenger) in 1610, with a text which reads like a traveller's account of exploration: 'And first I looked at the Moon from so close that it was scarcely two diameters distant.' Galileo holds the distinction of being the first person to publish illustrations of the lunar surface drawn with a telescope that he had constructed; and he would eventually produce an instrument capable of twenty-power magnification. It should be noted that views of the Moon rendered with the aid of an astronomical telescope, which inverts the image, were until recently usually reproduced upside down. For these rather dry woodcuts and descriptions in the *Sidereus nuncius* he used no nomenclature, merely referring to the large dark areas as the 'great or ancient spots'. However, his observations settled the ancient controversy over whether the Moon was a spherical, Earth-like body or something far more exotic such as a crystalline sphere, delivering the *coup de grâce* to Aristotelian ideas of its perfection.

Galileo's vivid wash studies – the basis for the illustrations in *Sidereus nuncius* – are presumably the original works made at the telescope. A careful review of them together with the engravings has made it possible to accurately determine the dates on which he made his observations. Galileo first observed the Moon on 30 November 1609. Apart from a small, rough sketch evidently made from memory and partially written over with calculations, Galileo did not make a drawing of the

full moon. The most probable reason for this being that he was interested in the body's considerable roughness, which is not apparent at its full phase. By using his telescope Galileo discovered that the spots on the lunar surface change shape over time and thus concluded that this phenomenon can be explained as shadows being cast onto mountains, with the lighted areas spreading from the tops of the mountains as the Sun rises. He also noted the irregular advance of night across the lunar surface caused by its uneven, complex surface. Kepler had drawn the same conclusion about the irregular edge of the terminator in his book on optics, *Astronomiae pars optica* (1604). Galileo also created a new pictorial rhetoric for the Moon, his words resembling visual paintings, and married artistic naturalism to the astronomical text preferred previously. Energized by the added charm of Galileo's written voice, this little book became a landmark in Western intellectual history. Its importance has been reinforced by a recent forgery of the *Sidereus nuncius* and the controversy surrounding it that was unmasked in 2013.

Several scholars have argued convincingly that it was Galileo's artistic training in sixteenth-century Florence that enabled him to accurately render in his drawings, and thus preserve for posterity, his telescopic observations. Whereas works by Van Eyck and Leonardo suggest that art preceded science in the observation of the Moon, art was also needed to translate the early flat maps of the Moon's surface. The subtlety of the chiaroscuro modelling – a part of the contemporary definition of perspective – in Galileo's wash sketches have a sophisticated aesthetic sensibility that captures the haunting quality of lunar light, including the light on its shadowy peaks and craters, which he called 'cavities'. Galileo's contemporaries certainly acknowledged his artistic skill and in 1613 he was admitted to the prestigious Florentine artistic academy the Accademia del disegno, which taught Euclidean geometry and perspective. Another folio in the same manuscript (folio 16r) shows a diagram for determining lunar heights, with the terminator clearly indicated. By applying a technique well known to students of

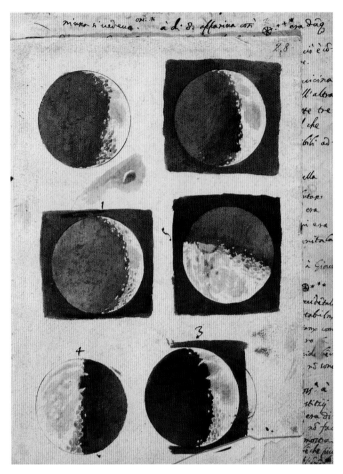

111 Galileo Galilei, sketches of the Moon, 1609, brown ink and wash on paper. MS Gal. 48, fol. 28, Biblioteca nazionale centrale, Florence.

astronomical observer Galileo praised. Cigoli represented a crater-pocked crescent Moon with visible earthshine in his *Immaculate Conception* (illus. 112), a subject which traditionally featured the Virgin standing on a stylized crescent Moon. Moreover, Cigoli's Moon has a telltale topographical, studied appearance, stressing its rock-like nature, something apparent only through a telescope. It has long been recognized that his cratered Moon with some earthshine apparent is a slightly foreshortened version of the engraving in the *Sidereus nuncius* depicting the Moon at first quarter, when it is about a week old. The connections in Cigoli's work between sight/optics and astronomy are further underlined by his having written a treatise on perspective entitled *Prospettiva pratica* (published posthumously in 1628); in addition other works by the artist reveal his keen interest in celestial events, both astronomical and meteorological. His *Adoration of the Shepherds* of 1602 and his *Deposition* of 1607 feature waxing Moons with earthshine and vapours surrounding the lunar disc, just like those described by Galileo. Cigoli met Peter Paul Rubens in Mantua in 1604 when the Flemish master painted himself with Galileo and four other friends in the famous group portrait previously mentioned.

Far more evocative and less topographical is the brilliant full moon (see illus. 243) displaying lunar maria painted by Adam Elsheimer in his *Flight into Egypt* (1609–10). The work was executed while the artist was living in Rome, where he may have encountered a copy of the *Sidereus nuncius* or at least heard about Galileo's telescopic discoveries. Interestingly, he suggests the maria by applying the pigment most carefully to the reflection in the water. For the actual Moon in the sky he concentrated on rendering the quality of the light reflecting off the lunar surface. (It is possible that the actual full moon was so bright that its structure really was more obvious in the duller reflection.)

While Elsheimer was interested in observational astronomy, in *Flight into Egypt* he seems to prioritize effect over accuracy. The diagonal band representing the Milky Way – the galaxy, constituted by stars and nebulae

perspective, Galileo revealed that the mountains of the Moon were even more spectacular in scale than those on Earth, although it is not clear how detailed were his instructions to the engraver.

Galileo must be considered in the context of the court of his patrons, the Medici Grand Dukes, as it was there that he studied the optics and perspective he would later employ in his drawings of the Moon. The court was an environment conducive to scientific studies, with Duke Cosimo i and his son Francesco i – who was obsessed with alchemy, the nascent science of chemistry – sponsoring many scientific endeavours. In turn Galileo influenced artists such as his lifelong friend the painter Lodovico Cardi, called Il Cigoli, whose abilities as an

of gas and dust, in which our solar system is located – is represented by too narrow a band and is wrongly located in the night sky. Nevertheless, his depiction of the Milky Way as a band of stars with evident nebulosity seems to offer direct evidence of his familiarity with Galileo's book, which contains no depiction of the entire galaxy, only an illustration of a small part of it resolved into individual stars. Elsheimer's composition was very popular and was copied in paint as well as disseminated as a print. Since other nocturnal works by Elsheimer and his circle include full moons, we know that Elsheimer was fascinated by this highly topical heavenly body.

112 Lodovico Cardi (Il Cigoli), detail of *The Immaculate Conception*, 1610–12, fresco, Santa Maria Maggiore, Rome.

During the decades following Galileo's marriage of Renaissance artistic techniques with scientific evidence, astronomers struggled to equal the reproductions produced by artists. Scientific illustrations of the Moon did not live up to those painted by Cigoli or Elsheimer, nor to that in Philippe de Champaigne's canvas of Saint Juliana's vision (illus. 113). Juliana, a thirteenth-century Norbertine canoness and mystic of Liège, venerated the Eucharist and at the age of sixteen began having visions of the full moon with a spot or dark line on it, which she understood to be a rebuke to the Church for not having a feast day to celebrate the miraculous transformation of the bread and wine during the Eucharist. Champaigne attempted to interpret Juliana's vision in a more modern, realistic manner by portraying a slightly distorted waxing gibbous Moon with maria instead of a spot; the resultant image evidences a familiarity with Galileo's observations. That Champaigne had an interest in astronomy is also demonstrated by his rendering of a solar eclipse in his *Christ Dead on the Cross* (1655; Musée de Grenoble).

The systematic mapping of the Moon's features began later in the seventeenth century. These developments in lunar cartography would have repercussions in art, precipitating a deluge of lunar portraiture. Generally these maps were patterned on Galileo's treatise, which was widely but clumsily copied (although the Jesuits continued to hold on to the representation of a virginal, spotless lunar surface, as can be seen in numerous paintings of the Immaculate Conception). The Moon's importance as a celestial compass became especially topical during this era because of the need to determine longitude for colonial exploration. A literary fixation on its poetic possibilities that included lunar travel, a dream since antiquity, also surfaced in Francis Godwin's *The Man in the Moone; or, a Discourse of a Voyage Thither by Domingo Gonsales, the Speedy Messenger* (1638) and Cyrano de Bergerac's *L'Autre monde, ou les états et empires de la lune, et les états et empires du soleil*, published posthumously in 1657. It is the earliest description of space flight by a vessel that has rockets attached and among the first science-fiction stories. These books

113 Philippe de Champaigne, *The Vision of St Juliana of Mont Cornillon*, c. 1645–50, oil on canvas, 47.5 × 38.7 cm.

reveal that after Galileo's publication the Moon became a solid alter ego of Earth, waiting for its features to be named and its surface visited.

The earliest of several new attempts to map the lunar surface was undertaken by the French astronomers Pierre Gassendi and Nicolas-Claude Fabri de Peiresc, who harnessed their observations of lunar eclipses to detail the advance of the shadow over the Moon's surface. To help them they enrolled the artist Claude Mellan, who knew Galileo and whose near-photographic precision delighted them (illus. 114). Mellan produced three etchings using two different plate states. While the prints, depicting the full moon and its first and final quarters, were never published, the collaboration signals a change in the relationship between art and science whereby art now becomes a domain of expertise in the service of science. When Peiresc died in 1637 the project lapsed, although Gassendi did send copies of Mellan's etchings to the Polish astronomer Johannes Hevelius, who had embarked on his own lunar mapping programme. For all their beauty, Mellan's engravings did not satisfy astronomers, who needed a map showing all the Moon's features equally, a way they would never appear in reality.

In 1645 the Belgian astronomer Michael Florent van Langren produced the first true map of the full moon with surface shadings and a large number of its topographical features identified. The names of these 325 features mostly reflected political exigencies and his Catholic orientation, although he did name a crater Langrenus after himself (providing one of the names that would stick). Like Mellan, Van Langren made preparatory studies for his engraved maps. His flat cartographic abstraction was the first extensive, Earth-type map of the lunar surface and was intended to solve the problem of determining lunar longitudes to aid marine navigation.

One of the men of science whom Van Langren included in his lunar nomenclature was his most ardent selenographic rival, the wealthy Polish brewer and astronomer Hevelius, who built an observatory known as Sternenburg and in 1647 published the first treatise devoted entirely to the Moon: *Selenographia: sive,*

lunae descriptio (Selenography: or, A Description of the Moon). With this tome, named after Selene, goddess of the Moon, Hevelius was established as the father of the science of selenography and the founder of Lunar topography (illus. 115). He also ground his own lenses and constructed telescopes, ultimately including a large Keplerian telescope with a 46-metre (150-ft) focal-length. He observed the Moon on every clear night for several years, recording his observations and later producing engravings from the drawings. He financed the publication of his sumptuous book – an atlas with forty illustrations and five hundred pages of text naming 275 features of the lunar surface. It includes plates illustrating phases of the Moon and three large plates of the full moon using his technique of 'single illumination', whereby equal light is shown to fall across the whole surface, an impossible situation rendered by compositing many observations. Hevelius also employed a nomenclature based on earthly features, which in Protestant countries was used into the eighteenth century. His convention of single illumination is used to this day, although modern maps follow Van Langren in using evening illumination rather than Hevelius' morning light. *Selenographia*'s frontispiece paid homage not only to Galileo but also to the influential eleventh-century Muslim polymath Hasan Ibn al-Haytham (Latinized as Alhazen), who wrote a treatise about the Moon (*On the Light of the Moon*).

Shortly after the publication of Hevelius' book, at a time when the Jesuits were becoming involved with the scientific revolution, the Italian priest and astronomer Giovanni Battista Riccioli fashioned a new nomenclature, the one still in use today. His ambitious *Almagestum novum* (New Almagest) appeared in 1651, with images by physicist Francesco Maria Grimaldi, a fellow Italian Jesuit, though the book sacrificed aesthetics in favour of a focus on naming. The Riccioli/Grimaldi nomenclature shrewdly combines ideas from its predecessors, but also gives prominence to astronomers and philosophers in the names given to lunar craters observed with telescopes. These include dedications to 24 Muslim astronomers, thereby acknowledging the importance

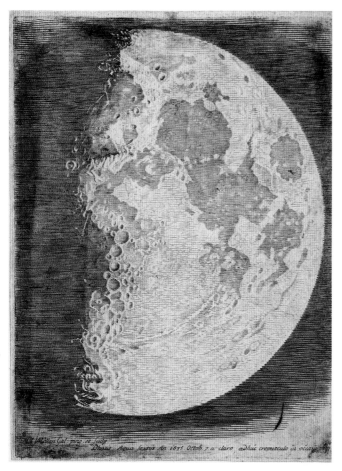

114 Claude Mellan, *Lunar Surface in Its First Quarter*, 1635, engraving, 23.8 × 18.1 cm.

commemorated individuals who were significant in the history of astronomy.

One of the most noteworthy early eighteenth-century artistic representations of astronomical imagery is Donato Creti's series of astronomical observations, commissioned by Count Luigi Ferdinando Marsili. As mentioned in Chapter Three, Marsili hoped to convince Pope Clement XI to support the construction of an observatory in Bologna. Creti's paintings (1711–12) showcased the astronomical instruments which Marsili owned and hoped that the observatory would house, and the miniaturist Raimondo Manzini painted the celestial bodies as seen through a telescope. The Pope agreed to the project. One of the most spectacular painted scenes features a huge full moon with lunar craters and maria, as well as clearly visible rays (illus. 116; see also illus. 52). To please his audience and show off his accuracy in lunar mapping, Manzini painted the Moon far larger than it ever appears from Earth. The way in which he rotated its craters suggests that he used a model from a printed book. In fact, his Moon is nearly identical to the full moon image that Cassini prepared for a total eclipse of the moon predicted for 28 July 1692. In both examples the Moon is oriented with the south up, as in a telescope when it is on the meridian (that is, passing due south), but it is drawn near moonrise, when south would be towards the lower right, at the latitude of Italy.

With his map of 1749, the German astronomer Tobias Mayer became the first person to assign the Moon proper longitude and latitude. He was also the first to take into account its libration (the remainder, the far side of the Moon, was not known until the Soviet Union sent a satellite around it in the 1960s). Mayer also used his libration calculations to produce an accurate map of the Moon's appearance during a lunar eclipse on 8 August 1748.

Founded in 1765, the Lunar Society of Birmingham in England was a cultural barometer of the importance of the Moon to all things earthly. From 1765 to 1813 members met regularly during the full moon because it afforded extra light for the journey home on horseback.

of Arabic astronomy and its influence on Western culture. Riccioli also incorporated current and recent figures in his scheme to suggest progress and dominance over ancient cultures, albeit christening naked-eye spots as seas with Latin names based on emotional states associated with the Moon, such as the Mare Tranquillitatis (Sea of Tranquillity).

Between 1671 and 1687 the Italian-born Gian Domenico Cassini, the first director of the Paris Observatory, worked with artists Jean Patigny and Sébastien Leclerc on a lunar map that lacked names. Here, and for a smaller version, they adopted Riccioli's nomenclature. The map became the cartographic standard of selenography as it most successfully

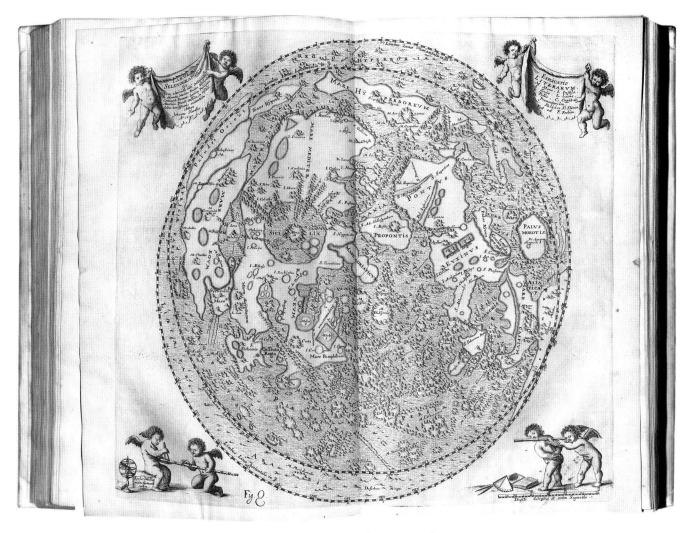

115 Johannes Hevelius, topographic lunar map, figure Q from *Selenographia* (Gdansk, 1647), engraving.

Founded as a forum for intellectual exchange between people from all walks of life, members focused on science and technology, sharing their excitement about the exhilaration of scientific discovery. Among its founders were Erasmus Darwin – doctor, inventor and grandfather of naturalist Charles – Matthew Boulton and William Small. Later the founders – who sometimes referred to themselves as 'Lunarticks', a pun on 'lunatics', from the Latin meaning 'moonstruck' – were joined by the inventor James Watt, the English potter and entrepreneur Josiah Wedgwood (Charles Darwin's maternal grandfather) and many others.

It was in England during the late eighteenth and early nineteenth centuries that another conjunction between the observational powers of artists and astronomers occurred. John Russell, a portraitist known for his work in oil and pastel, especially his likenesses of scientists, was also interested in astronomy. He was a friend of William Herschel, the King's Astronomer, whom Russell portrayed holding a star chart illustrating the discovery of the planet now known as Uranus. With the assistance of his daughter Jane de Courcy Russell and a powerful telescope from Herschel, Russell drew over two hundred sketches of the Moon and a lunar map, the latter of

which took him twenty years to complete. One of his pastel studies, of a waxing gibbous Moon, made with a refracting telescope fitted with an eyepiece micrometer, ranks among the most faithful early representations of the lunar sphere, albeit with distortions in lighting (illus. 117). The artist himself remarked that he wanted to create a work of art 'corresponding to the Feelings I had upon the first sight of the gibbous Moon through a Telescope'. For forty years Russell continued his lunar studies, measuring 34 of its features. From his observations he produced a planisphere of the near side of the Moon in a series of sectional gores, which he engraved and planned to paste on globes, each 30 centimetres (12 in.) in diameter. Of the few that were made, five or six were mounted on a complicated brass mechanism by which the lunar librations could be demonstrated. Russell called his device a 'Selenographia' (illus. 118) and published a pamphlet about it in 1797 entitled *A Description of the Selenographia: An Apparatus for Exhibiting the Phenomena of the Moon*. (In 1661 Sir Christopher Wren had been the first person to construct a globe of the Moon, which is now lost.) Of course, the advent of photography later in the nineteenth century quickly discouraged any further attempts at such an exacting and laborious task. Since Russell placed neither a coordinate grid of lunar latitudes and longitudes nor any form of nomenclature on his images, one can understand why his work never enjoyed the impact in selenographic circles that its artistic and scientific contributions merited.

The poetic and visual expressions of the prolific English artist and poet William Blake defy categorization. They tap into many topical issues of the time, including astronomy, as well as prefiguring a nascent Romantic sentiment. Blake's oeuvre contains many representations of the Moon, but among the most dramatic is *The Body of Abel Found by Adam and Eve*, which shows at the left Cain, the murderer, banished from Eden by God, who has placed upon him the mark of Cain (illus. 119). While the event is not found in the Bible, in Blake's work a 'blood moon' is used to symbolize God's wrath at the fratricide; this in turn recalls another lunar reference in his poem *Milton, A Poem in Two Books* (1811), in which an angered figure is described as 'reddening like the Moon in an eclipse'.

With the growth of Romanticism in the 1830s the Moon took pride of place as a fashionable and ubiquitous presence in poetry, music and art. Painted nocturnes did not merely depict picturesque landscapes but expressed ideas about industrialization and modernity that involved time, Nature and change. The quintessential German Romantic artist Caspar David Friedrich created three iconic paintings each depicting two people seen from the back, so that the viewer joins them in gazing at the Moon within a setting riddled with Sublime sentiments and the seductively mystical power of Nature (illus. 120). Friedrich, who was fascinated with transparencies, also seems to have experimented with them in images of the Moon to increase its power and uncanny light in his drawings. In the work shown in this book, the later of two similar pieces both titled *Two Men Contemplating the Moon*, Friedrich included a waxing crescent Moon lit by earthshine positioned close to the very bright 'evening star', the planet Venus. His earlier version (1819–20) also features two men, and in a third painting (*c.* 1835) the two protagonists are a man and a woman. Contemporary sources have identified the two men as Friedrich and his talented younger colleague August Heinrich. Pausing on their evening walk through a late autumnal forest, their shared contemplation relates to the fascination with the Moon and the communion with Nature expressed in the poetry, literature, philosophy and music of the time. Although they belong to the tradition of the wanderer, personifications of restless yearning that haunt Romantic works, the attire of both men conforms to the Old German dress code that had been adopted in 1815 by radical German students who opposed the ultraconservative policies being enforced in the wake of the Napoleonic Wars.

As science continued to change how Nature was seen, the lunar-lit landscape became a predominant theme for other early nineteenth-century landscape painters. This was especially the case in Germany, such as in the

116 Donato Creti and Raimondo Manzini, *Astronomical Observations: Moon*, 1711, oil on canvas, 51 × 35 cm.

117 John Russell, *Surface of the Gibbous Moon*, 1793–7, pastel on paper, 61 × 46 cm.

118 John Russell, Selenographia with small terrestrial globe, 1797, engraving over globe, mounted on a brass stand, 30.5 cm diameter.

works of Carl Gustav Carus, but also for British painters like Samuel Palmer. Obsessed by lunar and other celestial phenomena, Palmer, like his friend William Blake, placed the Moon in many nocturnal prints, watercolours and paintings. J.M.W. Turner included the Moon and the Sun in many watercolours and oil paintings where he sometimes raised in gesso and paint the solar orb to endow it with a two-dimensional presence, stressing its power. The English landscapist John Constable saw his artistic goals as in harmony with scientists and he familiarized himself with the work of some, including the English chemist and amateur meteorologist Luke Howard's study of cloud types. In 1836 Constable remarked in his *Discourses*,

Painting is a science and should be pursued as an inquiry into the laws of nature. Why, then, may not a landscape be considered a branch of natural philosophy, of which pictures are but experiments?

The first astronomer to devote much of his career to the Moon was the German Johann Hieronymus Schröter, who is most famous for studying the Moon over a long period of time. Although his drawings are inelegant, they initiated the modern interest in studying individual features such as rilles, fissures or narrow channels, mare ridges and the lunar limb. His results were published in a two-volume *Selenographische Fragmente* (1791). Two

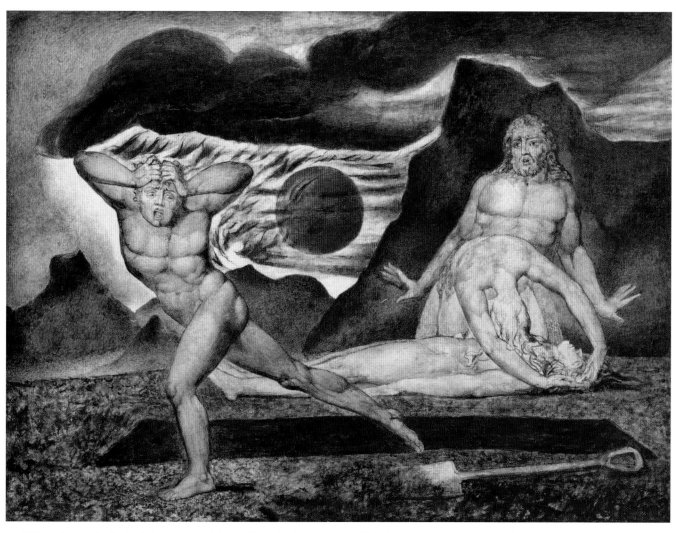

119 William Blake, *The Body of Abel Found by Adam and Eve*, 1826, tempera and ink with gold and gesso on a mahogany panel, 32.5 × 43.3 cm.

120 Caspar David Friedrich, *Two Men Contemplating the Moon*, c. 1825–30, oil on canvas, 34.9 × 43.8 cm.

fellow Germans, Wilhelm Beer and Johann Heinrich von Mädler, both of whom also have craters on the Moon named after them, published a magisterial lunar book and map in the mid-1830s. Mädler also drew important conclusions about the Moon based on his observations, discovering that it lacks an atmosphere and that the maria are not liquid. The mathematician Wilhelmine Witte used Mädler's map to create a lunar globe in 1838; Witte became the namesake of a volcanic feature on the planet Venus. Other individuals with a lunar addiction followed, including Julius Schmidt, who in 1878 published the largest and most detailed map of the Moon, measuring 2 metres (78½ in.) across. The map details no fewer than 32,856 craters.

With the popularization of astronomy and the development of excellent reproductive processes including photography, artists were soon exploiting the Moon and people's fascination with it for satirical purposes. Such is the case in a delightful caricature by the French artist Honoré Daumier which sets a very different mood from Friedrich's lunar paintings. In 'Effet de lunes', printed in the magazine *Le Charivari* on 10 May 1840, a long-married bourgeois couple in their nightdresses gaze at the Moon, which has become their passion, through an open window.

This same period also saw the Moon morph into a mere decorative embellishment, sometimes reverting to archaic conventions for humorous effects, as with the English brass letter opener from the mid-nineteenth century shown here, on which the Man in the Moon makes an appearance in the company of a stylized comet (illus. 121).

While certain astronomers continued to draw their observations, photography was coming rapidly to the fore and, as we discuss in Chapter Ten, cameras were aimed at the Moon. As early as 1839 the French painter and daguerreotypist Louis Daguerre posited that lunar photography would soon be possible. On 23 March 1840 John William Draper of New York made what are probably the earliest lunar images; his exposure time was thirty minutes. Unfortunately these daguerreotypes were

lost in a fire at the New York Lyceum in 1866, and thus the oldest surviving photograph of the Moon is one taken by Samuel Dwight Humphrey in upstate New York in 1849 (in the Harvard University collection). Two years earlier the inventor and photographer John Adams Whipple failed in his first attempts to make lunar daguerreotypes using the long focal length, high focal ratio Great Refractor in Harvard College Observatory. After succeeding in daguerreotyping a star in 1850, the next year Whipple and his assistant William B. Jones collaborated with the director of the Observatory William Cranch and his son George P. Bond to successfully capture an image of the Moon (see illus. 291). The precision of lunar photographs in the 1850s was already very high, and full-frame images of the Moon have scarcely been improved upon since. The English astronomer and inventor Warren De la Rue, inspired by the display of the Whipple/Bond Harvard daguerreotype at the Crystal Palace in 1851, began to investigate collodion plates and within two years had succeeded in capturing lunar photographs.

De la Rue was the quintessential wealthy British amateur astronomer active during the third-quarter of the nineteenth century. He was pre-eminent in pioneering the development and application of astrophotography. Among his achievements are an early stereoscopic view of the Moon from 1858, as well as detailed observations and photography of Earth's satellite. But his chief claim to fame was the application of art photography to astronomical research using the wet-collodion process – a relatively rapid method compared to that which Whipple had used. Using this process De la Rue obtained exquisitely defined lunar photographs, including some of eclipses and a series of twelve lunar phases taken in 1860 from his private observatory at Cranford. He showed these at the Great London Exposition of 1862 and subsequently packaged twelve of them into an album. The images remained unsurpassed until the 1865 publication of Lewis Morris Rutherfurd's Moon photographs.

The English painter John Brett was strongly committed to both art and astronomy. A gifted astronomer from a precociously early age, he is best known as a

121 Unidentified British maker, letter opener in the shape of a comet with the Moon, c. 1830–60, brass, 22.9 cm length.

painter attached to the later Pre-Raphaelites and as a protégé of the English critic and artist John Ruskin. Prior to buying his first telescope at the age of fourteen, Brett made his own observing tubes from metal pieces he collected in second-hand shops. In June 1871 he was elected a Fellow of the Royal Astronomical Society and in time submitted at least eleven papers to their journal *Monthly Notices*. Brett maintained an observatory at Daisyfield, his house in Keswick Road, Putney. In his lunar observations Brett followed in the footsteps of his artist predecessor John Russell and responded to Ruskin's encouragement of exacting Pre-Raphaelite ideals of truth to Nature, in this case meaning geological accuracy. His drawing of Gassendi's crater on the Moon (illus. 122) surpasses in its subtlety Robert Hooke's engraving of the crater Hipparchus (1664) and any photograph of the time. Despite the beauty and accuracy of his hand-drawn images, photographs had the advantage of being permanent and stable records, which could be produced in multiples. By the end of the nineteenth century light-sensitive emulsions had improved to such a degree that the position measurements of lunar features that could be discerned from photographs superseded eye-at-the-telescope measurements in both number and accuracy.

Even after the advent of advanced astronomical photography the Moon remained lodged in the imaginations of artists, scientists and cartographers. One noteworthy example is the retired Scottish engineer James Nasmyth, who constructed meticulously detailed three-dimensional plaster models of the surface of the Moon, some of which are preserved in the Science Museum, London. Nasmyth made the uncanny models to photograph as plates for the classic book he wrote with James Carpenter, *The Moon: Considered as a Planet, a World, and a Satellite* (1874).

Many artists continued to represent the Moon for its symbolism, expressiveness or to create a romantic mood of reverie, while in some works it has the effect of conjuring more eerie visions of a cosmic, metaphysical nature, as in Vincent van Gogh's *Starry Night* (see illus. 246). In the French silent film by Georges Méliès, *Le Voyage dans la lune* (A Trip to the Moon) of 1902 – inspired by Jules Verne's novels *De la terre à la lune* (From the Earth to the Moon, 1865) and its sequel *Autour de la lune* (Around the Moon, 1870) – a group of astronomers travel to the Moon on a cannon-propelled capsule to explore its surface. They are captured by an underground group of 'Selenites' but escape and, having seized one of their captors, return to Earth with the being. The moment in

122 John Brett, *Gassendi's Crater on the Moon*, 1884, black chalk with white heightening on paper, 21.5 × 16.9 cm.

which the capsule lands in the disgruntled Man in the Moon's eye remains one of the iconic and most frequently referenced images in the history of cinema (illus. 123). This internationally successful cinematic satire is regarded as the earliest example of the science-fiction film genre and is often ranked as one of the hundred greatest films of the twentieth century, but its significance also resides in its expression of the desire to explore space and other worlds. The film helped fix the popular image of the Moon as craggy, when in actuality its surface has smooth rolling hills, as discovered by the *Apollo 11* mission in 1969.

Seventeen years after Méliès' film, the International Astronomical Union was founded, leading to the eventual publication in 1935 of the *Named Lunar Formations*, or NLF (although issues of nomenclature continued to surface). In 1926 the American painter Howard Russell Butler – who had become interested in astronomy in 1918, when he was invited to view the total solar eclipse at the U.S. Naval Observatory – envisioned the age-old dream of lunar voyage in a prophetic painting of the Earth as seen from the Moon, with some putative, craggy lunar features in the foreground (illus. 124).

123 Georges Méliès, *Le Voyage dans la lune* (A Trip to the Moon, 1902), cinematic still photograph. Cinematographers: Théophile Michault and Lucien Tainguy.

124 Howard Russell Butler, *The Earth Seen from the Moon*, 1926, oil on canvas, 141 × 120.6 cm.

Some of the Moon's old mystery was periodically revived in works of art during the twentieth century. A case in point is the Spanish Surrealist Joan Miró's painting *Dog Barking at the Moon* (1926; Philadelphia Museum of Art), which draws on an earlier sketch by the artist depicting a Catalan folk tale. Complete with cartoon word balloons, the drawing shows a dog 'bow-wowing' at the Moon while the Moon looks down without pity, saying, 'You know, I don't give a damn.' Miró's painting is more abstract and enigmatic than his sketch, leaving the viewer wondering what is transpiring and in what kind of a world.

With *Le Voyage dans la lune* Méliès was not that much ahead of his time. The age of spacecraft exploration began less than sixty years later, in 1959, when the Soviets sent up *Luna 1*. That first attempt failed to meet

its target but was followed by a series of other missions, including *Luna 3*, which sent back images of the far side of the Moon. Fourteen years later, on 'Brain Damage', a track invoking a lunatic, Pink Floyd's David Gilmour intones the lyric invitation to see you on the dark side of the Moon, from which the band's best-selling 1973 album takes its name. We must note, though, that it is properly the 'far', not the 'dark', side of the Moon, since each side is light and dark; the dark side faces Earth during the new moon. China's *Chang'e 4* landed on the far side in 2019.

After *Luna 1* the Americans entered the scene, launching seven individual spacecraft between 1966 and 1968 through the Surveyor Program of NASA's Jet Propulsion Laboratory. In spite of the numerous landings and satellite launches since the first *Apollo* touchdown in 1969, the Moon still fascinates individuals who gaze

at the night sky. Contemporary artists continue to portray the Moon in order to underline its status as one of the most evocative and enduring images in the history of the visual arts. Not least among these, artist Vija Celmins, always attuned to the exquisite on Earth and in the heavens, paid homage to these events in her provocative graphite drawing of the surface of the Moon (1969; Museum of Modern Art, New York).

In the 1960s and 1970s Gerard Kuiper and his colleagues brought the era of telescopic lunar mapping to completion by publishing four comprehensive photographic atlases. His work is commemorated by a namesake crater on the Moon. Recently, NASA and the Japan Aerospace Exploration Agency mapped the Moon in 3D. This ever more accurate 3D cartography has led to improved predictions of Baily's beads (see Chapter Three). In addition, NASA's *Lunar Reconnaissance Orbiter* discovered water on the Moon in the form of ice at the southern pole. Other scientific missions scheduled to the Moon will no doubt continue the exploration while the SpaceX company, among others, plans lunar tourism missions. Other aerospace companies believe that there is still much to be gained from focusing on the Moon: from colonization to mining, lunar exploration could yield large dividends. One hopes that soon several nations will send people to the Moon and resume the human exploration that otherwise ended in 1972. No doubt such exploration will inspire new, different kinds of lunar mapping and art.

125 Gabriel Brammer, Comet c/2011 L4 (PANSTARRS), 19 April 2013, European Southern Observatory.

5 Comets: *'Wandering Stars'*

The appearance of comets is too beautiful for you
to consider an accident.
Seneca, *Natural Questions*, VII, 301–2

Like eclipses, comets were once thought of as portents
of doom and disasters (literally 'bad stars') and less
frequently as heralding positive events. From the Greek
word *kometes*, meaning 'long-haired' – a reference to
their fiery tails – comets have also been called 'hairy
stars', as well as 'wandering', 'errant', 'bearded' and
'blazing' stars. Unlike eclipses, which have no orbits,
most comets have extended elliptical orbits, which
explains why until the eighteenth century they were not
understood to be periodic. Their apparent unpredict-
ability added to their mystery and magnetism. Comet
apparitions also foster personal associations because they
bookmark events in people's lives, encouraging individu-
als to identify with them. A case in point is a poem by the
English Victorian poet Gerard Manley Hopkins entitled
'—I am like a slip of a comet'. Today their awesome beauty
continues to spark metaphysical speculation about the
universe and human beings' place in its infinite expanse.

Among the spectacular inhabitants of the heavens
(illus. 125), comets are nature's most dazzling icons

– single, wondrous images of awe that inspire a sense of
veneration and often of fear as well. Dramatically illumin-
ating the dome of the night sky, especially luminous to
observers before the advent of electricity, they seem to vio-
late the predictable, elegant order of the universe. Unlike
other spectacular celestial phenomena, some comets are
visible for months on end, and their mane-like tails can
stretch across vast reaches of the sky. It is no wonder that
observers throughout the centuries have become obsessed
with their beauty, enshrining them in Western art and
literature where they function as omens and symbols.

A Blazing Star,
Threatens the World with Famine, Plague, and War;
To Princes, death; to Kingdoms many crosses:
To all Estates, inevitable Losses:
To Herdsman, Rot: to Ploughman, hapless Seasons;
To Sailors, Storms; to Cities, civil Treasons.

Guillaume de Saluste Du Bartas, *La Semaine;
ou, Création du monde* (1578)

In many cultures comets were considered messengers
from the gods and as double-edged swords, heralding

126, 127 Denarius coin minted by Augustus commemorating Julius Caesar (reverse with a comet), c. 19–18 BC, silver, 19 mm diameter.

both good and bad but always auguring important events such as the rise and fall of rulers (hence their appearance in ancient numismatics). Only since the eighteenth century have astronomers known that comets can be periodic objects, a fact that removed some of the fear surrounding them. Most comets, however, still appear unexpectedly to ignite great excitement. Since before Babylonian times, when their appearance was first noted on cuneiform tablets – such as the one in the British Museum describing the 163 BC apparition of the comet we now identify as P1/Halley – comets have demanded attention and captured the imaginations not only of artists and writers but also the populace at large. Non-periodic comets are identified by the preface C/, whereas periodic comets are preceded by P/. The non-periodic comet C/-43 K1, also known as the Great Comet of 44 BC, was perhaps the most famous comet in antiquity and the brightest daylight comet in recorded Western history. It was also documented in China, after which it disintegrated and disappeared forever, as did Biela's Comet in 1846. It appeared during the funeral games in celebration of Julius Caesar and was immortalized on Roman coins associated with him (illus. 126, 127), acquiring the

moniker 'Caesar's Comet'. According to the Roman historian Suetonius, 'a comet showed for seven days, rising about the eleventh hour, and was believed to be the soul of Caesar.' In his *Metamorphoses*, written in the early first century AD, the Roman poet Ovid interpreted it as a sign of the recently assassinated ruler's deification, and it subsequently became a powerful tool of political propaganda for Caesar's adopted nephew and successor, Octavian, who renamed himself Augustus Caesar. Augustus consolidated his power through brilliant propaganda and exploited the comet of 44 BC, having coins struck with his profile portrait on the obverse and the comet on the reverse and many variations; and others with his image on the obverse and that of a deified Julius Caesar, wearing a laurel wreath and crowned by a comet, on the reverse. The Roman poet Virgil also noted this comet in his *Eclogues*, while Pliny in his *Natural History* recorded that Augustus erected a temple to Divus Iulius (Divine Julius [Caesar]) in the Forum (42 BC) with a large statue of Caesar that had a flaming comet fixed to its forehead, leading to the structure being called the 'Temple of the Comet Star' and the emergence of a comet cult. It was one of several statues Augustus consecrated to Caesar to

confirm the astral apotheosis of his adoptive father. In turn it is inferred that the comet also heralded Augustus' own reign and a time of well-being – the Golden Age that Virgil described in his *Georgics*.

Unlike their Western counterparts, Chinese astronomers in the eleventh century BC began keeping extensive records on the appearance, path and disappearance of hundreds of comets, copies of which Jesuit missionaries brought to the West and published in 1846 (Korean and Japanese observers also recorded sightings that were only known later in the West). The Chinese created extensive comet atlases dating back to the Han dynasty (206 BC–AD 220) that describe comets as 'long-tailed pheasant stars' or 'broom stars'. Their various forms were associated with different types of disasters, as in the 'Silk Texts', manuscripts written on silk discovered in a tomb at the Mawangdui archaeological site in Hunan province (illus. 128). These feature compiled astronomical texts with information dating as far back as 1500 BC and are illustrated with 29 comet sightings. Like their Western counterparts, the early Chinese observers regarded comets as

'vile stars', but their scrupulous record-keeping aided later astronomers in determining the objects' true nature.

A comet is a small, icy body containing dust, methane, ice, ammonia and carbon dioxide, among other elements, in orbit around the Sun. In 1950 the American astronomer Fred Whipple characterized their nuclei as 'dirty snowballs', although more recently comets have been called 'snowy dirtballs' because their nuclei are black as velvet. This view has been supported by subsequent satellite missions launched by the European Space Agency: the *Giotto* spacecraft flew around Halley's Comet in 1985–6 and photographed its nucleus (illus. 129), measuring it at 16 by 8 kilometres (10 by 5 mi.), or half the size of Manhattan. The *Rosetta* probe's lander module *Philae*, touched down on Comet 67P/Churyumov-Gerasimenko on 12 November 2014 (see illus. 302), and the main *Rosetta* spacecraft touched down on 30 November 2016. The impactor of NASA's *Deep Impact* struck the nucleus of Comet Tempel 1 in 2005. The photographs taken by *Rosetta* over its two years orbiting the comet revealed its nucleus to have a

128 Unidentified calligrapher, detail of the Mawangdui silk (tomb 3) with types of comets, 300 BC, ink and paint on silk.

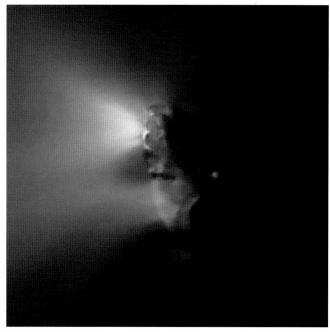

129 Nucleus of Halley's Comet, from the *Giotto* spacecraft, 1986.

volatile surface where cliffs collapse and boulders move hundreds of yards. Because comets belong to the primordial formation of the universe they contain the organic elements necessary for life. Scientists credit their impacts with engendering life on our planet. Although it was previously believed that comets and their meteor cousins brought vast quantities of water from space to Earth, recent information from the *Rosetta* probe indicates that the water on comets is different, leading scientists to suggest instead that terrestrial water came from asteroids, crashing into Earth, sometimes in great numbers. More than 4 billion years ago they pummelled the planet in a period of bombardment.

Astronomers pinpoint the source of many comets to two areas: the Kuiper Belt beyond the orbit of Neptune, and the Oort Cloud outside the orbit of Pluto. The latter is gravitationally part of the solar system but extends thousands of times further from the Sun than its outermost planets, reaching from the outside of the Kuiper Belt to our solar system's next nearest star. The Oort Cloud represents the remains of the primordial matter from which our Sun and its planets were formed some 4.6 billion years ago. Gravitational disturbances such as the mass of a passing star or the galactic tide occasionally nudge comets into trajectories bound towards the inner planets, where some become trapped in new orbits. Comets which round the Sun in periods of two hundred years or less are called short-period or Jupiter-family comets, whereas the more numerous long-period comets clock over two hundred years for their journeys; indeed, some take hundreds of thousands of years for a round trip. There are also non-periodic comets, which astronomers believe are in open-ended, hyperbolic paths. After surprising earthlings and subsequently rounding the Sun these unexpected comets glide off into interstellar space.

As comets approach the Sun they heat up, leading them to 'outgas', releasing gases and dust to create a vaporous coma, a visible, halo-like atmosphere around the comet. Outgassing sometimes also produces a tail of varying degrees and lengths – some are thought to be 320 million kilometres (200 million mi.) long.

Certain so-called 'sungrazer' comets, such as the Great September Comet of 1882 (see illus. 292), come so close to the Sun that they are vaporized entirely, while others return to the outer solar system diminished. These effects are due to solar radiation and the action of the solar wind on the nucleus of the comet. Comet nuclei range from a few hundred metres to tens of kilometres across. If sufficiently bright, they can be seen with the naked eye. Particularly large, spectacular comets are called 'Great Comets', like the Great Comet of 1811, which could be seen in the sky for ten months. Objects such as these, visible for extended periods, often have a substantial cultural impact in literature and the visual arts. By convention comets are named after their discoverer or discoverers, but several of the most famous periodic comets, such as Halley's Comet or Encke's Comet, were instead named after the person who first calculated their orbits. The first photographic discovery of a comet was made in 1881 by Edward Emerson Barnard, an American pioneer of celestial photography; prior to this era necessity dictated that astronomers, like artists, record their observations as drawings.

The eccentric, elliptical orbital periods of comets range from several years to several million years. Short-period comets originate in the Kuiper Belt, while long-period comets hail from the Oort Cloud. Based on the data collected by NASA's WISE spacecraft (renamed NEOWISE, or Near-Earth Object Wide-field Infrared Survey Explorer), these icy wanderers, which can have periods of thousands or even millions of years, are now believed to be more common than previously thought.

The nearest point to the Sun of a comet's orbit is known as its perihelion, while its furthest point from the Sun is termed its aphelion. Comets are anatomically divided into three major parts: the icy nucleus (usually a few kilometres in diameter); the halo-like coma formed around the nucleus as the comet heats up approaching the Sun (the nucleus and the fuzzy coma, with its centre of condensation, together are referred to as the head); and the tail, the flashiest part and the source of the name 'comet'. A comet's tail always flows away from the Sun

and increases in length as it grows nearer. There are two types of tails, and comets frequently exhibit both kinds simultaneously: a dust tail that forms a slightly curved, billowing trail reflecting the light of the Sun; and an ion or plasma tail (or tails), which is virtually straight and slimmer, composed of positively charged gas forced away by the solar wind. A dust tail may extend great distances, like that of the Great Comet of 1843, which had a 320-million-kilometre (200-million-mi.) tail, the longest ever recorded. Some comets, usually the smaller ones, never develop a tail, instead appearing in the sky as a fuzzy luminescence. Every comet's profile is unique, and because it is volatile its appearance fluctuates during each apparition as it loses material and leaves a wake of comet litter along its orbit. Comets are related to meteors, fireballs and bolides (see Chapter Six) as well as to asteroids, though the latter have a different origin and are formed in the asteroid belt, a circumstellar disc located between the orbits of Mars and Jupiter, and orbit the Sun. While comet hunters have discovered a mere four thousand over the centuries (albeit at an ever increasing rate), astronomers estimate that as many as a trillion comets populate our solar system.

Comets are volatile bodies. Comet Shoemaker-Levy 9 broke into 21 large fragments in 1992 and continued to break up over six days in July 1994. Some of the fragments slammed into Jupiter at high velocities, creating fireballs estimated to have been over 3,000 kilometres (1,850 mi.) high and forming bruised areas in the planet's gaseous atmosphere ranging in size from 6,000 to 12,000 kilometres across (3,600–7,500 mi.). The largest Shoemaker-Levy impact released energy estimated at 6 million megatons and permitted the first direct observation of an extraterrestrial collision of solar system objects. This information supports the widely accepted theory that the extinction of the dinosaurs was the result of a massive comet or asteroid impacting Earth during a Cretaceous-Paleogene event 66 million years ago. Astronomers now realize that the distinction between asteroids and comets is not clear-cut: some asteroids contain a lot of frozen volatile gases and show signs

of water vapour, while some comets stick to the main asteroid belt between Mars and Jupiter, only exhibiting comas during a part of their orbit. So-called extinct comets – objects that have exhausted their volatile material during repeated passes of the Sun – have for all intents and purposes become asteroids, that is, minor planets that have elliptical orbits between Mars and Jupiter in a zone called the asteroid belt.

Aristotle considered both comets and meteors to be atmospheric phenomena, in part because neither restrict their activities to the zodiac, the celestial band within which the planets are seen. Only meteoroids, innocuous space debris, enter into the Earth's atmosphere, becoming meteors. Colloquially meteors are sometimes nicknamed 'shooting stars'. When meteoroids enter the atmosphere they burn up, sometimes spectacularly, as bolides or fireballs (discussed in Chapter Six). Aristotle's view that comets and meteors are atmospheric phenomena fits into the Ptolemaic cosmological model whereby the planets were embedded in perfect revolving spheres and change was possible only below the orbit of the Moon. Not until the great Danish pre-telescopic astronomer Tycho Brahe measured the parallax of the Great Comet of 1577 (C/1577 V1) was Aristotle's long-held belief shattered. Tycho proved that comets are well outside the atmosphere and have trajectories that glide through the supposedly impenetrable spheres of the Ptolemaic system. The two-hundred-page analysis of his observations published in 1588 definitively transferred comets from meteorology to astronomy.

For a time Tycho was assisted in his work by Johannes Kepler, the German mathematician and astronomer. Kepler was a founder of the field of celestial mechanics and a confirmed Copernican, yet he failed to grasp that most comets have elongated, curving trajectories, believing instead that they follow a straight path. He contended that the apparent curve in the trajectories was an illusion caused by the motion of the Earth. However, once he had studied the findings of German mathematician Peter Apian – who noted from observing Halley's Comet (1P/1531) that cometary tails always point away

130 Michael Ostendorfer, Halley's Comet of 1531 (diagrammed with tail pointing away from the solar eclipse), detail from Peter Apian, *Astronomicum Caesareum* (Ingolstadt, 1540), hand-coloured woodcut.

from the Sun (illus. 130) – Kepler grasped an essential fact about the nature of comets: 'The head is like a conglobulate nebula and somewhat transparent,' he wrote in 1625 after observing comets in 1607 and 1618, and

> The train or beard is an effluvium from the head, expelled through the rays of the Sun into the opposed zone and in its continued effusion the head is finally exhausted and consumed so that the tail represents the death of the head.

In 1687 the English mathematician, physicist and astronomer Isaac Newton published his *Principia*, which included a theory with illustrations concerning comets, albeit one peripheral to the book's core aims. Comets, Newton argued, follow parabolic orbits around the Sun (illus. 131), and he applied his inverse-square law of universal gravitation to the 'sungrazing' Great Comet of 1680 (C/1680 V1, also called Kirch's Comet or Newton's Comet). His friend Edmond Halley, who both helped instigate and paid to publish the *Principia* (*Philosophiae naturalis principia mathematica*, or Mathematical Principles of Natural Philosophy), used Newtonian

principles to parse historical records of comets, making adjustments for gravitational disturbances and retrograde movements. He discerned similarities with comets observed in 1531 and 1607. Halley concluded that these comets were likely one and the same as a comet that had appeared in 1682, one which he had tracked from his private observatory in Islington, north London, calculating its periodicity at 76 years. In 1705 the Royal Society published his findings as the *Astronomiae cometicae synopsis*, which concluded with his prediction of the comet's return in 1758. His calculation was met with derision by many contemporaries, who noted that he timed its return safely beyond his own lifetime and would, therefore, escape the humiliation of being disproven. Halley died in 1742 but was vindicated when the comet returned with only days to spare on 25 December 1758. An amateur German astronomer, Johann Palitzsch, spotted the comet with a homemade telescope 2 metres (7 ft) long and Halley's name was quickly attached to it. Western and Chinese records have allowed astronomers to tentatively date the comet's earliest recorded apparition as far back as 466 BC (X/-466?).

Halley had the good fortune to live at precisely the time when comet studies had reached a crucial stage. Although his theories about comets took years to formulate and involved a complex collaborative relationship with Newton, the time was ripe for a serious definition of comet orbits. Other astronomers had suggested that comets moved in an elliptical manner, but they had not applied the idea to the observed data through good scientific practice. Halley wrote in his 'Ode to Isaac Newton':

> . . . Now we know
> the sharply veering ways of comets, once
> A source of dread, no longer do we quail
> Beneath the appearance of bearded stars.

Halley's Comet (or P1/Halley, for 'periodic-comet Halley') was thus the first to be recognized as periodic. It is the most celebrated comet in history and is

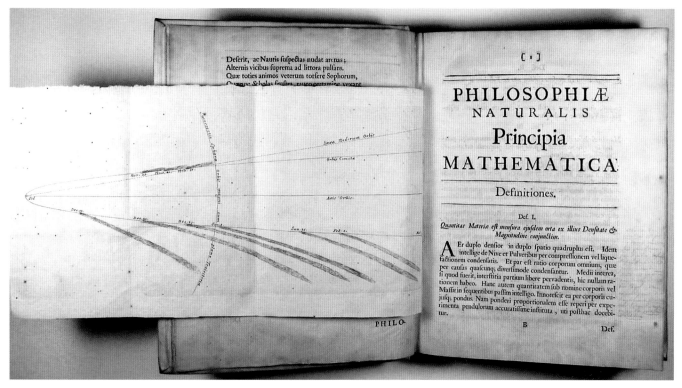

131 Isaac Newton, the path of the Great Comet of 1680–81 after Edmond Halley, fold-out from *Philosophiae naturalis principia mathematica* (London, 1687), etching.

surrounded by a magical aura of tradition and fascination. Furthermore, it is the only comet with an orbital period of less than two hundred years that is visible to the naked eye. Since it is also the only comet that might appear more than once in a human lifetime, it can be seen to simultaneously underline both our mortality and the wonder of the universe. The relative precision with which we know this comet's orbital period has allowed for 29 definitive apparitions to be identified in historical records, reaching back to at least 240 BC and probably to 466 BC. It is possible that its periodicity was discerned in ancient times: a passage from the Talmud tells of 'a star which appears once in seventy years that makes ship captains err'.

Throughout the nineteenth century and beyond people continued to anticipate the comet's arrival with great excitement. For example Mark Twain, who was born in 1835, a year of Halley's appearance, wrote humorously

about a comet in *A Connecticut Yankee in King Arthur's Court* (1889). He wanted desperately to live until the next apparition and then die with it, or so he dramatically claimed after suffering a series of heart attacks. His wish was fulfilled in 1910, when he died one day after the comet reached perihelion.

The first useful Western records of Halley's Comet are Roman reports from 12–11 BC (1P/-11 Q1) and from AD 66 (1P/66 B1), when Jerusalem was under siege by the Romans. The first-century AD historian Josephus described the comet's apparition as a sword that hung over the city for a year, prophesying the latter's destruction four years later. The first recorded Western image of the comet outside commemoratory numismatics dates from AD 684 (illus. 132), although the woodblock was designed eight centuries after the fact and published in 1493 in the *Liber chronicarum* (Nuremberg Chronicle), a history of the world and the city of Nuremberg

132 Unidentified artist, Halley's Comet of AD 684, detail of folio 157r from *Liber chronicarum* (Nuremberg Chronicle; Nuremberg, 1493), woodcut.

looks like a primitive rocket spewing flames and is accompanied by the inscription 'They are in awe of the star.' Indeed, the 1066 apparition caused mass terror over Europe and was widely said to portend calamities, such as war and the death of kings. Not surprisingly, King Harold II of England perished at the Battle of Hastings, but the comet was a double-edged sword, for it also augured victory for the Normans and changed the face of England forever.

While there are examples in sculpture and other media, most medieval and early Renaissance depictions of comets are found in illuminated manuscripts. In the margins of the Eadwine (Canterbury) Psalter the monk Eadwine recorded Halley's 1145 apparition (1P/1145 G1), commenting on the radiance of the 'hairy star' (illus. 134). At the time, Western learning was centred in the Catholic Church and to a lesser extent in the courts. Meanwhile, Arab astronomers kept the fires of astronomy burning with their translations of ancient texts. These Muslim treatises were gradually translated into other languages, contributing to a general secular revival of classical learning. While some of the Western manuscript illustrations treat comets as prodigies and link them to historical events, others ally them to zodiacal signs. In an exercise of verbal and visual hyperbole, many of the illustrations take the fanciful forms – such as swords – that have often been ascribed to them since antiquity. The medieval period was rich in comets, with the appearance of Halley's in 1222 (1P/1222 R1); the comet of 1264 (C/1264 N1) – one of the finest ever recorded, with a tail spanning ninety degrees; and the comet of 1299 (C/1299 B1). On the threshold of the fourteenth century comets began to be observed more objectively and their physical properties described. This new spirit was motivated in part by the vain hope of discovering physical bases for astrological beliefs.

It took the eyes of the Florentine painter Giotto di Bondone to shatter the established, stylized conventions for representing comets. A great pioneer of Early Renaissance naturalism, Giotto created the first convincing 'portrait' of a comet, commemorating his observation

by Hartmann Schedel with illustrations by Michael Wolgemut and Wilhem Pleydenwurff. The stylized woodcut and variants of it reappear throughout the volume to illustrate other comet apparitions.

With the advent of Christianity, pagan content often wore Christian clothing, such that only the context of comet imagery changed. Popular beliefs that the fates of both nations and individuals were ruled by the stars and planets often remained, and comets and other celestial phenomena were similarly interpreted as signs of God's wrath or approval. Among the earliest secure depictions of Halley's Comet executed near the time of its apparition is found on the crewel embroidery known as the Bayeux Tapestry, portraying it in 1066 (illus. 133). Numerous contemporary accounts comment on the sensational nature of the comet, calling it 'a torch of the sun' and 'a flaming beam'. On the Tapestry the comet

133 Halley's Comet of 1066, detail of the *Bayeux Tapestry*, 1073–83, wool and linen. Town Hall, Bayeux.

134 Eadwine, the 1145 apparition of Halley's Comet, from the Eadwine (Canterbury) Psalter, 1145, brown ink on parchment. MS R.17.1, detail of folio 10r, Wren Library, Trinity College, Cambridge University.

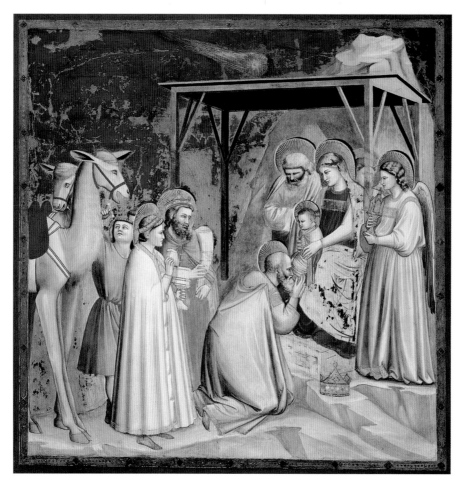

135 Giotto, Halley's Comet of 1301 in the *Adoration of the Magi*, c. 1303–5, fresco, Scrovegni Chapel, Padua.

136 Paolo Uccello, clock with comet dial, 1443, fresco and gilded copper, approx. 2 m diameter, Cathedral, Florence.

137 Paolo dal Pozzo Toscanelli, Halley's Comet of 1456, ink on parchment. MS Banco Rari 30, folio 251v, Biblioteca nazionale centrale, Florence.

of the 1301 apparition of Halley's Comet (illus. 135). The comet's return is also recorded by contemporary chroniclers who report it being visible from 14 September to 31 October 1301 (1P/1301 R1 Halley). Giotto's remarkable *stella cometa* (comet star) appears in his *Adoration of the Magi* scene in the Scrovegni Chapel in the university town of Padua, a place renowned for its connections to mathematics and nascent astronomy. The artist depicted a flaming 'broom star' in place of the more traditional Star of Bethlehem, thus marrying his observations of Halley's with the Church Fathers' doctrine that the miraculous Star was indeed a comet (albeit that no comet is mentioned per se in the New Testament). Giotto's portrayal is the first Western naturalistic representation of an identifiable comet, and it can be considered a portrait because, like people, comets have unique characteristics and profiles. Giotto's brushstrokes effectively capture the comet's anatomy: the pulsing energy of

its coma, the centre of condensation within the more diffuse coma and the tail that convincingly trails off into the atmosphere. Small wonder that the European Space Agency named the first satellite to fly close by a comet in 1985–6 *Giotto*.

Renaissance Florentines were extremely conscious of comets because the hand of the huge clock in Florence Cathedral was designed like a gilded metal comet (illus. 136). In 1443 the Operai di Santa Maria del Fiore commissioned Paolo Uccello to fresco the clock face on the cathedral's interior west wall. The clock tells the time from the hour after sunset in 24 one-hour segments. This modern, functional device took pride of place in the cathedral, usurping the spot traditionally reserved for a rose window on the entry wall. In the course of a recent conservation treatment, conservators consulted documents describing the original metal hand and accordingly reconstructed it as a comet, using as a model

138 Diebold Schilling the Younger, effects of Halley's Comet in 1456, detail from the *Lucerne Chronicle*, 1508–13, tempera and ink on parchment. MS S.23, folio 61v, Zentralbibliothek, Lucerne.

the Star of Bethlehem in the Nativity rose window that Uccello had designed for the octagonal drum supporting the dome above the crossing of the cathedral.

When Halley's Comet returned in 1456 (1P/1456 K1) the Florentine astronomer, mathematician and cosmographer Paolo dal Pozzo Toscanelli plotted its course in a sky chart in an early attempt to track a comet's course across the heavens against the backdrop of constellations (illus. 137). Alongside these scientific endeavours, superstitions still abounded. Rumour claimed that Pope Callixtus III excommunicated the comet in a papal bull; in reality he condemned 'the Devil, the Turk and the comet' in his call during the 1456 Ottoman Turk siege of Belgrade for a prayer for the success of the crusade. In 1468 Toscanelli also designed the gnomon still seen in Florence Cathedral that records the summer solstice to

within half a second. Later sources such as the *Lucerne Chronicle* (*Die Schweizer Bilderchronik des Luzerners*, 1508–13) of Swiss author Diebold Schilling the Younger record the comet with illustrations of its supposedly pernicious effects, baneful influences including monstrous births, earthquakes, illnesses and red rain (illus. 138). For all its superstitious content, Schilling's illustration captures the comet both before and after perihelion. Florentines observed the comet on 15 May with a long tail pointing towards the East. On 15 June (after perihelion on 8 June) its tail had switched directions pointing towards the West and contained rays the colour of fire. This 'rare' and 'grandiose' spectacle was visible for fifty days. Schilling similarly captured the comet of 1472 (C/1471 Y1), which was also recorded by Chinese observers as well as by Regiomontanus. Schilling took

the two apparitions – before and after perihelion – to be two separate comets, as seen on folio 77r of his chronicle, both with meteors in their wake.

Comet fever reached new heights in the sixteenth century when Western civilizations were undone by apparitions in the sky. Prophets of doom churned out lurid pamphlets predicting all manner of associated evils as cometary science took tentative steps forward. The age of Copernicus, Martin Luther, Michelangelo, Sir Thomas More, Shakespeare, Leonardo da Vinci and Tycho Brahe was a time of extremes, vacillating between the darkest superstitions and the promise of a new scientific age. While it witnessed the Reformer Martin Luther's condemnation of astrology (he called comets 'harlot stars'), the terror of retribution and guilt aroused by the Reformation – and Luther's fear of an impending apocalypse – only served to strengthen the hold of super-stition on the popular imagination. At the same time, widespread use of the new printing press accelerated the dissemination of inflammatory material in the form of scandal leaflets called broadsides. On the other hand, the obsession with collecting specimens and cataloguing that characterized this century fostered an intellectual curiosity that led to the rebirth of science and astronomy.

Copernicus' heliocentric theory, fully articulated in his *De revolutionibus orbium coelestium* of 1543, invalidated Ptolemy's geocentric scheme, although conservative factions like the Church were slow to accept his radical theory and its implications. Other scientific advances included those of the aforementioned Apian, who in his *Astronomicum Caesareum* stated that comets' tails always point away from the Sun, a fact he observed with Halley's Comet in 1531 (see illus. 130).

Nevertheless, these dire times with their religious and peasant-class religious wars and peasant revolts produced a generally apocalyptic climate, especially in northern Europe. With impassioned zeal people turned to interpret natural events as omens of calamities to come, continuing the tradition from antiquity to read celestial signs as fiery portents from the gods and God. Following the prototype of the fourth-century, late Roman author Julius Obsequens (*Liber prodigiorum*), these portentous interpretations of natural events were compiled in a pseudo-scientific manner. Conrad Lycosthenes' *Prodigiorum ac ostentorum chronicon*, published in 1557, was the most popular as well as among the most ambitious of the genre. It features many comets, some fanciful, others real, occasionally illustrated by

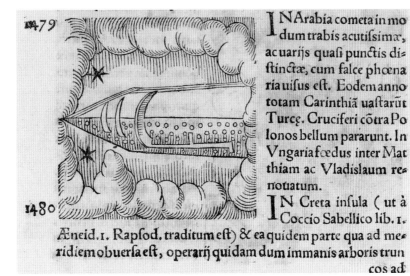

139 Conrad Lycosthenes, comet seen in Arabia in 1479, detail of page 494 from *Prodigiorum ac ostentorum chronicon* (Basel, 1557), woodcut.

131

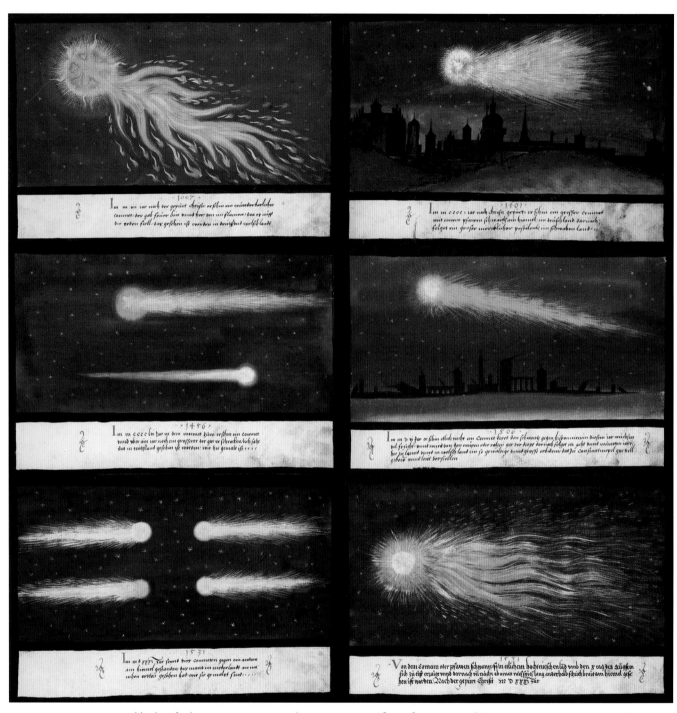

140, 141, 142, 143, 144, 145 Unidentified artist, comets reported in 1007, 1401, 1456, 1506, 1531, 1533, folios 34, 74, 79, 92, 121 and 125 from the *Augsburg Book of Miracles* (*Augsburger Wunderzeichenbuch*), c. 1550, watercolour, gouache and black ink on paper. The Cartin Collection.

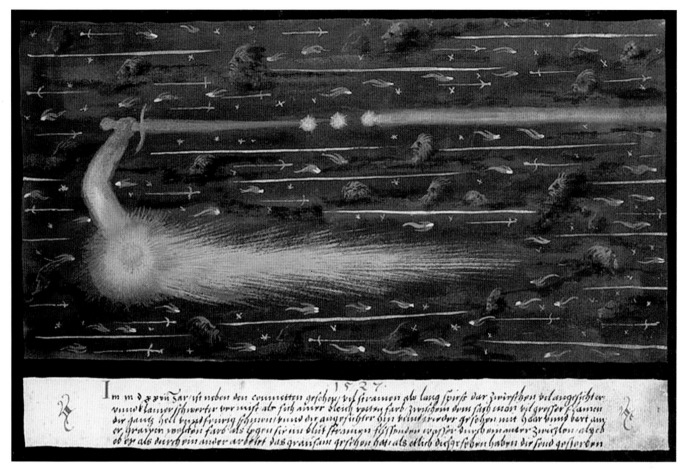

146 Unidentified artist, comet reported in 1527, folio III from the *Augsburg Book of Miracles* (*Augsburger Wunderzeichenbuch*), c. 1550, watercolour, gouache and black ink on paper. George Abrams Collection.

stylized woodcuts that are repeated throughout the text. Some of its comets assume marvellous guises such as swords, axes, knives, a bloody shower of daggers, hideous faces or an Arabian comet that looks like a spaceship straight from the Art Deco sets of *Flash Gordon* (illus. 139). The popularity of these compendiums of portents coincided with the last gasp of astrology's tyranny.

The *Augsburger Wunderziechenbuch* (Augsburg Book of Miracles), illustrated by a mid-sixteenth-century amateur hand with large-scale gouache and watercolour landscapes, compiles the recorded appearances of celestial phenomena interpreted as heralds of future events or disasters (illus. 140–45). With the exception of the imaginative anthropomorphic comet brandishing a

sword (illus. 146), its 26 representations of comets draw more on contemporary descriptions (including those of Halley's apparitions in 1456 and 1531) than the formulaic ancient types found in other compilations. Many of these vivid images incorporate observations that foreshadow later scientific developments, especially those regarding comet anatomy. Another unidentified amateur artist documented his observations of the Comet of 1532 (C/1532) in a watercolour (Science Museum, London), an apparition that was also noted by Apian and the poet-astronomer Girolamo Fracastoro, who claimed it was three times as bright as Jupiter.

The German artist Albrecht Dürer, who knew Regiomontanus, participated in the humanistic learning

147 Albrecht Dürer, *Melencolia I*, 1514, engraving, 24 × 18.5 cm plate.

The next apparition to attract attention was the comet of 1556 (C/1556 D1), which is dramatically preserved in a broadside by Herman Gall (illus. 148). Similar prints flooded Europe, especially Germany, and luridly proclaimed each event in the manner of today's tabloids or Instagram, Snapchat and Twitter feeds. Because they were the equivalents of modern empirical reporting, these broadsides had a significant influence on people's lives. Excitement about the comet of 1556 resulted in the publication of multiple treatises, including some debating the relevance of comets to astrology and others questioning the validity of astrology itself. By the end of the century, the credibility of that pseudoscience among the intelligentsia was ended.

Cometology as a science was born during the sixteenth century, beginning with Apian and Tycho Brahe. The latter had a well-equipped observatory on the island of Hven, which he named Uraniborg (Heavenly Castle). It was the first major observatory in Christian Europe; when it became too small he built Stjerneborg (Castle of the Stars). Among Tycho's accomplishments were his issuing of an accurate star catalogue, the discovery of the comet of 1582 (C/1582 J1), and his shattering of Aristotle's model of nested crystalline spheres by proving that comets are distinct objects in space. Much of his work concerned the bright daylight comet of 1577 (illus. 149), which he correctly positioned as orbiting the Sun, albeit mistakenly labelling it Earth. The Great Comet of 1577 was discussed in such a flood of treatises that it took one scholar some one hundred pages to compile a bibliographical list of them. This notorious comet caused so much excitement that it inspired Taqi al-Din Muhammad ibn Ma'ruf al-Shami al-Asadi to found the Istanbul Observatory in the Ottoman capital. Of the vivid Turkish comet illustrations that soon followed, the first appeared in the 'Secaatname' manuscript (Erol Patkin, Istanbul Universitesi Rektorlug) and the second in the 'Semailname' manuscript. In the latter the comet is shown hanging over Istanbul, which is seen in a birds-eye perspective (illus. 150).

When explorers opened the New World to Europeans in the sixteenth century, they encountered

characteristic of the Renaissance and maintained an observatory in his Nuremberg house. In his art he walked a fine line between science and superstition, exploiting the latter for emotional reasons in his prints illustrating the Book of Revelation (see illus. 196, 205). He also created beguiling star maps and painted a galvanizing bolide that he had witnessed exploding (see illus. 200). In a highly personal allegory of artistic creation, *Melencolia I* (illus. 147), he positioned the seated, winged personification of Melancholy (one of the four humours), ruled over by Saturn, under the aegis of a comet and a rainbow as harbingers of change (or possibly disaster). This complex, spiritual self-portrait coincided with the surge in printing technology and the contingent flood of simpler pamphlets and broadsides that circulated more sensational images across Europe.

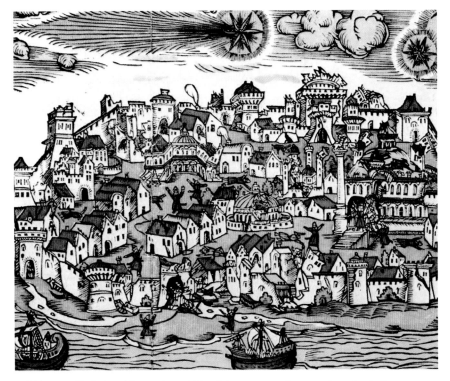

148 Herman Gall, detail from a broadside of the comet and two earthquakes in Rossana and Constantinople, 5 March 1556, hand-coloured woodcut.

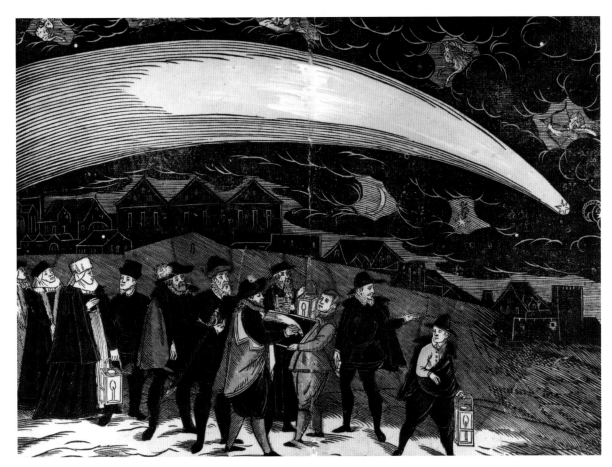

149 Jiri Daschitzsky, detail from a broadside of the Comet of 1577 seen at Prague, as reported by Peter Codicillus, woodcut.

150 Unidentified Ottoman artist, *The Great Comet of 1577*, 1579, watercolour, ink and gold on paper. 'Semailname' manuscript, folio 58, Central Library, Istanbul.

151 Moctezuma II transfixed by a comet in 1519–20, detail from Fray Diego Durán, *Historia de las Indias de Nueva España* (written 1574–81, published 1867–80), hand-coloured engraving.

among the indigenous people some ideas about comets that resembled the superstitions of Western antiquity. The Maya believed that comets and meteor showers precipitate a change in leadership. The Inca regarded comets as an intimation of divine wrath from their sun-god, Inti, and believed the 1531 apparition of Halley's Comet heralded the Spanish invasion led by Francisco Pizarro. Several Spanish histories – including one narrated by Domenican Friar Diego Durán in his *Historia de las Indias de Nueva España* (illus. 151) – relate that the Aztec ruler Moctezuma II was so frightened by the appearance of a comet that, on the advice of court astrologers, he refused to act while it hung in the sky. Hernán Cortés thus easily subdued the Aztec empire and became regarded as the blond-haired god of Aztec myth.

The ancient comet types described by Ptolemy and subsequent commentators were revived and illustrated in an attempt at classification and specificity, though one that nonetheless still treated them as prognostications,

most often linked with war and destruction. Each shape supposedly precipitated a specific effect. Among the most sumptuous representations are those in a late sixteenth-century manuscript treatise on comets and their terrestrial effects now held at the Warburg Institute, London. The text is based on a French translation of a thirteenth-century Spanish manuscript (illus. 152–5). It features representations of ten comet types – listed as Miles, Aurora, Argentum, Scutella, Azcime, Rosa, Veru, Pertica, Gebea and Domina Capillorum – together with comments about and illustrations of other celestial phenomena including parhelia, meteor showers and the aurora borealis.

During the sixteenth century serious scientific inquiries into the nature of comets pushed pre-telescopic observation to its limits. Having proved Copernicus' theory of heliocentricity, Kepler was able to conclude that the Sun provides the reflected light of the comet and its tail. He mistakenly thought they travel in straight lines

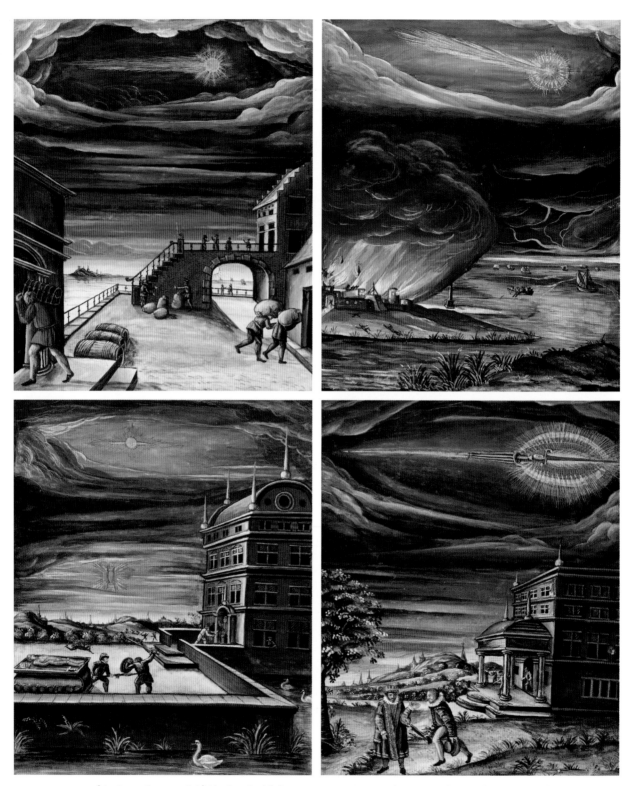

152, 153, 154, 155 (clockwise from top left) Unidentified Belgian artist, comet types Argentum, Aurora, Pertica, Veru, from *Des comettes et de leúrs signifiances generales et particulières selon Ptolomée . . . et aústres astrologues*, c. 1587, gouache on paper, 13.6 × 11.5 cm. MS FMH 1290, folios 17, 21, 35, 39, The Warburg Institute, London.

but he was again correct in stating that comets 'are as numerous as fish in the sea', though we see only a limited number of them.

The birth of telescopic astronomy was the cure for the sixteenth century's comet crisis. While many individuals experimented with lenses and telescopes for terrestrial use, its profound application to astronomy must be credited to Galileo. It was he who took the first step, in 1609, when he learned about the magnifying lenses that he would later employ in his telescopic observations. In the autumn of 1618 three comets appeared, q1, v1 and w1, the latter two of which could be seen together for a time. They were visible to the naked eye but were also observed with telescopes, the first being reported from Hungary in Kepler's *De cometis libelli tres*. Orazio Grassi, the leading astronomer and Jesuit in Rome at the time, also wrote a book about the three comets the following year.

As a brilliant new scientific thinker Galileo not only favoured the Copernican heliocentric system but also began to research astronomical problems as purely mechanical ones. The controversy between Galileo and the Jesuits over the nature of comets enlarged on their previous controversy over the discovery of sunspots, the subject of Galileo's book of 1613, and addressed the veracity of what the human eye saw or did not see through the telescope (see illus. 51). A lengthy discussion of the topic brought Galileo before the Inquisition, which ultimately concluded that he was 'vehemently suspected of heresy' and sentenced him to house arrest until his dying day. The controversy is of both scientific and philosophical significance because it was in this context that Galileo disclosed his conception of the scientific method, which was vastly influential on the course of modern thought. Indeed, Galileo's discussion of comets in his *Il Saggiatore* (The Assayer) of 1623 is of extraordinary literary merit and is sometimes considered the greatest polemic ever written in the domain of physical science. In the book Galileo dedicates several pages to condemning German astronomer Simon Marius for apparently claiming to have discovered the moons of Jupiter before he did – Galileo first noted them one day ahead of Marius in

1609, although it is true that the names of Galilean satellites Io, Europa, Ganymede and Callisto come from Marius' 1614 book. Ultimately much of Galileo's vehemence arose from a confusion, in that Marius was using the old Julian calendar from his site in Germany while Galileo, in Italy, had adopted the Pope's new Gregorian calendar. The change of calendar meant that Marius' independent discovery of Jupiter's four largest moons was written down one day after Galileo's recording.

The quest for truth and authenticity often associated with the Reformation culminated in the seventeenth century with the birth of modern science and its emphasis on verification by experience. After fifty years of Counter-Reformation austerity the Catholic Church decided to combat the Protestant challenge in a positive manner by stressing humanity and sensual immediacy. Empiricism and optimism replaced mysticism and pessimism in both art and science. These developments brought the study of comets to a critical point. Wealthy mercantile Protestants in the Netherlands and post-Reformation Catholics in Italy led the way in commissioning works of art that reflected this new spirit of enquiry. During the latter half of the century many monarchs commissioned national observatories to house the new, more powerful telescopes that were being developed, enabling astronomers in centres such as Paris and Greenwich to observe the course of comets as never before. It was during this time that the gathering of data and development of theories on comets reached critical mass; Halley and Newton, the proper fathers of cometological studies, forged their pivotal theories during this epoch.

It was especially appropriate that the apparition of Halley's Comet in 1607 was the first comet of the century. Of the three comets that illuminated the skies in 1618, the second one was the first brilliant comet of the century. Its tail extended up to seventy degrees and dramatically split into numerous star-like fragments, commemorated in medals. The English writer John Milton was a boy of ten when he observed this comet. He would continue to be haunted by it, frequently alluding to comets in his writings – having lost his

sight completely by the age of 46, he knew that it was the only one he would ever see.

While broadsides proclaiming prodigious events continued to appear, there was a subtle change of emphasis in people's willingness to accept comets as natural phenomena precipitating terrestrial effects. Between 1618 and 1665 four comets appeared, but none struck terror into the hearts of Europeans until the comet of 1665 (C/1665 F1) lit up the sky and the plague descended on the continent and England. In the following year came the Great Fire of London. English astrologer John Gadbury responded to the events in his *De cometis* (1665): 'These Blazeing Starrs! Threaten the World with Famine, Plague & Warrs,' he proclaimed; 'To Princes, Death: to Kingdoms, many Crosses; To all Estates, inevitable Losses!' The laws of chance were with him.

Some of the most lavish, large-format, multivolume comet treatises ever published were produced during this era, and the comet of 1665 precipitated two of the most significant. The first, *Cometographia* (1668) by the Polish astronomer Johannes Hevelius, was the first systematic account of past comets and was undertaken with the collaboration of his wife Elizabeth. Its frontispiece attests to the century's preoccupation with scientific instruments and the puzzlement about comet orbits that abounded before Newton and Halley had formulated their ideas – one of these was that comets move past the Sun in curved orbits, but unlike boomerangs never return. The second treatise was the sumptuously illustrated *Theatrum cometicum*, first published in 1666 in the Netherlands and written by the Polish astronomer Stanisław Lubieniecki. It was a universal history of comets from the biblical flood through to the comet of 1665 and included a reference to the Star of Bethlehem.

The first telescopic discovery of a daylight comet in 1680 (C/1680 V1) caused a flurry of activity but also revived old superstitions. While astronomers gazed coolly at the apparition through telescopes, an irrational element in society grew hysterical about the gigantic, red-tinted comet, one of the most brilliant ever recorded. Visible to the naked-eye and with a seventy-degree tail,

the comet was first spotted before sunset on 14 November 1679 and last observed on 19 March 1681 by Newton, who concluded that comets are controlled by the Sun's gravitation. Newton's gravitational theory was a direct attack on all superstitions connected with comets, which during the seventeenth century grew to encompass witchcraft. In his classic *Pensées sur la comète* (1682) Pierre Bayle launched a scathing satirical attack on the bigotry and intolerance associated with comet superstitions. Bayle, a teacher in Rotterdam, was attacked in turn by a reactionary preacher who believed in witchcraft. A similarly Calvinist mood prevailed in New England America, where Increase Mather stated in a sermon of 1680 entitled 'Heaven's Alarum to the World' that comets are 'God's sharp razors on mankind'. The culmination of these and other like sentiments was the infamous Salem witch-hunt of 1693.

Inflammatory broadsides peppered the European continent (illus. 156) and, as in earlier times, comet

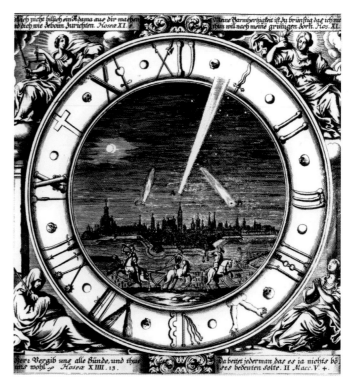

156 Johann Jacob Schönigk, detail of a broadside of the Comet of 1680 over Augsburg, 1680, woodcut.

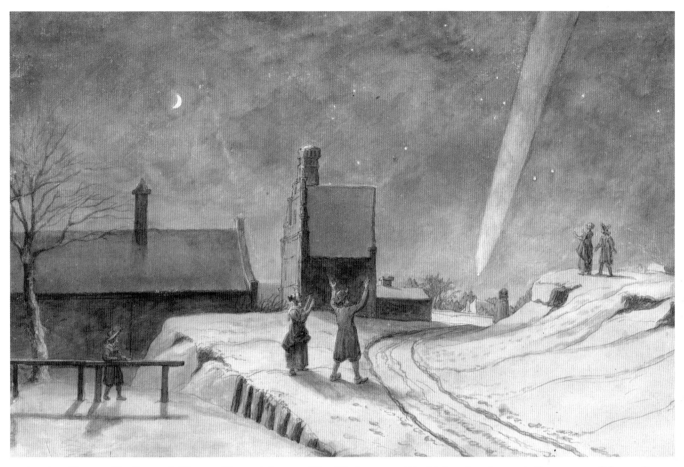

157 Lambert Doomer, *The Comet of 1680 over Alkmaar in January 1681*, 1681, brown and black ink and wash over chalk on paper, 26.8 × 40.8 cm.

medals were struck in Germany for the comet of 1680. One is inscribed: 'This star threatens evil things. Trust in God who will turn them into good.' The Dutch painter Judith Leyster took a more celebratory, phlegmatic view and took to signing her paintings with a clever monogram: an 'L' pierced through by the tail of a comet. It is a visual play on words as Leyster means 'lodestar' or 'polestar' in Dutch and she was described as a 'leading star' in contemporary art.

The comet of 1680 – the first comet discovered with a telescope and the first whose apparently parabolic orbit was calculated – was discovered by Berlin astronomer Gottfried Kirch. It was a portent of the ensuing Enlightenment and galvanized the intellectuals of the day. Thomas Brattle observed the comet methodically from

Harvard College in Cambridge, Massachusetts, and his results reached Newton in time to be incorporated in the *Principia*. The intellectual French socialite Madame de Sévigné wrote that the giant comet had the most beautiful tail she had ever seen. Her dispassionate view, one shared by others, reflects common sense and a pragmatic disbelief that comets should frighten anyone. Bernard Le Bovier de Fontenelle, a frequent guest at Madame de Sévigné's salon, lampooned astrology in his comedy *La Comète* (1681). For the first time comets were generally regarded with enough dispassion that they could be relegated to decorative motifs on real clock faces or on allegorical prints featuring clocks that were inspired by this very comet (illus. 156). Of course, at the time clocks were an essential device in accurate astronomical record-keeping.

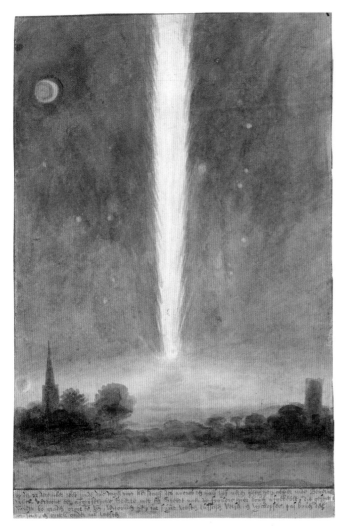

158 Unidentified artist, *The Comet of 1680 over Beverwijk on 22 December, 1680*, 1680, watercolour on paper, 34.2 × 23.8 cm.

another boldly executed watercolour depicted the amazing tail of this comet over the town of Beverwijk on 22 December, calling it a 'ghastly star' (illus. 158). The comet was a bright sungrazer and a member of the Kreutz group of remnants resulting from a comet break-up around 1106 that passed too close to the Sun. After 1680, eight more comets crossed the heavens before the close of the century, but with the exception of Halley's Comet in 1682 none created the furore sparked by the comets of 1665 and 1680.

Most seventeenth-century comet-oriented thought focused on critical scientific theories like those of Newton and Halley, while artists were less concerned with comet imagery than with depictions of life. Nevertheless, in this period comets do appear in novel and more candid contexts than ever before, revealing that they remained topical. For example, since it was believed incorrectly that comets affect the weather, making it warmer, they were thought to precipitate superior wines. Since higher temperatures create a greater sugar concentration, the idea of comet-wine and comet vintages arose, and they were promoted as particularly superb.

Cometology came of age during the eighteenth century as stronger telescopes beckoned astronomers beyond the confines of our solar system, promising a universe vaster than previously imagined. When on Christmas Day 1758, sixteen years after Halley's death, Halley's comet returned precisely as he had predicted, it established not only that comets could be periodic but also that they travel in elliptical orbits around the Sun – simultaneously validating Newton's system of gravitation (illus. 159). Thanks to new, sophisticated instruments such as the precision chronometer, astronomers were able to make their systematic observations with increasing accuracy. William Herschel and his sister Caroline, also his amanuensis, were among the astronomers intensely dedicated to observation. Caroline was the first female comet-hunter, discovering eight comets, and she drew many of them in her log (see illus. 42). She was lampooned in one of the many biting caricatures that became the rage during this age of fledgling journalism

Dutch artists, who were steeped in Protestant realism, were particularly successful in expressing the new scientific outlook. Of note is a view drawn by Lambert Doomer in January 1681, when on the tenth day of that month the comet's tail measured 55 degrees in length (illus. 157). Lieve Verschuier painted it ablaze over Rotterdam on 26 December 1680 (Historisch Museum, Rotterdam) and depicted people studying it with cross-staffs. Inscriptions on Verschuier's preparatory observational drawings confirm that he cropped its magnificent tail in his canvas. The unidentified artist of

159 Josiah Wedgwood, plaque of Isaac Newton with Halley's Comet, before 1780, jasperware, white relief on blue, 11 × 8.5 cm oval.

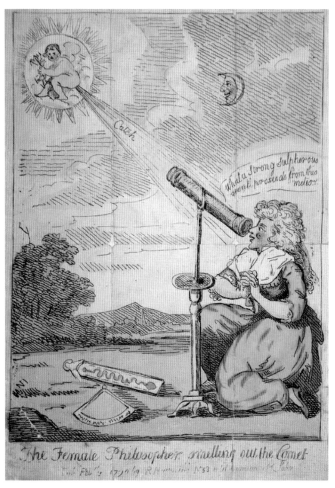

160 Hawkins(?) in the style of Thomas Rowlandson, *The Female Philosopher [Caroline Herschel] Smelling Out the Comet*, 1790, hand-coloured etching, 24.5 × 17.5 cm.

in which satire flourished (illus. 160). Extraordinary progress in the field of optics and physics also aided in the sighting of at least 62 comets during the century. In the last quarter of the century at minimum one comet was spotted each year. The keen interest in celestial observation, both professional and amateur, became so widespread that by 1800 observatories had multiplied throughout the world.

The eighteenth century was an optimistic age with a decided belief in progress. Comets as well as meteors became an obsession for some artists and scientists, and for the public at large, who showed a growing

appetite for science in general. Because of previous discoveries and the development of new technologies, people's insatiable curiosity about comets and meteors engendered more objective observations of these celestial fires – though their natures remained controversial. It was only in the eighteenth century, when it seemed that the heavens were on fire, that comets and meteors were finally differentiated, largely due to the efforts of the many dedicated English observers who published their sightings and illustrations in the *Philosophical Transactions of the Royal Society*. Scientists put cometology on a more objective standing by studying comets as

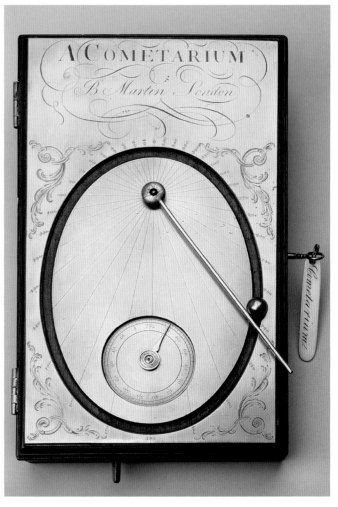

161 Unidentified English maker, tremblant comet hat pin, 1759, steel, height 11 cm.

162 Benjamin Martin, Cometarium, c. 1766, mahogany and brass, 30 × 18 × 5.5 cm.

part of a wider celestial mechanics. This in turn resulted in a more thorough understanding of the physical nature of comets. By the end of this fascinating century the distinct natures of comets, meteors and meteorites were clearly distinguished and the axiom 'If it moves and is in the heavens, call it a comet' no longer applied.

The eighteenth century brought Rococo style and the Enlightenment and was the era of Voltaire, Immanuel Kant and Wolfgang Amadeus Mozart, as well as Denis Diderot's 28-volume *Encyclopédie.* Comets were topical not just in England but on the continent, where King Louis xv dubbed astronomer Charles Messier 'the comet

ferret' in recognition of the fifteen or more comets he discovered. Comets continued to figure as literary images and sparked the extravagant imagination of the century. Among the outrageous, towering wigs worn by members of high society was one called 'The Comet' in celebration of Halley's posthumous triumph, and comet jewellery became de rigueur with every spectacular apparition (illus. 161).

Science itself became fashionable, although comets still carried some of their former apocalyptic connotations. The growing obsession with scientific observation is depicted in a series of eight paintings in the Vatican

Museum: *The Astronomical Observations* (1711) by Donato Creti. It showcases heavenly bodies including a comet, the Sun and the Moon (see illus. 52, 116) and features astronomers with their telescopes. The comet was probably based on an astronomer's sketch of a naked-eye apparition early in the century, either that in 1702 (C/1702 H1) or 1707 (C/1707 W1).

With the growing popularization of science and a prosperous exhibition business, savvy instrument makers (in Great Britain especially) began to demonstrate the new scientific findings about comets and to show off new technologies to a very eager public, hungry for astronomical roadshows. There were formal lectures at the Royal Society, the Royal Institution and in university classes, as well as informal ones in homes staged by travelling lecturers. High among Georgian and early Victorian

astronomical delights were discussions about the periodicity of comets, which were illustrated by devices called 'cometaria' or 'cometariums' (illus. 162). These mechanisms used gears in vertical and horizontal alignments to display on a flat plane how the speed of a comet varies in its orbit around the Sun, in accordance with Kepler's second law. They were probably first invented by J. T. Desaguliers in 1734. Similarly, astronomical toys and games were fashionable with the middle-class. A deck of 52 cards produced by Henry Corbould around 1829–31 included images of a comet and each of the planets, including the new planet discovered by William Herschel in 1781; the set was thus also educational in nature.

With the birth of journalism and the displaying of prints in coffee shop windows, celestial occurrences were reported with great zeal and frequency. But in

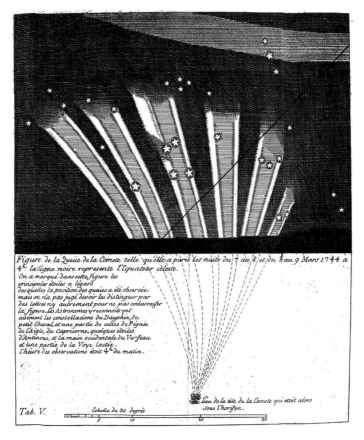

163 Unidentified artist, De Chéseaux's comet of 1744, from J.-P. Loys de Chéseaux, *Traité de la comète* (Lausanne, 1744), engraving.

the era following Halley's death and the vindication of his theories there was a marked change in the attitude towards comets. Reports become less sensational and more descriptive; the sense of wonder was transformed into an empirical fascination with the scientific aspects of the comet's appearance. A case in point is the very odd comet that appeared in late 1743 and 1744 (c/1743 x1). In Middelburg in the Netherlands, Jan de Munck discovered it in late November 1743, and Dirk Klinkenberg in Haarlem sighted it on 9 December. Four days later the Swiss astronomer Jean-Philippe Loys De Chéseaux also sighted it, and it is sometimes referred to as De Chéseaux's comet (illus. 163). This sometime daylight Great Comet was visible to the naked eye and at its absolute magnitude was one of the brightest ever. A few days after perihelion in March 1744 it developed a multiple, peacock-like tail that at one point had at least six fanning rays. Although it remained brilliant for only a short time it attracted a great deal of attention and may have inspired the comet motif that English artist William Hogarth incorporated in the first print of his scathing indictment of social corruption *Marriage à la Mode* (1743–5), where it hangs as an omen above Lord Squanderfield's portrait as a comment on the doomed, frivolous couple and Squanderfield's pomposity and folly.

Because of its many spectacular apparitions – about thirteen comets visible to the naked eye and nearly three hundred comets sighted in all (294 from 1801 to 1900) – the nineteenth century should rightfully be known as *the* comet century. These comets passed over the Earth during a pivotal period in Western civilization, one that saw the gigantic upheavals of the Industrial Revolution, nationalism and positivism, together with the publication of the theories of Charles Darwin, Sigmund Freud and Karl Marx, among others – in short, nothing less than the birth of the modern age. During this modern century, larger refracting telescopes were constructed to aid celestial sleuthing. One compact type named the Comet-Watcher was featured in a satirical print of the time (illus. 164) and was especially popular for charting cometological data. Consequently, much of the remaining

LOOKING AT THE COMET TILL YOU GET A CRIEK IN THE NECK.

164 Thomas Rowlandson, *Looking at the Comet till You Get a Criek* [sic] *in the Neck*, 1811, hand-coloured etching, 34.5 × 24.6 cm.

mystery and lore surrounding comets – what had not already been dispelled by the momentous discoveries of the previous centuries – disappeared entirely for natural scientists in this period. Nevertheless the public, fed by popular media as much then as today, seems to have preferred either to cling to age-old superstitions of comets as instant doomsday machines or to invent contemporary fantasies based on old themes. This condition was only natural, since the era was, in general, prone to excess and hysteria, both of which tended to exacerbate the recurring bouts of virulent comet fever in this comet-crazy century.

As the nineteenth century opened, the diminutive Napoleon Bonaparte was casting his long shadow over

165 Thomas Rowlandson, *John Bull Making Observations on the Comet*, 1807, hand-coloured etching, 24.6 × 34.7 cm.

European civilization. Never a man to doubt his own powers and a master of self-promotion well aware of the tradition associating comets with kings and great rulers, Napoleon cannily adopted various comets as his protecting *genii*. By attaching his reign to comet symbolism, Napoleon garnered for his rule a sense of traditional resonance and legitimacy. The first historical comet linked with Napoleon was the Great Comet of 1769 (C/1769 P1), sometimes called Napoleon's Comet, which by all reports had an unusual red lustre and a tail spanning more than sixty degrees. Since portents can be interpreted in various ways for propagandistic purposes, Napoleon's enemies later described it as foreshadowing bloodshed, destruction and devastating war, while his supporters construed it as auguring his glorious reign.

The appearance of the Great Comet of 1811–12 (C/1811 F1), a brilliant daylight comet also referred to as Napoleon's Comet, captivated not only all those interested in astronomical phenomena but nearly everyone. Napoleon greeted it as his guiding star and the controller of his destiny. English caricaturists, on the other hand, made great fun of the situation in seemingly endless printed caricatures, with the satirist Charles Williams personifying Napoleon as a malevolent comet eyeing England, inscribing his print *Malignant Aspects ... a New Planetary System* of 1807 with the caption 'A Corsican Comet / Frenchified!' The Emperor and his exploits remained grist to the mill of English satirists, who continued to capitalize on Napoleon's Romantic infatuation with comets: see for example Thomas Rowlandson's 1807 print *John Bull Making Observations on the Comet*, in which Napoleon's profile is used as the comet's head (illus. 165). The artist evidently harnessed scientific knowledge in his drawing as he accurately represented the comet as reflecting the Sun – depicted as none other than King George III. Napoleon's ill-fated heir

166 William Elmes, *The Gallic Magi Led by the Imperial Comet*, 1811, hand-coloured etching, 23.9 × 34.3 cm.

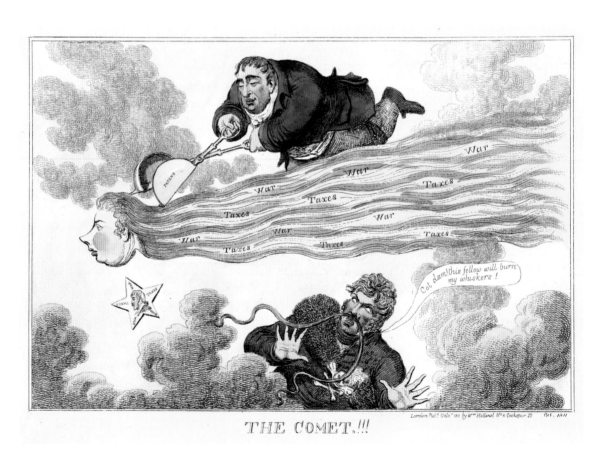

167 Charles Williams, *THE COMET!!!*, 1811, hand-coloured etching, 24.7 × 35 cm.

did not escape his dynastic inheritance, as seen in a print of 1811 (illus. 166) in which William Elmes has personified the Star of Bethlehem as a comet with a gas-expelling newborn in its coma leading the Magi to the Holy Family – none other than Napoleon, Marie-Louise and their son, the infant King of Rome. (How heretically far the Magi have journeyed since Giotto's *Adoration of the Magi*.) Satirists of the time such as Charles Williams also harnessed comet imagery to lampoon English political situations and to poke fun at 'hairy-stars' and their tradition of engendering baleful 'war' and 'taxes' (illus. 167).

As he assembled the greatest army in Europe since Xerxes invaded Persia in 480–479 BC, Napoleon claimed that this 1811–12 comet foretold his victory in the Russian Campaign. Ironically, the reverse proved to be true, and as long as the comet blazed in the sky Napoleon was well on his way to being defeated by the cruel Russian winter. The Great Comet of 1811–12 was not only the most spectacular naked-eye comet of Napoleon's reign but also one of the most ominous of modern times. Visible for 260 days it held the record for the longest naked-eye apparition in recorded history until it was dethroned by Comet Hale-Bopp in 1997. The Great Comet's tail reached a span as wide as seventy degrees in December 1811, and it seems to have displayed the largest coma ever recorded, at over 1.6 million kilometres (1 million mi.) in diameter – considerably larger than the Sun's and yet with only a tiny fraction of the Sun's mass. As Napoleon and his Grande Armée, some 700,000 men strong, marched into Russian territory, the comet burned with an intensely brilliant light and its tail performed frightening acrobatics by splitting in two. Around October the tail reached a maximum length of about 160 million kilometres (100 million mi.) and a breadth of 80 million kilometres (50 million mi.). None of us will probably ever see its like unless another rogue comet comes into view, since its period has been estimated (albeit not without some controversy) at about 3,065 years, give or take fifty. No wonder, then, that a world working its way out of the Enlightenment's rationality regarded the stupendous comet of 1811 with awe. Its cultural impact

on visual artists was huge, not least in the work of John Linnell – whose elegant drawings held at the British Museum were made with observations of the comet as scrupulous as those of his contemporary astronomers – and William Blake, who used it to fuel his poetic hallucinations (illus. 168).

As Napoleon's troops were taking Moscow in September 1812 the Great Comet was no longer visible, but on 12 July a periodic comet (12P/Pons-Brooks) appeared in the sky. Visible for a brief time, it was confused by non-scientists with the earlier comet. Russian author Leo Tolstoy exercised artistic licence and used the comet apparition of 1812 in his novel *War and Peace* (1867), where, as Napoleon's troops invade the Russian capital, the comet functions not only as a sign of war but

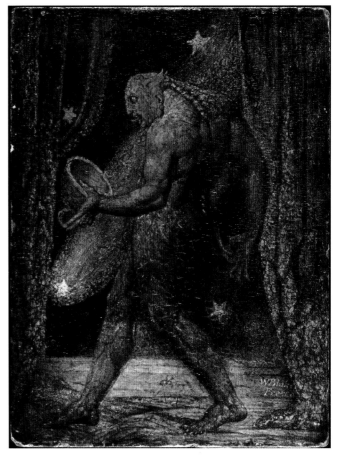

168 William Blake, *The Ghost of a Flea*, 1819–20, tempera heightened with gold on mahogany, 21.4 × 16.2 cm.

as a metaphor for the renewing power of love. It likewise played a role in the hit millennial musical *Natasha, Pierre, and the Great Comet of 1812*, loosely based on Tolstoy's novel.

In the nineteenth century comets became more than mere vagabonds of the solar system to be watched and studied; they were popular symbols that haunted the imagination, that universe more real to many Romantics than physical reality. Artists and writers, wishing to escape sordid reality, often represented in their work comets that did not refer to specific apparitions but rather to their own personal visions. Sometimes these non-specific comets were part of an already existing literary and/or artistic tradition and thus symptomatic of the age's historicism. A case in point is William Blake, who retreated from the Enlightenment's rationalism to a private world where he expanded the symbolism associated with comets into fantastic, poetic images. A mystic of great complexity, Blake was captivated by comet symbolism. In his illustrations for Thomas Gray's *Poems* of 1797 Blake portrayed a comet as a metaphor of Fame. Later, in his illustrations to *Milton: A Poem in Two Books* (1804–11), again a marriage of poetry and the visual arts, he represented a comet or a shooting star four times (see illus. 218).

Even more bizarre is Blake's hallucinatory painting *The Ghost of a Flea*, which depicts the artist's most memorable comet (see illus. 168). Blake described his own vision: 'Here he comes! His eager tongue whisking out of his mouth, a cup in his hands to hold blood, and covered with a scaly skin of gold and green.' While Blake drew its preparatory sketch, 'the flea told him that all fleas were inhabited by the souls of such men, as were by nature bloodthirsty to excess.' (Incidentally, comets were in traditional lore also referred to as 'bloodthirsty'.) How insidiously terrifying is Blake's vision, even today, conjuring human wickedness with its bloodthirsty tongue flicking like that of a lizard and its bulging eye aglow with infernal light. Between the ghost's feet rests the tiny flea. The comet with its phosphorescent glow is convincing, for its coma and tail convey the characteristic

vaporous reflection and fluorescence, perhaps preserving his memory of the Great Comet of 1811.

Certainly the comet of 1811 and Halley's 1835 apparition inspired John Martin's operatic painting *The Eve of the Deluge* (illus. 169). Martin's scene, taken from Genesis 6:5–8, is echoed in Lord Byron's sublime dramatic poem 'Heaven and Earth', which speaks of

The earth's grown wicked
And many signs and portents have proclaimed
A change at hand, and an o'erwhelming doom
To perishable beings.

Martin's stupendous comet plunges downward towards the Sun and rising Moon, a vivid prophecy of the impending cataclysmic flood. At the lower right the Israelites continue their revels, heeding neither the comet nor the ravens (another ill omen). On the promontory the family of Noah gathers around Methuselah, who consults the scrolls of his father, Enoch, to read the portents. The painting was controversial because at the time palaeontology and geology were beginning to demonstrate that the world was older than a historical reading of the Old Testament allowed.

The Great Comet of 1843 (c/1843 d1) was observed and drawn by Charles Piazzi Smyth, an assistant to Thomas Maclear at the Royal Observatory on the Cape of Good Hope, South Africa. Smyth was experimenting with the new technology of photography but also realized the importance of an ability to draw what he observed – indeed he published a significant paper in the 1843 *Memoirs of the Royal Astronomical Society* with a fascinating, milestone account of the usefulness of astronomical drawing (also acknowledging the difficulty of translating observational drawings into more permanent printed media). With the notable exception of William Herschel, drawing was a discipline that many astronomers overlooked, contenting themselves with hasty sketches.

The 1843 comet inspired the French illustrator and caricaturist Honoré Daumier to depict a large comet suspended over a melancholy Victor Hugo as

169 John Martin, *The Eve of the Deluge*, 1840, oil on canvas, 16.2 × 21.4 cm. Royal Collection Trust, Her Majesty Queen Elizabeth II.

an ironic metaphor of fame (*Hugo Looks at His Depression*, published in *Le Charivari*, 31 March 1843). The print's caption asks why the tail of the comet is longer than the ticket lines for Hugo's new and unsuccessful play *Burgraves*. Daumier's satirical, detached tone about the comet's portentous nature is reminiscent of French writer Alexandre Dumas' quip in *The Count of Monte Cristo* (1844), 'What's the matter, baron? . . . You look disturbed and that frightens me, a worried capitalist is like a comet, he always presages some disaster for the world.' The brilliant daylight comet of 1843, a Kreutz sungrazer, became very bright in March. It boasted a tail of an estimated two astronomical units (300 million km/186 million mi.) in length, the longest recorded until

Comet Hyakutake in 1996. According to an astronomer in Naples, its tail was bright enough to be noticeable above Vesuvius during a full moon.

Comets were the darlings of great illustrators. Among them was J. J. Grandville (the moniker of Jean-Ignace-Isidore Gérard), one of the shining stars of the golden age of French illustration, who created *Travels of a Comet* as part of his fantasy book *Un autre monde* (illus. 170). George Cruikshank's print *Passing Events; or, The Tail of the Comet of 1853* (illus. 171) and its preparatory graphite and ink drawing reflect the English public's consciousness of comets. Both of Cruikshank's works feature a grinning anthropomorphic comet head whose tail encompasses all noteworthy and trivial events of that

170 J. J. Grandville, *Travels of a Comet*, 1844, plate from *Un autre monde* (Paris, 1844), hand-coloured wood engraving.

171 George Cruikshank, 'Passing Events; or, the Tail of the Comet of 1853', 1854, from *George Cruikshank's Magazine*, I/1 (1853), hand-coloured etching.

entire year, drawn in antlike scale. While there were four comets observed in 1853, two of which were visible to the naked eye, and one comet observed in January 1854, Cruikshank certainly did not intend to refer to a specific comet.

Comets remained a hot topic throughout the century – and no wonder, for in 1857 alone seven comets were recorded. By mid-century, astronomy, which for the masses meant comet-seeking, became a popular fad and thus rich fodder for satire. *Une surprise* by Daumier (illus. 172) depicts an amateur astronomer standing before his telescope. He has blindly failed to find his quarry, causing the comet to tap the man on the shoulder. In 1857, the year of seven comet apparitions (including the short-period 5/D Brorsen's), Daumier satirized bourgeois attitudes towards comets in a series of ten cartoons for the magazine *Le Charivari*. He continued this theme with nine additional prints that year and two lithographs in 1858, a year of eight comet apparitions. Daumier is the artist who holds the record for creating the most comet representations. The universality of his insight into human nature is painfully evident in one vignette in which a thief picks the pocket of a gentleman as the latter gazes at the sky, transfixed by a comet.

In 1858 Donati's Comet (C/1858 L1), which is considered by many to be the most beautiful comet in history, made its first and only recorded appearance. On 2 June in Florence, Giovanni Battista Donati first sighted through a telescope his famous namesake. By 29 August Donati's Comet was visible to the naked eye, and it remained observable by telescope until 4 March 1859. Its fame derives from its unusual profile, which was characterized by one large dust tail and two thin plasma or ion tails whose interaction produced a symphony of curves and knots in their formation. Donati's Comet also had a number of fluctuating envelopes of light (three around the head and seven around the entire comet), which astronomers recorded in delicately shaded drawings. The detailed information in these scientific studies enabled Fred Whipple in 1978 to determine retroactively the rotation rate for Donati's Comet by deducing the intervals

172 Honoré Daumier, *Une surprise*, no. 52 from 'Actualités', in *Le Charivari* (Paris, 1853), lithograph.

of the dust emissions that formed its halos. It holds the distinction of being the first comet to be successfully photographed (see Chapter Ten). It is not known when or if Donati's Comet will ever return to give us a chance to photograph it again, but cometologists anticipate that it is a periodic comet positioned in an elliptical orbit with a period of around two thousand years.

On 5 October 1858, five days before perihelion, Donati's Comet passed in front of the very bright star Arcturus, as shown in an extraordinarily accurate watercolour by Samuel Palmer, where the star is to the right of the comet's tail (illus. 173). To everyone's surprise, neither dimmed the light of the other, and it is estimated that the comet's tail (spanning around forty degrees) had grown from a length of 22.5 million kilometres (14 million mi.) in August to 80 million kilometres (50 million mi.). Palmer portrayed it just after sunset, when most comets

are clearly visible, shortly before Donati's Comet passed in front of Arcturus at 7.00 p.m. He also rendered with relative precision the stars Epsilon, Delta and Eta in the constellation Boötes, and two stars of Corona Borealis. So wondrous were the pyrotechnics of Donati's Comet on 5 October that the *Annual Register* declared that 'the population of the western world was probably out of doors gazing at the phenomenon'. Among the other artists who were dedicated watchers of Donati's Comet were William Turner of Oxford (illus. 174), with at least another version of this watercolour in the Victoria and Albert Museum, and Robert Havell Jr – the engraver of John James Audubon's *The Birds of America* – who painted watercolours of Donati's Comet suspended above the Hudson River on two successive nights (illus. 175). The works of English author Thomas Hardy, who observed Donati's and was duly mesmerized by its apparition, are peppered with comet imagery. In his 1882 novel *Two on a Tower* (the tower of the title being an improvised observatory) his astronomer protagonist estimates Donati's period at thirty centuries.

During the mid-nineteenth century several other memorable comets careened across the sky, two of which were commonly associated by Americans with the Civil War. On 13 May 1861 the amateur astronomer John Tebbutt first spotted from Windsor, Australia, the Great Comet C/1861 J1, subsequently named after him. According to contemporary descriptions this naked-eye apparition did not surpass the beauty of Donati's Comet, but it did have other attractions, including a yellowish-red head, a complex nucleus, eleven surrounding envelopes and an extremely long tail estimated at between 90 and 120 degrees. Remarkably, it was so brilliant between 29 June and 1 July that it cast shadows at night. Tebbutt's Comet was also visible during daylight and is thought by some to have been the brightest comet of the century. Its appearance stimulated another generation of artists to employ topical comet imagery. For example, Gustave Moreau's *The Procession of the Kings* of 1861 (Musée Gustave Moreau, Paris) upholds the tradition of substituting a comet for the Star of Bethlehem,

while an illustration for *Vanity Fair* the same year personifies General Winfield Scott, a U.S. warmonger, as 'The Great War Comet of 1861'. A caricatured portrait of the General functions as the head of the comet; the General's Victorian whiskers and hair form the coma; and an army of rattling, sharply pointed bayonets comprises the comet's tail in this humorous image.

Tebbutt's Comet was the first comet to receive attention from a professional photographer, the Englishman Warren De la Rue, one of the great pioneers of astronomical photography. After seeing daguerreotypes at the Great Exhibition of 1851 he photographed the Sun and eclipses. He also tried, without success, to record not only Donati's Comet – as did William Cranch Bond in America (see illus. 291) – but also other comets. De la Rue did manage, however, to preserve a record of Tebbutt's Comet for posterity in the drawings that he made with the aid of a telescope.

Another 'Civil War comet' was the Great Comet of 1862, the periodic comet Swift-Tuttle (109P/Swift-Tuttle) discovered simultaneously by two Americans, Lewis Swift and Horace Parnell Tuttle. Although it failed to equal Tebbutt's Comet in either magnitude or brilliance, it was visible to the naked eye and striking for the peculiar jets of light, frequently altering in their forms, that spurted from its nucleus. It is also the icy parent of the annual Perseid meteor showers in August, which are especially spectacular every 133 years when Earth passes through the comet's tail (see Chapter Six). Some superstitious comet watchers interpreted these celestial fireworks as a herald of the Civil War battles of Shiloh and Williamsburg.

On 17 April 1874, J. E. Coggia sighted a bright comet from Marseilles (C/1874 H1). It had at least three nuclei points and at one time exhibited a star-shaped nucleus. Bright jets spurted from its head, and a black line was seen bisecting its tail. Astronomical drawings of the time attest that the head of Coggia's Comet was surrounded by many envelopes.

Despite all the technical advances of the comet-crazy century, comets were never entirely stripped of their

173 Samuel Palmer, *Donati's Comet of 1858 over Dartmoor*, 1858, watercolour, gouache and albumen on paper, 31.1 × 69.9 cm.

174 William Turner of Oxford, *Donati's Comet, Oxford, 7.30 p.m. 5 October 1858*, 1858, watercolour and gouache over graphite on paper, 25.8 × 36.7 cm.

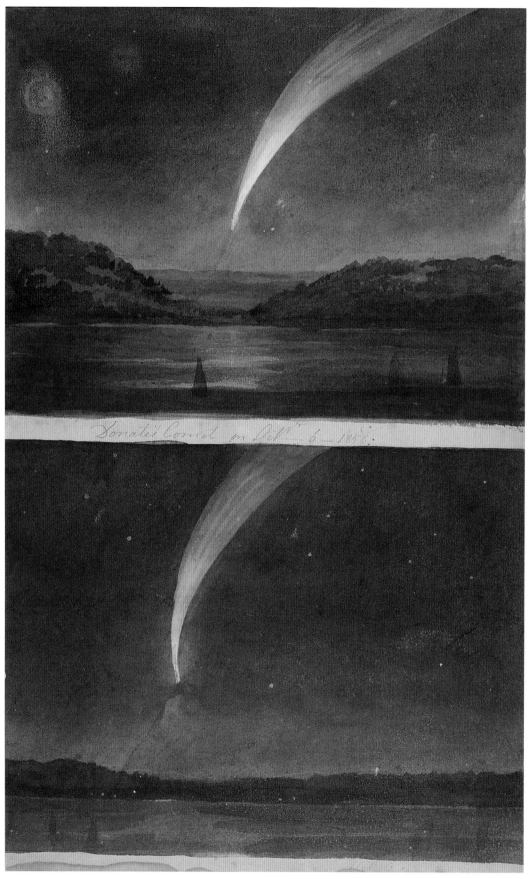

175 Robert Havell Jr, *Two Views of Donati's Comet on October 6th and 8th over the Hudson River*, 1858, watercolour and gouache on paper, 32.9 × 21.5 cm sight size.

176 Gustave Moreau, *The Death of Phaeton*, 1878, watercolour over graphite on paper, 99 × 65 cm.

mythology and they continued to embellish a myriad of decorative objects (see illus. 121). Towards the end of the century, as the charm of realism somewhat waned, many artists, intoxicated by actual apparitions, once again realized the potent, emotional symbolism of comets. In 1878, the year of three comets, Jules Verne published *Off on a Comet!*, in which he wrote, 'Quit his Comet! Never! His Comet was his castle.'

That so many comets populated the skies of the nineteenth century was in part because sophisticated telescopes made more discoveries possible. Furthermore, before the advent of the television, comet-watching was a diverting way for the middle class to spend their evening hours. No wonder that depictions of comets were especially popular among artists in the late nineteenth century. When American artist Frederic Remington

177 Edward Poynter, *The Great September Comet of 1882 over Loch Luichart*, 1882, black and white chalk on paper, 17.7 × 33.8 cm.

illustrated Henry Wadsworth Longfellow's poem 'Hiawatha' in a series of paintings in 1890, in *Ishkoodah, The Comet*, he depicted the comet as an American Indian warrior with long trailing hair flying over a landscape. ('Glared like Ishkoodah, the comet, / like the star with fiery tresses'.) So pervasive was comet fever that when James Smetham represented a scene from Alfred Lord Tennyson's *Idylls of the King* in his painting *Sir Bedivere Throwing Excalibur into the Lake* (1869; private collection) he converted Tennyson's aurora borealis into a comet, demonstrating that he was no stranger to the literary tradition wherein comets signal the death of kings. Another type of death and destruction is symbolized by the large comet in another work by Moreau, a cosmic watercolour titled *The Death of Phaeton* (illus. 176). Two comets, Comet Encke (2P/Encke) – named after the calculator of its 3.3-year period, Johann Franz Encke – and Comet Tempel 2 (10P/1878 01), were in fact sighted by the naked eye in 1878, the very year Moreau painted the watercolour.

The 1880s witnessed several remarkable comets. Among them was the Great Southern Comet of 1880 (C/1880 C1), best seen from the southern hemisphere, with its forty-degree tail extending from below the horizon. On 22 May 1881 Tebbutt spotted another comet from Windsor, Australia, which several people photographed. But it is Sir David Gill, the British astronomer who observed at the Cape of Good Hope, who is credited with first successfully photographing a comet with its tail – the Great Comet of September 1882 (C/1882 R1) – in a watershed moment that altered the course of cometology forever (see illus. 292). Because of its long, sweeping tail, whose shape since ancient times has been likened to a Turkish Scimitar, the Great Comet of 1882 was the type that traditionally struck terror into people's hearts. Its tail had multiple disruptions, which added to the drama, and a portion of the comet's mass separated from the parent body to form an independent satellite, a feature that made it especially compelling to the masses. The comet was another member of the Kreutz

178 Edward Poynter, *The Ides of March*, 1883, oil on canvas, 153 × 112.6 cm.

sungrazers and was visible to the naked eye for five and a half months, remaining in telescopic view yet longer. The importance of the new photographic technology dawned on cometologists, who realized that they could thus preserve evidence of apparitions that otherwise might have been lost or undiscovered. Nevertheless, some people, like the Pre-Raphaelite painter John Brett, who was a precocious astronomer and eventually a Fellow of the Royal Astronomical Society, continued to draw comets with black and white chalks as well as diagram their structures in sketchbooks from his observations. Victorian polymath Sir Edward John Poynter recorded his observations of the same Great Comet over Loch Luichart in an atmospheric drawing, precisely dated and timed (illus. 177). He applied these observations in his canvas *The Ides of March* (illus. 178), which he exhibited at the Royal Academy in London the following year (1883). Poynter's canvas visualizes the conversation between Caesar and his wife in William Shakespeare's play *Julius Caesar*, wherein Calpurnia says to the Emperor, 'When beggars die there are no comets seen; / The heavens themselves blaze forth the death of princes.' Poynter replicated the subject in 1916 in a pastel drawing in which the comet's tail that augurs Caesar's assassination by Brutus on 15 March has grown in length. Hardy's aforementioned novel *Two on a Tower*, published in 1882, features a comet – perhaps a compilation of a number he had observed, including, of course, the Great September Comet of that year. Symbolically it has a sexual dimension but it also saves the life of Hardy's star-crossed fictional astronomer:

> The strenuous wish to live and to behold the new phenomenon supplanting the utter weariness of existence . . . gave him a new vitality. The crisis passed . . . The comet had in all probability saved his life. The limitless and complex wonders of the sky resumed their old power over his imagination.

The author continued his interest in comet observation and comet symbolism, even embellishing 'A Sign-Seeker'

in his *Wessex Poems* (1898) with an illustrated headpiece depicting a large, vaporous comet.

A comet is the perfect emblem for the twentieth century, for comets have traditionally signalled change. As the nineteenth century rolled over to a new millennium there was a pervasive feeling that something had gone wrong with European civilization. Intimations of profound change and political revolution were in the air. Some people consequently buried themselves in hedonism, but no one could deny that German philosopher Friedrich Nietzsche had proclaimed that God was dead, and Thomas Robert Malthus's doctrine of overpopulation was fast becoming a reality. Philosophers and writers alike had attacked the Victorian taste for outward convention, conformity and order. Emancipation of workers and women had begun in tandem with a general democratization of society. In progressive artistic circles such changes produced an exhilaration whose momentum was reflected in H. G. Wells's utopian, futuristic book *In the Days of the Comet* (1906). A clear writing style had cut through the verbosity of the previous age. Art for art's sake, the aesthetic trend, had paved the way for abstract, non-representational art. The accelerated rate of scientific discoveries and their implications – those of Albert Einstein's new physics, for instance – were heady but frightening. This influx of novel information argued that beneath visual reality lurk hidden, subtle forces never before imagined. Traditional styles and images, which had corresponded to a stable, orderly universe in which thought and expression were tamed and disciplined, were thrown away as invalid.

Since the Church and state were no longer major art patrons, artists could retreat into their own private worlds, experimenting and creating images for themselves and their private patrons. French philosopher Henri Bergson's writings echo these subjective developments and the loss of absolute standards. Russian-born artist Wassily Kandinsky's painting *Comet (Night Rider)* of 1900 (illus. 179) seems to straddle the two centuries. Its decorative, sinuous forms and strong palette grow out of the German Jugendstil movement, the Art Nouveau of

179 Wassily Kandinsky, *Comet (Night Rider)*, 1900, watercolour and gold-bronze pigment on paper, 19.8 × 22.9 cm.

180 Fernand Léger, *Head of a Comet and Trunk of a Tree: Study for the Murphy Screen for Villa America*, 1930–31, graphite on paper, 43.5 × 29.4 cm.

Munich, and foreshadow the simplified abstract forms of the artist's later style. Kandinsky, like the German Expressionists, also looked to early German broadsides for inspiration to forge their bold, simplified styles and in the process certainly encountered the sixteenth-century flood of comet images. While the motifs of the castle and knight on horseback were derived from the nineteenth-century Romantic vocabulary, Kandinsky adopted the rider as both his own personal symbol of liberation and as the logo for the pivotal German Expressionist group to which he belonged, Der Blaue Reiter (The Blue Rider). Kandinsky's huge comet sweeping across the firmament suggests the mystery of cosmic forces that always intrigued the artist, as noted in his famous essay *Concerning the Spiritual in Art* (1912). His comet seems to presage change: for the world, for art and for science.

During the twentieth century there were several hundred comets sighted, though very few with the naked eye. The first memorable one, a brilliant daylight comet, appeared in 1910. It was followed in the same year by the long-awaited return of Comet Halley, which probably inspired the following lines in James Joyce's *Finnegans Wake*: 'Any dog's life you list you may still hear them at it . . . as ever sure as Halley's comet'. By the 1890s scientific photographs of comets had become quite common, equipping scientists for an unparalleled comprehensive study of the 1910 apparition of Halley's Comet and resulting in whimsical illustrations and celebrations of this famous comet in all kinds of ephemera. The effects of its memorable apparition – not least Earth's passing through the comet's tail, which many people needlessly found frightening – lasted for years. As in previous ages comet imagery generally appealed to artists with a penchant for bizarre or esoteric symbolism.

The seemingly playful but metaphysical oeuvre of the Swiss-German Expressionist Paul Klee, an artist of Jewish ancestry, is filled with astronomical and cosmic symbols including several comets, one with a head formed by the Star of David (illus. 1). Klee painted it from behind the wartime front while on leave after being drafted into the German army, dreaming about his earlier time in Paris to escape the horrors of war. With characteristic dry humour he depicts himself, seemingly crowned by a Jewish comet, whose head is a Star of David, across whose brow threatens another comet, perhaps symbolizing war. His friend Franz Marc did not survive the war. Before his death in battle in 1916 Marc had also depicted a comet in a collection of illustrated poetry, *Stella peregrina*, published posthumously in 1917.

After the sensation of Halley's apparition in 1910 there followed a lengthy hiatus in naked-eye apparitions until the 1927 appearance of Comet Grigg-Skjellerup (26P/Grigg-Skjellerup), which would be visited by the *Giotto* probe in 1992. In this earlier apparition the comet was bright for only a few nights. Thereafter another comet desert occurred until the 1940s, when several comets approaching the Sun were visible without the aid of a telescope.

During these periods of few spectacular apparitions, however, artists continued to create provocative comet images. As a result of the disillusionment and apocalyptic climate in the wake of the First World War, comets once again functioned as portents or, alternatively, as vehicles of escape, often associated with the powers of nature. The latter is the case in a drawing by Fernand Léger, one of several with comets that the French artist drew as studies for a screen he designed for Gerald and Sara Murphy, the jazz-age, Lost Generation, American expatriate couple who were darlings of Pablo Picasso's circle (illus. 180). The screen decorated their celebrated Villa America in the French Rivera town of Cap d'Antibes. On this two-sided sheet, featuring abstracted vignettes with comets on the verso, Léger rendered a powerful comet's anatomy – not only its tail and centre of condensation but also the concentric envelopes of light around its head. By including a tree and perhaps water, the artist suggests that comets were interstellar engenderers of life.

Art Deco, the svelte style of the 1920s and '30s whose celebration of modern glamour was based on geometry and chic, was also a form of escapism. Since the style embraced heavenly images such as stars and the Moon, it is no wonder that it also spawned a number of

streamlined comets. One of the most beautiful is René Lalique's glass car-hood ornament (illus. 181), a charming marriage of form and function. A comet once again takes the form of a woman with flowing locks in Maurice Guiraud-Rivière's bronze Art Deco sculpture *The Comet* (*c.* 1925). The French designer Paul Iribe, who created furniture and the famous silhouette logo for Lanvin, designed several pieces of jewellery using comet motifs, among them a graceful, dazzling diamond necklace for French fashion couturier Coco Chanel that has been reproduced in the twenty-first century by the fashion house she founded and cloned in other related pieces such as rings. The stunning necklace's tail sinuously drapes around the back of the wearer's neck to cascade down the chest (illus. 182).

The disillusionment precipitated by the First World War expressed itself most vociferously in the artistic-literary movement Dada. In the 1920s some of the adherents of Dadaism rode the phoenix of resurrection of Surrealism to the subterranean currents of the human mind. They employed such techniques as automatic writing, dreams, hallucinations and drug use to evoke new worlds and to tap unusual symbols in the human unconscious. André Masson, a French artist who was traumatized by his experiences in the trenches during the war, produced many works with images suggestive of comets and other whirling cosmic forms, as in his oil painting *Landscape of Wonders* of 1935. His contour drawing *Mithra* of 1933, published in 1936 in a portfolio series of etchings entitled *Sacrifices, The Gods Who Die,*

181 René Lalique, *comète*, car hood ornament, 1927, glass, 9 × 19 cm.

182 Paul Iribe, comet necklace (for Coco Chanel), c. 1932, platinum and diamonds.

alludes to the Roman mystical god who slayed the cosmic bull, thereby releasing the beneficent forces of the earth. Masson placed a swirling comet in the upper left-hand section of his composition, indicating that he was familiar with James George Frazer's eclectic anthropological book on dying fertility gods, *The Golden Bough*, as well as the ancient Roman visual tradition wherein Mithra is represented in the company of comets. In the same year Masson also designed a backdrop for the ballet *Les présages* for the Ballets Russes de Monte Carlo Theatre in Paris, choreographed by Léonide Massine with music from Pyotr Ilyich Tchaikovsky's Fifth Symphony. Masson's sci-fi backdrop featured all sorts of dramatic heavenly turbulence – whirling suns, shooting stars and a comet – as symbols of cosmic instability in a sky marked by brilliant zones of colour. Giorgio de Chirico, who was also influenced by Frazer's *Golden Bough*, designed costumes for Diaghilev's surrealistic staging of the ballet

Le Bal in 1929; De Chirico's costume design for the Astrologer features two comets on its coat tails (see illus. 16). Joan Miró, another Surrealist artist, also employed suggestive comet-like forms in his works, though they are usually more generalized and personal than those of Masson. The Surrealists were often concerned with sexual themes and symbols, as seen in Dorothea Tanning's *The Truth about Comets* (1945; private collection) or in Helen Lundeberg's strange conjunctions of enigmatic objects, including a print of a comet leant against a table leg (1937).

The Second World War followed all too quickly on the heels of the earlier war, intensifying the escapist use of comet imagery in art. In one of M. C. Escher's enigmatic, highly manipulated perspectives, where gravity seems not to exist (see illus. 234), the comet adds both a disquieting note and a sense of strange familiarity in a visionary universe that appears alien yet tantalizing. To quote the British biologist J.B.S. Haldane, 'My own suspicion is that the universe is not only queerer than we suppose, but queerer than we can suppose.' The existential post-war world was a place where human beings were condemned to terrifying loneliness and despair; only action validated existence. In the art world, action painting or Abstract Expressionism, here exemplified by Jackson Pollock's *Comet* (illus. 183), was born to puzzle some and intrigue others. This atmosphere exacerbated the need for artists to create their own worlds and expression. The Mexican painter Rufino Tamayo painted several comets in his work *The Astrologers of Life* as well as in *El hombre (Man)* (see illus. 2). He was knowledgeable about pre-Columbian astronomy and was one of six artists invited to the NASA headquarters in Washington, DC, to meet with scientists in discussions about the theoretical relationship between art and science.

The experiments with rockets during the Second World War segued into the serious exploration of space and the decades of *Sputnik* and other satellites. In 1957, two non-periodic comets appeared: Comet Arend-Roland (C/1956 R1), with its unusual frontward spike (illus. 184), which Whipple suggested may result from

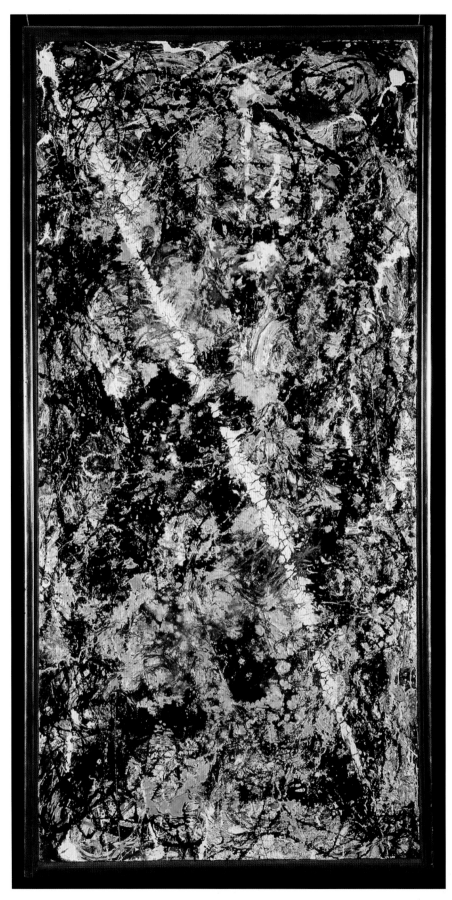

183 Jackson Pollock, *Comet*, 1947, oil on canvas, 94.3 × 45.4 cm.

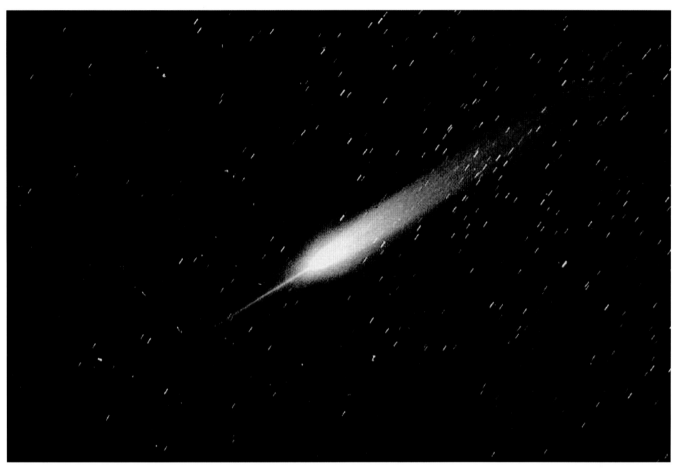

184 Comet Arend-Roland, 25 April 1957, from Lick Observatory, California.

a newly formed, unbaked comet; and Comet Mrkós (C/1957 P1). During the succeeding years the exploration of space continued, but there were disappointingly few memorable comets, save those of the sungrazer Comet Ikeya-Seki (C/1965 S1), Comet Bennett (C/1969 Y1) and Comet Kohoutek (C/1973 E1). If it were not for the Skylab space station experiments these years would be easily forgettable. Kohoutek was actually observed by U.S. astronauts outside Skylab during a spacewalk 1,160 kilometres (720 mi.) above Earth, but it disappointed terrestrial observers, for whom a months-long buildup led to dashed expectations. The next spectacular comet was Comet West (C/1976 V1), which was discovered telescopically and whose breakup was photographed. Its head divided into four parts and threw out streamers

of dust every two or three days, creating a fanning tail (illus. 185).

Bright comets usually appear with a notice of only days or weeks, but for the 1985–6 apparition of Halley's Comet there were centuries of notice. For the first time it was possible to send spacecraft to encounter the comet. So a flotilla was launched towards the comet by the European Space Agency, NASA and the Soviet Union. The American and Soviet spacecraft flew by at a great distance, and the American spacecraft had scientific instruments but no camera. The prime close-up views, the first ever for a comet, were from ESA's *Giotto* space-craft (see illus. 129). These revealed not only rocks and ice on the comet's variegated surface but also giant jets of gas. These jets were already suspected as a source

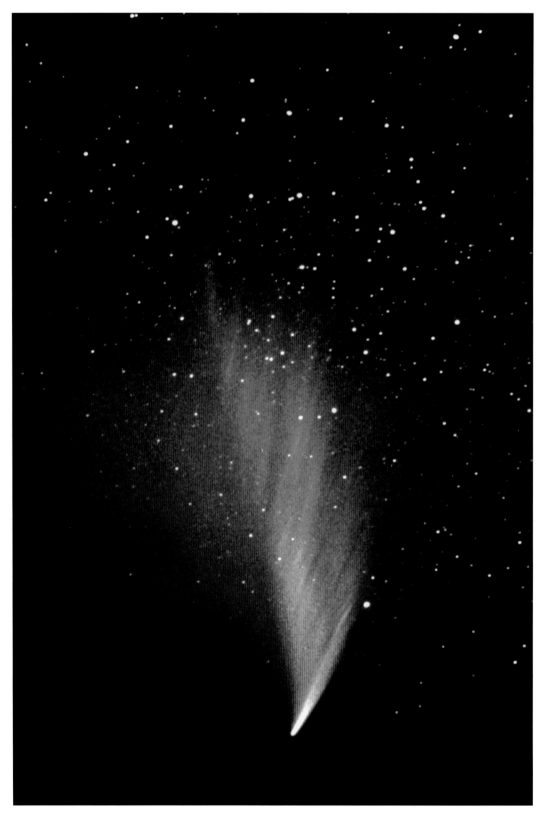

185 Comet West, in early March 1976.

186, 187, 188, 189 Dorothea Rockburne, *Euclid's Comet*, 1997, fresco secco, 1.5 × 24.3 m on three walls, Media Union, University of Michigan, Ann Arbor.

of the 'non-gravitational forces' that affected the orbits of earlier comets, but the *Giotto* photographs were a watershed in providing a detailed view, forever changing our idea of cometary surfaces.

The Great Comet Hyakutake (C/1996 B2) came within 0.1018 astronomical units (15 million km) of Earth on 25 March 1996. It was the intrinsically brightest comet to pass so close to Earth since 1556 and was observed almost directly overhead during the pre-dawn hours, shining as bright as zero magnitude and against a dark sky sporting a tail that approached one hundred degrees in length. It has been called 'One of the grandest comets of the millennium'. Then Comet Hale-Bopp (C/1995 O1) appeared and was visible with the naked eye from July

1996 through to October 1997, an all-time record. It is perhaps the most widely observed comet of the twentieth century. Skywatchers could see both a prominent dust tail and a fainter gas tail, each 15 to 20 degrees long. Artists working at the time turned again to comet imagery with a vengeance, either on a small scale – such as Veja Celmins in her *Untitled #13 (Comet)*, a charcoal drawing (1996; Museum of Modern Art, New York) – or large scale – such as Dorothea Rockburne's mural (illus. 186–9). Artist and amateur astronomer Russell Crotty made meticulous drawings of stars, comets, asteroids and planets as viewed from the telescope in his homemade observatory in Malibu, California, and more recently from Ojai, California. Crotty's drawing is one of five

'gatefolds' of the night sky that make up his book *Five Nocturnes*, including the one reproduced herein seen from the ground (illus. 190). Simultaneously reminiscent of nineteenth-century scientific illustrations and the repetitive patterns of minimalist art, each page spread shows a different aspect of the artist's drawing practice, which ranges from austere celestial maps to more mystical evening landscapes.

Cometomania is alive and well in the twenty-first century, feeding from an unfathomable amount of comet memorabilia produced in the twentieth century. Comets decorate postcards, playing cards, stained-glass windows, shoes, nightgowns, video games and advertising of all sorts. It is easy to understand why comets are symbolically charged images and why the very word 'comet' connotes magic. Even the group Bill Haley and His Comets (the name pronounced like Bailey, not Hall-ee or Hahlee) rock-and-rolled to notoriety with a little help from their catchy name. The wondrous word has even been attached to such mundane objects as cleansers, chocolates, ice-cream cones and automobiles, lending them a miraculous, seductive attraction. There

is something inherently exciting about Meteor Beer, the *Blue Comet* train, the Blazing Star Ferry or the Comet Travel Agency, and something undeniably star-crossed and magnetic about the rue de la Comète in Paris or the Teatro della Cometa in Rome. Comets are evocative.

The twenty-first century started out with a bang with Comet McNaught (illus. 191), also known as the Great Comet of 2007 (c/2006 p1). It is one of over fifty comets discovered by British-Australian astronomer Robert H. McNaught. It reached its peak brilliance on 13 and 14 January of that year, when many could easily spot it in broad daylight just by blocking the Sun with a hand. The comet then moved into the evening skies of the southern hemisphere, unfurling a gigantic, fan-like tail containing a number of luminous bands, eventually reaching a maximum length of 35 degrees on 23 January. It was followed by another Kreutz sungrazer, Comet Lovejoy (c/2012 w3), discovered by Terry Lovejoy, an amateur astronomer who also discovered several other comets. It passed within 0.005584 astronomical units (835,000 km) of the Sun.

In spite of recent triumphs in science it seems that human nature has not changed much in thousands

190 Russell Crotty, *Five Nocturnes*, 1996, ballpoint pen on paper, bound into a book, 157.5 × 297.2 cm open.

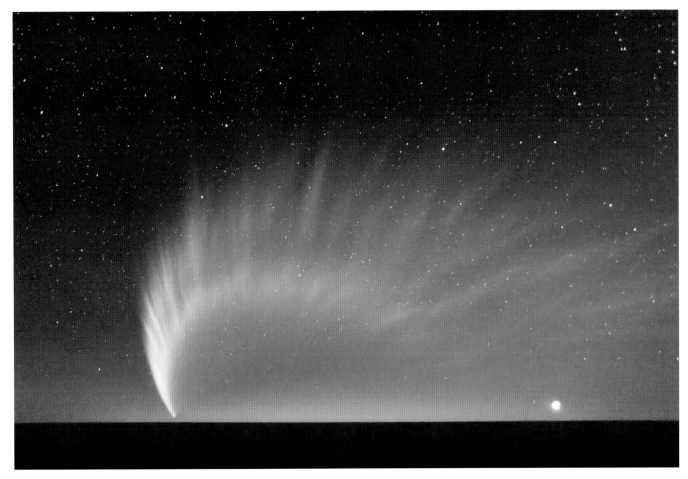

191 Comet McNaught over the Pacific Ocean, January 2007, image taken from Paranal Observatory, Atacama Desert.

of years, even if other factors in our environment and society have altered. Human beings now stand on a razor's edge, possessing unforetold potential to destroy themselves completely – not only spiritually, with apathy, cynicism and disillusionment, but quite literally as well, with deadly weapons and despoiling of the environment. By their very existence comets argue against this bleak scenario. They can be understood not only as portents of good or evil but as eloquent symbols of change within the continuum of our universe. They quietly argue for the preservation and improvement of our planet, while offering scientists elemental clues to the formative processes of the universe. They are beacons of hope and inspiration for the discovery of new worlds and the maintenance of our microscopic chip of the cosmos, planet Earth.

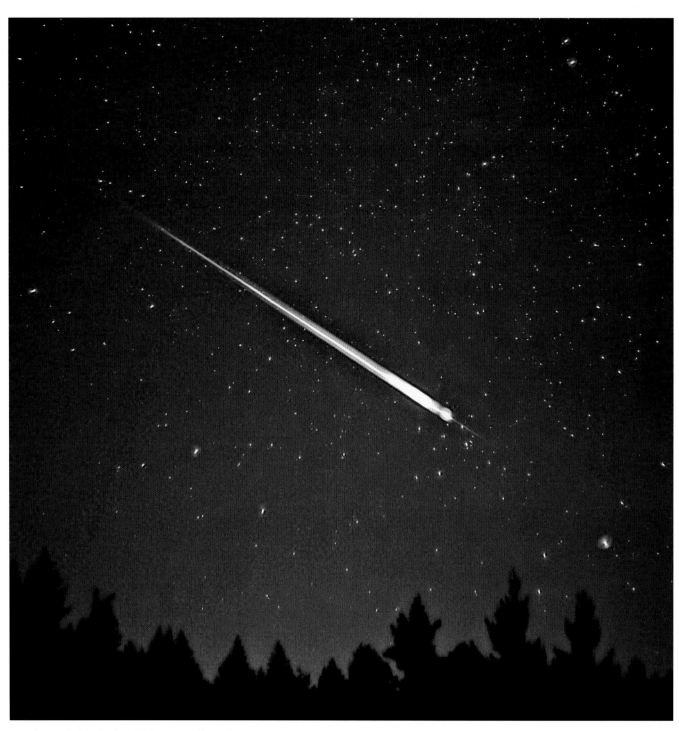

192 Meteor during the Leonid shower, 17 November 2009.

6 Meteors, Bolides and Meteor Showers

Until their differentiation during the late eighteenth century in England, meteors (illus. 192), bolides (or exploding meteors) and meteor showers (illus. 193) were confused with their comet cousins. Although Aristotle believed them to be atmospheric phenomena, like comets they are small bits of interplanetary debris cast off from the nuclei of comets or asteroids in their orbits around the Sun. When they enter Earth's atmosphere, at speeds from 70,000 to 250,000 kilometres per hour (45,000 to 155,000 mph), they burn up, sometimes spectacularly, and appear as streaks of light. When in space they are known as meteoroids. If they survive their passage as meteors and impact Earth, they are known as meteorites.

Whether in outer space or moving in our solar system, meteoroids are small rocky or metallic bodies that are significantly smaller than asteroids. They range in size from small grains to objects a metre wide, but when much smaller they are classified as micrometeoroids or space dust. An estimated 15,000 tons of meteoroids, micrometeoroids and different forms of space dust enter Earth's atmosphere every year. According to recent calculations, 4,000 tons per annum and more than 10 tons per day of micrometeoroids fall to Earth. Though most are fragments from comets or asteroids, a small percentage can be traced to debris resulting from collision impacts in space and are ejected from bodies like the Moon or Mars.

Once a meteoroid enters Earth's atmosphere it becomes a meteor. It aerodynamically heats up thanks to friction, producing a streak of light emanating both from the glowing object and from the trail of incandescent particles that it leaves in its wake, as can be seen in a compound photograph capturing a meteor, its afterglow and its wake as distinct components. The visible light produced by a meteor may assume various hues depending on the chemical composition of the meteoroid and its speed. As its layers abraid and ionize, the colours may change according to the layering of its minerals; for example, in illustration 192 the violet is from calcium and the blue-green from magnesium. Unlike comets, which can remain visible in the sky for days or months, meteors light up for seconds like brilliant flares across the nocturnal firmament. Even a micrometeorite as minute as a grain of sand can produce a bright track tens of kilometres high in the sky, visible 420 kilometres (260 mi.) away.

In medieval times both meteors and comets were considered errant stars and assigned fanciful names such as 'flying dragons', 'serpents' and 'heavenly flames', and

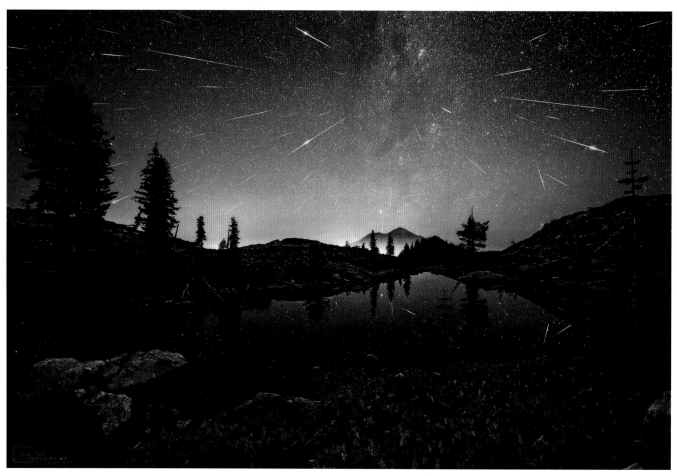

193 Brad Goldpaint, composite image of Perseid meteor shower from Mount Shasta, 8 August 2016.

they were frequently depicted in those fanciful forms. Today the popular colloquial term for a meteor is 'shooting star' or 'falling star', underlining their characteristic ephemeral trajectories and differentiating them from the fixed stars, just as the seventeenth-century Flemish painter Peter Paul Rubens, a friend of Galileo, represented them in the sky of a nocturnal scene he painted outdoors near his country house, the Château de Steen (illus. 194).

The Roman natural philosopher Pliny the Elder thought that everyone had a specific star in the heavens and that it shone brightly or dimly according to the luck of the respective person. Later, the Christian religion equated stars with the souls of individuals, leading to the belief that a shooting star ambivalently symbolized either the passing of the soul from the world or its birth (illus. 195). Meteors, like comets, were variously interpreted as good or bad omens. In the upper regions of the northern hemisphere, the folklore of some cultures stated that when a star fell, heaven opened briefly, and that if you were quick to wish, the gods would hear your request and perhaps grant it. Archaeoastronomers studying Mayan culture now believe that meteors, like comets, may have precipitated changes in rulers. They cite, for example, the political changes at Caracol and Chichen Itza that followed the once-in-a-millennium meteor storm of 10 April 1531 of the Eta Aquariads, formed by the detritus in the wake of Comet 1P/Halley.

194 Peter Paul Rubens, *Landscape by Moonlight*, c. 1635, oil on panel, 64 × 90 cm.

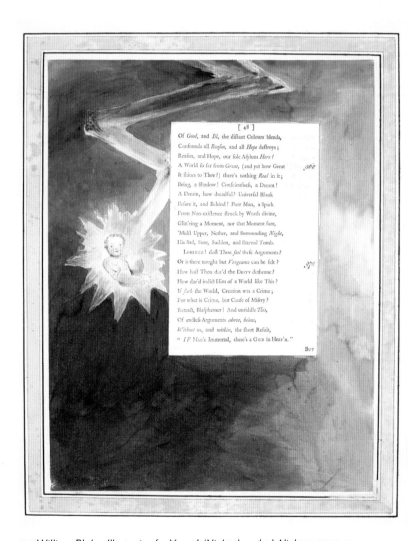

195 William Blake, *Illustration for Young's 'Night-thoughts', Night VII*, 1795–7, grey ink and wash, watercolour and graphite on paper, 42 × 32.5 cm. The British Museum, London.

196 Albrecht Dürer, 'The Opening of the Seventh Seal', from *The Apocalypse* (1511 edn), woodcut, 15.5 × 11 cm sheet.

197 Matthias Gerung, 'Sounding of the Fifth Trumpet', from *The Apocalypse*, 1547, woodcut, 23.3 × 16.2 cm.

Albrecht Dürer, who was knowledgeable about astronomy and who built an observatory into his Nuremberg house, depicted a meteor as a symbol of unleashed chaos in a woodcut illustrating the apocalyptic Book of Revelation (illus. 196). Balancing Christian imagery with natural disasters, Dürer, like other Renaissance artists, preserved his observations of natural phenomena by depicting them in his art, enabling viewers who may also have experienced them to identify with the scenes he represented. Later in the century, when Martin Luther and the Protestant Reformation had gone viral, the German printmaker and artist Matthias Gerung followed suit to illustrate Revelation 8:10–11,

wherein a shooting star falls to Earth and poisons a third of its water: 'And the third angel sounded and there fell a great star from heaven burning as it were a lamp . . . And the name of the star is called Wormwood.' Gerung represented another meteor that becomes a meteorite in the same series of woodcuts (illus. 197) to illustrate Revelation 9:1–3: 'And the fifth angel sounded, and I saw a star fall from heaven onto the earth: and to him was given the key to the bottomless pit [crater] and there arose smoke out of the pit.'

Large meteors that survive ablation, remain intact and impact Earth as burnt chunks of rock are known as meteorites; they sometimes create craters. The world's

best-preserved crater was made by the Canyon Diablo meteorite near Winslow, Arizona. It is 1,200 metres (4,000 ft) in diameter and 170 metres (560 ft) deep. Meteors can also explode catastrophically above Earth's surface, as in the Tunguska event in Russia on 30 June 1908 that levelled half a million hectares (2,000 sq. mi.) of forest. Classified as an impact event even though no impact crater has been found, the meteor is thought to have disintegrated 5 to 10 kilometres (3 to 6 mi.) above the ground. Meteorites can also implode on other planets, like the fragment of Comet Shoemaker-Levy 9 that in 1994 slammed into Jupiter, creating fireballs estimated at 3,200 kilometres (2,000 mi.) in height.

Meteorites are classified into three types. The most numerous are chondrites, which are stony (non-metallic) meteorites that have not been modified through melting; they are not easily discovered unless their fall is observed. Chondrites range from single stones to thousands of stones; in the Holbrook fall of 1912 an estimated 14,000 stones rained down in northern Arizona. 'Iron' meteorites, which consist of an iron-nickel alloy known as meteoric iron, account for only around 6 per cent of all meteorites but are the most frequently found because they do not disintegrate and because they don't look like normal rocks. Achondrites, which are also non-metallic and lack chondrules (round grains formed when molten), are thought to be more recently formed and number around 8 per cent of all meteorites.

Some 65 million years ago, meteorites and comets bombarded all the bodies in our solar system. Evidence of this bombardment is found in the pockmarked appearance of Earth's Moon and the other planets of our solar system. A widely accepted theory holds that a comet or an asteroid also collided with Earth during that era, creating a huge cloud that surrounded the planet for several years and led to the extinction of the dinosaurs and many other species. The darkness reduced photosynthesis, destroying the plants upon which the giant herbivores fed, and the food chain supporting the dinosaurs and other species collapsed. Palaeontologists have found evidence of this dust cloud in the residual mud layers between strata of sedimentary rock from the period as well as in the huge 66-million-year-old fossil crater named Chicxalub in the Mexican Yucatán, which measures about 200 kilometres (125 mi.) across and whose date coincides with the extinction event of the dinosaurs.

Perhaps the most famous meteorite in recorded history is the chondrite weighing 127 kilograms (280 lb) which on 7 November 1492, following a loud, thunderous noise heard 160 kilometres (100 mi.) away, hurtled from the sky and plunged into a wheat field near Ensisheim in Alsace, in what is now France (illus. 198). A young boy was the sole witness of this daylight fall that ranks as the earliest witnessed meteorite in the West from which pieces are preserved. Today, that meteorite is displayed in the city's museum. When it fell, the Ensisheim meteor created a gaping, metre-wide hole in the ground and sent ripples through the media of the time, which described it as the size of a saltlick. The German satirist Sebastian Brant wrote a poem about its portentous nature, claiming it was a positive sign for King of the Romans (from 1508 Holy Roman Emperor) Maximilian I but an evil omen for his enemies. Brant's poem circulated in illustrated broadsides with a text in Latin and German as well as in three pirated editions, investing the phenomenon with the new authority of the printed word. Illustrations of this celebrated event appear not only in the manuscript known as the *Lucerne Chronicle* (*Die Schweizer Bilderchronik des Luzerners*, 1508–13) by Diebold Schilling the Younger, but also in woodcuts in the *Nuremberg Chronicle* (1493) by Hartmann Schedel and the *Prodigiorum ac ostentorum chronicon* of Conrad Lycosthenes (1557).

Extremely bright meteors with heavenly pyrotechnics are called 'fireballs'. The International Astronomical Union defines a fireball as 'a meteor brighter than any of the planets' that is of apparent magnitude of minus fourteen or brighter and twice as bright as a full moon. It seems to explode as it vaporizes and is frequently accompanied by a slightly delayed loud noise. Fireballs are also known as bolides, from the Greek word *bolis* meaning

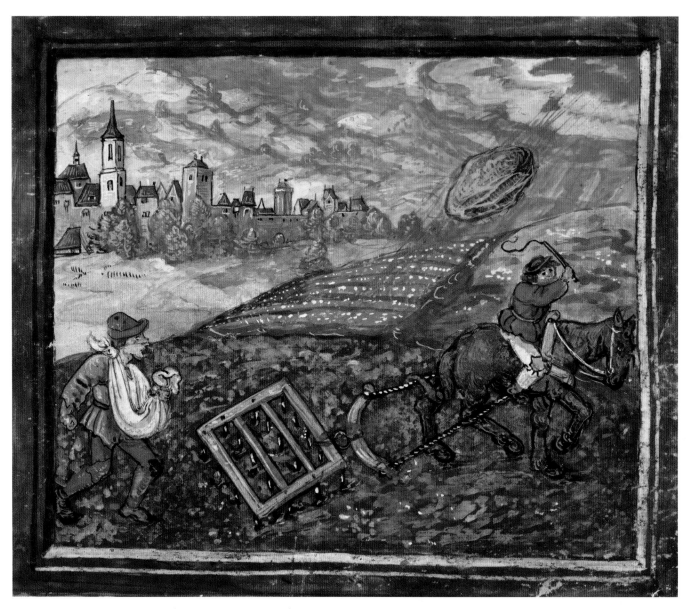

198 Diebold Schilling the Younger (or Hans von Arx, Hand B), the Ensisheim meteorite on 7 November 1492, detail from the *Lucerne Chronicle*, 1508–13, tempera and ink on parchment. MS S.23, folio 157r, Zentralbibliothek, Lucerne.

199 Aleksandr Ivanov, super bolide exploding over Chelyabinsk Oblast, Russia, 15 February 2013, from Kamensk-Uralsky.

missile or to flash (illus. 199), since they explode near the ends of their trails. Pliny described this short-lived sky phenomenon in 76 BC in his *Natural History* as 'a flame of bloody appearance' that fell to Earth.

Dürer captured the phenomenon's visual impact most vividly on the reverse of his devotional painting of *St Jerome* (illus. 200). After witnessing a powerful bolide, the artist harnessed its potent symbolism to underline the saint's spiritual enlightenment or, more likely, to allude to the fact that while in the wilderness Jerome is said to have heard the trumpets of the angels at the time of the Last Judgement. A number of people have misidentified Dürer's bolide as the explosion of what would later be known as the Ensisheim meteorite. Not least among the many reasons arguing against this connection is the nocturnal nature of Dürer's bolide, which is quite unlike the daylight meteorite.

While fireballs are frequent, few are witnessed because they are localized occurrences. One must be in precisely the right place and able to look up the instant they appear, often catching them out of the corner of one's eye. In the past fireballs have been interpreted as presaging important events; a case in point is the one Raphael painted below the rainbow in the background of his *Madonna of Foligno* (illus. 201). From Rome the artist probably witnessed the fireball of 4 September 1511

200 Albrecht Dürer, bolide on the reverse of *St Jerome*, 1496, oil on pear wood panel, 23.1 × 17.4 cm.

201 Raphael, detail of the *Madonna of Foligno*, 1512, oil on panel, transferred to canvas.

that detonated at noon and produced a shower of stones in Crema, Italy. The altarpiece's patron, papal secretary and historian Sigismondo de' Conti, commissioned the painting as an ex-voto to commemorate his gratitude for having miraculously survived a siege. Marking Conti out as an unusual individual and inadvertently presaging the elderly man's death in January 1512, Raphael has depicted him on the right of the canvas with a cadaverous visage, kneeling in adoration of the Madonna and Child.

A series of many meteors that seem to originate from the same fixed point in the sky over a period of days is known as a meteor shower (illus. 202–8). Swishing,

crackling and hissing sounds similar to those reported with intense displays of auroras (see Chapter Nine) have been heard accompanying meteor showers. When Earth passes through the orbit of a living or defunct comet, as it does in October and May each year with Halley's Comet, meteor showers or a seeming rain of stars are created in its wake – the case with Halley's Orionids and the Eta Aquarids. Three other important meteor showers are the Bielids, associated with the breakup of Biela's Comet in 1846; the Leonids (see illus. 202–4), linked to the periodic Comet 55P/Tempel-Tuttle; and the Perseids (see illus. 193), the most famous of all the cosmic

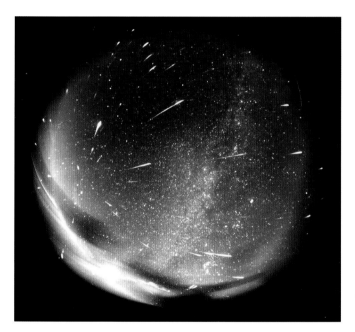

202 Juraj Tóth, four-hour time lapse of a Leonid meteor shower, with fish-eye photographic camera, 17 November 1998, at Modra Observatory, Slovakia.

203 Adolph Völlmy, *The Leonid Meteor Shower of 13 November 1833* (after a painting by Karl Jauslin), from *Bible Readings for the Home Circle* (Battle Creek, Michigan, 1889), woodcut.

204 Étienne Léopold Trouvelot, *The November Meteors*, observed 13–14 November 1868, plate XII from *The Trouvelot Astronomical Drawings Manual* (New York, 1881), chromolithograph, 94 × 71 cm.

205 Albrecht Dürer, 'The Opening of the Fifth Seal', from *The Apocalypse*, 1511, woodcut, 15.5 × 11 cm sheet.

The storm was so bright that people were unable to sleep and thought that the Sun had risen. An estimated 24,000 meteors ignited over a period of nine hours in this celestial show, which attracted immense popular attention. Abraham Lincoln even wrote about it, thereby dragging meteors from scientific obscurity. Observations of the Leonids in 1799 (by, among others, the Prussian polymath Alexander von Humboldt), 1833 and 1866 established them as cometary debris.

The 1860s was also a time of meteor orbit calculation. In 1866, searches of historical records showed that similar showers had occurred as far back as 13 October 902 (Julian calendar), revealing a shift of three weeks which the British astronomer John Couch Adams calculated was due to perturbations of the planets. Again in 1868 and then in 1966 the unpredictable Leonids staged an impressive show over the United States when more than 100,000 meteors rained down per hour. The French astronomer Étienne Léopold Trouvelot captured the 1868 Leonid showers first in a pastel drawing and then in a chromolithograph (illus. 204). The best winter meteor show is the Geminids, which takes place around 14 December. We await the return of a spectacular Leonid storm: one is promised for 2031 or 2032.

Extraordinarily unnatural and frightening displays of meteor showers have been used by artists since the sixteenth century as visual devices to depict a passage from St John the Evangelist's apocalyptic descriptions in Revelation (6:12–13). Dürer visualized the passage in his monochrome woodcut (illus. 205) so intensely that the viewer sees the colours described in the text:

> And I beheld when he had opened the sixth seal, and lo, there was a great earthquake; and the sun became black as sack cloth of air, and the moon became as blood. And the stars of heaven fell onto the earth.

Prior to that century only a few progressive early Renaissance artists had harnessed the visual power of meteor showers by representing their own observations as naturalistic symbols foreshadowing evil and the

showers, from Comet 109P/Swift-Tuttle. The Perseid meteors are visible from mid-July to mid-August and display between 5,000 and 25,000 meteors per hour in the northern hemisphere under optimum conditions (such as a new moon and clear skies). The annual Perseid shower has a 133-year orbit, and the stream of debris from which the meteors arise is called the Perseid cloud. The Perseids, or the sons of Perseus, are so-called because they appear to originate from a point, the radiant, within the constellation of Perseus.

Sometimes a shower is so spectacular that it is known as a meteor storm (illus. 203), as with the famous case of the Leonids on the night of 12–13 November of 1833.

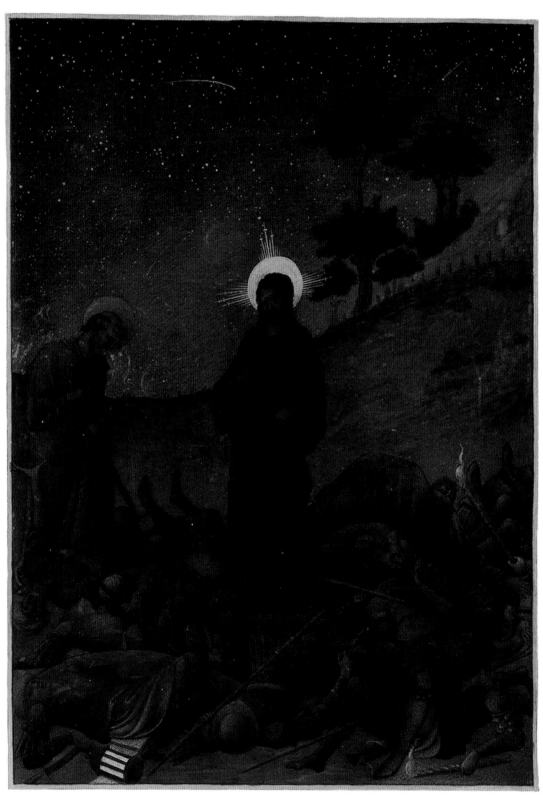

206 The Limbourg brothers, *Christ in the Garden of Gethsemane*, detail from, *Les Très Riches Heures du Duc de Berry*, 1416, watercolour and gold pigment on parchment. MS 65, folio 142r, Musée Condé, Chantilly.

207 Pietro Lorenzetti, detail of *The Betrayal of Christ*, 1316–20, fresco, Lower Church, San Francesco, Assisi.

cosmos in chaos. Take, for example, two early scenes by Herman, Paul and Johan Limbourg and Pietro Lorenzetti of the Betrayal of Jesus by Judas in the Garden of Gethsemane that include meteor showers (illus. 206, 207) to visually reference the biblical prophecy foreshadowing the doom of Jesus: 'the stars will fall from the sky' (Matthew 24:29; Luke 21:25). Lorenzetti also painted an earlier, less intense phase of this shower in his *Last Supper* fresco, the scene that precedes the climactic Betrayal scene in his Passion narrative in the Lower Church of San Francesco at Assisi. The artist echoed this time-lapse technique for the position of the Moon in the pair of nocturnal scenes. So keen were Lorenzetti's observations that all the meteor trails, save the prominent diagonal one that points didactically to Jesus, seem to originate from the same source, the radiant, a phenomenon only recognized scientifically in 1794. Moreover, the 1974 cleaning of the adjacent vaults in the nave of the lower church, which Giotto and his workshop had frescoed blue with gold stars, has revealed that each

star has a circular convex mirror embedded in its centre to lend a convincing twinkle. This brilliant enhancement would have prepared the worshipper to view Lorenzetti's dazzling celestial displays, the first large-scale depictions of meteor showers in Western art. They embody the cosmic agony over Judas' tragic ignominy.

While many representations of the Apocalypse – from those in medieval manuscripts of the Book of Revelation through to contemporary works – employ meteor imagery, meteors' potential for destruction remains a potent creative force in the universe. In the twentieth century, a coloured lithograph by Giorgio de Chirico, *The Apocalypse* (illus. 208), uses meteor showers not only to echo the New Testament tradition of the end of the world, when it is said the Sun and Moon will come together, but also to personify the Surrealist artist's fears about the Second World War. The remainder of this chapter will examine the evolution of the science and the iconography of meteors, beginning in the sixteenth century when observation and a nascent scientific

.....e le stelle del cielo caddero sulla terra.

208 Giorgio de Chirico, *L'Apocalisse* (*The Apocalypse*), *No. 9*, 1941, coloured lithograph, 34.5 × 27 cm.

209 Unidentified artist, meteorite and solar eclipse in 862, folio 70 from the *Augsburg Book of Miracles* (*Augsburger Wunderzeichenbuch*), c. 1550–52, watercolour, gouache and black ink on paper. The Cartin Collection.

method coexisted with the superstitions and fears precipitated by the Reformation.

Early modern illustrated chronicles, both in manuscript form and in the relatively new medium of prints, attempted to compile important events and link them to natural phenomena reported throughout the ages in the hope of discerning patterns. Among the phenomena they recorded and illustrated are meteorites, such as a scene in the *Augsburg Book of Miracles* that features one that fell from the sky in Saxony during heavy wind and rain in 862, causing, it is said, blood-red crosses to appear on people and darkness to fall on the Sun (illus. 209).

Meteor showers tend to appear in smaller works but rarely in larger oil paintings. One exception is a depiction by an unknown Dutch artist of Lot and his daughters at the fall of Sodom and Gomorrah (*c.* 1520; Musée du Louvre, Paris). In this panel the radiant of the meteor shower ('brimstone and fire out of heaven', as described in Genesis 10:24) is as evident as the symbolism expressing the rage of the heavens at the father's unnatural behaviour and the apocalyptic end to the two cities. Among the imaginative representations of reported meteor showers in the *Book of Miracles* is one reported in 1119 (illus. 210–12); the book's compiler described the showers as fiery arrows or spears that appeared

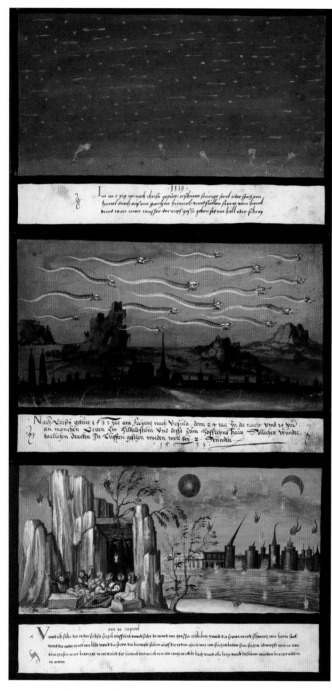

210, 211, 212 Unidentified artist, meteor showers in 1119, 1533, and Revelations 6:12–14, folios 41, 129, 176 from the *Augsburg Book of Miracles (Augsburger Wunderzeichenbuch)*, c. 1550–52, watercolour, gouache and black ink on paper. The Cartin Collection.

in the heavens, adding that as they fell from the heavens, they screamed or made a noise as if water was poured over them – perhaps the swishing sounds that have at other times been reported. Other showers were reported as sounding like cannon, which led to their appearing in illuminated manuscripts, woodcuts and broadsides as celestial artillery firing rocks. The shower noted in 1533 on the twenty-fourth day after St Ursula's feast day reputedly assumed the form of wondrous dragons, seen in the air for two hours beginning around ten o'clock in the evening. The same unknown artist who envisioned these reported apparitions used a meteor shower in conjunction with solar and lunar eclipses to illustrate the Book of Revelation 6:12–14, as Dürer and others had before him.

Not until the eighteenth century, when the heavens seemed on fire with many reports of meteors and bright, long-lived comets, did scientists definitively differentiate between comets and meteors. With the popularization of science and urge to classify during the post-Enlightenment period, these celestial 'fires' became objects of obsession and a veritable spectator sport for astronomers, artists and the public at large. In a flurry of activity that involved ever more objective observation coupled with a further dispassionate, scientific attitude and an optimistic belief in progress, a largely English effort paved the way for the absolute differentiation of the various phenomena. Edmond Halley overcame the Aristotelian view that meteors were an upper-atmospheric phenomenon and introduced their extraterrestrial nature; he also estimated their height and velocity. Until the latter half of the century, artists who employed stock visual conventions for rendering comets did likewise for meteors. Gradually, the concerted effort to physically understand these phenomena resulted in substantial progress that allowed their more accurate description and the depiction of their distinctive characteristics.

Although a watershed moment occurred with a very bright meteor in 1783, prior to that time, as previously noted, comets and especially meteors could be depicted in bizarrely imaginative shapes. This was the case even

with the most significant platform for scientific discussions, the Royal Society's *Philosophical Transactions*, and the numerous preparatory drawings for the engraved plates in its articles (available for study at the Royal Society's headquarters in London). In one strange illustration, a reported meteor in 1764 resembles the tail of an aeroplane, with a trail of bristling forms that look like horizontal icicles. Standing in sharp contrast are the complex depictions of the meteor that appeared on 16 November 1758, whose stages John Pringle, a physician and President of the Royal Society, meticulously recorded.

Because most eighteenth-century natural philosophers doubted that meteorites, which at the time were called 'thunderstones', had fallen to Earth from space, the topic remained a burning controversy until Ernst F. F. Chladni established the correct scientific ideas about meteors in 1794. Natural philosophers' denial of the unusual but nonetheless genuine phenomenon has been a great embarrassment to scientists. One explanation for this lack of judgement, which is especially ironic since it occurred during the Enlightenment, is that scientists (notably members of the Académie royale des sciences in Paris) were overzealous in denying eyewitness reports in a desire to eradicate popular superstitions. This scepticism regarding meteorites relates directly to prevalent theories about meteors and fireballs and was perpetuated by a lack of knowledge about their relationship, size and chemical composition. In fact, prior to the publication of Chladni's treatise there were only a few fleeting conjectures that shooting stars and fireballs might be extraterrestrial matter. Perhaps this controversy over meteors is best reflected in Benjamin West's *Aeneas and Creusa* (illus. 213), a canvas dependent on an ancient literary source and touched by the awe-inspiring sentiments of the Sublime. West painted a plunging meteor in the turbulent sky to visualize Book II of Virgil's *Aeneid*:

> There shot a streaming Lamp along the Sky,
> Which on the winged Lightning seem'd to fly;
> . . .

> And trailing, vanish'd . . .
> It swept a path in Heav'n . . .
> Then in a steaming stench of Sulphur dy'd.

One of the landmarks in meteor observation occurred on 18 August 1783. Not surprisingly, the apparition was confused with a comet in some records, where it was identified with the ancient type of comet known as *Draco volans*, 'flying dragon', although it was a fireball. Since both written and visual accounts record that the bright meteor exploded near the end of its path it can be identified as a bolide, a particularly bright meteor whose appearance is accompanied by an explosive sound or sonic boom.

In this pre-photographic time when art and science were collegial partners, an unusually large number of individuals from both the scientific and artistic communities reported the apparition. No fewer than six articles concerning it were published in volume 74 of the Royal Society's *Philosophical Transactions*, and there followed a seminar to discuss the topic. By comparison with previous meteors, the fireball of 1783 was reported with an unusual level of care. In addition, two of the articles in the *Philosophical Transactions*, those written by the Italian-born natural philosopher and physician Tiberius Cavallo and by the English astronomer Nathaniel Pigott, contain fascinating fold-out engravings that transcribe the original drawings representing the bolide's three stages submitted with the authors' manuscripts. Along with other depictions of the celestial event these illustrations show the meteor progressing from the left to the right. Each paper empirically describes the weather and viewing conditions, and the objectivity of their scientific investigations is clouded only incidentally by traditional assumptions about meteors. Archdeacon of York William Cooper's lengthy contemporary account includes important information from observations made on horseback after smelling 'sulphureous vapors':

> In the midst of this gloom . . . a brilliant tremulous light appeared to the N.W. by N. At the first it seemed

213 Benjamin West, *Aeneas and Creusa: Book II, from Virgil's 'Aeneid'*, 1771, oil on canvas, 188 × 142.2 cm.

stationary; but in a small space of time it burst from its position, and took its course to the S.E. by E. It passed directly over our heads with a buzzing noise, seemingly at the height of sixty yards. Its tail, as far as the eye could form any judgement, was about eight or ten yards in length. At last, this wonderful meteor divided into several glowing parts or balls of fire, the chief part still remaining in its full splendour. Soon after this I heard two great explosions, each equal to the report of a cannon carrying a nine-pound ball.

Alexander Aubert, another Fellow of the Royal Society, reported in his paper on this spectacular meteor together with another he observed on 4 October 1783, in an unusual attempt to synthesize his observations on the two apparitions. To make his report more reliable he had, like other observers, revisited the places of the initial sightings with proper instruments in order to reconstruct them more precisely. Aubert noted important information at the close of his report:

> it left behind several globules of various shapes; the first which detached itself being very small, and the others gradually larger and larger, until the last was nearly as large as the remaining preceding body; soon afterwards they all extinguished gradually, like the bright stars of a sky-rocket.

He calculated the entire time of visibility to around ten or twelve seconds which, based on recent videotaped observations, is reasonable for a fireball. Like another observer, he noted that it had red and blue colours; other depictions of the fireball suggest that it also had yellow in its palette.

One of the most interesting of these reports is the one mentioned above by Cavallo, another Fellow who was involved with electrical studies and experiments. He related that he watched the fireball from the north terrace of Windsor Castle in the company of Dr James Lind, a Dr Lockman, the artist Thomas Sandby and a few other persons, two of whom are known from works

of art depicting the scene to have been women (illus. 214, 215). Cavallo remarked that they had a perfect view of the fireball and that each person contributed something to his account:

> Some flashes of lambent light, much like the aurora borealis, were first observed on the northern part of the heavens, which were soon perceived to proceed from a roundish luminous body, nearly as big as the semidiameter of the moon, and almost stationary in the above mentioned point of the heavens . . . This ball, at the beginning, appeared of a faint bluish light . . . but it gradually increased its light, and soon began to move, at first ascending above the horizon in an oblique direction towards the east . . . and moving in a direction nearly parallel to the horizon . . . A short time after . . . the luminous body passed behind the above-mentioned small cloud . . . but as soon as the meteor emerged from behind the cloud, its light was prodigious . . . the meteor appeared of an oblong form . . . but it presently acquired a tail, and soon after it parted into several small bodies, each having a tail, and all moving in the same direction, at a small distance from each other, and very little behind the principal body, the size of which was gradually reduced after the division.

Cavallo's observational sketch, and the engraved plate after it, focus on the meteor's progression and correspond to his description of the riveting contemporary spectacle.

These descriptions also agree with a rare aquatint (see illus. 214) published by Paul Sandby, and with four fascinating, related watercolours variously attributed to him and his brother Thomas, who witnessed the meteor's fall with Cavallo (illus. 215, 216). Three of the watercolours feature a similar haunting depiction of the triple stages of the 18 August 1783 meteor from Windsor Castle's terrace, although one lacks any figures – it and a fourth watercolour, minus the apparition but with the final arrangement of the figures as they appear in the print, were studies that were combined for the aquatint. Like the other illustrations of the phenomenon, Paul

214 Paul Sandby based on Thomas Sandby, *The Meteor of Aug. 18, 1783, as It Appeared from the Northeast Corner of the Terrace at Windsor Castle*, 1783, aquatint, 27.3 × 49.3 cm image.

215 Thomas or Paul Sandby, *The Meteor of 18 August 1783 in Three Aspects Seen from the Northeast Corner of the Terrace of Windsor Castle*, 1783, watercolour over traces of graphite on paper, 28.5 × 46 cm.

Sandby's print captures the strange light cast by the sputtering meteor and also conveys its motion in three stages, like freeze-frame stills taken by a movie camera that when combined create the progressive movement noted in contemporary reports – some of which also mention analogies to electricity. The work's wonderful illumination was achieved by the artist's technical innovations in the medium, including brushing a liquid resin onto the plate, rather like a watercolour wash, to produce subtle qualities of tone and light. The fact that the Sandbys' observations were made in the presence of natural philosophers, including Cavallo, and collaboratively dedicated to Sir Joseph Banks, President of the Royal Society as well as a patron of Paul Sandby, underlines the commerce between artists and scientists at the time. William Herschel watched the bolide from his observatory at Datchet, 2.5 kilometres (1½ mi.) to the northeast of Windsor Castle, where he was ensconced as the King's Astronomer. Since it was his practice to observe every hour of each clear night, the meteor did not escape Herschel's attention as it traversed an arc of 167 degrees.

The configuration of the third stage of the meteor of 18 August 1783 – the stage after it had formed multiple projectiles – corresponds to another beautiful celestial apparition painted on canvas (illus. 217). This painting had previously been misattributed and incorrectly identified as the apparition of Halley's Comet over the Thames in 1759. In earlier publications, we correctly identified the phenomenon by comparing it with the works by the Sandbys, among others, and with verbal descriptions of the extraordinary event. Note that the specifically rendered opening of the clouds resembles the precise meteorology that the Sandbys depicted in their works. This unusually dark nocturnal scene, accentuated by the discolouring of its varnishes, features a horizontally disposed celestial body with a large head trailed by little staccato pieces, exactly the configuration the Sandbys

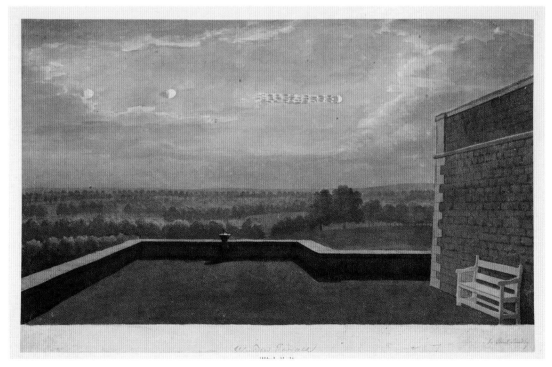

216 Paul or Thomas Sandby, *The Meteor of 18 August 1783, as Seen from the East Angle of the North Terrace at Windsor Castle*, 1783, watercolour with touches of pen and ink over graphite on paper, 31.8 × 48.3 cm.

217 William Marlow (formerly attributed to Samuel Scott), *The Meteor of 18 August 1783 over the Thames*, c. 1783, oil on canvas, 81.9 × 111.8 cm.

represented as the third stage of the sensational meteor of 18 August. Beneath the painting's varnish are reddish-pink and yellow areas in the tail's smaller globules and in the head. Given the dazzling passages of fireballs across the sky in mere seconds, this explanation would account for the amazement registered by the majority of the observers in the foreground. It is also significant that there is a bright reflection of the light on the water of the Thames, as comets are usually too faint for such an extensive reflection. A fireball, however, can be ten thousand times brighter than a comet, making such a reflection more likely.

As we discussed in Chapter Five, William Blake, poet and painter, was captivated by comet/meteor symbolism. He peppered at least twenty works with comets, meteors

or shooting stars. Blake was an artist with a keen interest in literature and a mystic of great complexity and singular thought. He was also a transitional figure, on the cusp between centuries, who seems to stand outside history. His imaginative images constitute a reaction against the rationalism of the Enlightenment that began in the eighteenth century and developed with increasing rapidity in the following century. At the moment when the scientific community was demystifying comets and meteors, these mesmerizing vagabonds of the solar system were transformed into popular, anachronistic symbols that piqued the imaginations of many. Artists and writers wishing to escape sordid reality frequently represented comets and meteors without any reference to specific apparitions. As we have seen, these non-specific

apparitions also belonged to a rich historical literary and artistic tradition that could be mined. Blake was an innovative and subjective illustrator, often grafting his own highly original ideas onto those of the authors he illustrated. His unorthodox yet eclectic beliefs were personal and radical. Certainly he was aware of the scientific ferment about comets and meteors. In the very year (1794) when Chladni issued his treatise arguing for the cosmic origin of meteors Blake published his famous *Songs of Experience*, whose memorable poem 'The Tyger' has in its fifth stanza the following provocative lines alluding to a meteor shower: 'When the stars threw down their spears / And water'd heaven with their tears'. Blake's image is related directly to some notable meteors that occurred during the poet's lifetime and, specifically, to a legend concerning the famous Perseid meteor showers, which, as we noted earlier, still appear annually around 12 August. In fact Blake may have seen one of the spectacular displays in the years just prior to the publication of 'The Tyger'. These meteor showers were known traditionally as the 'tears of St Lawrence' because they appeared near the saint's feast day, and they were also colloquially called 'the fiery tears', referring to the saint's martyrdom by being roasted alive on a gridiron. Only in 1866 were they called the 'Perseids', by the Italian astronomer Giovanni Schiaparelli who named them after the constellation Perseus, from which they seem to issue.

Blake's fascination with evocative meteor imagery appears in several other works. Around 1797 he illustrated the poems of Thomas Gray, providing 116 watercolours for this unfinished project. Blake's seventh illustration to Gray's poem 'The Bard. A Pindaric Ode' depicts Edward III, avenger of his father Edward II, as the scourge:

> Robed in the sable garb of woe,
> With haggard eyes the Poet stood;
> (Loose his beard and hoary hair
> Stream'd, like meteors, to the troubled air).

In his illustration Blake transferred the meteor image from the hair of the bard in the poem to Edward's whip, whose tripartite thongs terminate in meteor-like spikes. Immediately before the Gray project Blake had been commissioned in 1795 to illustrate Edward Young's *Night-thoughts* (1742–5), in which he featured many comets or meteors, some not found in Young's text. For image number 313 Blake drew two meteors accompanying a tormented figure symbolizing the life of the soul who is self-destructing like a fiery fireball plummeting towards annihilation; the more graceful trajectories of the two shooting stars provide contrast with his lethal fall. Here Blake relied on the tradition that meteors, meteor showers and comets are linked with the Apocalypse. Blake's meteor in *Night-thoughts* (his image number 320) includes a babe encased in a star-like form with a zigzag tail (see illus. 195) that engenders thoughts about cosmic creation and immortality. In these works Blake was not actively observing astronomical phenomena but rather responding to symbolic literary and visual traditions, having been stimulated by the cultural and intellectual interest in comets and meteors and the rise in amateur and professional observation. In fact, in *Night-thoughts* number 509 Blake drew a large telescope to illustrate the line, 'O for a Telescope, His Throne to make!' Like Young, Blake is thus linking telescopes and astronomy to God. As mentioned previously, Blake depicted a comet (or more probably a shooting star) four times in *Milton: A Poem in Two Books* (1810) (illus. 218). Each time it symbolizes poetic inspiration and embodies the soul of the great English Puritan poet John Milton, who also used many comet references, especially in *Paradise Lost*. Blake personally identified with the great poet, a bright star in the literary constellation. In plate 29 he depicted the soul of the bard Milton embodied in the form of a five-pointed star with a flaming tail, hand-coloured in delicate blues and pinks and electric greens. Milton calls out Blake's name, 'WILLIAM', as the shooting star charges like an electric current through the artist's spasmodically racked body.

During the nineteenth century meteors and meteor showers provided vivid imagery for European and American artists and writers. The French illustrator

J. J. Grandville, mentioned in Chapter Five, employed meteors as well as comets in his book *Un autre monde*, to great effect (see illus. 170). In his illustration of the 'Juggler of the Universe' the celestial conjurer tosses the Cross of the Legion of Honour in the guise of a meteor to the artist holding his portfolio. A more lugubrious note is sounded in Grandville's most famous book, *Les Animaux: Scènes de la vie privée et publique des Animaux* (1842), where he represents the moment of a turtledove's passing by a shooting star's trajectory that embodies the bird's soul, signifying his noble death from unrequited love. In the illustrator's imaginative wood engravings for *Les Étoiles* (1849) he also personified a beautiful woman as a falling star (*étoile filante*) in a meteor shower, as well as envisioning evil stars. Even the realistically oriented socialist artist Jean-François Millet painted an imaginative canvas, *The Shooting Stars*, that envisions Canto 5 of the *Inferno* of Dante's *Commedia* (illus. 219), wherein the souls of the lustful whirl endlessly around the skies of Hell, blown by a great gale. Millet's cadaverous figures emit light – the red contour around the man of the left-hand couple communicates the heat of passion – while their elongation conveys their voluptuousness, transient as shooting stars. Millet's more realistic rendering of a meteor shower in the forest of Fontainebleau just after sunset in his *Starry Night* (illus. 220) closely resembles the summer Perseids and recalls their similarity to fireflies in the sky. While the painting appears to be an intensely realistic observation of landscape and the meteorological effects of the night sky, a passage from one of the artist's letters reveals a more Romantic, mystical attitude towards nature. For Millet, as well as other artists, meteors still signified a loss of order in the universe. Millet's wonder and quiet fear was reinterpreted by Vincent van Gogh in *Café Terrace at Night* (1888; Kröller-Müller Museum, Otterlo), where the stars seem like hallucinatory exploding flashbulbs. They reach a fever pitch in the Dutch artist's *Starry Night* (see illus. 246), admittedly influenced by Millet's work and painted while the artist was resident in the mental asylum at Saint-Rémy-de-Provence.

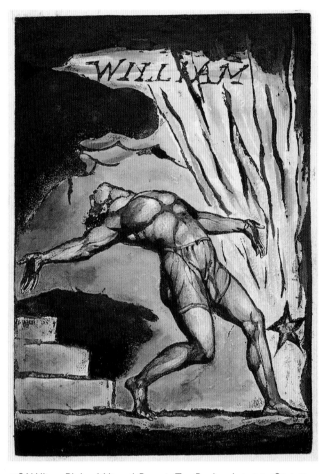

218 William Blake, *Milton: A Poem in Two Books*, plate 29, 1804–11, relief etching with watercolour and pen and ink on paper, 16.1 × 11.3 cm.

Van Gogh's pulsating forms of throbbing light, some resembling identifiable heavenly bodies, including a spiral nebula, swirl like dervishes in the cosmic mix of the heavens, although none can be identified as meteors.

Bolides (illus. 221) and their cousins grabbed attention on both sides of the Atlantic. In the United States, the summer and early autumn of 1860 was an unusually active time for atmospheric phenomena. Comets, meteors and even the aurora borealis were visible up and down the Atlantic seaboard. Newspaper articles and letters to editors testify to a widening ripple of unease about these events. Some used metaphors that consistently invoked artillery, which were variously

219 Jean-François Millet, *The Shooting Stars*, 1847–8, oil on board, 18.7 × 34.5 cm.

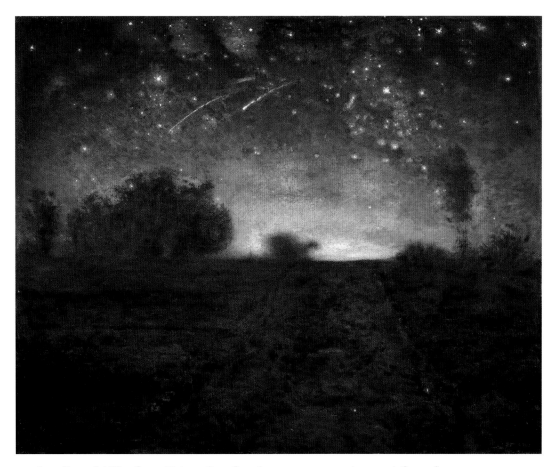

220 Jean-François Millet, *Starry Night*, c. 1850–65, oil on canvas mounted on panel, 65.4 × 81.3 cm.

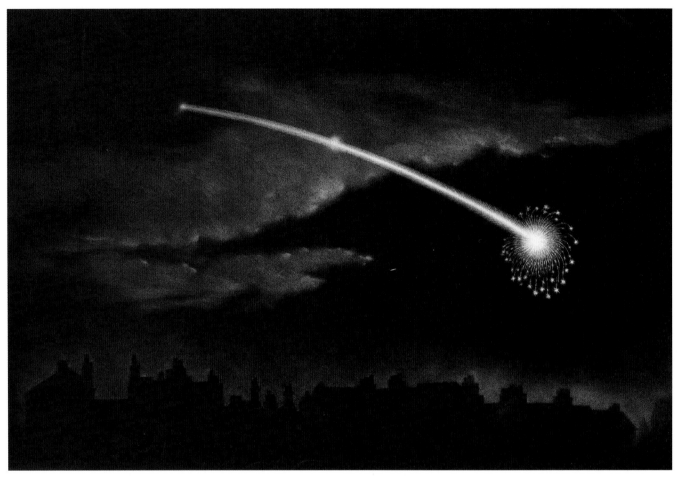

221 Matthew Coates Wyatt, *Meteor Seen at Paddington about 12 Minutes...*, 1850, mezzotint, 33.2 × 46 cm.

interpreted as omens of impeding conflict, doom or victory. Contemporary poets likened the abolitionist John Brown, whose actions helped spark the Civil War, and his fiery trajectory across the political firmament to a meteor. Herman Melville penned a poem linking the meteors of 1859 with Brown, portraying him as an equally disturbing force of nature. Melville closed 'The Portent' with lines comparing Brown's beard with the tail of a meteor: 'But the streaming beard is shown / (Weird John Brown), / The meteor of the war'. Anyone seeking portents of war in celestial activity felt vindicated by the cosmic display of the Perseid meteor showers that held much of the Eastern seaboard spellbound through July and August 1860.

On 20 July a meteor streaked across the eastern sky, mesmerizing the artist Frederic Edwin Church, who was instinctively attracted to astronomical displays and had previously drawn two views of the spectacular arcing tail of Donati's Comet on 1 October 1858. No ordinary meteor, it caught the attention of scientists and amateur enthusiasts alike. This was a large, Earth-grazing meteor, so-called because its trajectory was within Earth's atmosphere but never reaching the ground. Like the 1783 meteor over England, it exploded as a bolide into several parts, streaking across the sky with a sparkling necklace of burning pieces in its wake. The *New York Times* reported that high on the Hudson River, 'The meteor was seen, under very favorable circumstances, from the

Catskill Mountain House plateau. It seemed to those at that point to be within a few feet of them. And appeared to strike the valley.'

Church recorded the meteor's breakup on a small canvas representing its double fireball leading the lesser satellites as it streaked across the sky like a rocket; he entitled the work *Meteor of 1860* (illus. 222). The cover of *Harper's Weekly* on 4 August ran the fireball's transit as the lead story, accompanied by three wood-engraved images. Press coverage reached as far west as Cincinnati and St Louis, and the *Chicago Press and Tribune* ran articles reporting that it was first thought to be a rocket or a balloon on fire. The poet Walt Whitman had observed the meteor storm of 1833, when thousands of Leonids descended over the sky in a matter of hours, and also witnessed the Earth-grazing meteor that Church painted. It inspired him to write 'Year of Meteors. (1859–60)', which also cites the Great Comet of 1860 (Comet 1860 III), in his collection *Leaves of Grass*:

YEAR of meteors! brooding year!
. . .
the strange huge meteor-procession dazzling and clear,
shooting over our heads,
(A moment, a moment long, it sail'd its balls of
unearthly light over our heads,
Then departed, dropt in the night, and was gone;)
. . .
Year of comets and meteors transient and strange! – lo!
even here one equally transient and strange!
As I flit through you hastily, soon to fall and be gone,
what is this chant,
What am I myself but one of your meteors?

Church's small painting captures the remarkable phenomenon of this large Earth-grazing meteor as it fragmented early in its encounter with the atmosphere, creating multiple meteors trailing in nearly identical paths. Known as a meteor procession, the awe-inspiring

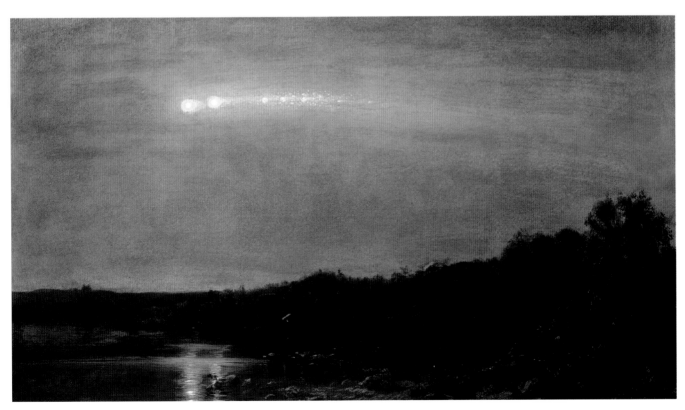

222 Frederic Edwin Church, *Meteor of 1860*, 1861, oil on canvas, 25.4 × 44.5 cm.

223 Harriet Powers, detail of a quilt with meteor showers, 1895–8, cotton plain weave, pieced, appliquéd, embroidered and quilted.

224 F. Ad. Richter & Co., Rudolstadt, Germany, Meteor, c. 1900, wood, ceramic, paper, cardboard, 5.7 × 22.5 × 22.5 cm.

passage of a series of evanescent sparking fireballs is an amazing spectacle.

Despite rampant industrialization, the power of meteor showers continued to engage nineteenth-century individuals who were still attuned to the sky. Among them was Harriet Powers, who created an extraordinary quilt with many astronomical symbols, including one square emblazoned with a meteor shower (illus. 223). Born a slave, Powers farmed four acres of land with her husband near Athens, Georgia. She could neither read nor write, but described the scene as 'The falling of the stars on Nov. 13, 1833. The people were frightened and thought that the end had come. God's hand staid the stars. The varmints rushed out of their beds.' Accounts of the unprecedented, eight-hour Leonid meteor shower of 1833 were passed down through generations to become part of the oral tradition on which Powers drew for her imagery.

As far back as the 1890s, images of meteors were being captured on photographic plates, and in 1894 photographers attempting to take images of meteors began employing rotating shutters, not only to capture meteor trails but also to measure their speed across the sky. This technique was followed by photographic meteor spectroscopy and then in the second half of the twentieth century by radar observation – an apparatus that boasts the decided advantage of being able to work around the clock, while visual observation is limited to the dark hours. By the turn of the twentieth century the sting and threat of meteors had been removed, permitting the marketing of the playful Meteor game, where marbles constitute the meteors (illus. 224). Nevertheless, artists continued to employ meteors as evocative images in their works. Since at least Elizabethan times meteors, like comets, have been allied with love and sexual union, for example in Edmund Spenser's epic poem *The Shepheardes Calender* (1579). Arthur Rackham echoed this tradition in a preparatory watercolour for an illustrated edition of Shakespeare's *A Midsummer Night's Dream* published by William Heinemann in 1908. To envision the lines delivered by Oberon, King of the Fairies, in Act II, Scene 1 of the play, Rackham created a poetic celestial spectacle of shooting stars:

> Since once I sat upon a promontory,
> And heard a mermaid on a dolphin's back
> Uttering such dulcet and harmonious breath
> That the rude sea grew civil at her song
> And certain stars shot madly from their spheres,
> To hear the sea-maid's music.

Rackham related the meteor shower to armed Cupid in a roundel at the top of the composition, encouraging the interpretation that the god of love is releasing the

225 Theodore Roszak, *Study – Meteor*, 1962, fibre-tipped pen, brush and ink on paper, 28.4 × 21.6 cm.

226 Robert Indiana, *Year of Meteors*, 1961, oil on canvas, 2.28 × 2.13 m.

227 Jody Pinto, *Henri with a Soft Meteor*, 1983, watercolour, gouache, crayon and graphite on rag paper, 1.83 × 2.44 m.

meteors as celestial arrows from his bow. Like many writers Shakespeare sprinkled his plays with meteor and comet symbolism, providing potent symbols for illustrators throughout the ages.

Blazing stars are more difficult to capture in three dimensions, but the artist Theodore Roszak drew *Study – Meteor* as a preparatory drawing for a metal sculpture (illus. 225). There is no doubt that his conception was influenced by the pitted remains of meteorites that he must have seen, but Roszak enlivened his memory with the directional momentum of a futurist cosmic explosion.

American Pop artist Robert Indiana, best known for his iconic *LOVE* works, employed advertising lettering and techniques for his *Year of Meteors* (illus. 226), which visualizes quotations from Whitman's famous poem. Himself a poet, Indiana employed an unusual number of letters and words in this image to enshrine Whitman's ideas. Instead of representing an actual meteor shower, his forms are conceptual, alluding to the cosmic, timeless nature of meteors. The two concentric circles suggest the cosmos, and the eight points of an embedded star-like shape symbolize eternity. The work's green-and-blue palette alludes to the marriage of Earth and heaven that

interlock in the endless landscape of the cosmos and 'sing of the wonder'.

By contrast, painter Jody Pinto introduces the human body into a cosmically speculative painting from her *Henri* series (illus. 227). Henri LaMothe, the artist's neighbour and a former Olympic swimmer, performed humorous yet death-defying feats of physical prowess. Pinto considered LaMothe as an alter ego and has described him as a daredevil who acted out fantasies with a tremendous energy and humour. In this canvas she paints him bright red and pulsing with energy, an anonymous everyman careening in the sky accompanied by a large yellow and red shooting star from below and trails of fizzling meteors in blue, white and yellow above.

Most astounding for the unusual nature of its media is Sigmar Polke's *The Spirits That Lend Strength are*

Invisible II (Tellurium Terrestrial Material) (1988; San Francisco Museum of Modern Art) that is created from meteor dust suspended in resin and painted on canvas. The work triggers speculations about the meaning of creativity and about art that takes on a cosmic, timeless dimension that springs from otherworldly sources or from deliberately selected cosmic materials.

Today, all members of the meteor family continue to engage skywatchers and stargazers, while announcements of annual displays of meteor showers still grab the public's attention across all media, including social media. Meteoric phenomena can still stop human beings in their tracks, reminding us of our more primitive ties to the sky and Earth, connecting us to the wider expanse of the universe and to issues that transcend our quotidian lives. Most important, they inspire awe.

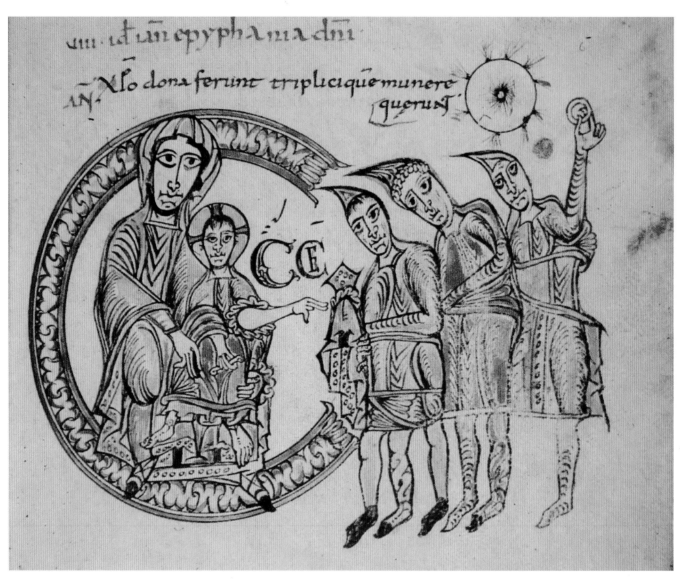

228 Unidentified artist, supernova of 1006 or 1054 in the C initial of the *Adoration of the Magi* of the Antiphony-Gradual of S. Stefano, second quarter of 11th century, black ink and watercolour on parchment. Codex 123, folio 40r, Biblioteca Angelica, Rome.

7 Primordial Matter of the Big Bang:
Novae, Nebulae and Galaxies

What happened in our universe over 13 billion years ago? We now know that our universe is expanding, with clusters of galaxies flying apart at increasing speeds. If we were to trace back the expansion, things would become closer and closer until we reach the realm where twenty-first-century astronomers do not know how to merge the general theory of relativity with quantum mechanics to give an accurate explanation of the science. But it is generally accepted by scientists that the universe started expanding very rapidly within the first fraction of a second of what we call the Big Bang. Advanced as a derisive term from a proponent of a rival, now discarded cosmological theory known as Steady State, the term 'big bang' remains accepted as our current theory of the early moments of our universe.

The universe was so hot and dense that matter as we know it now did not exist. After about one second, and extending for about three minutes, the universe cooled enough that protons formed the nuclei of hydrogen, followed by a thousandth of a per cent of deuterium, or 'heavy hydrogen', a nucleus of a proton and a neutron. An even smaller trace of lithium also arose, as did some helium, but no heavier elements. Those first thousand seconds are known as the era of nucleosynthesis.

It then took about 400,000 years for the universe to cool enough for electrons to join with protons to form hydrogen atoms. The radiation from hydrogen atoms occurs only at specific colours, not continuously, so the 'cosmic microwave background radiation' was set free. It took millions of years after that for individual stars and galaxies to form. With new methods astronomers are increasingly able to observe back to those early epochs of our universe.

Although the stars visible from Earth have been seen and mapped for thousands or even tens of thousands of years, it is much more difficult to perceive invisible phenomena. In this chapter we will discuss parts of the universe that are not normally seen with the eye but which sometimes explode and brighten, or otherwise become visible.

When a star became visible where no star had been seen it was called 'miraculous', and indeed when a star seemed to appear in 1596 the astronomer David Fabricius named it 'Mira'. We realize now that Mira is one of billions of 'variable stars', that is, stars whose brightness varies over intervals of days, months or years. By the time that Johann Bayer published his *Uranometria* in 1603 the star Mira was given the Greek letter omicron in the

229 Unidentified German maker, star mantle of Emperor Henry II, 1020, violet silk twill with gold threads, 297 cm diameter.

constellation Cetus and was thus named Omicron Ceti. (When mapped it was roughly the fifteenth brightest star in Cetus and so was assigned with the fifteenth Greek letter along with the genitive form of the constellation name.) Mira varies in brightness by a factor of over 100 across a six-month period. It is one of a whole class of thousands of so-called 'Mira variables' or 'long-period variables'. Astronomers have ascertained that this red giant star varies in brightness because it is pulsing in size.

Often an apparently new star (that is a star and not a comet, though these have at times been lumped together along with meteors and novae) appears and is called a 'nova', from the Latin for 'new'. We now know that novae come about from matter falling onto a type of collapsed star known as a white dwarf, and flaring up with intense light. Such a flare-up can happen over and over again, with events sometimes separated by mere decades.

In the nineteenth century a brightening star of this kind appeared in the Great Nebula in Andromeda, which is in fact a spiral nebula. Measuring its apparent brightness allows its distance to be calculated when compared to other novae of known brightness and distance. But it turns out that the Great Nebula in Andromeda is really more than just a spiral agglomeration in the sky; it is a whole 'island universe' by itself, the Andromeda Galaxy. Given its distance from Earth, a 'nova' occurring in the Andromeda Galaxy had to be a 'supernova', millions of times brighter than a mere nova. While a nova is a mere brightening of a bit of a star's surface, a supernova is the explosion of the entire star.

How bright a supernova looks to us is based on both how bright it is intrinsically and how far it is from Earth. To find references to the oldest supernovas, historians of astronomy interpret old documents from civilizations around the world. The consensus is that

Chinese chronicles first recorded a supernova in their year equivalent of the West's 185 BC. The brightest supernova or stellar event in history was recorded on 30 April 1006. It was visible in daylight and it stayed visible in the night sky for many months. The event may be reflected later in that century in a manuscript with a scene of the *Adoration of the Magi* (illus. 228) in which the traditional Star of Bethlehem is represented as a supernova. It is analogous to Giotto's substituting his portrait of Halley's Comet of 1301 for the stylized Christmas star (see illus. 135); indeed, there are astronomers who argue that the reported new star the three kings saw in the sky as they journeyed from the East to Bethlehem to witness the baby Jesus was a supernova. There was another

supernova recorded in 1054, whose remnants we will discuss below. Since the manuscript illustration is not specifically dated, its new star may reflect either the supernova 1006 (SN 1006) or that of 1054 (SN 1054) in the Crab Nebula (see illus. 295). What is certain, however, is that the unidentified artist drew a powerful celestial object that is unique and followed no conventions; one which we can thus infer must reflect his own experiences. At the centre he delineated a circle with rays extending outwards, which is surrounded by a larger circle whose circumference is punctuated with multiple dynamic jets of spitting rays. The entire ensemble resembles later fireworks and convincingly evokes the cosmic explosion that defied the order of the heavens.

The 'miraculous' appearance of the 1006 supernova is probably what led Emperor Heinrich II to commission an unidentified German maker to weave a star-embellished ceremonial cape that reportedly contains a representation of a supernova (illus. 229). As discussed earlier, celestial apparitions, it was mistakenly believed, could presage important events on earth, and, like a comet, a supernova could herald the advent of a new ruler.

The reports of these unusual and unsettling supernovae remained in the oral tradition and the public consciousness for long periods of time. A watercolour from around 1450 illustrates an event following the coronation of Holy Roman Emperor Henry III in Rome in 1046 while he was touring Tivoli and Frascati to consolidate his power. The artist depicts a supernova in the sky over the town of Tivoli, with the ostentatiously crowned Henry pointing to it as a vindication of his authority (illus. 230). Another famous supernova from almost a millennium ago, the event of 1181 (SN 1181) in Cassiopeia, was recorded by an anonymous artist in an Italian Romanesque fresco in the church of San Pietro in Valle, Ferentillo, again in a depiction of the *Adoration of the Magi* (illus. 231).

Supernovae occur about once a decade in each spiral galaxy, our own included, while bright ones – meaning those relatively near to our Sun – appear every century or so. The best-known supernovae are associated with

230 Workshop of Diebold Lauber, 'Henry III and the New Star in Tivoli', from *Historia septem sapientum dt. Martinus Oppaviensis. Chronicon pontificum*, 1450. Cod. Pal. germ. 149, folio 20v, Universitätsbibliothek Heidelberg.

231 Unidentified artist of the Roman School, supernova of 1181, detail of *Adoration of the Magi*, c. 1182, fresco, San Pietro in Valle, Ferentillo.

the famous astronomers who observed them: Tycho Brahe's supernova of 1572 (SN 1572) and Johannes Kepler's supernova of 1604 (SN 1604), although many other people also saw them. Tycho wrote a whole book, entitled *De nova stella*, about the 1572 supernova (illus. 232). Tycho's supernova also appeared in the constellation Cassiopeia, and when radio astronomy was invented in the mid-twentieth century the supernova remnant was found to be the brightest radio source in that constellation, and was assigned the notation Cassiopeia A. Various telescopes, including the high-resolution Hubble Space Telescope, are used to assess its structure and to follow its expanding gas.

The idea of supernovae as opposed to mere novae was championed about a century ago by the astronomer Fritz Zwicky at the California Institute of Technology, Pasadena. Now the wide-field telescope (a telescope that images a wide view of the sky) with the two narrow-field telescopes – including the great 5-metre (16-ft) '200-inch' Hale telescope, the largest in the world from when it was built in 1948 until the mid-1990s – comprise the Zwicky Transient Facility (ZTF) at the Palomar Observatory on Palomar Mountain in southern California. ZTF is providing images of the whole part of the sky visible from Palomar at least twice a week as astronomy moves into the realm of Big Data.

One kind of supernova occurs when a white dwarf, a collapsed star the size of Earth, gains some mass from a companion star. The further, abrupt collapse always comes exactly when the star just barely exceeds 1.4 times the Sun's mass, which is the maximum that a white dwarf can have, so each supernova generated in that fashion has basically the same peak brightness. As such, by comparing the observed brightness with the known peak intrinsic brightness, astronomers can calculate the distance of the supernova and its host galaxy from Earth. Around twenty years ago it was determined that some extremely distant supernovae were fainter than they should have been if the universe were expanding uniformly, leading to the conclusion that the universe's expansion is accelerating. These ideas garnered the

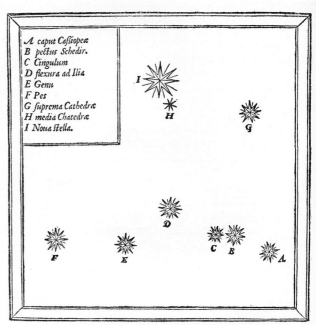

232 Tycho Brahe, supernova of 1572 in a star map of Cassiopeia, page B from *De nova stella . . .* (Copenhagen, 1573), woodcut.

Nobel Prize in Physics in 2011 for Saul Perlmutter, Adam Riess and Brian Schmidt. The findings also elaborated on the realization that normal matter makes up only about 4 per cent of everything in the universe, with invisible dark matter taking up another 30 per cent or so and the force of expansion deriving from an unknown dark energy constituting the remaining two-thirds.

In his star atlas of 1603, discussed in Chapter Two, Johann Bayer recorded only point-like objects, the stars, and no diffuse objects in the sky. With the first telescopic views of the heavens recorded in his *Sidereus nuncius* (1610) Galileo found more stars in the constellation of Orion's Belt than could be seen with the naked eye, but he did not record any nebulosity. Eventually the nebulosity in Orion's Belt became known as the Great Nebula in Orion – and unlike the Great Nebula in Andromeda

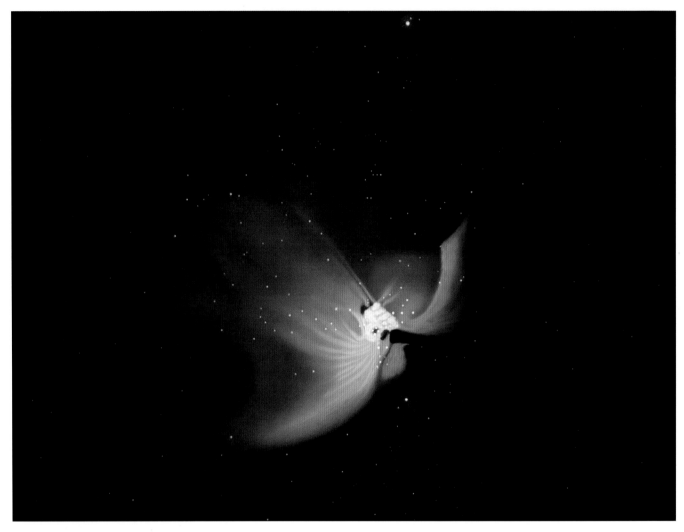

233 Étienne Léopold Trouvelot, *The Great Nebula in Orion*, observed 1875–6, plate xv from *The Trouvelot Astronomical Drawings Manual* (New York, 1881), chromolithograph, 71 × 94 cm.

turned out to be interstellar gas rather than a distant galaxy. Étienne Léopold Trouvelot beautifully drew the structure in the Orion Nebula, first in the 1870s in pastel and later using these as models for chromolithographs issued at the beginning of the 1880s (illus. 233). We now know that this gas is heated by a trio of stars, known as the Triangulum, embedded in the gas. Indeed, these stars have formed out of the gas; the Orion Nebula is a nursery of star formation.

Twentieth-century artist M. C. Escher suggests the enigmatic and infinite variation of objects in the universe in an otherworldly woodcut (illus. 234). In *Other World* we seem to peer out from an intricately arcaded architectural structure with unsettling, surrealistic perspectives at some of the universe's constituents, including craters, a comet, a spiral galaxy and other, unknown forms.

In 1920 a 'Great Debate' was held at the National Academy of Sciences in Washington, DC, between two noted California astronomers, Harlow Shapley and Heber Curtis. They debated whether the spiral nebulae were intrinsic to our own Milky Way structure or if they were independent galaxies, 'island universes' of their

234 Maurits Cornelis Escher, *Other World*, 1947, wood engraving and woodcut printed in three colours, 31.8 × 26.1 cm.

own. Shapley believed that the spiral nebulae were small and were located in the outer parts of our own galaxy, while Curtis argued that they were independent galaxies, making them distant and consequently large. But Shapley relied on some false evidence: another distinguished astronomer had mistakenly concluded that he had seen motions in the Andromeda Galaxy, which would make them relatively close. Why such a distinguished astronomer so fooled himself (and others) is still being debated. So Shapley – who continued as director of the Harvard College Observatory and become a major public voice for astronomy – came to the wrong conclusion, but using sound reasoning.

The distance to the Andromeda Galaxy was finally determined by the American astronomer Edwin Hubble, who found a variable star in that galaxy in 1923. When he noticed the variation he went back and marked the star on the photographic plate in red nail polish with 'VAR!' for 'variable'. The star turned out to be a rare and special type of variable star that became known as a Cepheid variable, since the prototype was the star delta in the constellation Cepheus.

In the early twentieth century 'computers' were people for hire who computed things, rather than the machines we have today. Over a century ago the mostly female workforce of 'computers' at the Harvard College Observatory studied the brightness and spectra of hundreds of thousands of stars. Henrietta Swan Leavitt in particular studied many Cepheid variables in the Large Magellanic Clouds, satellite galaxies of our own. All those stars were relatively close to each other compared with the distance from Earth to there, so if one looked brighter than another it really was brighter, the inverse-square distance effect having been removed. (As light spreads out in a sphere, whose area depends on the square of this radius, the amount of light received in the same telescope diminishes by one over the square of the radius.) What was long called the period-luminosity relation – linking the period of a Cepheid variable (in a method not valid for any other type of star) to its luminosity – is now called Leavitt's Law. By merely observing a star's period,

you can use Leavitt's Law to find its intrinsic brightness and compare the intrinsic brightness with its apparent brightness (how bright it appears to you); with these two results you can calculate the distance. The release in 2018 of detailed observations of star positions from the European Space Agency's *Gaia* spacecraft is giving more accurate distances to a few nearby Cepheids, putting Leavitt's Law on a more accurate footing. From Hubble's observations of a Cepheid variable ('VAR!') in the Andromeda Galaxy, Wendy Freedman of the University of Chicago and her colleagues have generalized by using the Hubble Space Telescope to find Cepheid distances to dozens of other galaxies, elaborating upon what is called the 'cosmic distance ladder' that takes us to the age and size of the universe as a whole.

The term 'galaxy' has only been in the public vernacular around a century. American painter Jackson Pollock's Abstract Expressionist canvas *Galaxy* (1947; Joslyn Art Museum, Omaha, Nebraska) demonstrates widespread popular understanding of the term. The Surrealist artist Max Ernst's *Birth of a Galaxy* of 1969 (illus. 235) captures eloquently the turmoil, yet also the order, that may well be involved in galaxy formation. In the twenty-first century, with our powerful computer chips we can look far into space, back billions of years in time to before the point at which most galaxies took their current regular shapes. We are thus continuing to learn about the formation of galaxies, and astronomers expect to use the infrared capabilities of NASA's James Webb Space Telescope, whose launch date continues to be pushed ahead, to study galaxies whose peak light is extremely redshifted. It will allow us to see back perhaps 10 billion years out of the universe's more than 13 billion.

Images of thousands of individual galaxies are being made at ground-based observatories and from space. One of the first to use three-colour techniques to take individual monochromatic galaxy images using telescopes and shooting through several filters was astronomer and photographer David Malin at the Anglo-Australian Observatory (now the Australian Astronomical

235 Max Ernst, *Birth of a Galaxy*, 1969, oil on canvas, 92 × 73 cm.

Observatory) in Sydney. Malin was initially hired for his darkroom chemistry knowledge. His image of the Sombrero Galaxy (illus. 236) shows a galaxy seen edge-on (like looking at a dinner plate from the side instead of above) with a dust ring that perhaps resulted from a merger of two galaxies in the distant past. New York artist Vija Celmins is known for her drawings and prints of celestial phenomena. Her graphite drawing *Galaxy* (1975; Tate, London) matches the look of the original National Geographic Society – Palomar Observatory Sky Survey carried out in the 1950s with the wide-field 'Schmidt' telescope at the Palomar Observatory. The cosmic significance of galaxies has been used by many artists, including the American painter Jasper Johns, who even included one to the right of the stripes of the American flag in the blue field (illus. 237).

From images taken with the Hubble Space Telescope – a joint project of NASA and the European Space Agency – we now know of millions of galaxies, initially using the Hubble Deep Field (HDF) of 1995, then the Hubble Ultra Deep Field (HUDF) and, most recently, the eXtreme Deep Field (XDF). The main camera on Hubble was left to point for many days at some small region of space, the size of a grain of rice held at the end of your arm, with the result that thousands of galaxies were imaged. The closest ones show some structure while the most distant ones, redshifted and so looking reddish, seem incomplete or even unresolved.

The Space Telescope Science Institute – NASA's organization on the campus of Johns Hopkins University, Baltimore, which handles the programming and data from the Hubble Space Telescope and will eventually do so for the James Webb Space Telescope – provides a website with hundreds of galaxy images, some even optimized for desktop backgrounds on home computers. A sample of a nearby spiral galaxy, one of the first in which

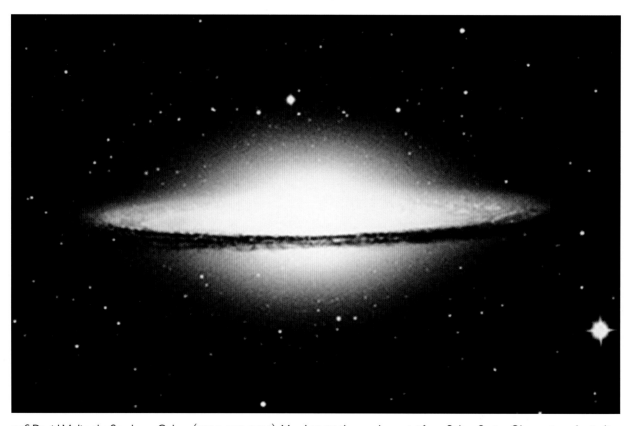

236 David Malin, the Sombrero Galaxy (M104. NGC 4594), March 1993, three-colour print from Siding Spring Observatory, Australia.

237 Jasper Johns, *Untitled*, 2001, collage and acrylic over aquatint and etching on paper, 46.2 × 68.1 cm.

238 Hubble Space Telescope, Whirlpool Galaxy M51 (NGC 5194), January 2005, imaged by the Advanced Camera for Surveys.

239 William Parsons, 3rd Earl of Rosse, first drawing of spiral nebula M51, April 1845, from the Rosse Papers L/3/2. Birr Castle Archives.

240 Jason Chu, the Milky Way over Haleakalā, Maui, Hawaii, 27 March 2017.

its structure was discovered (by the pioneering William Parsons, 3rd Earl of Rosse, at Birr Castle in Ireland in the mid-nineteenth century), shows the whitish stars as well as reddish nebulosity outlining the spiral arms (illus. 239).

All these galaxies lie beyond our own galaxy. The central disc of our Milky Way can be seen edge-on from the observatory site at the peak of Haleakalā on Maui, Hawaii (illus. 240). But how did the Milky Way form? Surely not literally from breast milk expressed by Venus, as the Venetian Renaissance painter Jacopo Tintoretto imaginatively painted it, adding the flourish of a whirling helix form (illus. 241). Rubens' similar conception seems more earthbound and thus even more literal for such a cosmic phenomenon (illus. 242). In our contemporary, light-polluted days city-dwellers rarely see the Milky Way, but in earlier times it mesmerized stargazers, as seen in a seventeenth-century religious painting by Adam Elsheimer (illus. 243), created just as Galileo was making his first telescopic observations. As part of his astronomical series, Trouvelot also rendered the Milky Way in a vertical format more completely (illus. 244), while French Pointillist Henri-Edmond Cross' water-colour *Landscape with Stars* captures the Milky Way in a less literal manner (illus. 245). One of the most famous

paintings with an astronomical reference is Vincent van Gogh's *Starry Night* (illus. 246), which may have influenced Cross. Much studied over the years, its astronomy is not exacting but rather expressive of the artist's wonder at the swirling infinity of the cosmos. The brightest object in the canvas is the planet Venus at lower left, just to the right of the tree. The crescent moon appears, unnaturally yellow, at top right. While the circular and even spiral patterns around the stars and Venus may be invoking the discovery of the spiral nebula now known as M51, the Whirlpool Galaxy, by Lord Rosse about fifty years earlier, the artist also included the Milky Way in his tempestuous nocturne.

Near the Milky Way is the constellation Taurus. The first radio source discovered in it, Taurus A, turns out to be the previously mentioned famous supernova from 1054. The optical images seemed to resemble some crab-like features drawn by Lord Rosse in the nineteenth century and the object has ever since been called the Crab Nebula (illus. 247, 295). For technical photographic reasons, black-and-white imaging was much more efficient than colour in the mid-twentieth century, so images were taken at the largest telescopes on black-and-white photographic plates but through different filters. Then, by putting together several of the black-and-white

241 Jacopo Tintoretto, *The Origin of the Milky Way*, c. 1575–80, oil on canvas, 149.4 × 168 cm.

242 Peter Paul Rubens, *The Origin of the Milky Way*, c. 1636–7, oil on canvas, 181 cm × 244 cm.

243 Adam Elsheimer, *The Flight into Egypt*, 1609–10, oil on copper, 31 × 41 cm.

images, it became possible to make a polarized colour view of the Crab Nebula (illus. 247). This composite image allows us to see the shreds of the star that blew apart. Electrons spiralling along the magnetic field in those shreds give off polarized light, emphasized in this view, with ordinary stars in the background.

In the twenty-first century we now use computers to make the composites that were once done in a photographic darkroom. A sample Hubble Space Telescope view of a group of interacting galaxies was made through a combination of individual monochromatic views (illus. 248). Fifty years ago at Palomar Mountain, California,

astronomer Halton 'Chip' Arp compiled an atlas of weird-looking galactic shapes in the sky. Though one of his central ideas – that since quasars (a contraction of quasi-stellar radio sources) often appear near weirdly shaped galaxies and thus must be connected and not much farther away than the galaxies – was disproved on statistical grounds, his *Atlas of Peculiar Galaxies* remains influential.

Everything discussed so far in this book involves light in some form, or its analogues as X-rays, radio waves or other sorts of what is called electromagnetic radiation. From quantum mechanics we learned in the

244 Étienne Léopold Trouvelot, *Part of the Milky Way*, from a study made in 1874, 1875 and 1876, plate XIII from *The Trouvelot Astronomical Drawings Manual* (New York, 1881), chromolithograph, 94 × 71 cm.

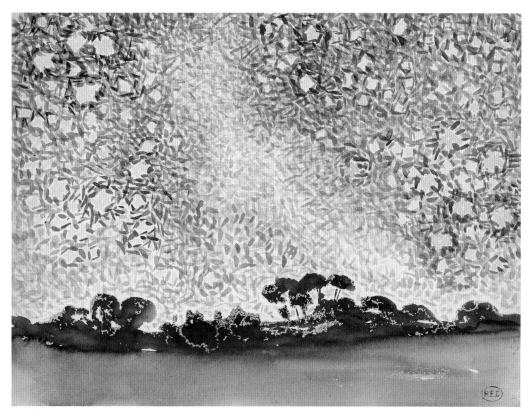

245 Henri-Edmond Cross, *Landscape with Stars*, c. 1905–8, watercolour over graphite on paper, 24.4 × 32.1 cm.

246 Vincent van Gogh, *The Starry Night*, 1889, oil on canvas, 73.7 × 92.1 cm.

247 David Malin (Anglo-Australian Observatory) and Jay M. Pasachoff, polarized image of the Crab Nebula from Palomar Observatory.

twentieth century that such electromagnetic radiation can act seemingly like waves and sometimes like particles, which are called photons. Sometimes we receive ordinary particles from outer space: 'cosmic rays'. The big twenty-first-century discovery has been about gravitational waves, an entirely different phenomenon. These gravitational waves are distortions of space itself, and they travel through space at the speed of light.

Albert Einstein's general theory of relativity from 1916 took decades to interpret. In the 1930s the idea was put forward that a distortion of space from, say, a supernova explosion could travel through space as a gravitational wave; however, the distortions would be so small that even Einstein himself thought that these waves would never be detected. But after a forty-year effort, culminating in 2015, gravitational waves were detected. The original theory was that a supernova explosion would cause the gravitational waves, but nobody was certain. So while the instrument-builders were creating a device, the theoretical physicists were calculating what kinds of things or events

248 Hubble Space Telescope, interacting galaxies Arp 273, 17 December 2010, imaged by the Wide Field Camera.

249 A. Simonnet, model of merging black holes from the detection of gravitational waves.

in space might cause gravitational waves and how the waves would be different depending on their causes.

Building on an idea by the MIT professor Rainer Weiss for instrumentation, with instrumental skills by Ron Drever, and with theory by Caltech professor Kip Thorne, the U.S. National Science Foundation funded two identical instruments, each a Laser Interferometer Gravitational-wave Observatory (LIGO). One was installed in the Pacific Northwest, in Hanford, Washington, while the other was placed thousands of kilometres away in Livingston, Louisiana. This way, no local disturbance – such as a truck on a road – could fool the system into registering that a gravitational wave was passing. (In fact, the ocean waves on the Atlantic Coast of the United States were so strong compared to LIGO's

sensitivity that the eastern system was put in Louisiana near the Gulf Coast, since the Gulf's waves are weaker.) Eventually Barry Barish was recruited to make the system work. Subsequently Weiss, Thorne and Barish received the 2017 Nobel Prize in Physics.

Just as the system was turned on in 2015, a gravitational wave came through. People even thought it might be just a test of noise artificially put into the system, but it was real. The signal LIGO got matched the one it was predicted would come from two black holes merging, with each black hole having around thirty times the mass of the Sun (illus. 249). The resultant giant black hole, of over sixty solar masses, was one solar mass lighter than the sum of the two originals, with the remaining mass set into space according to E=mc². The gravitational wave

travelled 1.3 billion light years, taking over 1.3 billion years, reaching Earth and distorting both LIGO instruments in the same way. Over a fraction of a second the distortions got quicker and quicker, which corresponds to a rising frequency. When translated into sound the event sounded like a chirp. The actual distortion of the 4-kilometre-long (2½-mi.) arms of the LIGO apparatus was only a hundredth of the diameter of a proton, equivalent to the thickness of a human hair compared with the distance to the nearest star beyond the Sun, but it was clearly detected. Since this first measurement, more events have been detected.

Another major step in the emerging field of gravitational-wave astronomy was a weaker event that turns out to have been two neutron stars merging, rather than black holes. The neutron stars are the remnants of stars that were themselves not massive enough to collapse to become black holes. The neutron-star mergers not only sent off gravitational waves, but also sent out all kinds of electromagnetic radiation. Thousands of astronomers on Earth used telescopes on the ground and in space to successfully pick up the signal from the event. Gamma rays were detected in space, and a bright spot in the sky was picked up with various ordinary telescopes.

As we write, more gravitational-wave observatories are being established, joining the LIGOs and the Virgo in Italy. Additional set-ups in India and Japan are under way. The greater the number of such observatories, the easier it will be to determine the direction from which a gravitational-wave signal is coming, and so to turn optical telescopes in that direction. The days of astronomers observing only light reaching us from afar – in the twentieth century supplemented by a wider spectrum including X-rays, radio waves and other types of 'electromagnetic radiation', such as ultraviolet and infrared – are over.

250 Caravaggio, *Jove, Neptune and Pluto*, c. 1597, oil on plaster, 3 × 1.8 m, Villa Boncompagni-Ludovisi, Rome.

8 The Planets of the Solar System

Philosophically, does one discover mathematical truths or invent them? Were they embedded in the universe already? Similarly, how can one be the discoverer of a planet when they have been there for millions of years? Nobody, including the International Astronomical Union, had defined what a planet is until they were faced with a conundrum.

The word 'planet' comes originally from the ancient Greek *planan*, 'wanderer', as the planets other than our own Earth were seen for tens of thousands of years by early humans as points in the sky wandering among the stars, which kept the same configurations even while they rose and set or orbited the visible celestial pole. Our major planets are named after the ancient Graeco-Roman Olympian gods and goddesses. The myths around these deities figure in works of art across the centuries, not least Caravaggio's fresco on the ceiling of the Villa Boncompagni-Ludovisi in Rome, which he painted for one of Galileo's patrons, Cardinal Francesco Maria del Monte (illus. 250). NASA's Jet Propulsion Laboratory, run by the California Institute of Technology, has named its current Jupiter-orbiting spacecraft after the Roman queen of the gods and Jupiter's (or Jove's) wife, Juno. The *Juno* spacecraft is festooned with technical devices for

measuring particles and fields near the planet Jupiter, but it also carries a camera to provide images for citizen scientists and the general public (illus. 251, 252, 254).

Our solar system is largely in a geometrical plane, the 'ecliptic plane', so named because eclipses of the Sun and Moon occur near it (though the lunar orbit around Earth is tilted by 5 degrees). Most spacecraft travelling in the solar system take advantage of Earth's speed in its orbit to zoom in, or near the ecliptic, to save the energy it would require to go high above or far below it. But the *Juno* spacecraft uses Jupiter's gravity to slingshot itself in just that unusual orbit, a highly elongated ellipse that passes over Jupiter's poles. It takes about three months to complete a single orbit. When it comes close to a pole its pictures are first-rate, showing swirls (illus. 252) rather than the bands of cloud that show at lower latitudes.

The ordinary views of Jupiter from telescopes on Earth are equatorial views in which we see the various belts and zones that circle Jupiter at different speeds, often rolling storms between them much like the way you can roll a pencil between your hands. One result is the Great Red Spot, which has been visible for hundreds of years and is shown in this chapter in a chromolithograph

251 Jupiter cloudscape, from the *Juno* spacecraft,
11 December 2016.

He saw first three and eventually four points of light moving to and fro, alternately appearing from either side of Jupiter (illus. 255). He soon realized that he was seeing moons orbiting the planet rather than mere background stars. At the time Galileo had a book in press about his new celestial discoveries, his aforementioned *Sidereus nuncius* (Starry Messenger), and he rushed these new discoveries into the book, which was published on 13 March 1610.

Unbeknown to Galileo, far to his north in Germany another astronomer, Simon Marius, also had access to a telescope (although he was borrowing one from a neighbour rather than building and modifying his own like Galileo). Marius, however, who also had a book in preparation though on another subject, did not rush to publish his latest observations in it. The next year he did insert an illustration of four moons orbiting Jupiter into an almanac for 1612, and in 1614 he produced his magnum opus, *Mundus Iovialis*, in which he described what he had discovered 'in 1609'. His book included what is arguably the first diagram of the orbits of the moons of Jupiter (illus. 256), as well as a table showing observations that Galileo could not have made. But the competitive Galileo took violent exception to the idea that Marius might have some priority over his discovery, implied by the very mention of the year 1609. Because Marius, who was living near Nuremberg, used the old Julian calendar retained by Protestants the discovery dates needed to be adjusted if they were to be compared with Galileo's. In the end Marius' claimed date was one day after that of Galileo. There is, however, no way of knowing how long in advance either of them began observing rather than writing notes, and so the issue remains properly unresolved. We do know that the names Io, Europa, Ganymede and Callisto, which we still use for these 'Galilean satellites' of Jupiter, are those provided by Marius in his book.

At the time of writing, NASA is planning a mission to Europa – which has a global ocean flowing underneath its ice-encrusted surface – to look for possible signs of life. In recent years the Hubble Space Telescope has

made after a pastel by Étienne Trouvelot almost 150 years ago (illus. 253). Viewed from earlier spacecraft that journeyed to Jupiter, such as NASA's *Galileo*, the Great Red Spot was seen to have its own internal circulation and now we study it close up from *Juno* (illus. 254).

As one of the brightest planetary points of light in the sky, second only to Venus, Jupiter is the only planet that is sometimes visible in the sky all night (as an inner planet of our solar system, Venus never strays too far from the Sun). In the early seventeenth century, when word spread around Europe that a device had been constructed that could make distant objects appear closer, Galileo Galilei in Padua was among the first to point such a device – which he called a 'perspicillum' – skyward. (He also took his perspicillum to the campanile of St Marks Basilica in Venice to demonstrate to local nobles how the device would allow them to see ships further out at sea than otherwise, thus offering commercial and military advantage.)

What Galileo observed he began sketching on 7 January 1610 (by the Gregorian calendar that had been introduced by Pope Gregory about two decades earlier).

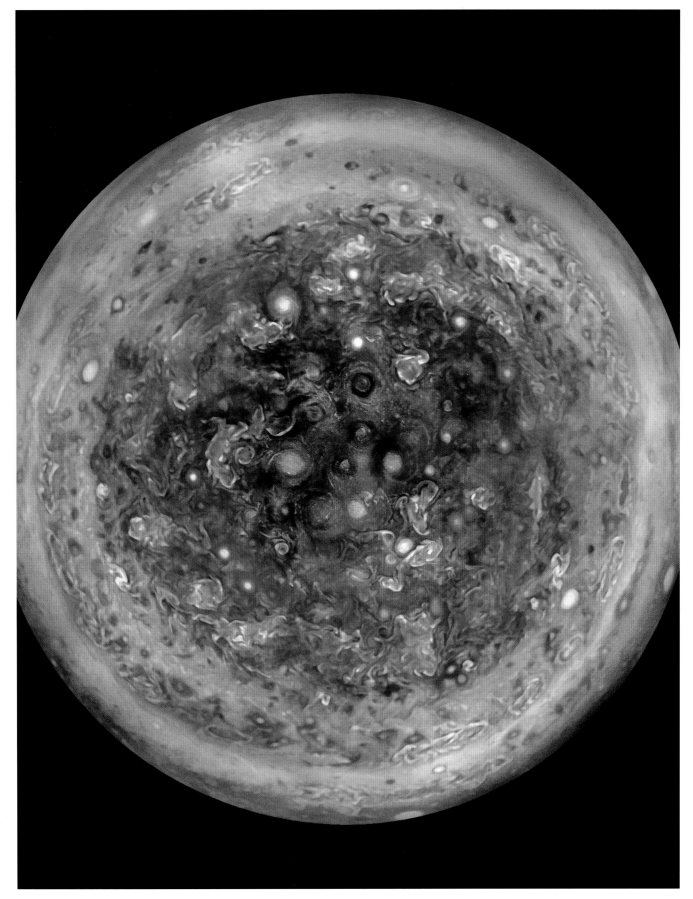

252 Jupiter's South Pole, from the *Juno* spacecraft.

253 Étienne Léopold Trouvelot, *The Planet Jupiter*, observed 1 November 1880, plate IX from *The Trouvelot Astronomical Drawings Manual* (New York, 1881), chromolithograph, 71 × 94 cm.

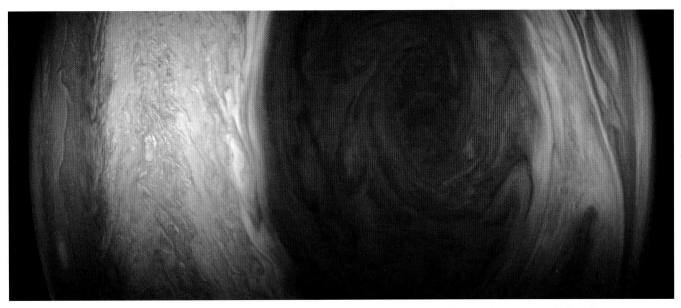

254 Gerald Eichstädt, Great Red Spot of Jupiter, enhanced-colour image created by using data from the *Juno* spacecraft's JunoCam.

OBSERVAT. SIDEREAE

Ori.　　　　　* ＊O ＊　　　　　Occ.

Stella occidentaliori maior, ambæ tamen valdè con-
fpicuæ, ac fplendidæ: vtra quæ diftabat à Ioue fcrupu-
lis primis duobus; tertia quoque Stellula apparere cœ-
pit hora tertia priùs minimè confpecta, quæ ex parte
orientali Iouem ferè tangebat, eratque admodum e-
xigua. Omnes fuerunt in eadem recta, & fecundum
Eclypticæ longitudinem coordinatæ.
　　　Die decimatertia primùm à me quatuor confpectæ
fuerunt Stellulæ in hac ad Iouem conftitutione. Erant
tres occidentales, & vna orientalis; lineam proximè

Ori.　　　　　* O＊*＊ ＊　　　　　Occ:

rectam conftituebant; media enim occidétalium pau-
lulum à recta Septentrionem verfus deflectebat. Abe-
rat orientalior à Ioue minuta duo: reliquarum, &
Iouis intercapedines erant fingulæ vnius tantùm mi-
nuti. Stellæ omnes eandem præ fe ferebant magnitu-
dinem; ac licet exiguam, lucidiffimæ tamen erant, ac
fixis eiufdem magnitudinis longe fplendidiores.
　　　Die decimaquarta nubilofa fuit tempeftas.
　　　Die decimaquinta, hora noctis tertia in proximè
depicta fuerunt habitudine quatuor Stellæ ad Iouem;

Ori.　　　O ＊ *＊　 ＊　　　Occ.

occidentales omnes: ac in eadem proxim recta linea
difpofitæ; quæ enim tertia à Ioue numerabatur pau-
lulum

255 Galileo Galilei, observations of the moons of Jupiter, page 18 from *Sidereus nuncius* (Venice, 1610), engraving.

256 Simon Marius, frontispiece with the symbol for Jupiter and four moons and their orbits, from *Mundus Iovialis anno MDCIX detectus ope perspicilli Belgici* (Nuremberg, 1614), woodcut.

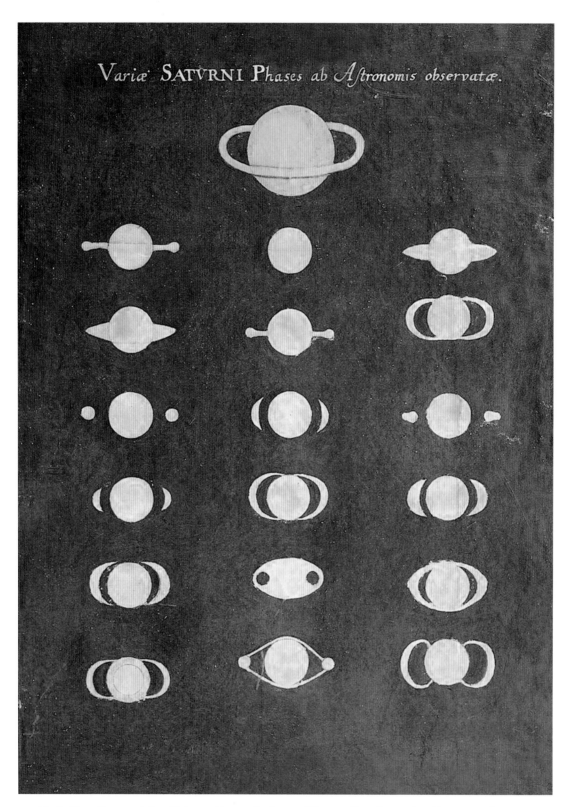

257 Maria Clara Eimmart (after Christaan Huygens), phases of Saturn, 1693–8, pastel on blue paper, 64 x 52 cm.
Mds 124L, Museo della Specola, Università di Bologna.

258, 259 Rebecca Emes and Edward Barnard I, tankard with the planets and the Comet of 1811, 1811–12, silver with gilt interior, 14.9 cm height.

spotted plumes that are likely to be water vapour issuing from Europa's surface and which reach up more than 160 kilometres (100 mi.). The *Galileo* satellite flew through one of these plumes in 1997. The *Europa Clipper* mission may launch as soon as 2022 to orbit Jupiter with dozens of flybys of Europa. That same year the European Space Agency's *JUpiter ICy Moons Explorer* (*JUICE*) may set off to visit not only Europa but also Ganymede and Callisto, also reaching the Jupiter system in about 2029.

Galileo also looked at Saturn in 1610 but did not know what to make of what he saw. There were protrusions, 'ears', to the sides of the planet. It was decades before the Dutch astronomer Christiaan Huygens, using a better telescope than was available to Galileo, realized in 1655 that the apparent ears were in fact rings surrounding Saturn. A few decades later the German astronomer and engraver Maria Eimmart showed the configurations of Saturn with its ring as seen from Earth in a watercolour

(illus. 257). By 1811–12, when Rebecca Emes and Edward Barnard I created a view of the planets and of the Great Comet of 1811 on a silver tankard, Jupiter's moons and Saturn's rings were well known (illus. 258, 259). (The rings of Jupiter, Uranus and Neptune were discovered only in the late twentieth century.) Trouvelot, of course, included a ringed Saturn in the sets of pastels and chromolithographs of his astronomical series (illus. 260).

Saturn remained among the most interesting objects for amateur astronomers and the general public to see, through even small telescopes; it is still astonishing to see its rings. The full glory of the planet's rings was revealed when NASA, the European Space Agency and the Italian Space Agency sent their *Cassini* probe (with the *Huygens* lander delivered to Titan, Saturn's largest moon) to study Saturn and its systems and satellites, a trip that began in 1997. The probe was named after the seventeenth-century scientist Giovanni Domenico Cassini, who is known for

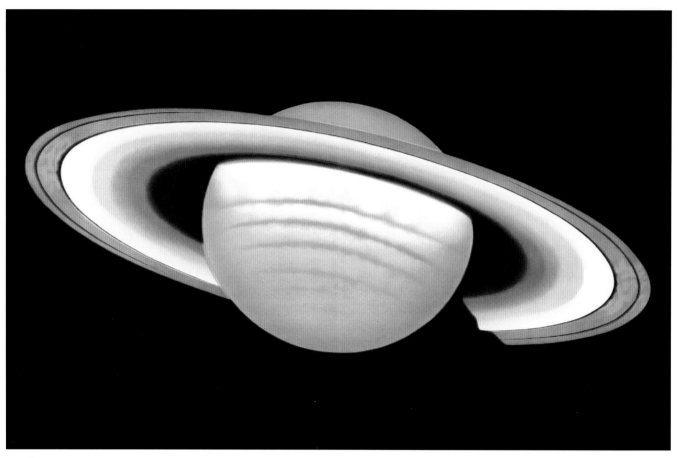

260 Étienne Léopold Trouvelot, *The Planet Saturn*, observed 30 November 1874, plate x from *The Trouvelot Astronomical Drawings Manual* (New York, 1881), chromolithograph, 71 × 94 cm.

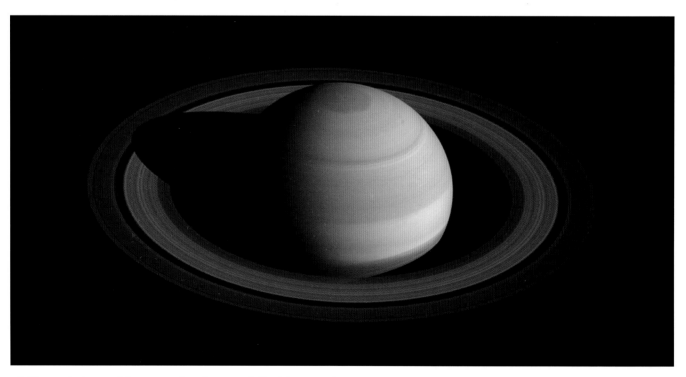

261 Composite image of Saturn, 2016–17, from NASA's *Cassini* spacecraft.

262 Elsa Schiaparelli, dinner jacket from the 'Cosmique' collection (embroidery by Maison Lesage, Paris), 1937, silk, velvet, metallic foil thread, glass beads and rhinestones.

his discovery of a gap between an inner and an outer ring of Saturn. Before *Cassini* was purposely crashed into Saturn's clouds in 2017 – burning up like a meteor into a wisp of stray atoms and ensuring that there would be no possibility that it could contaminate any of Saturn's dozens of moons with remnants of terrestrial life – it sent back pictures of the planet and its rings so detailed that each of the resulting composites could be enlarged to fill a wall without showing its pixelated resolution. *Cassini* went high enough off the ecliptic plane that it could even see Saturn's north pole fairly well and, surprisingly, a hexagon of jet streams that surround it (illus. 261).

The rings of Saturn make it an eminently recognizable celestial body, and for this reason it has attracted great interest across the artistic community. The Italian designer Elsa Schiaparelli, niece of the astronomer Giovanni Schiaparelli, incorporated planetary motifs, including Saturn, on the elegant astronomical dinner jacket (illus. 262) from her Art Deco inspired 'Cosmique' collection. More recently, the American artist Vija Celmins, whose work often draws on astronomical phenomena, has developed a new take on the planet, creating a lithograph of 42 repeated postage-stamp-like images of the planet (illus. 263). Her *Saturn Stamps* is a witty serial take on the practice of issuing commemorative stamps, in this case two years before the *Cassini* mission to Saturn was launched (though, of course, the project had long been in development).

Mars is also a bright planet, though never as bright in the sky as Jupiter and Venus. Named after the Roman god of war, Mars is known for its reddish tinge; the star Antares, also reddish, sits 'opposite Mars', taking its name from Mars' Greek counterpart, Ares. Nineteenth-century views of the planet, such as by Trouvelot (illus. 264), show much more contrast than can actually be discerned through Earth's murky atmosphere. Optical quirks led nineteenth-century Italian astronomer Schiaparelli to identify a network of straight lines on the Martian surface which he called 'canali'. The term was mistranslated as 'canals' (rather than simply 'channels'), and indeed the American astronomer Percival Lowell, who had set up his own observatory in Arizona, became so convinced that there was a system of canals on Mars that he reasoned that Martians must have built them. Howard Russell Butler's paintings of Mars as seen from a fanciful position on its smaller moon, Deimos, propagated this misinformation concerning straight, narrow lines criss-crossing Mars's surface (illus. 265). The widespread belief that Martians could exist established the conditions for the American panic that erupted during Orson Welles's radio dramatization of *The War of the Worlds* in 1938. The story describes a Martian invasion of Earth (New Jersey, in particular); the broadcast, widely taken as real, caused pandemonium.

263 Vija Celmins, *Saturn Stamps*, 1995, offset lithograph, 31 × 23.8 cm.

264 Étienne Léopold Trouvelot, *The Planet Mars*, observed 3 September 1877, plate VII from *The Trouvelot Astronomical Drawings Manual* (New York, 1881), chromolithograph, 71 × 94 cm.

Since the 1970s NASA has sent a series of orbiters and landers to Mars. Its *Curiosity* rover mission, part of Mars Solar Laboratory, is gradually making its way across a varied Martian surface, including the Vera Rubin Ridge (named after the astronomer whose observations provided convincing evidence of matter heading towards Mount Sharp). NASA has compiled an accurate map of the planet's surface (illus. 266) that shows a region with a giant valley and three huge volcanoes.

The planets outside Earth's orbit around the Sun can appear anywhere in the sky at night, but the inner planets, Mercury and Venus, orbit so close to the Sun that they are never visible for more than several hours before sunrise in the eastern sky or several hours after sunset in the western sky. At times they pass right between the Earth and the Sun in what is referred to as a 'transit'.

When Johannes Kepler compiled his *Rudolphine Tables* in 1627 he used them to correctly predict a transit of Mercury in 1631, but he somehow missed the transit of Venus in 1639. In England the young graduate Jeremiah Horrocks improved Kepler's table for Venus enough

265 Howard Russell Butler, *Mars as Seen from Deimos*, c. 1920, oil on canvas, 125.5 × 100 cm.

266 A global mosaic of Mars's surface (MDI M2.1), based on *Viking* spacecraft observations, colourized.

to realize that there might be a transit in 1639. Though the exact timing was uncertain by a day or two, he was vindicated; Horrocks and a friend were the only two people in the world to view the transit. Kepler's laws allowed the proportionality between the distances of the planets to be calculated from their periods of revolution around the Sun, but no absolute distances were known. In 1716 Edmond Halley – who would later become the second Astronomer Royal of England – identified a method of determining Venus' distance from the Sun during transit by using pairs of very distant points on the Earth. Accordingly, the nations of the world sent out expeditions all over to observe the 1761 and 1769 transits of Venus.

The 1761 transit was famously observed from St Petersburg, Russia, by Mikhail Lomonosov, though he mistakenly interpreted an optical effect he observed as Venus's black silhouette neared the bright edge of the Sun to indicate that the blackness outside the silhouette was actually Venus's atmosphere. He already 'knew' that Venus had an atmosphere, for how else were the people who lived on Venus (whose existence was common knowledge in that time) to breathe? This 'black-drop effect' was a mystery for a long time, until one of us participated in spacecraft analysis of the 1999 transit that showed how it was a mere result of the contrast.

Famously, Captain James Cook took his ship *Endeavour* and his astronomer companion James Green to Tahiti for the 1769 transit of Venus. They had clear weather and also observed a black-drop effect, which both drew (illus. 267). Transits of Venus come in pairs whose components are separated by eight years, with intervals of 105.5 or 117.5 years before the next pair begins. Thus the transits of 1761 and 1769 were followed by transits in 1874 and 1882, and in our own time by transits in 2004 (illus. 268) and 2012.

Mercury is much closer to the Sun than is Venus and therefore orbits it faster, making over a dozen transits per century. Italian Futurist artist Giacomo Balla, who was intensely interested in motion and movement, painted

267 James Cook, transit of Venus, 1769, detail of plate XIV from 'Observations . . . Made at King George's Island [Tahiti] in the South Sea', *Philosophical Transactions of the Royal Society of London*, LXI/397 (1771), engraving.

over a dozen works about the 1914 transit of Mercury (illus. 269) – appropriately enough, Mercury is the classical deity of artists. His suggestive paintings capture the cosmic energies that lie within the universe. A composite from NASA's Solar Dynamics Observatory (illus. 270) shows how tiny Mercury appears against the solar disc, even compared with Venus (which is larger and twice as close to Earth). New imaging techniques known as 'adaptive optics' and the fairly recent Goode Solar Telescope at the New Jersey Institute of Technology's Big Bear Solar Observatory in California have allowed for the capture

of incredible detail as Venus transited the solar granulation (a boiling element of solar gas the size of Texas) in 2016 (illus. 271).

Ever more ambitious planetary studies are in the works. Among them are the European Space Agency's 2018 BepiColumbo mission to Mercury (with a travel time of over six years); the Japanese Venus Climate Orbiter, now orbiting that planet having previously been thought lost in space; a variety of spacecraft orbiting Earth and Mars; and rovers on Mars. In addition, there are also the two NASA projects discussed above: the

268 Jay M. Pasachoff and the Williams College team, observations of the 2004 transit of Venus from Greece.

269 Giacomo Balla, *Mercury Passing before the Sun*, 1914, tempera on paper lined with canvas, 120 × 100 cm.

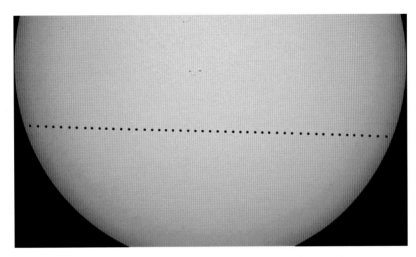

270 Transit of Mercury, 2016, composite, with NASA's Solar Dynamics Observatory.

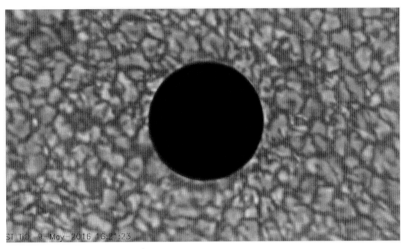

271 Jay M. Pasachoff, Glenn Schneider, Dale Gary and Bin Chen, Transit of Mercury, 2016, close-up with adaptive optics.

Juno mission currently orbiting Jupiter and the JUICE spacecraft, set to be launched in the near future. But beyond these, and with NASA's *Cassini* spacecraft having completed its mission in 2017, there are no solar system close-ups planned. Uranus and Neptune can be monitored to some extent with the Hubble Space Telescope, but not with the precision resolution of an orbiter or a flyby. Perhaps in the 2020s we will benefit from another mission to those outer planets. NASA's *Psyche* orbiter mission to an asteroid between Mars and Jupiter, and its *Lucy* probe mission to half a dozen asteroids of various types leading and trailing Jupiter in its orbit, are planned for launch in the early 2020s. But *Lucy* will not be sending back its images and other data until 2027–33, and *Psyche* is not scheduled to reach its asteroid until 2030. At least we can foresee specific spacecraft and space observatories, but the sky is the limit for artists inspired by the cosmos and we cannot wait to see their creations.

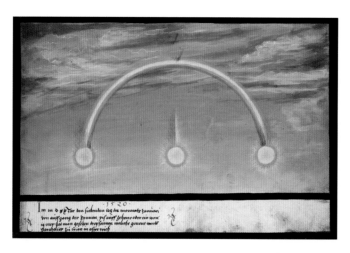

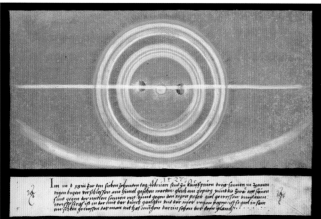

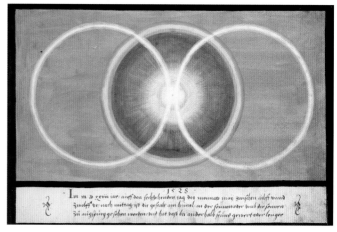

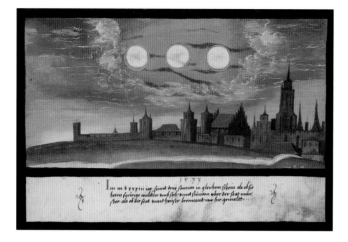

272, 273, 274, 275 Unidentified artist, parhelia in 1520, 1527, 1528?, 1533, folios 106, 112, 113, 131, from the *Augsburg Book of Miracles* (*Augsburger Wunderzeichenbuch*), c. 1550–52, watercolour, gouache and black ink on paper. The Cartin Collection.

9 The Aurora Borealis:
Magnetic Celestial Fireworks

Among the earliest recordings of celestial phenomena are those associated with the Earth's atmosphere, such as the glow of the zodiacal light and parhelia, or 'sun dogs'. In his influential sixteenth-century chronicle *Prodigiorum ac ostentorum chronicon* (1557), Conrad Lycosthenes collected ancient Roman reports on these phenomena and other portentous events, illustrating his book with repeating stylized woodcuts. In the fourth century BC Aristotle had described parhelia on either side of the Sun in his treatise *Meteorology*, and thereafter they were thought of and represented as 'mock suns'. As had been the case with comets and meteors before the end of the seventeenth century, these phenomena were considered divine omens of impending events. With the growing religious tensions around the Protestant Reformation and the proliferation of printing presses in the mid-sixteenth century, broadsides or single-leaf broadsheets publicized strange earthly and celestial occurrences, from 'monstrous births' to swords and fires in the sky. These tabloids were widely circulated, especially by Protestants in centres of Reform, at a time when Roman Catholics still focused on the miracles of the saints. Although rife with superstitious rhetoric, these reports of natural phenomena represent a fledgling attempt at scientific observation and reportage. Many of the portentous events they advertised are also recorded in contemporary manuscripts and in arresting watercolours from a commonplace book known as the *Augsburg Book of Miracles*, which was painted by an unknown amateur German who depended on published chronicles and broadsides. Among the celestial marvels he portrayed are parhelia, including over a dozen watercolours with intriguing variations, four of which are reproduced here (illus. 272–5).

These very bright sun dogs are optical atmospheric phenomena consisting of brilliant spots on either side of the Sun (they also occur with the Moon). Although they can appear anywhere in the world during any season, they are more common in colder northern and southern regions. Parhelia are brightest when the Sun is close to the horizon and they are sometimes accompanied by a luminous ring known as a 22-degree halo, as seen in the first of the quartet from the *Book of Miracles* (illus. 272). Sun dogs belong to a large family of halos that are caused by light interacting with dense hexagonal ice crystals in the atmosphere, creating the illusion that the Sun has been divided into three. The 1527 apparition of these cold-weather equivalents of rainbows, shown in the second image from the *Book of Miracles*, features

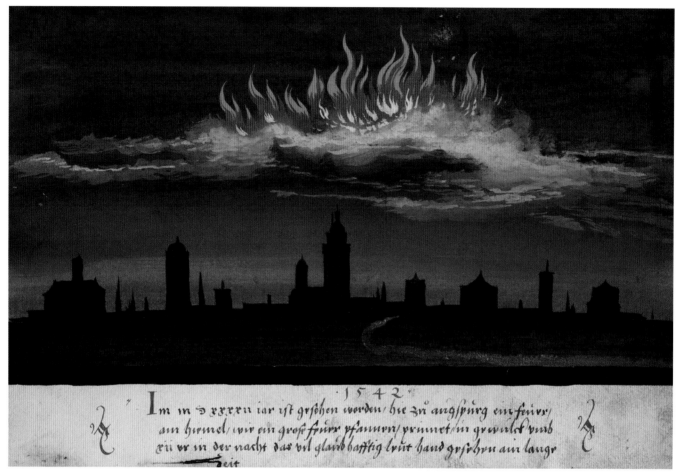

276 Unidentified artist, aurora borealis in 1542, folio 144 from the *Augsburg Book of Miracles (Augsburger Wunderzeichenbuch)*, c. 1550–52, watercolour, gouache and black ink on paper. The Cartin Collection.

two parhelia, parhelic circles, a white line on the same altitude as the Sun, and other halos. The third water-colour of the quartet depicts parhelia from 1528 that have very different optical configurations. The text accompanying the unusual parhelia in the fourth watercolour reports that,

> In 1533, three suns shone simultaneously and equally strong, as if they had fiery clouds around themselves, and they stood over the city of Münster, as if the city and the houses were burning, as painted here.

As noted, the phenomenon can also be lunar. This is illustrated in the Augsburg manuscript as well as

reported multiple times in Lycosthenes' chronicle, including an account by the ancient historian Dio Cassius, who recorded in his *Roman History* that three moons were visible in many parts of Italy in 223 BC. The lunar trio, which was sometimes portrayed as stylized crescents though more commonly as full moons, was sometimes joined by other celestial apparitions that could be both actual and imagined. This new impetus in the sixteenth century to observe and record natural phenomena, as evidenced by Lycosthenes and the *Book of Miracles*, presaged the age of science.

Among the most spectacular light shows that blaze across the vault of heaven is the aurora borealis, whose southern counterpart, the aurora australis, work in

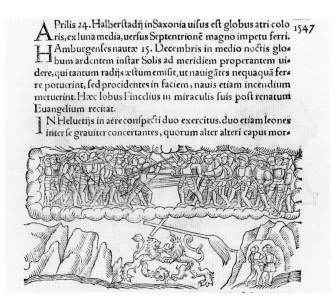

Aprilis 24. Halberstadij in Saxonia uisus est globus atri colo 1547
ris, ex luna media, uersus Septentrionē magno impetu ferri.
Hamburgenses nautæ 15. Decembris in medio noctis glo-
bum ardentem instar Solis ad meridiem properantem ui-
dere, qui tantum radijs æstum emisit, ut nauigātes nequaquā fer-
re potuerint, sed procidentes in faciem, nauis etiam incendium
metuerint. Hæc Iobus Fincelius in miraculis suis post renatum
Euangelium recitat.
IN Heluetijs in aëre conspecti duo exercitus, duo etiam leones
inter se grauiter concertantes, quorum alter alteri caput mor-

277 Conrad Lycosthenes, battle in the sky over Hamburg on 15 December 1547, detail of page 595 from *Prodigiorum ac ostentorum chronicon* (Basel, 1557), woodcut.

tandem with each other. Aristotle considered them atmospheric phenomena and called them 'exhalations' or 'airy meteors'. The French astronomer Pierre Gassendi is often credited with coining the term 'aurora borealis' or 'northern dawn' in 1621, in reference to the Roman goddess of dawn, Aurora, and the Roman god of the north wind, Boreas. However, Gassendi did not publish his 1621 observations until 1649, and some historians believe that Galileo was the first to use the term, in 1619. Auroras are caused by the collision of charged plasma particles in the solar wind with Earth's magnetic field at the North and South Poles. As one might expect, because it appears in the northern hemisphere and thus closer to more inhabited regions, there are many more representations of the aurora borealis than the aurora australis.

Like comets, meteors and other portents, auroras have been reported since antiquity by both Western and Eastern cultures. The unknown illustrator of the *Book of Miracles* painted one of the most dramatic early representations of the phenomenon in colour (illus. 276), adding the caption, 'In 1542, a fire, which burns like a big fire pan in the clouds at the twelfth hour in the night

. . . in Augsburg'. The artist also depicted other possible auroras that are more bizarre, such as one featuring a sword-wielding red giant reported in 1531. Lycosthenes also reports auroras in his chronicle, illustrating them with black-and-white thumbnail woodcuts, sometimes as generic celestial turbulences and at other times more imaginatively. Among the latter is a report taken from Pliny the Elder, who in his *Natural History* (AD 77–9) characterized them as battles in the sky (illus. 277). According to eyewitness accounts, loud noises and the flares of explosive devices accompanied these apparitions. In another print of the time the aurora borealis assumes the quaint, literal form of a row of candles burning in the sky above Bohemia (illus. 278), while in a manuscript mostly about comets the light effects of the aurora borealis include armies in the sky and spiralling beams of light resembling fireworks (illus. 279).

What is more beautiful on a cold winter's night than catching a glimpse of the scintillating curtains of the aurora borealis dancing across the sky? For thousands of years people in the northern hemisphere have marvelled at their stunning displays illuminating the nocturnal firmament. The remarkable phenomenon is deeply embedded in the mythology of many cultures, which have associated them with dancing or fighting spirits, the Valkyries or God's anger. Although cave paintings from 30,000 BC may record the northern lights, the earliest known Western record of the phenomenon is on a Babylonian tablet from 567 BC in the Staatliche Museum, Berlin (a Chinese description said to have been made by Fu-Pao, mother of the Yellow Emperor Shuan-Yuan, in 2600 BC may describe them as well). These ephemeral mesmerizing spectacles also feature prominently in the Icelandic sagas, Norse mythology and the folklore of the far North, where they are visible annually from September to April. In Inuit legends and those of some Native American peoples, auroral displays have been interpreted mystically as embodying spirits of the dead or animals killed in the hunt; their whistling, crackling noises are thought to be the voices of these spirits. The geomagnetic disruptions of the aurora displays do in fact

278 Unidentified artist, detail of the aurora borealis (as candles in the sky) over Bohemia, 1570, woodcut.

279 Unidentified Belgian artist, rays of fire and horsemen in the sky, from *Des comettes et de leúrs signifiances generales et particulieres selon Ptolomée . . . et aústres astrologues*, c. 1587, gouache on paper, 13.6 × 11.5 cm (image). MS FMH 1290, folio 55, The Warburg Institute, London.

impact living species and in some cases, as with whales for example, are thought to alter the animals' behaviour.

The cause of the aurora borealis was a matter not only of myth but also of scientific speculation, especially in post-Enlightenment England. This was a time when the natures of comets and meteors were also being hotly debated, and discussions and numerous reports of auroras appeared in the *Philosophical Transactions of the Royal Society* and in the popular *Gentleman's Magazine*. Into the eighteenth century many people believed that the aurora borealis formed from vapours emanating from the Earth, but Edmond Halley theorized that subterranean magnets created its displays, which is not so far removed from the truth. Then in 1733 the French scientist Jean-Jacques d'Ortous de Mairan published a treatise suggesting that auroras were linked to material from the solar atmosphere. Using triangulation the British natural historian and physicist Henry Cavendish made the first scientific study of auroras in 1790; he determined that their displays occur approximately 100 kilometres (60 mi.) above Earth's surface. The subject remained topical into the 1830s because the English scientist Michael Faraday – who was engaged in experiments with electromagnetism – remarked,

> I hardly dare venture, even in the most hypothetical form, to ask whether the Aurora Borealis and Australis may not be the discharge of electricity, thus urged towards the poles of the earth, from whence it is endeavouring to return by natural and appointed means above the earth to the equatorial regions.

Its dynamic, haunting visual spectacle made the aurora borealis an ideal candidate for poetic imagery, especially during the Romantic age, when William Wordsworth, Ralph Waldo Emerson and Alfred Lord Tennyson – who called them 'wizard lightnings' ('In Memoriam', 1849) – conjured in words their powerful visions. In 1840 Lowell Mason, a professor at the Boston Academy of Music, composed the song 'Aurora Borealis', publishing it in *Parley's Magazine*. American poet Emily

Dickinson's father Edward knew the magazine, and the song may have influenced her reference to these light shows in the poem 'Of Bronze – and Blaze – ' (1862). Both John Greenleaf Whittier's 'The Aerial Omens' (1857) and Herman Melville's commemorative verse 'Aurora Borealis' (1865), a paean to the dissolution of the armies after the end of the American Civil War, evocatively refer to the tradition of casting the aurora borealis as a portent in which celestial armies cross the sky, the wavering curtains conjuring troops advancing. Melville witnessed a display on 23 December 1864 that was visible as far south as Fredericksburg, Virginia, believing it to be a portent of the Northern triumph; as he asks in his poem, 'What power disbands the Northern Lights?'

While the northern lights appear as vivid literary images in poetry and prose, they have inspired fewer visual artists. Among the exceptions are the English artist George Romney (illus. 280) and the Danish painter Jens Juel (illus. 281), who both captured the nocturnal lightshow of the aurora borealis in the 1790s, when the phenomenon's nature was still the subject of heated discussion. Juel observed the phenomenon while out walking and tried to set it down faithfully on canvas, thus explaining his work's original title, *Attempt to Paint the Aurora Borealis*. He set the aurora borealis above a naturalistic, quotidian landscape whose sentiment harmonizes with German writer and statesman Johann Wolfgang von Goethe's drawing of the phenomenon over his garden house in Weimar, Germany, rendered in black and white chalks on dark blue paper (*c.* 1804, Goethe National Museum, Weimar). By contrast, Romney transposed his experience of the aurora into a perfect, magical backdrop for his hallucinatory imagining of a scene from William Shakespeare's play *A Midsummer Night's Dream*.

Among the most unusual appearances of the aurora borealis is the one of 17 October 1848 which reached all the way to Naples, Italy, where Salvatore Fergola, a painter of the local so-called 'School of Posillipo', captured it (illus. 282). In order for the aurora borealis to appear as far south as Naples the Sun had to be very active, a conclusion that is supported by the records of

280 George Romney, *Titania and Her Attendants, Shakespeare's 'A Midsummer Night's Dream', Act II, Scene 2*, c. 1790, oil on canvas, 119.4 × 149.9 cm.

281 Jens Juel, *Landscape with the Northern Lights*, 1790s, oil on canvas, 31.2 × 39.5 cm.

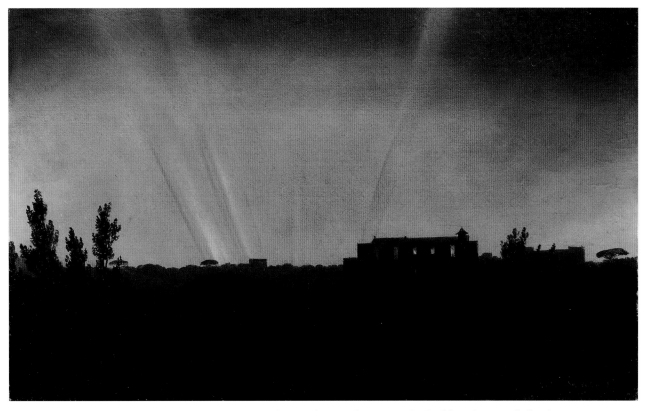

282 Salvatore Fergola, *Aurora Observed from Naples on 17 October, from the Osservatorio Reale of Capodimonte*, 1848, oil on canvas, 44 × 72.3 cm.

sunspot activity. The existence of at least three versions of the subject by Fergola indicates the popularity of this astounding apparition, whose blood-red colour was reported to have been glimpsed reflected in Lago Maggiore in north Italy, as well as being seen in Rome and further north, in London.

By 1899 scientists were still attempting to solve the puzzle of the northern lights by staging expeditions to study its nature and effects. Since photography was in its infancy and the latest spectrographs and other instruments were not capable of capturing the aurora, the Danish Meteorological Institute invited Danish painter Harald Moltke to join their winter expedition as its official draughtsman in Iceland (and again the following year in Finland). During the expedition Moltke, who spoke of the auroras as 'supernatural' and 'dancing revelations', executed many sketches in pencil that were

used as studies for his paintings (illus. 283). Later he also issued a series of eleven lithographs based on a selection of his paintings. Moltke's works rank among the most significant artistic renderings of the aurora borealis, showcasing the phenomenon's volatile, evanescent effects in a way rivalled only by video.

Little more than a century ago, no one suspected the intricate connections between auroras and the Sun. In 1896 Norwegian scientist Kristian Birkeland created artificial northern lights by simulating the Earth's magnetosphere with a 'terrella' – an apparatus first created some three hundred years earlier by the English physician William Gilbert. Subsequently Birkeland organized the Norwegian Polar Expedition to study global electric currents, and in 1902–3, inspired by the discovery of X-rays, he was able to apply his theories of atmospheric electrical currents to the problem, concluding that the

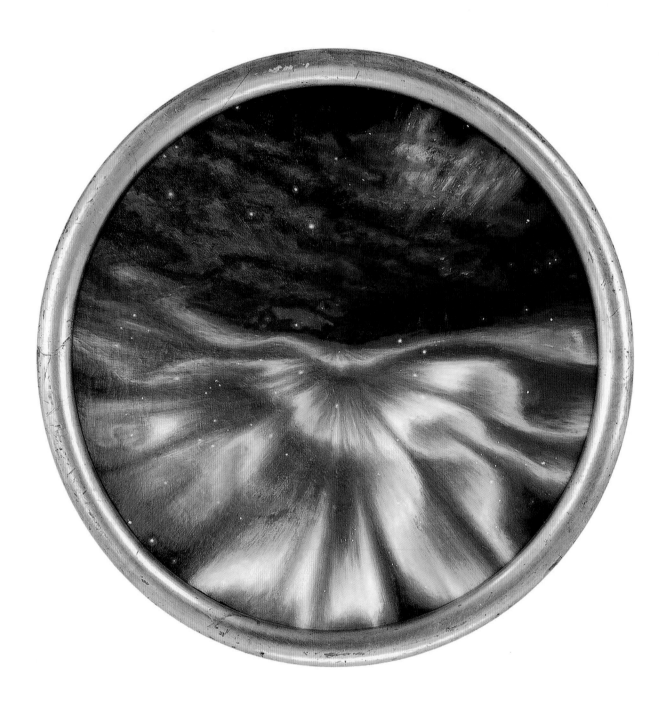

283 Harald Moltke, *Aurora, 23 September 1899*, 1899, oil on canvas, 58 cm diameter.

Sun bombards Earth with particles and that auroral light was caused by currents flowing through the gas of the upper atmosphere in a manner analogous to the way we now know neon lights function.

Following decades of research it is now known that auroras appear when charged particles from the Sun interact with the Earth's magnetic field, directing the particles into the atmosphere, where they collide with gases and emit the fluctuating light known as the auroras. By monitoring the activity of the Sun it is therefore possible to forecast the strength and location of auroras. Like eclipses, these awe-inspiring spectacles – which are atmospheric phenomena but combine celestial charged particles with earthly magnetism (Earth is the only inner planet with a strong magnetic field) – have become tourist attractions. The auroral sheets of plasma visible from within the Arctic and Antarctic regions occur when ionized nitrogen and oxygen molecules in the upper atmosphere regain electrons and emit photons. During particularly intense solar activity auroral displays are stirred into raging storms. Among the most sensational in history were the great geomagnetic storms of 1859. During late August and early September these were so bright that Bostonians could read their newspapers outdoors in the middle of the night. At the height of the sunspot cycle the aurora borealis can sometimes be seen further south of the north magnetic pole than usual, as occurred in 1848. Nevertheless, even when there is no solar storm, magnetic waves from the Sun continue to drive the aurora borealis and aurora australis.

Members of the British Imperial Antarctic Expedition (also called the Nimrod Expedition, 1908–9) led by Ernest Shackleton produced a book of the expedition called *Aurora Australis*. It was printed on site at their ersatz publishing house 'Sign of the Penguins' by Ernest Joyce and Frank Wild, with George Marston providing the illustrations (illus. 284). The rare volume was one of the cultural activities Shackleton encouraged while they wintered at Cape Royds on Ross Island in McMurdo Sound to ensure that 'the spectre of "polar ennui" never made its appearance'.

284 George Marston, frontispiece from *Aurora Australis*, ed. Ernest Shackleton (Winter Quarters of the British Antarctic Expedition, 1908), coloured engraving.

Absolute proof of Birkeland's theories about the auroras only arrived after a probe was sent into space. The crucial results were obtained from U.S. Navy satellite 1963–38C, launched in 1963, which carried a magnetometer above the ionosphere. But for the general public auroras still retain some of their mystery and much of their majesty, not to mention the dangerous possibility of their causing satellites and power grids to fail.

Like most artists interested in celestial phenomena, the second-generation Hudson River School painter Frederic Church – whose portrayals of comets, stars and bolides were discussed in Chapter Six – was moved to capture the hypnotic and eerie volatility of the northern lights in his canvas *Aurora Borealis* (illus. 285). In painting this tour-de-force, commissioned by the important

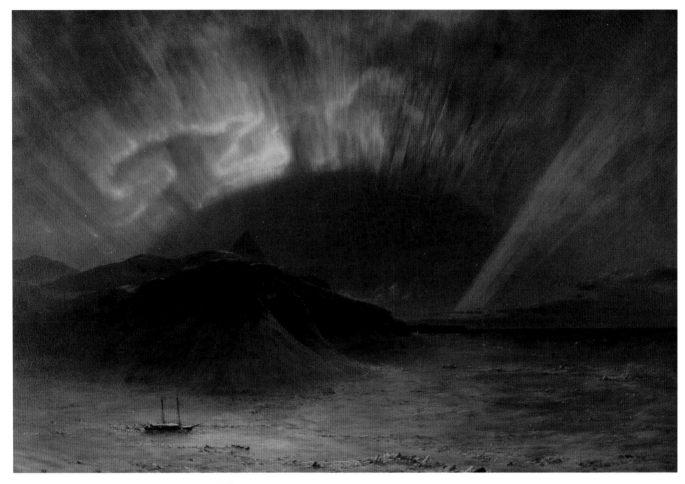

285 Frederic Edwin Church, *Aurora Borealis*, 1865, oil on canvas, 142.3 × 212.2 cm.

art collector William T. Blodgett, Church consulted sketches and a written description by his friend the Arctic explorer Isaac Israel Hayes, whom Church had tutored in drawing before Hayes embarked on his 1860–61 polar expedition. Although careful records of auroral displays were not kept until after 1877, Church witnessed their unusual light shows in the mid-nineteenth century. Among these were the exceptional ones mentioned above that resulted from a solar superstorm belonging to a rare type occurring only every five hundred years. They were observed from Canada to Cuba from August to September 1859 and coincided with the largest solar flare that had ever been recorded, which took place over the first two days of September.

Another eruption of the northern lights occurred over New York City in December 1864, the year Church began his canvas, and garnered much press attention. It also inspired the aforementioned Melville poem with its apocalyptic imagery allying the aurora borealis – for centuries occasionally envisioned as a celestial portent of war with militaristic imagery in the sky – with the American Civil War. The poem also connects the apparition with the traditional idea that the aurora borealis is a rainbow unhinged from its cosmic moorings. Church executed at least two oil sketches of the northern lights as he had seen them in Labrador, Maine and New York City. In Maine he painted a sketch, dated 1860, that features blue and pink streamers; another, undated sketch contains a

diaphanous green curtain pierced by a wide red beam. These small works, either painted *en plein air* or in the studio directly after his observations, prepared him to tackle the monumental commission from Blodgett.

Aurora Borealis is Church's last remarkable investigation of natural phenomena. It shows the chilling prospects of Hayes' schooner, ss *United States*, as it lay ice-bound off Greenland's Cape Alexander during the frigid winter, when Hayes attempted his unfulfilled goal to reach the Arctic Ocean and open the way to the North Pole. Its wavy, arcing blue, green, yellow and red kinetic curtains ripple majestically over the ice-bound,

diminutive ship, lit to signal human life, and the insect-like sled team, playing a symphony of the Sublime. Later, in his book *The Open Polar Sea* (1867), Hayes wrote a brilliant description of the aurora borealis that echoes Church's canvas. It is telling that Church had a copy of Whittier's poetry containing 'The Aerial Omens' in the library of his home, 'Olana', in Hudson, New York. To further understand the painting it is helpful to know that Hayes and Church, both members of the American Geological and Statistical Society, were inspired by the writings of the revered Prussian polymath Alexander von Humboldt, who forged a union of science, religion,

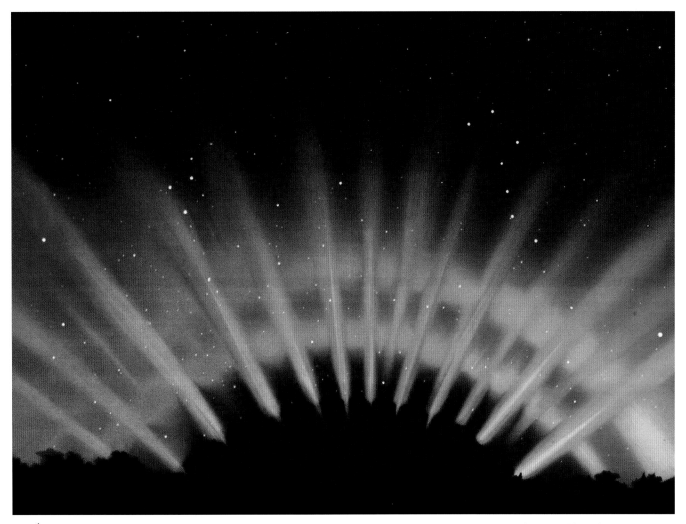

286 Étienne Léopold Trouvelot, *Aurora Borealis*, observed 1 March 1872, plate IV from *The Trouvelot Astronomical Drawings Manual* (New York, 1881), chromolithograph, 71 × 94 cm.

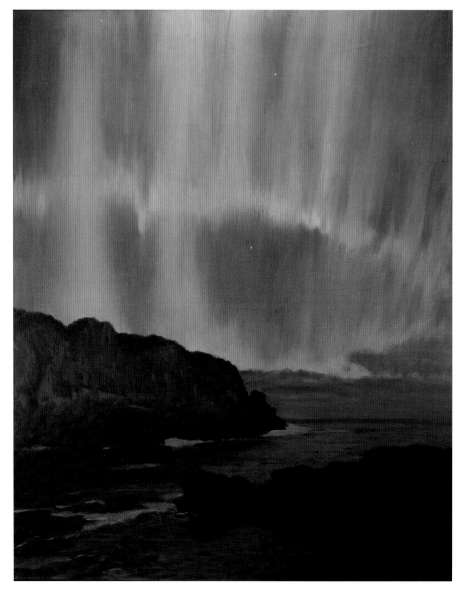

287 Howard Russell Butler, *Northern Lights, Ogunquit, Maine*, 1925, oil on canvas, 125.5 × 100 cm.

nature and art. Not surprisingly, contemporary critics praised Church for the scientific nature of his painting and his investigations of natural phenomena.

While many Scandinavian artists also recorded powerful cosmic skyscapes lit by the aurora borealis, the French artist and astronomer Étienne Léopold Trouvelot dramatically captured, first in a pastel drawing and then in a chromolithograph, both the soft, diaphanous nature of the display and the arc of darkness commonly seen on the horizon in 'rayed' auroras (illus. 286). Although he noted the precise time of his observation (1 March 1872 at 9.25 p.m.), the radiant symmetry of his works look stylized and frozen in time compared to the dynamic, fleeting, asymmetrical dancing of the phenomenon. As such it is probable that Trouvelot's depiction, which also includes the star field of the northern sky, are a distillation of his observations. The arc of darkness Trouvelot captured, which is also seen in Church's

painting, is caused by the orientation of the display towards magnetic north.

Like Church, the American physicist and artist Howard Russell Butler observed the northern lights and drew them from Maine before colour photography was in the astronomer's toolbox (illus. 287). Butler had also painted riveting solar eclipses (see illus. 88) with only two minutes to watch the Moon block the Sun (except for the blazing corona), perfecting a technique for sketching using colour notes that he also utilized in capturing the evanescent choreography of the aurora borealis. The Russian-born polymath Nicholas Roerich – a painter, writer, philosopher, theosophist and peace and art activist, among many other things – harnessed his observations of the aurora borealis in Russia and Finland for a number of visionary paintings. His works are characterized by simplified forms and bold colours indebted to Russian folk art and clearly evidence his direct experience of the phenomena. Roerich was fascinated by celestial phenomena and used comet and eclipse symbolism in many works (among them, illus. 89).

With the advent of more sophisticated photography the need to describe auroras declined, although the Italian artist Luigi Russolo froze their activated power into stylized patterns (illus. 288). The static rays he

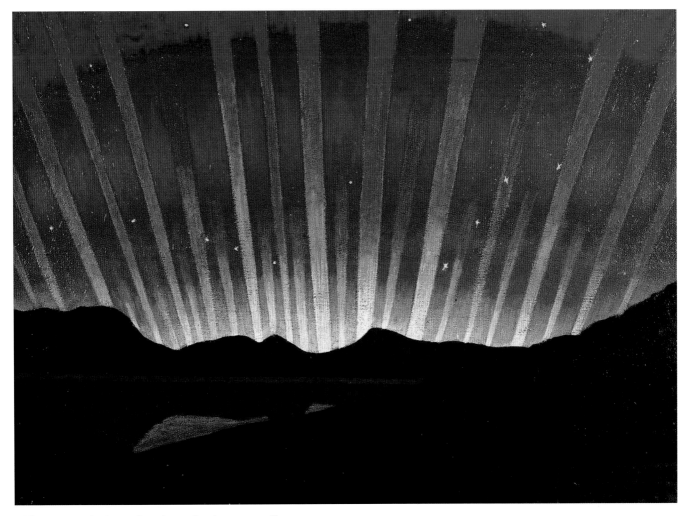

288 Luigi Russolo, *Aurora Borealis*, 1938, oil on canvas, 60 × 91 cm.

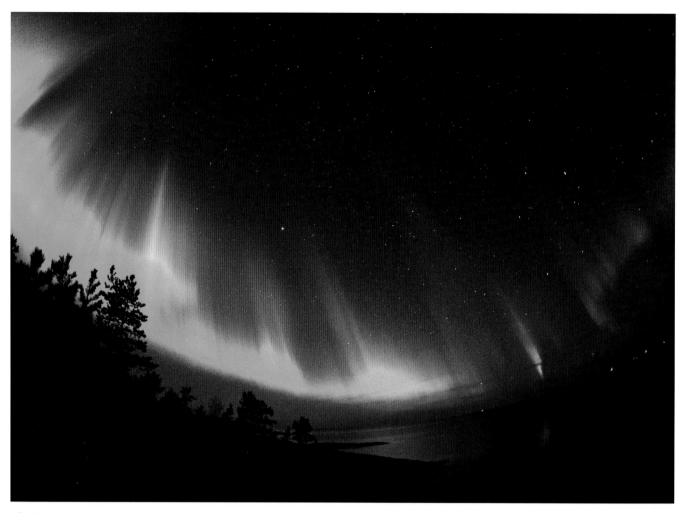

289 Pekka Parviainen, aurora borealis, 17 March 2015, southwest archipelago of Finland.

painted seem oddly decorative for a Futurist such as Russolo, who aimed to portray the movement of things through space and based his canvas on his observations. The work's reverse is inscribed: 'Aurora Borealis on 25.1.1938 seen and painted at Cerro di Laveno [near Lago Maggiore in the southern Alps] by Luigi Russolo'. With pioneering multiple-exposure and multiple-filter technique, photographers including Pekka Parviainen from Finland have now captured the aurora's subtlest colour gradations and veils of light (illus. 289). Because of their dynamism the only way to do justice to the auroras is to observe their hypnotic dancing via the medium of video or, better yet, to travel to see them *in situ*.

Like Earth, Jupiter and Saturn have strong magnetic fields and atmospheres, and thus they too have auroras. The Hubble Space Telescope recorded an image of an aurora in ultraviolet light around Jupiter's north magnetic pole composited here with a photograph in which the base image of Jupiter is in visible light (illus. 290). Jupiter's auroras are hundreds of times more powerful than those of Earth. This combination image was released in 2016 at the time NASA inserted its *Juno* spacecraft into orbit around Jupiter to study the planet's magnetic field and interior.

For centuries the northern polar landscape of Earth has stood as the embodiment of nature's stern

290 Hubble Space Telescope, aurora (in ultraviolet light) around Jupiter's north magnetic pole, 2016.

and heartless grandeur. Today it is viewed as a mortally wounded region. What we have lost along with the inviolable wilderness is the possibility of awe that is resonant in Church's brooding, melancholic elegy to the frozen majesty of the north (see illus. 285). The painting coincided with the Romantic concept of the Sublime and forced viewers to confront their own mortality. While earlier artists found in the stark beauty and omnipresent peril of the polar regions a heroic drama that seemed tailor-made for metaphysical enquiry, we are now faced with its threatened, imperilled status, one more chapter in the total tragedy of planet Earth.

291 John Adams Whipple, W. C. Bond and George P. Bond, view of the Moon 26 February 1852, daguerreotype.

10 New Horizons in the Cosmos: *Photographs of Space*

Modern astronomical progress has long been linked not only with bigger and better telescopes but also with the Earth-shattering power of photography. Even Louis Daguerre in his original 1839 proposal for what we now know as daguerreotypes linked his ideas with those of French astronomer François Arago, the director of the Paris Observatory and the secretary of the French Academy of Sciences. Daguerre, often called the father of photography, was trained as a painter and as a physicist. He had previously worked with French inventor Nicéphore Niépce, who had arguably captured an image on a photoengraved printing plate even earlier than Daguerre, around 1826–7.

Daguerre's process took twenty to thirty minutes and provided unique images, with no clear way of duplicating them (other than reimaging them). At about the time the English inventor William Henry Fox Talbot succeeded in making images on a paper. His negative image could be used to make not only single copies, as was the case for a daguerreotype, but also duplicate and even multiple prints. For the first years, 'wet plates' were used, with chemicals applied just before the images were taken. By 1880 'dry plates' that could be prepared in advance and stored had become standard.

Astronomers were keen to harness the new technology and it seemed clear that the world's largest telescopes would be best for using Daguerre's process to make astronomical images, an assumption that in fact proved to be wrong. In any case, the world's largest telescopes at the time were two 38-centimetre (15-in.) devices by Georg Merz and Joseph Mahler located at the Pulkovo Observatory in Russia and at the Harvard College Observatory in Cambridge, Massachusetts. In 1851 the Boston daguerreotypist John Adams Whipple, who had hitherto largely been engaged in producing portraits, was brought across the Charles River by Harvard College Observatory director William Cranch Bond to attempt astronomical photographs. Only when they realized that the focus of the image for the blue sensitivity of the daguerreotype was in a different location from the focus for what the eye saw ('visual light') did they succeed in making an image of the Moon (illus. 291). However, the long-focus refracting telescope at Harvard, typical of the time, was not suitable for imaging faint, diffuse objects.

In 1858 the English portrait photographer William Usherwood used a portrait camera, which had a shorter focal length and more favourable focal ratio (lens diameter to focal distance), to successfully photograph

292 David Gill, *Great September Comet of 1882*, 1882, enhanced photographic negative.

was visible (see illus. 177) David Gill, Her Majesty's Astronomer at the observatory at the Cape of Good Hope in South Africa, working with a local photographer, was able to capture an image showing the extensive tail (illus. 292).

The first photograph of a solar eclipse has been credited to one 'Berkowitz' (first name unknown but sometimes called Johann Julius Friedrich) of Königsberg, Prussia (now Kaliningrad, Russia), who captured the 1851 eclipse (only copies survive). By the total solar eclipse of 1882, however, photography of astronomical phenomena was firmly established. A comet even appeared in at least one of the eclipse images (illus. 293). Some 'eclipse comets' were really comets, while others turn out to have been 'coronal mass ejections', releases of solar material from the Sun, as studied extensively at the end of the twentieth century and the beginning of the twenty-first from the *Solar and Heliospheric Observatory*'s coronagraph built by the U.S. Naval Observatory as part of the NASA liaison with the European Space Agency.

For many decades film was sensitive only to blue light, the shortest visible wavelengths, since their photons have more energy than yellow or red wavelengths. The extension to panchromatic films in the 1930s and '40s, with sensitivities extending through the yellow and green bands of the spectrum into the red, brought full-colour capability to match the response of the human eye. The celebrated use of colour in the 1939 movie *The Wizard of Oz* was striking in large part because of its novelty. It used a patented Technicolor technique in which three monochromatic images are layered using colour filters of the appropriate wavelengths to recreate the original colour.

In the 1950s Bill Miller, specialist photographer at the Mount Wilson and Palomar observatories in California, used large-format colour slide film to take astronomical images for public distribution. His set of colour photographs became standard in the world, especially his wide-field view of the Great Nebula in Andromeda, M31 (illus. 294).

In the 1960s David Malin was hired by the Anglo-Australian Observatory to make astronomical

a comet – beating even the Harvardians to the accolade. The comet was the spectacular Donati's Comet (see illus. 173–5). Unfortunately, all originals and copies of Usherwood's work have been lost. Bond also tried to photograph this comet, on a collodion plate with the Great Refractor at Harvard, but only captured its nucleus and a little nebulosity. In his log book Bond also sketched the comet and stated that he had seen it in a 'Comet Seeker', a small telescope. As previously discussed, at this juncture astronomical drawing was still essential for recording observations.

With technological advances like wet plates and then dry plates, by the time the Great Comet of 1882

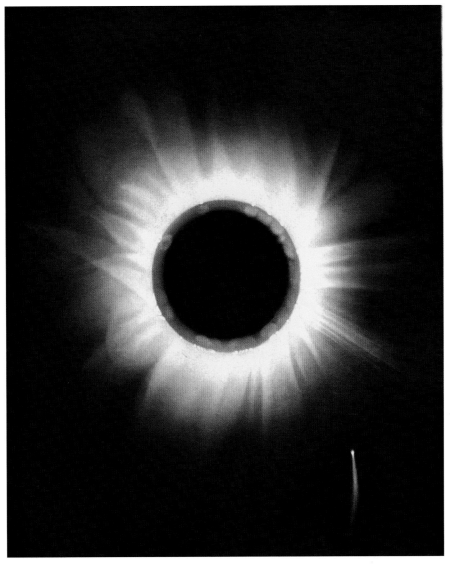

293 W. H. Wesley, corona of eclipse with Tewfik's Comet on 17 May 1882, colourized image from Arthur Schuster's photographs.

photographs using the Anglo-Australian Telescope at Siding Spring, Australia. In his Sydney lab he used a three-colour additive technique, printing through filters from individual monochrome (RGB) plates to recreate the natural colours of astronomical objects, including even a set of Palomar plates of the Crab Nebula (illus. 295). He also transformed a second set of three Palomar images taken through polarizers at different angles into a single image showing the polarization caused by magnetic fields in the nebula (illus. 247). Malin's process was remarkably simple. He used a standard enlarger and readily available materials to produce true-colour images, using an updated version of James Clerk Maxwell's famous 1861 additive-colour experiment.

Most people do not realize that since the Moon is essentially the same distance from the Sun as is the Earth, the settings on a camera to make photographs of the Moon are about the same as the typical settings

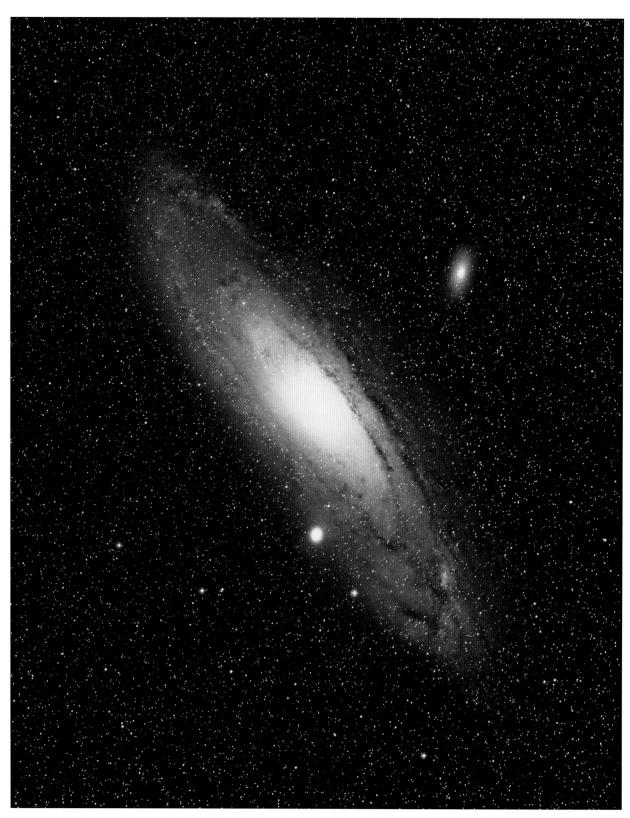

294 Andromeda Galaxy, 1950s, one of the first colour sky photos, supervised by Bill Miller, Mt Wilson Observatory.

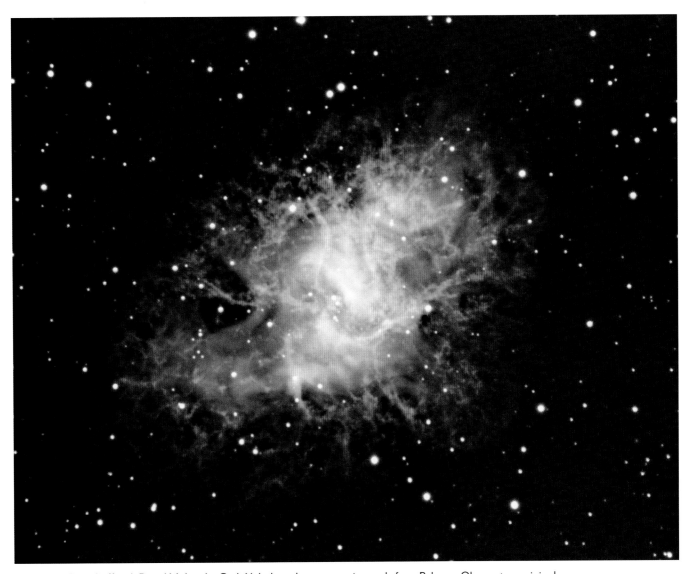

295 Jay M. Pasachoff with David Malin, the Crab Nebula, colour composite made from Palomar Observatory originals.

296, 297 Views of the *Apollo 17* Moon landing: Harrison Schmitt with lunar rover, EVA-3, and Harrison Schmitt next to Split Rock, 13 December 1972.

used for views of terrestrial scenery. For example, a normal daytime exposure on Earth using Kodachrome (1935–2002) film, with an ASA (American Standards Association) of 25, would use a shutter speed of 1/125th of a second at aperture f/8. (The ASA film-speed scale was combined in 1974 with the Deutsches Institut für Normung or DIN scale to make the current International Standards Organization, ISO, scale of film speed.) For today's digital cameras on iPhones or other smartphones the same is still true: if they can take a photo of scenery on Earth, they can automatically photograph the surface of the Moon. When the astronauts used Hasselblad film cameras on the Moon they used similar exposure times to those used for terrestrial photography (Hasselblads are medium format, offering a larger negative than the 35mm cameras more widely used). Here we see some photographs taken during the sixth and last *Apollo* moon landing, *Apollo 17*, in 1972 (illus. 296, 297).

Mars has been looked at and photographed at all resolutions. The Hubble Space Telescope's resolution

is about seven times finer than normal ground-based resolution (illus. 298, 299), allowing us to see details on Mars' surface that, among other things, leave us in no doubt that Schiaparelli's 'canali' were not canals as Percival Lowell had proposed.

When NASA launched its *Galileo* mission to Jupiter in 1989 the spacecraft's trajectory used gravitational assists from passing near inner planets several times to boost its speed. It flew by Venus and twice by the Earth to steal some of their energy, and even so still took six years to arrive at the Jupiter system. As it passed the Earth's system it produced a gorgeous portrait of the Earth and Moon (illus. 300). The spacecraft remained in orbit until 2003; it had carried an atmospheric-entry probe that was crashed into Jupiter's clouds a few months after the main spacecraft's 1995 arrival.

An even longer and more incredible journey was that of NASA's *New Horizons* spacecraft, a much smaller (and less expensive) spacecraft than the *Galileo* 'flagship' mission. Launched in 2006, *New Horizons* reached

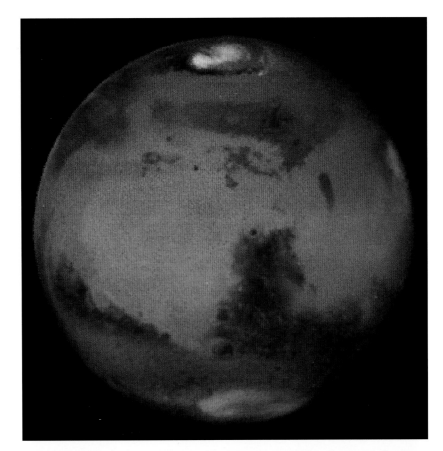

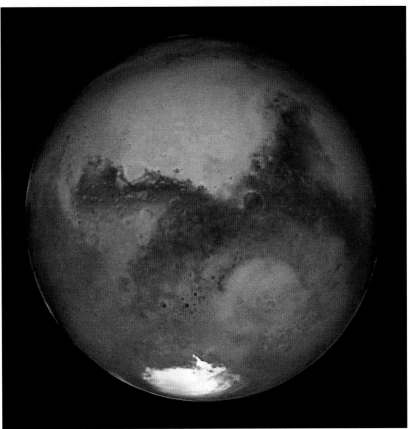

298, 299 Hubble Space Telescope, two views of Mars, 27 April–6 May 1999 and 26 August 2003.

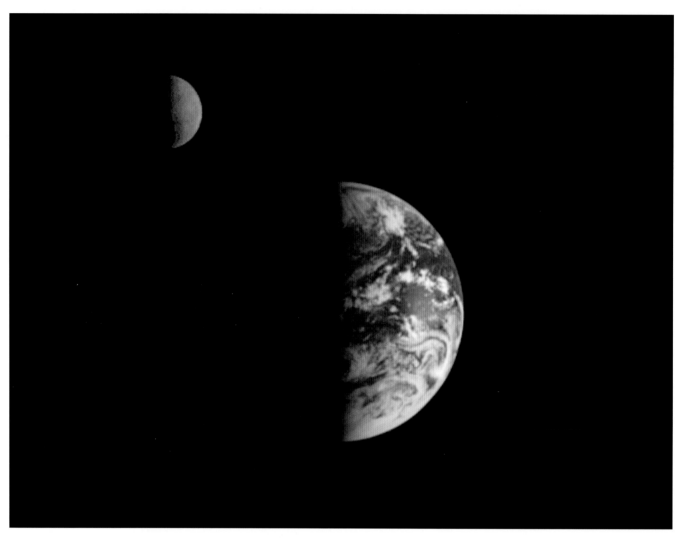

300 Earth-Moon system, 16 December 1992, from the *Galileo* spacecraft.

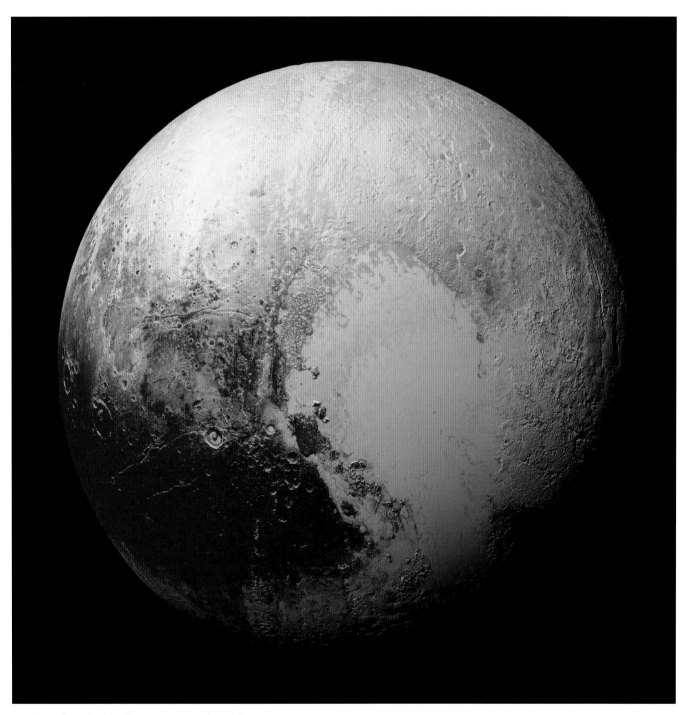

301 Pluto, from the *New Horizons* spacecraft, 14 July 2015.

302 Close-up of Comet Churyumov–Gerasimenko, August 2014, from the *Rosetta* spacecraft.

Pluto only after a journey of over nine years. While it was travelling the International Union came to realize that Pluto – the mass of which had fairly recently been calculated to be only 1/500th the mass of Earth rather than the 90 per cent posited when it was first discovered – belonged more in a class of objects in the outer solar system known as Trans Neptunian Objects (TNOS) or Kuiper Belt Objects (KBOS). With that realization Pluto became the best-known of the 'dwarf planets', which are insufficiently massive to be a planet but massive enough to have gravity make them roundish. The detail on the images of Pluto taken by *New Horizons* was astounding (illus. 301). A huge lightly coloured, heart-shaped plain was named Tombaugh Regio after Clyde Tombaugh, who discovered Pluto in 1930. The mountains that

surrounded this plain are so steep that they must have silica in them and cannot be made of only ice alone. A few craters – including one named Elliot after Jim Elliot of MIT, who had discovered Pluto's atmosphere during a terrestrial flight on a NASA instrumented airplane – were also imaged. Yet more astounding were the observations made of Charon, which the spacecraft revealed to be a fascinating world in its own right. Only days before the data was collected the consensus had been that Charon was so small that it would be boring, merely covered with craters. But it contains a giant set of canyons and a huge north-polar region darkened by tholins (organic molecules) that was named after the foreboding realm of Mordor from J.R.R. Tolkien's *The Lord of the Rings*. The spacecraft went on to image a small (30 km) object,

303 Mars rover *Curiosity* on Vera Rubin Ridge, 3 January 2018, with the rim of Gale Crater visible on the left and right and Mount Sharp in the distance.

2014 MU69, nicknamed Ultima Thule, with the closest passage on 1 January 2019. One of us had been part of an expedition to Argentina in 2017 to pin down the position of MU69 by trying to capture it occulting a star.

Spacecraft trajectories can be very complicated. The European Space Agency sent its *Rosetta* spacecraft to a comet; the name *Rosetta* implying that data collected by the mission might help to uncover the origin of the solar system just as the Rosetta Stone (discovered in Egypt and now in the British Museum, London) allowed ancient Egyptian hieroglyphics to be understood. The comet is designated 67P, as it is the 67th periodic comet to have its orbit computed, and is also named

Churyumov–Gerasimenko, after its Russian discoverers. The spacecraft was launched in 2004 and was purposely crashed into the comet's surface in 2017 after travelling with the comet through its perihelion to observe its increasing activity as jets of gas (sublimated ice) and dust erupted from it. The mission enjoyed a rousing success, with thousands of images at various resolutions taken at a wide variety of distances (illus. 302).

Since 1971 there have been seven rovers dispatched to the planet Mars. The most recent, *Curiosity*, was launched on 26 November 2011 and landed on 6 August 2012. The rover took a self-portrait on 31 January 2018 on the Vera Rubin Ridge, with Mount Sharp in

304 Hubble Space Telescope, interacting galaxies IRAS 21101 + 5810, April 2008.

the background (illus. 303); as of the time of writing, *Curiosity* is still functional. NASA's Mars *InSight* (*Interior Exploration using Seismic Investigations, Geodesy and Heat Transport*) landed in late 2018 to make seismometer and heat measurements of Mars' interior.

The photographs taken by the *Hubble Space Telescope* have been such a spectacular success that meeting the public's heightened expectations will be difficult in the future (illus. 304). The *Hubble Space Telescope* example shows a pair of interacting galaxies, which appear yellowish at upper left of centre. The interaction has caused the two galaxies to have irregular shapes. The galaxies are known from their celestial longitude and latitude along with IRAS to indicate their discovery with the *Infrared Astronomical Satellite*, a joint project of the U.S., UK and the Netherlands. NASA has been working for years on the *James Webb Space Telescope* (*JWST*), which boasts a mirror 6 metres (20 ft) across, much larger than Hubble's 2.4 metres (8 ft). But *JWST* will function only in the infrared range, so it will not produce true-colour images like the ones so popular from Hubble. Its mirrors – the 6-metre mirror is too large to launch in any current spacecraft, so it will be made up of unfolded smaller mirrors – are coated in gold because of the metal's high reflectivity of infrared. Still, false-colour images made from three or more individual infrared wavelengths should carry high-interest and high-quality imaging further into the twenty-first century. As of this writing, launch is scheduled to take place in 2021. Just what artistic decisions will be made to show the different infrared colours translated to the visual range remains to be determined.

Amateur and professional astronomers alike still use photography to image the heavens, but rarely is film still used. The sensitivity of contemporary electronic detectors is about a hundred times better than that of film, so various electronics are common to astronomical observatories. Furthermore, the sensitivities of the electronics have increasingly been extended into the infrared range. Whereas a few decades ago infrared images had to be built up point by point, today there are infrared-sensitive arrays and the available pixel counts continue to increase.

While a few amateur astronomers enjoy sketching what they see through telescope eyepieces, in the professional sphere the transition from direct viewing with the eye and making drawings that record those observations to today's electronic imaging is complete. An example is the *Gaia* all-sky map of 2018, which reveals the structure of our galaxy to an unprecedented degree. It shows the 1.7 billion stars observed by the European Space Agency's *Gaia* satellite since 2014. The Milky Way spreads horizontally, with the Large and Small Magellanic Clouds further south in the sky. *Gaia* also measured the colours and motion for 1.3 billion of these stars with its twin cameras, each of which captures at 1.5 gigapixels (that is, 1,500 megapixels – around a hundred times more pixels than an ordinary digital camera). No doubt future imaging techniques will allow us to probe even deeper the hidden mysteries of the cosmos.

305 Giorgio de Chirico, *Mephistopheles and the Cosmos,* design for the prologue curtain of Arrigo Boito's *Mefistofele* at La Scala, 1952, oil on linen paper, 40 × 30 cm.

Conclusion: *Infinity*

With our conclusion of this grand tour of astronomical phenomena, we anticipate new technological triumphs and artistic speculation in media that increasingly encompasses computers and photography, further linking science and art. Infinity awaits as terrestrial challenges demand attention and the magnetic draw of the cosmos encourages the art of exploration.

In the future, new worlds will continue to unfurl for science and art. The year 2019 marks the twentieth anniversary of the launch of NASA's Chandra X-ray Observatory into space. The Crab Nebula was one of the first objects it examined and has remained a frequent focus for the telescope ever since. It is one of several cases where there is strong historical evidence of when the star exploded, namely in 1054 (SN 1054), in the direction of the constellation Taurus, making it a touchstone for astronomers and stargazers. Today astronomers know that the Crab Nebula is powered by a highly magnetized, spinning neutron star called a 'pulsar' that was formed when the massive star ran out of fuel and collapsed. It generates an intense electromagnetic field that creates jets of matter and anti-matter moving away from its poles and an intense wind. The latest image of the Crab from Chandra (illus. 306) is a composite, consisting of X-rays from Chandra as well as images from NASA's Hubble Space Telescope and Spitzer Space Telescope, adding yet further knowledge to the accumulated scientific legacy spanning nearly two decades.

For centuries artists like M. C. Escher envisioned mathematically inspired worlds beyond the visible one to express the mysteries of the universe that tempt human minds towards discovery (see illus. 234). Escher's vision, like that of Pittura Metaphysica painter Giorgio de Chirico in his celestial skyscape curtain for the prologue of the opera *Mefistofele* by Orrigo Boito (illus. 305), as performed in 1952 at La Scala in Milan, harmonize with the speculative remarks of the British biologist J.B.S. Haldane: 'My own suspicion is that the universe is not only queerer than we suppose, but queerer than we can suppose.'

One thing is certain: artists and scientists will continue to push boundaries in their explorations of new dimensions in the cosmos. Their creative inspiration will surely lead to the discovery and contemplation of new worlds.

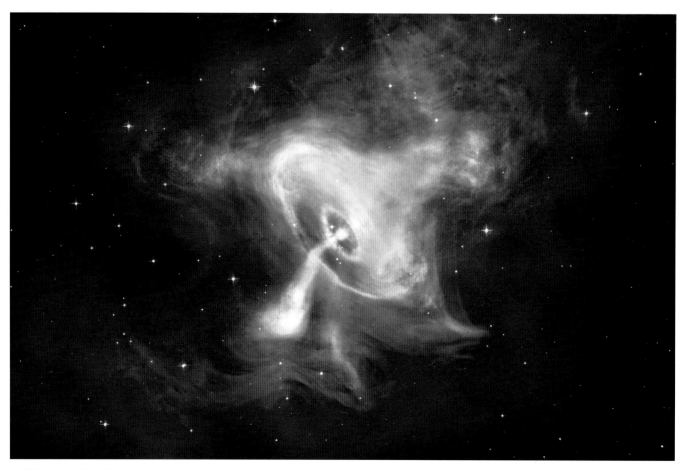

306 The core of the Crab Nebula, 2000–2013, images composited in 2018, from NASA's Chandra X-ray Observatory, Hubble Space Telescope and Spitzer Space Telescope. Composited image with X-ray (blue), optical (purple) and infrared (pink).

Select Bibliography and Further Reading

General

Benson, Michael, *Cosmigraphics: Picturing Space through Time* (New York, 2014)

Blume, Dieter, et al., *Sternbilder des Mittelalters Der gemalte Himmel zwischen Wissenschaft und Phantasie*, 2 vols (Berlin and Boston, MA, 2016)

Borchert, Till-Holger, and Joshua P. Waterman, *The Book of Miracles – Das Wunderzeichenbuch – Le Livre des miracles*, 2 vols (Cologne, 2013)

Brashear, Ronald, and Daniel Lewis, *Star Struck: One Thousand Years of the Art and Science of Astronomy* (San Marino, CA, 2001)

Castellotti, Marco Bona, Enrico Gamba and Fernando Mazzocca, *La ragione e il metodo: Immagini della scienza nell'arte italiana dal XVI al XIX secolo*, exh. cat., Centro culturale Sant'Agostino, Crema (Milan, 1999)

Clair, Jean, ed., *Cosmos: From Goya to De Chirico, from Friedrich to Keifer: Art in Pursuit of the Infinite*, exh. cat., Palazzo Grassi, Venice (Milan, 2000)

——, *Cosmos: From Romanticism to Avant-garde*, exh. cat., Montreal Museum of Fine Arts (Munich and New York, 1999)

Corbin, Brenda G., 'Étienne Léopold Trouvelot (1827–1895), the Artist and Astronomer', *Library and Information Services in Astronomy, V, Astronomical Society of the Pacific Conference Series*, CCLXXVII (2007), pp. 352–60

Cunningham, Clifford J., Brian G. Marsden and Wayne Orchiston, 'The Attribution of Classical Deities in the Iconography of Giuseppe Piazzi', *Journal of Astronomical History and Heritage*, XIV/2 (2011), pp. 129–35

Dekker, Elly, and Silke Ackermann, eds, *Globes at Greenwich: A Catalogue of the Globes and Armillary Spheres in the National Maritime Museum, Greenwich*, exh. cat., National Martime Museum, London (Oxford, New York and London, 1999)

Galluzzi, Paolo, ed., *Galileo: Images of the Universe from Antiquity to the Telescope*, exh. cat., Palazzo Strozzi, Florence (Florence, 2009)

Hadingham, Evan, *Early Man and the Cosmos: Explorations in Astroarchaeology* (New York, 1984)

Hess, Wilhelm, *Himmels- und Naturerscheinungen in Einblattdrucken des XV. bis XVIII. Jahrhunderts* (Nieuwkoop, 1973; reprint of Leipzig, 1911)

Holländer, Eugen, *Wunder, Wundergeburt und Wundergestalt in Einblattdrucken des fünfzehnten bis achtzehnten Jahrhunderts* (Stuttgart, 1921)

Hoskin, Michael A., *Cambridge Illustrated History of Astronomy* (Cambridge 1997)

——, *Caroline Herschel: Priestess of the New Heavens* (Sagamore Beach, MA, 2013)

——, *Discoverers of the Universe: William and Caroline Herschel* (Princeton, NJ, 2011)

—, *William Herschel, Pioneer of Sidereal Astronomy* (London, 1959)

Incerti, Manuela, Fabrizio Bònoli and Vito F. Polcaro, 'Transient Astronomical Events as Inspiration Sources of Medieval and Renaissance Art', *The Inspiration of Astronomical Phenomena*, vol. VI: *Proceedings of a Conference Celebrating the 400th Anniversary of Galileo's First Use of the Telescope*, ed. Enrico M. Corsini, ASP Conference Series, CCCCXLI (San Francisco, CA, 2011), pp. 139–50

Krupp, E. C., *Echoes of the Ancient Skies: The Astronomy of Lost Civilizations* (Mineola, NY, 2003)

—, *Skywatchers, Shamans and Kings: Astronomy and the Archaeology of Power* (New York, 1997)

Launay, Françoise, 'Trouvelot à Meudon Une "affaire" et huit pastels', *L'Astronomie*, CXVII (October 2003), pp. 452–60

MacDonald, Angus, and Alison D. Morrison, eds, *A Heavenly Library: Treasures from the Royal Observatory's Crawford Collection*, exh. cat., National Museums of Scotland, Edinburgh (Edinburgh, 1994)

MacDonald, John, *The Arctic Sky: Inuit Astronomy, Star Lore and Legend* (Toronto, 1998)

Millburn, John R., *Benjamin Martin: Author, Instrument-maker, and 'Country Showman'* (Leiden, 1976)

North, John David, *Cosmos: An Illustrated History of Astronomy and Cosmology* (Chicago, IL, and London, 2008)

Olson, Donald W., *Celestial Sleuth: Using Astronomy to Solve Mysteries in Art, History and Literature* (New York, 2014)

Olson, Roberta J. M., and Jay M. Pasachoff, 'Comets, Meteors, and Eclipses: Art and Science in Early Renaissance Italy', *Meteoritics and Planetary Science*, XXXVII (2002), pp. 1563–78

Orchiston, Wayne, *John Tebbutt: Rebuilding and Strengthening the Foundations of Australian Astronomy* (Cham, 2017)

Pasachoff, Jay M., *Peterson Field Guide to the Stars and Planets* (Boston, MA, 2017)

—, and Alex Filippenko, *The Cosmos: Astronomy in the New Millennium* (Cambridge, 2019)

Reeves, Eileen, *Painting the Heavens: Art and Science in the Age of Galileo* (Princeton, NJ, 1997)

Saxl, Fritz, *Verzeichnis astrologischer und mythologischer illustrieter Handschriften des lateinischen Mittelalters*, 3 vols in 4 (Heidelberg, 1915–53)

Schilling, Govert, *Atlas of Astronomical Discoveries* (New York, 2011)

Thorndike, Lynn, *A History of Magic and Experimental Science*, 8 vols (New York, 1923–58)

1 Astronomy: *The Personification and the Practice*

Cunningham, Clifford J., *Discovery of the First Asteroid, Ceres: Historical Studies in Asteroid Research* (Cham, 2016)

Cunningham, Clifford J., Brian G. Marsden and Wayne Orchiston, 'The Attribution of Classical Deities in the Iconography of Giuseppe Piazzi', *Journal of Astronomical History and Heritage*, XLI/2 (2011), pp. 129–35

Jones, Alexander, *A Portable Cosmos: Revealing the Antikythera Mechanism, Scientific Wonder of the Ancient World* (Oxford, 2017)

Joost-Gaugier, Christine L., 'Ptolemy and Strabo and their Conversation with Appelles and Protogenes: Cosmography and Painting in Raphael's School of Athens', *Renaissance Quarterly*, LI/3 (1998), pp. 761–87

Lippincott, Kristen, 'Raphael's "Astronomia": Between Art and Science', in *Making Instruments Count: Essays on Historical Scientific Instruments Presented to Gerard L'Estrange Turner*, ed. R.G.W. Anderson, J. A. Bennett and W. F. Ryan (Aldershot and Brookfield, VT, 1993), pp. 75–87

2 The Mechanics of the Cosmos: *Star Maps, Constellations and Globes*

Barentine, John C., *The Lost Constellations* (Chichester, 2016)

—, *Uncharted Constellations* (Chichester, 2016)

Bertola, Francesco, *Imago mundi* (Cittadella, 1997)

Blume, Dieter, Mechthild Haffner and Wolfgang Metzger, *Sternbilder des Mittelalters*, 2 vols (Berlin, 2012)

Canova, Giordana Mariani, 'Padua and the Stars: Medieval Painting and Illuminated Manuscripts', *The Inspiration of Astronomical Phenomena*, vol. VI: *Proceedings of a Conference Celebrating the 400th Anniversary of Galileo's First Use of the Telescope*, ed. Enrico M. Corsini, ASP Conference Series, vol. CCCCXLI (San Francisco, CA, 2011), pp. 111–50

Condos, Theony, *Star Myths of the Greeks and Romans: A Sourcebook* (Grand Rapids, MI, 1997)

Forti, Giuseppe, et al., 'Un planetario del XV secolo nella sacrestia vecchia di S. Lorenzo in Firenze una cupola dipinta reproduce con grande precision il cielo diurno di un giorno d'estate del 1442: è forse la commemorazione di un evento cittadiano?', *L'Astronomia*, LXII (1987), pp. 5–14

Harris, Lynda, 'Visions of the Milky Way in the West: The Greco-Roman and Medieval Periods', *The Inspiration of Astronomical Phenomena*, vol. VII, ed. Nicolas Campion and Rolf Sinclair, *Culture and Cosmos* special issue, XVI/1–2 (2012), pp. 272–82

Helden, Albert van, *The Invention of the Telescope* (Philadelphia, PA, 1977)

Kanas, Nick, *Star Maps: History, Artistry, and Cartography* (New York, 2012)

King, Henry C., *The History of the Telescope* (New York, 1979)

Marshall, David Weston, *Ancient Skies: Constellation Mythology of the Greeks* (New York, 2018)

Mendillo, Michael, and Aaron Shapiro, 'Scripture in the Sky: Jeremias Drexel, Julius Schiller and the Christianizing of the Constellations', in *The Inspiration of Astronomical Phenomena*, vol. VI: *Proceedings of a Conference Celebrating the 400th Anniversary of Galileo's First Use of the Telescope*, ed. Enrico M. Corsini, ASP Conference Series, CCCCXLI (San Francisco, CA, 2011), pp. 181–203

Metzger, Wolfgang, 'Stars, Manuscripts and Astrolabes: The Stellar Constellations in a Group of Medieval Manuscripts between Latin Literature and a New Science of the Stars', in *The Inspiration of Astronomical Phenomena*, vol. VI: *Proceedings of a Conference Celebrating the 400th Anniversary of Galileo's First Use of the Telescope*, ed. Enrico M. Corsini, ASP Conference Series, CCCCXLI (San Francisco, CA, 2011), pp. 533–45

Molaro, Paolo, and Pierluigi Selvelli, 'On the Telescopes in the Paintings of Jan Brueghel the Elder', in *The Role of Astronomy in Society and Culture: Proceedings IAU Symposium No. 260*, ed. David Valls-Gabaud and Alec Bokensberg (Cambridge and New York, 2011), pp. 327–32

Rowell, Margit, et al., *Miro and Calder's Constellations* (New York, 2017)

Schaefer, Bradley E., 'The Epoch of the Constellations on the Farnese Atlas and their Origin in Hipparchus's Lost Catalogue', *Journal for the History of Astronomy*, XXXVI/2 (2005), pp. 167–96

Stoppa, Felice, *Atlas coelestis, Il cielo stellato nella scienza e nell'arte* (Milan, 2006) (with appendix: E. H. Burritt, *The Geography of the Heavens, Atlas*, New York, 1835)

Stott, Carol, *Celestial Charts: Antique Maps of the Heavens* (London, 1995)

Stoyan, Ronald, et al., *Atlas of the Messier Objects: Highlights of the Deep Sky* (Cambridge and New York, 2010)

3 The Sun and Solar Eclipses

Alexander, David, *The Sun* (Santa Barbara, CA, 2009)

Aveni, Anthony, *In the Shadow of the Moon: The Science, Magic, and Mystery of Solar Eclipses* (New Haven, CT, 2017)

Berman, Bob, *The Sun's Heartbeat, and Other Stories from the Life of the Star that Powers Our Planet* (New York, 2011)

Bhatnagar, Arvind, and William C. Livingston, *Fundamentals of Solar Astronomy* (Singapore, 2005)

Brunier, Serge, and Jean-Pierre Luminet, *Glorious Eclipses: Their Past, Present, and Future*, trans. Storm Dunlop (Cambridge, 2000)

Carlowicz, Michael J., and Ramon E. Lopez, *Storms from the Sun: The Emerging Science of Space Weather* (Washington, DC, 2000)

Débarbat, Suzanne, 'Une retombée inattendue de l'éclipse du 11 août 1999', *Compt rendus de l'Académie des sciences Paris*, 4th ser. (2000), pp. 359–61

Espenak, Fred, *Fifty Year Canon of Solar Eclipses, 1986–2035* (Greenbelt, MD, 1987)

Golub, Leon, and Jay M. Pasachoff, *Nearest Star: The Surprising Science of Our Sun* (New York, 2013)

——, *The Solar Corona* (Cambridge, 2010)

——, *The Sun* (London, 2017)

Lang, Kenneth R., *The Sun from Space* (New York, 2006)

Olson, Roberta J. M., and Jay M. Pasachoff, 'St Benedict Sees the Light: Asam's Solar Eclipses as Metaphor', *Religion and the Arts*, XI (2007), pp. 299–329

——, 'Blinded by the Light: Solar Eclipses in Art – Science, Symbolism, and Spectacle', in *The Inspiration of Astronomical Phenomena*, vol. VI: *Proceedings of a Conference Celebrating the 400th Anniversary of Galileo's First Use of the Telescope*, ed. Enrico M. Corsini, ASP Conference Series, CCCCXLI (San Francisco, CA, 2011), pp. 205–15

——, 'The Solar Eclipse Mural Series by Howard Russell Butler', in *The Inspiration of Astronomical Phenomena*, vol. VIII: *City of Stars*, ed. Brian Patrick Abbott, Astronomical Society of the Pacific Conference vol. DI (San Francisco, CA, 2015), pp. 13–20

——, 'The 1816 Solar Eclipse and Comet 1811 I in John Linnell's Astronomical Album', *Journal for the History of Astronomy*, XXIII (1992), pp. 121–33

Pasachoff, Jay M., *The Complete Idiot's Guide to the Sun* (Indianapolis, IN, 2003)

Reaves, Mary Kerr, and Gibson Reaves, 'Antoine Caron's Painting *Astronomers Studying an Eclipse*', *Publications of the Astronomical Society of the Pacific*, LXXVII (1965), pp. 153–7

Schove, D. Justin, and Alan Fletcher, *Chronology of Eclipses and Comets AD 1–1000* (Woodbridge, Suffolk, and Dover, NH, 1984)

Sinclair, Rolf M., 'Howard Russell Butler: Painter Extraordinary of Solar Eclipses', *The Inspiration of Astronomical Phenomena*, vol. VII, ed. Nicolas Campion and Rolf Sinclair, *Culture and Cosmos* special issue, XVI/1–2 (2012), pp. 345–99

Zirker, Jack B., *Journey from the Center of the Sun* (Princeton, NJ, 2001, paperback, 2004)

——, *Sunquakes: Probing the Interior of the Sun* (Baltimore, MD, 2003)

——, *The Magnetic Universe: The Elusive Traces of an Invisible Force* (Baltimore, MD, 2009)

4 Earth's Moon and Lunar Eclipses

Ariew, R., 'Galileo's Lunar Observations in the Context of Medieval Lunar Theory', *Studies in the History and Philosophy of Science*, XV/3 (1984), pp. 213–27

Bambach, Carmen, *Leonardo da Vinci Rediscovered*, 4 vols (London, 2018), see vol. II and III

Barbieri, Cesare, and Francesca Rampazzi, eds, *Earth–Moon Relationships, Proceedings of the Conference held in Padova, Italy at the Accademia Galileiana di Scienze Lettere ed Arti* (Dordrecht, Boston, MA, and London, 2001)

Braham, Helen, and Robert Bruce-Gardner, 'Rubens's "Landscape by Moonlight"', *Burlington Magazine*, CXXX/1025 (1988), pp. 579–96

Brosche, Peter, 'Sie betrachten auch die Venus: Astronomisches zu Caspar David Friedrichs berühmtem Gemälde', *Sterne und Weltraum*, XXXIV/3 (1995), pp. 194–6

Bussey, Ben, and Paul D. Spudis, *The Clementine Atlas of the Moon* (New York, 2004)

Cocks, Elijah E., and Josiah C. Cocks, *Who's Who on the Moon: A Biographical Dictionary of Lunar Nomenclature* (Greensboro, NC, 1995)

Contini, Roberto, *Il Cigoli* (Soncino, 1991)

Crotts, Arlin, *The New Moon: Water, Exploration and Future Habitation* (Cambridge, 2014)

Drake, Stillman, 'Galileo's First Telescopic Observations', *Journal for the History of Astronomy*, VII (1976), pp. 153–68

Dupont-Bloch, Nicolas, *Shoot the Moon: A Complete Guide to Lunar Imaging* (Cambridge, 2016)

Edgerton, Samuel Y., 'Galileo, Florentine "Disegno" and the "Strange Spottednesse" of the Moon', *Art Journal*, XLIV/3 (1984), pp. 225–32

——, *The Heritage of Giotto's Geometry: Art and Science on the Eve of the Scientific Revolution* (Ithaca, NY, and London, 1991)

Evans, James, *The History and Practice of Ancient Astronomy* (Oxford and New York, 1998)

Farago, Claire J., et al., *Codex Leicester: A Masterpiece of Science* (New York, 1996)

Faranda, Franco, *Ludovico Cardi detto il Cigoli* (Rome, 1986)

Galileo Galilei, *Sidereus nuncius magna, longeque admirabilia spectacula pandens, suspiciendaque propenens unicuique, praesertim vero* (Venice, 1610)

Galles, Carlos D., and Carmen J. Gallagher, 'The Enigmatic Face of the Moon', in *The Inspiration of Astronomical Phenomena, vol. VI: Proceedings of a Conference Celebrating the 400th Anniversary of Galileo's First Use of the Telescope*, ed. Enrico M. Corsini, ASP Conference Series, CCCCXLI (San Francisco, CA, 2011), pp. 31–5

Heiken, G. H., D. T. Vaniman and B. M. French, *Lunar Sourcebook: A User's Guide to the Moon* (New York, 1991)

Lapi Ballerini, Isabella, 'Considerazioni a margine del restauro della "cupolina" dipinta nella Sagrestia Vecchia', in *Donatello-Studien*, ed. M. Cämmerer (Munich, 1989), pp. 102–12

——, 'Gli emisfero celesti della Sagrestia Vecchia e della Cappella Pazzi', *Rinascimento*, XXVIII (1988), pp. 321–55

——, 'Il planetario della Sagrestia Vecchia', in Umberto Baldini et al., *Brunelleschi e Donatello nella Sagrestia di S. Lorenzo* (Florence, 1989), pp. 113–21

Laurberg, M., et al., *The Moon: From Inner Worlds to Outer Space* (Copenhagen, 2018)

Le Conte, David, 'Warren De La Rue: Pioneer Astronomical Photographer', *Antiquarian Astronomer*, V (2011), pp. 14–35

Leonardo da Vinci, *The Codex Hammer of Leonardo da Vinci*, trans. Carlo Pedretti (Florence, 1987)

——, *Codex Leicester: A Masterpiece of Science*, ed. Claire Farago (New York, 1996)

——, *Leonardo da Vinci: The Codex Leicester – Notebook of a Genius*, ed. Michael Desmond and Carlo Pedretti (Sydney, 2000)

——, *Il Codice Atlantico della Biblioteca Ambrosiana di Milano*, 3 vols (Florence, 2000)

——, *The Literary Works of Leonardo da Vinci*, 2 vols, ed. J. P. Richter (London, New York and Toronto, 1939)

Matteoli, Anna, *Lodovico Cardi – Cigoli pittore e architetto* (Pisa, 1980)

Mendillo, Michael, 'Landscape by Moonlight: Peter Paul Rubens and Astronomy', in *The Inspiration of Astronomical Phenomena, vol. VIII: City of Stars*, ed. Brian Patrick Abbott, Astronomical Society of the Pacific Conference vol. DI (San Francisco, CA, 2015), pp. 21–30

Montgomery, Scott L., 'The First Naturalistic Drawing of the Moon: Jan van Eyck and the Art of Observation', *Journal for the History of Astronomy*, XXV (1994), pp. 317–32

——, *The Moon and the Western Imagination* (Tucson, AZ, 2001)

Nicolson, Marjorie Hope, *Voyages to the Moon* (New York, 1948)

——, 'A World in the Moon: A Study of the Changing Attitude toward the Moon in the Seventeenth and Eighteenth Centuries', *Smith College Studies in Modern Languages*, XVII (1936), pp. 1–71

Olson, Roberta J. M., and Jay M. Pasachoff, 'Moon-struck: Artists Rediscover Nature and Observe', in *Earth–Moon Relationships. Proceedings of the Conference held in Padova, Italy at the Accademia Galileiana di Scienze Lettere ed Arti*, ed. Cesare Barbieri and Francesca Rampazzi (Dordrecht, Boston, MA, and London, 2001), pp. 303–41

Ostrow, Stephen F., 'Cigoli's Immacolata and Galileo's Moon: Astronomy and the Virgin in Early Seicento Rome', *Art Bulletin*, LXXVII (1996), pp. 218–35

Pigatto, Luisa, and Valeria Zanini, 'Lunar Maps of the 17th and 18th Centuries: Tobias Mayer's Map and its 19th-century Edition', in *Earth–Moon Relationships. Proceedings of the Conference held in Padova, Italy at the Accademia Galileiana di Scienze Lettere ed Arti*, ed. Cesare Barbieri and Francesca Rampazzi (Dordrecht, Boston, MA, and London, 2001), pp. 365–77

Price, Fred W., *The Moon Observer's Handbook* (Cambridge, 2009)

Reeves, Gibson, and Pedretti, Carlo, 'Leonardo da Vinci's Drawings of the Surface Features of the Moon', *Journal for the History of Astronomy*, XVIII (1987), pp. 55–8

Rükl, Antonín, *Atlas of the Moon* (Waukesha, WI, 1990)

Ryan, W. F., *John Russell, RA, and Early Lunar Mapping* (Washington, DC, 1966)

Scott, Elaine, *Our Moon: New Discoveries About Earth's Closest Companion* (New York, 2016)

Spudis, Paul D., *The Once and Future Moon* (Washington, DC, 1996)

Stone, E. J., 'Note on a Crayon Drawing of the Moon by John Russell, RA, at the Radcliffe Observatory, Oxford', *Monthly Notices of the Royal Astronomical Society*, LVI (1896), pp. 88–95

Verwiebe, Birgit, 'Erweiterte, Wehrnehmung: Licht – Evscheinungen Transparent – Bilder Synästhesie', in *Casper David Friedrich: Die Erfindung der Romantik*, exh. cat, Hamburger Kunsthalle (Munich, 2006), pp. 338–44

Wells, Gary N., 'The Long View: Light, Vision, and Visual Culture after Galileo', in *The Inspiration of Astronomical Phenomena,* vol. VI: *Proceedings of a Conference Celebrating the 400th Anniversary of Galileo's First Use of the Telescope*, ed. Enrico M. Corsini, ASP Conference Series, CCCCXLI (San Francisco, CA, 2011), pp. 89–97

——, 'The Moon in the Landscape: Interpreting a Theme of Nineteenth Century Art', *The Inspiration of Astronomical Phenomena VII*, ed. Nicolas Campion and Rolf Sinclair, *Culture and Cosmos* special issue, XVI/1–2 (2012), pp. 373–84

Whitaker, Ewen A., 'Galileo's Lunar Observations and the Dating of the Composition of 'Sidereus Nuncius', *Journal for the History of Astronomy*, IX (1978), pp. 155–69

——, *Mapping and Naming the Moon: A History of Lunar Cartography and Nomenclature* (Cambridge, 1999)

Wilhelms, Don E., *To a Rocky Moon: A Geologist's History of Lunar Exploration* (Tucson, AZ, 1993)

Wlasuk, Peter T., *Observing the Moon* (London, 2000)

Wood, Charles, 'Lunar Hall of Fame', *Sky and Telescope*, CXXIV/6 (2017), pp. 52–4

5 Comets: *'Wandering Stars'*

Altfeld, H.-H., *Bibliographical Guide for Cometary Science* (Munich, 1983)

Bond, G. P., *Account of the Great Comet of 1858* (Cambridge, MA, 1862)

Freitag, Ruth, *Halley's Comet: A Bibliography* (Washington, DC, 1984)

Hellman, C. Doris, *The Comet of 1577: Its Place in the History of Astronomy* (New York and London, 1944)

Hughes, David, *The Star of Bethlehem: An Astronomer's Confirmation* (New York, 1979)

Kapoor, R. C., 'Nuruddin Jahangir and Father Kirwitzer: The Independent Discovery of the Great Comets of November 1618 and the First Astronomical Use of Telescope in India', *Journal of Astronomical History and Heritage*, XIX (2016), pp. 264–97

Karam, P. Andrew, *Comets: Nature and Culture* (London, 2017)

Kronk, Gary W., et al., *Comets: A Descriptive Catalogue*, vol. I: *Ancient–1799*; vol. II: *1800–1899*; vol. III: *1900–1932*; vol. IV: *1933–1959*; vol. V: *1960–1982*; vol. VI: *1983–1993* (Cambridge and New York, 1999–2017)

Levy, David H., *The Quest for Comets: An Explosive Trail of Beauty and Danger* (New York, 1994)

Littmann, Mark, and Donald K. Yeomans, *Comet Halley: Once in a Lifetime* (Washington, DC, 1985)

Marsden, Brian G., and Gareth V. Williams, *Catalog of Cometary Orbits* (Cambridge, MA, 2003)

Massing, Jean-Michel, 'A Sixteenth-century Illustrated Treatise on Comets', *Journal of the Warburg and Courtauld Institutes*, XL (1977), pp. 318–22

Olson, Roberta J. M., 'The Comet of 1680 in Dutch Art', *Sky and Telescope*, LXXVI/6 (1988), pp. 706–8

——, 'The Comet in Moreau's Phaeton: An Emblem of Cosmic Destruction and a Clue to the Painting's Astronomical Prototype', *Gazette des beaux-arts*, CI (1983), pp. 37–42

——, 'The Draftsman's Comet', *Drawing*, VII/3 (1985), pp. 49–55

——, *Fire and Ice: A History of Comets in Art* (New York, 1985)

——, 'Giotto's Portrait of Halley's Comet', *Scientific American*, CCXL/5 (1979), pp. 160–70

——, 'Much Ado about Giotto's Comet', *Quarterly Journal of the Royal Astronomical Society*, XXXV (1994), pp. 145–8

——, 'Quand passent les comètes', *Connaissance des Arts*, 380 (October 1983), pp. 72–7

——, '. . . And They Saw Stars: Renaissance Representations of Comets and Pretelescopic Astronomy', *Art Journal*, XLIV/3 (1984), pp. 216–24

——, 'A Water-colour by Samuel Palmer of Donati's Comet', *Burlington Magazine*, CXXXII/1052 (1990), pp. 795–6

——, and Jay M. Pasachoff, 'The Comets of Caroline Herschel (1750–1848), Sleuth of the Skies at Slough', *The Inspiration of Astronomical Phenomena VII*, ed. Nicolas Campion and Rolf Sinclair, *Culture and Cosmos* special issue, XVI/1–2 (2012), pp. 53–76

——, *Fire in the Sky: Comets and Meteors, the Decisive Centuries in British Art and Science* (Cambridge, 1998)

——, 'Historical Comets over Bavaria: The Nuremberg Chronicle and Broadsides', in *Comets in the Post-Halley Era*, vol. II, ed. R. C. Newburn Jr et al. (Dordrecht, Boston, MA, and London, 1991), pp. 1309–41

——, 'Is Comet P/Halley of AD 684 Recorded in the Nuremberg Chronicle?', *Journal for the History of Astronomy*, XX (1989), pp. 171–4

——, 'Letter: Comets and Altdorfer's Art', *Art Bulletin*, XXXII/2 (2000), p. 600

——, 'New Information on Comet Halley as Depicted by Giotto di Bondone and Other Western Artists', *Proceedings of the 20th ESLAB Symposium on the Exploration of Halley's Comet*, vol. III (Paris, 1986), pp. 201–13 (reprinted with new information in *Astronomy and Astrophysics*, CLXXXVII/1–2 (1987), pp. 1–11; *Exploration of Halley's Comet*, ed. M. Grewing, F. Praderie and R. Reinhard, Berlin and Heidelberg, 1988)

——, and Margaret Hazen, 'The Earliest Comet Photographs: Usherwood, Bond, and Donati 1858', *Journal for the History of Astronomy*, XXVII (1996), pp. 129–45

Schechner, Sara, *Comets, Popular Culture and the Birth of Modern Cosmology* (Princeton, NJ, 1999)

Schilling, Diebold, *Diebold Schilling Luzerner BilderChronik, 1513*, ed. Robert Durrer and Paul Hilber (Geneva, 1932)

Thorndike, Lynn, ed., *Latin Treatises on Comets between 1238 and 1368 AD* (Chicago, IL, 1950)

Verschuur, Gerrit L., *Impact! The Threat of Comets and Asteroids* (New York, 1996)

Vsekhsvyatskii, S. K., *Physical Characteristics of Comets* (Jerusalem, 1964)

6 Meteors, Bolides and Meteor Showers

Bias, Peter V., *Meteors and Meteor Showers: An Amateur's Guide to Meteors* (Cincinnati, OH, 2005)

Burke, John G., *Cosmic Debris: Meteorites in History* (Berkeley, CA, and London, 1986)

Dick, Steven J., 'Observation and Interpretation of the Leonid Meteors over the Last Millennium', *Journal of Astronomical History and Heritage*, I/1 (1998), pp. 1–20

Hughes, David. W., 'The History of Meteors and Meteor Showers', *Vistas in Astronomy*, XXVI/4 (1982), pp. 325–45

——, 'The World's Most Famous Meteor Shower Picture', *Earth, Moon, and Planets*, LXVII/1–3 (1995), pp. 311–22

Imoto, Susumu, and Ichiro Hasegawa, 'Historical Records of Meteor Showers in China, Korea and Japan', *Smithsonian Contributions to Astrophysics*, II/6 (1958), pp. 131–44

Jenniskens, Peter, *Meteor Showers and their Parent Comets* (Cambridge, 2006)

Kronk, Gary W., *Meteor Showers: An Annotated Catalogue* (New York, 2014)

——, *Meteor Showers: A Descriptive Catalog* (Hillside, NJ, 1988)

Larsen, Jon, *In Search of Stardust: Amazing Micro-meteorites and their Terrestrial Imposters* (Minneapolis, MN, 2017)

Marvin, Ursula B., 'The Meteorite of Ensisheim: 1492 to 1992', *Meteoritics and Planetary Science*, XXVII (1992), pp. 28–72

Newton, H. A., 'The Fireball in Raphael's Madonna di Foligno', *Publications of the Astronomical Society of the Pacific*, III/15 (1891), pp. 91–5

Olson, Donald W., and Marilynn S. Olson, 'William Blake and August's Fiery Meteors', *Sky and Telescope*, LXXVIII/2 (1989), pp. 192–9

Olson, Donald W., et al., 'Walt Whitman's "Year of Meteors"', *Sky and Telescope*, CXX/1 (2010), pp. 28–33

Olson, Roberta J. M., 'First Light: Pietro Lorenzetti's Meteor Showers', *The Sciences*, XXVIII/3 (1988), pp. 36–7

——, 'Pietro Lorenzetti's Dazzling Meteor Showers', *Apollo*, CXLIX/447 (1999), pp. 3–10

——, and Jay M. Pasachoff, 'The "Wonderful Meteor" of 18 August 1783, the Sandbys, "Samuel Scott", and Heavenly Bodies', *Apollo*, CXLVI/429 (1997), pp. 12–19

——, 'Letters: Dürer's bolide', *Apollo*, CXLIX/453 (1999), p. 58

Paffenroth, Kim, 'The Star of Bethlehem Casts Light on Its Modern Interpreters', *Quarterly Journal of the Royal Astronomical Society*, XXXIV/4 (1993), pp. 449–60

Romero, James, 'Halley's Comet and Mayan Kings', *Sky and Telescope*, CXXXV (April 2018), pp. 36–40

Stothers, Richard B., 'The Roman Fireball of 76 BC', *The Observatory*, CVII (October 1987), pp. 211–13

Wasson, John T., *Meteorites: Their Record of Early Solar-system History* (New York, 1985)

7 Primordial Matter of the Big Bang: *Novae, Nebulae and Galaxies*

Adams, Fred, and Greg Laughlin, *The Five Ages of the Universe* (New York, 1999)

Bartusiak, Marcia, *Einstein's Unfinished Symphony: The Story of a Gamble, Two Black Holes, and a New Age of Astronomy* (New Haven, CT, and London, 2017)

Begelman, Mitchell, and Martin Rees, *Gravity's Fatal Attraction: Black Holes in the Universe* (New York, 1996)

Berendzen, Richard, Richard Hart and Daniel Seeley, *Man Discovers the Galaxies* (New York, 1976)

Bloom, Joshua S., *What Are Gamma-ray Bursts?* (Princeton, NJ, 2011)

Cavina, Anna Ottani, 'On the Theme of Landscape, II: Elsheimer and Galileo', *Burlington Magazine*, CXVIII/876 (1976), p. 139

Clark, David H., and F. Richard Stephenson, *The Historical Supernovae* (Oxford and New York, 1977)

Clegg, Brian, *Gravitational Waves: How Einstein's Spacetime Ripples Reveal the Secrets of the Universe* (London, 2018)

Couper, Heather, and Nigel Henbest, *Encyclopedia of Space* (New York, 2009)

Danielson, Dennis, *The Book of the Cosmos: Imagining the Universe from Heraclitus to Hawking* (New York, 2000)

Ferris, Timothy, *Coming of Age in the Milky Way* (New York, 2003)

——, *The Whole Shebang: A State-of-the-Universe(s) Report* (New York, 1997)

Finkbeiner, Ann, *A Grand and Bold Thing: An Extraordinary New Map of the Universe Ushering in a New Era of Discovery* (New York, 2010)

Friedlander, Michael, *A Thin Cosmic Rain: Particles from Outer Space* (Cambridge, MA, 2000)

Gates, Evalyn, *Einstein's Telescope: The Hunt for Dark Matter and Dark Energy in the Universe* (New York, 2010)

Giacconi, Riccardo, *Secrets of the Hoary Deep: A Personal History of Modern Astronomy* (Baltimore, MD, 2008)

Gingrich, Mark, 'Great Comets, Novae and Lady Luck', *Sky and Telescope*, LXXXIX/6 (1995), pp. 86–9

Goldsmith, Donald, *The Astronomers* (New York 1991)

——, *The Runaway Universe: The Race to Find the Future of the Cosmos* (Cambridge, MA, 2000)

Greene, Brian, *The Hidden Reality: Parallel Universes and the Deep Laws of the Cosmos* (New York, 2011)

——, and Erik Davies, *The Elegant Universe: Superstrings, Hidden Dimensions, and the Quest for the Ultimate Theory* (New York, 1999)

Griffiths, Martin, *Planetary Nebulae and How to Observe Them* (New York, 2012)

Guth, Alan H., and Alan Lightman, *The Inflationary Universe: The Quest for a New Theory of Cosmic Origins* (New York, 1997)

Harrison, Edward, *Darkness at Night: A Riddle of the Universe* (Cambridge, MA, 1989)

Hawking, Stephen, *A Brief History of Time: From the Big Bang to Black Holes* (London, 1988)

——, *A Brief History of Time*, updated and expanded edition (New York, 1998)

——, *The Illustrated Brief History of Time* (New York, 1996)

——, and Leonard Mlodinow, *The Grand Design* (New York, 2010)

Hirshfeld, Alan W., *Parallax: The Race to Measure the Cosmos* (New York, 2001)

Hoskin, Michael, 'Rosse, Robinson and the Resolution of the Nebulae', *Journal for the History of Astronomy*, XXI/4 (1990), pp. 331–44

——, 'William Herschel and the Nebulae, Part 1: 1773–1784', *Journal for the History of Astronomy*, XLII/2 (2011), pp. 177–92

——, 'William Herschel and the Nebulae, Part 2: 1785–1818', *Journal for the History of Astronomy*, XLII/3 (2011), pp. 321–38

Howard, Deborah, and Malcolm S. Longair, 'Elsheimer, Galileo, and *The Flight into Egypt*', in *The Inspiration of Astronomical Phenomena*, vol. VI: *Proceedings of a Conference Celebrating the 400th Anniversary of Galileo's First Use of the Telescope*, ed. M. Corsini, ASP Conference Series, CCCCXLI (San Francisco, CA, 2011), pp. 23–9

Kaku, Michio, *Hyperspace: A Scientific Odyssey through Parallel Universes, Time Warps and the 10th Dimension* (New York, 1994)

Kaler, James B., *Heaven's Touch: From Killer Stars to the Seeds of Life, How We Are Connected to the Universe* (Princeton, NJ, 2009)

——, *Hundred Greatest Stars* (New York, 2002)

——, *Stars and their Spectra: An Introduction to the Spectral Sequence* (New York, 2011)

Katz, Jonathan I., *The Biggest Bangs: The Mystery of Gamma-ray Bursts, the Most Violent Explosions in the Universe* (New York, 2002)

Kirshner, Robert P., *The Extravagant Universe: Exploding Stars, Dark Energy, and the Accelerating Cosmos* (Princeton, NJ, 2002, paperback 2004)

Krauss, Lawrence M., *A Universe from Nothing: Why There Is Something Rather Than Nothing* (New York, 2012)

Krupp, E. C., 'Crab Supernova Rock Art: A Comprehensive, Critical, and Definitive Review', *Journal of Skyscape Archaeology*, I/2 (2015), pp. 167–97

Kwok, Sun, *Stardust: The Cosmic Seeds of Life* (New York, 2013)

Lederman, Leon M., and David N. Schramm, *From Quarks to the Cosmos: Tools of Discovery* (New York, 1995)

Lemonick, Michael, *Echo of the Big Bang* (Princeton, NJ, 2003)

Levin, Janna, *Black Hole Blues and Other Songs from Outer Space* (New York, 2017)

Lightman, Alan, and Roberta Brawer, *Origins: The Lives and Worlds of Modern Cosmologists* (Cambridge, MA, 1990)

Livio, Mario, *The Accelerating Universe: Infinite Expansion, the Cosmological Constant, and the Beauty of the Cosmos* (New York, 2000)

Loeb, Abraham, *How Did the First Stars and Galaxies Form?* (Princeton, NJ, 2010)

Malin, David, and Timothy Ferris, *The Invisible Universe* (Boston, MA, 1999)

Mather, John, and John Boslough, *The Very First Light: The True Inside Story of the Scientific Journey back to the Dawn of the Universe* (New York, 2008)

Mazure, Alain, and Vincent LeBrun, *Matter, Dark Matter, and Anti-matter: In Search of the Hidden Universe* (New York, 2011)

Melia, Fulvio, *The Black Hole at the Center of Our Galaxy* (Princeton, NJ, 2003)

——, *The Edge of Infinity: Supermassive Black Holes in the Universe* (Cambridge, 2003)

——, *The Galactic Supermassive Black Hole* (Princeton, NJ, 2007)

——, and Roy Kerr, *Cracking the Einstein Code: Relativity and the Birth of Black Hole Physics* (Chicago, IL, 2009)

Murdin, Paul, and Lesley Murdin, *Supernovae* (Cambridge and New York, 2011)

NASA Astrobiology Program, *Astrobiology: The Story of Our Search for Life in the Universe* (Moffett Field, CA, 2010–18)

Ostriker, Jeremiah, and Simon Mitton, *Heart of Darkness: Unraveling the Mysteries of the Invisible Cosmos* (Princeton, NJ, 2013)

Overbye, Dennis, *Lonely Hearts of the Cosmos: The Scientific Quest for the Secret of the Universe* (New York, 1991)

Pasachoff, Jay M., and Alex Filippenko, *The Cosmos: Astronomy in the New Millennium* (New York, 2019)

Pasachoff, Jay M., Hyron Spinrad, Patrick Osmer and Edward S. Cheng, *The Farthest Things in the Universe* (Cambridge, 1995)

Petersen, Carolyn Collins, and John C. Brandt, *Visions of the Cosmos* (Cambridge, 2003)

Rees, Martin, *Our Cosmic Habitat* (Princeton, NJ, 2001)

——, *Universe: The Definitive Visual Guide* (New York, 2008)

Rieke, George H., *Measuring the Universe: A Multiwavelength Perspective* (New York, 2012)

Rosse, W. Parsons, Earl of, *The Scientific Papers of William Parsons, Third Earl of Rosse, 1800–1867*, ed. Sir C. Parsons (London, 1926)

Rowan-Robinson, Michael, *The Nine Numbers of the Cosmos* (Oxford, 1999)

Rubin, Vera C., *Bright Galaxies, Dark Matters* (Woodbury, NY, 1997)

Sandage, Allan, and John Bedke, *The Carnegie Atlas of Galaxies* (Washington, DC, 1994)

Schilling, Govert, *Flash! The Hunt for the Biggest Explosions in the Universe* (Cambridge, 2002)

——, *Ripples in Spacetime: Einstein, Gravitational Waves, and the Future of Astronomy* (Cambridge, MA, 2017)

Schultz, David A., *The Andromeda Galaxy and the Rise of Modern Astronomy* (New York, 2012)

Silk, Joseph, *The Infinite Cosmos: Questions from the Frontiers of Cosmology* (Oxford, 2006)

Smoot, George, and Keay Davidson, *Wrinkles in Time: The Imprint of Creation* (New York, 1994)

Sobel, Dava, *The Glass Universe: How the Ladies of the Harvard Observatory took the Measure of the Stars* (New York, 2017)

Stewart, Ian, *Flatterland: Like Flatland, Only More So* (New York, 2001)

Thorne, Kip, *Black Holes and Time Warps: Einstein's Outrageous Legacy* (New York, 1994)

Tucker, Wallace H., and Karen Tucker, *Revealing the Universe: The Making of the Chandra X-ray Observatory* (Cambridge, MA, 2001)

Waller, William H., The *Milky Way: An Insider's Guide* (Princeton, NJ, 2013)

——, and Paul W. Hodge, *Galaxies and the Cosmic Frontier* (Cambridge, MA, 2003)

Weinberg, Steven, *The First Three Minutes: A Modern View of the Origin of the Universe* (New York, 1993)

Weintraub, David A., *How Old is the Universe?* (Princeton, NJ, 2011)

Wheeler, J. Craig, *Cosmic Catastrophes: Supernovae, Gamma-ray Bursts, and Adventures in Hyperspace* (Cambridge, 2000)

Whitney, Charles A., 'The Skies of Vincent Van Gogh', *Art History*, IX/3 (1986), pp. 351–62

Wilford, John Noble, ed., *Cosmic Dispatches: The New York Times Reports on Astronomy and Cosmology* (New York, 2001)

Wolfson, Richard, *Simply Einstein: Relativity Demystified* (New York, 2003)

Zuckerman, Ben, and Matthew A. Malkan, *The Origin and Evolution of the Universe* (Boston, MA, 1996)

8 The Planets of the Solar System

Alexander, Rachel, *Myths, Symbols and Legends of Solar System Bodies* (New York, 2015)

Baker, David, and Todd Ratcliff, *The 50 Most Extreme Places in Our Solar System* (London and Cambridge, MA, 2010)

Bartusiak, Marcia, *Archives of the Universe: A Treasury of Astronomy's Historic Works of Discovery* (New York, 2004)

Beatty, J. Kelly, Caroline Collins Petersen and Andrew Chaikin, *The New Solar System* (Cambridge, MA, and Cambridge, 1999)

Boime, Albert, 'Van Gogh's Starry Night: A History of Matter and a Matter of History', *Arts Magazine*, LIX/4 (1984), pp. 86–103

Boyce, Joseph M., *The Smithsonian Book of Mars* (Washington, DC, 2002)

Brown, Mike, *How I Killed Pluto and Why It Had It Coming* (New York, 2010)

Buratti, Bonnie, *Worlds Fantastic, Worlds Familiar: A Guided Tour of the Solar System* (Cambridge, 2017)

Chaikin, Andrew, *A Passion for Mars* (New York, 2008)

De Pater, Imke, and Jack J. Lissauer, *Planetary Sciences* (Cambridge, 2010)

Grady, Monica M., Giovanni Pratesi and Vanni Moggi Cecchi, eds, *Atlas of Meteorites* (Cambridge, 2013)

Hargitai, Henrik, and Mateusz Pitura, *International Catalogue of Planetary Maps* (Budapest, 2018)

Jones, Barrie W., *Pluto: Sentinel of the Outer Solar System* (Cambridge, 2010)

Kluger, Jeffrey, *Moon Hunters: NASA's Remarkable Expeditions to the Ends of the Solar System* (New York, 2001)

Lang, Kenneth R., *The Cambridge Guide to the Solar System* (New York, 2011)

Lomb, Nick, *Transit of Venus: 1631 to the Present* (New York, 2011)

Lorenz, Ralph, and Jacqueline Mitton, *Titan Unveiled: Saturn's Mysterious Moon Explored* (Princeton, NJ, 2010)

Maor, Eli, *June 8, 2004: Venus in Transit* (Princeton, NJ, 2000)

Pasachoff, Jay M., and William Sheehan, 'Lomonosov, the Discovery of Venus's Atmosphere, and Eighteenth-century Transits of Venus', *Journal for the History and Heritage of Astronomy*, XV/1 (2012), pp. 1–12

Pasachoff, Jay M., Glenn Schneider and Leon Golub, 'The Black-drop Effect Explained', in *Transits of Venus: New Views of the Solar System and Galaxy*, ed. D. W. Kurtz and G. E. Bromage (Cambridge, 2005), pp. 242–53

Pyle, Rod, *Destination Mars: New Explorations of the Red Planet* (Amherst, NY, 2012)

Pyne, Stephen J., *Voyager: Seeking Newer Worlds in the Third Great Age of Discovery* (New York, 2010)

Rothery, David A., Neil McBride and Iain Gilmour, eds, *An Introduction to the Solar System* (Cambridge, 2011)

Sagan, Carl, *Pale Blue Dot* (New York, 1994)

Sobel, Dava, *The Planets* (New York, 2006)

Squyres, Steven, *Roving Mars: Spirit, Opportunity, and the Exploration of the Red Planet* (New York, 2005)

Stern, S. Alan, *Our Worlds: The Magnetism and Thrill of Planetary Exploration: As Described by Leading Planetary Scientists* (Cambridge, 1999)

——, and David Grinspoon, *Chasing New Horizons: Inside the Epic First Mission to Pluto* (New York, 2018)

Tyson, Neil deGrasse, and Donald Goldsmith, *Origins: Fourteen Billion Years of Cosmic Evolution* (New York, 2004)

Weintraub, David A., *Is Pluto a Planet? A Historical Journey through the Solar System* (Princeton, NJ, 2009)

Yeomans, Donald K., *Near-Earth Objects: Finding Them before They Find Us* (Princeton, NJ, 2012)

9 The Aurora Borealis:
Magnetic Celestial Fireworks

Angot, Alfred, *The Aurora Borealis* (London, 1896)

'Aurora Borealis [by Frederic Edwin Church]', Smithsonian American Art Museum, www.americanart.si.edu, accessed 1 December 2016

Brekke, Asgeir, and Alv Egeland, *The Northern Lights: Their Heritage and Science* (Oslo, 1994)

Brekke, Pål, and Fredrik Broms, *Northern Lights: A Guide* (Oslo, 2014)

Briggs, J. Morton, Jr, 'Aurora and Enlightenment: Eighteenth-century Explanations of the Aurora Borealis', *Isis*, LVIII/4 (1967), pp. 491–503

Eather, R. H., *Majestic Lights: The Aurora in Science, History, and the Arts* (Washington, DC, 1980)

Falck-Ytter, Harald, *Aurora: The Northern Lights in Mythology, History and Science*, trans. Robin Alexander (Hudson, NY, 1999)

Odenwald, Sten F., and James L. Green, 'Bracing for a Solar Superstorm: A Recurrence of the 1859 Solar Superstorm Would Be a Cosmic Katrina, Causing Billions of Dollars of Damage to Satellites, Power Grids, and Radio Communications', *Scientific American*, CCXCIX/2 (2008), pp. 80–87

Stephenson, F. Richard, David M. Willis and Thomas J. Hallinan, 'The Earliest Datable Observations of the Aurora Borealis', *Astronomy and Geophysics*, XLV/6 (2004), pp. 6.15–6.17

10 New Horizons in the Cosmos:
Photographs of Space

Audouze, Jean, and Guy Israël, *The Cambridge Atlas of Astronomy* (Cambridge, 1994)

Bartusiak, Marcia, *Einstein's Unfinished Symphony: The Story of a Gamble, Two Black Holes and a New Age of Astronomy* (New Haven, CT, and London, 2017)

Belloli, Jay, et al., *The History of Space Photography* (CreateSpace Independent Publishing Platform, 2014)

Bendavid-Val, Leah, *National Geographic: The Photographs* (Washington, DC, 1994)

Brunier, Serge, *Majestic Universe: Views from Here to Infinity* (Cambridge, 1999)

Covington, Michael A., *Astrophotography for the Amateur* (Cambridge, 1999)

Cox, Brian, and Andrew Cohen, *Wonders of the Universe* (London, 2011)

DeVorkin, David, and Robert W. Smith, *Hubble: Imaging Time and Space* (Washington, DC, 2008)

——, *The Hubble Cosmos: 25 Years of New Vistas in Space* (Washington, DC, 2017)

——, *The Space Telescope: Imaging the Universe* (Washington, DC, 2004)

Dickinson, Terence, *Hubble's Universe: Greatest Discoveries and Latest Images* (Richmond Hill, Ontario, 2017)

Friedl, Lawrence, and NASA, *Earth as Art* (Washington, DC, 2012)

Gendler, Robert, and R. J. GaBany, *Breakthrough! 100 Astronomical Images That Changed the World* (Basel, 2015)

Goodwin, Simon, *Hubble's Universe: A New Picture of Space* (London, 1996)

Hitchcock, Susan Tyler, and National Geographic Editors, eds, *Rarely Seen: Photographs of the Extraordinary* (Washington, DC, 2015)

Hughes, Stefan, *Catchers of the Light: The Forgotten Lives of the Men and Women who First Photographed the Heavens; Their True Tales of Adventure, Adversity and Triumph*, vol. I: *Catching Space: Origins, Moon, Sun, Solar System and Deep Space*; vol. II: *Imaging Space: Spectra, Surveys, Telescopes, Digital and Appendices* (Paphos, 2013)

Lachièze-Rey, Marc, and Jean-Pierre Luminet, *Celestial Treasury: From the Music of the Spheres to the Conquest of Space* (Cambridge, 2001)

Lankford, John, 'The Impact of Photography on Astronomy', in *The General History of Astronomy*, vol. IV: *Astrophysics and Twentieth-century Astronomy to 1950, part A*, ed. Owen Gingerich (Cambridge, 1984), pp. 16–39

Malin, David, *Ancient Light: A Portrait of the Universe* (New York, 2009)

——, and Dennis di Cicco, 'Astrophotography: The Amateur Connection, the Roles of Photography in Professional Astronomy, Challenges and Changes', http://encyclopedia.jrank.org/articles

Murdin, Paul, and Phaidon editors, *Universe: Exploring the Astronomical World* (New York, 2017)

Nataraj, Nirmala, *Earth and Space: Photographs from the Archives of NASA* (San Francisco, CA, 2015)

Pasachoff, Jay M., Roberta J. M. Olson and Martha L. Hazen, 'The Earliest Comet Photographs: Usherwood, Bond, and Donati 1858', *Journal for the History of Astronomy*, XXVII (1996), pp. 129–45

Ressmeyer, Roger, *Space Places* (San Francisco, CA, 1990)

Schilling, Govert, *Atlas of Astronomical Discoveries* (New York, 2011)

Shayler, David J., with David M. Harland, *Enhancing Hubble's Vision: Service Missions That Expanded Our View of the Universe* (Basel, 2016)

Shostak, Anthony, ed., *Starstruck: The Fine Art of Astrophotography* (Lewiston, ME, 2012)

Smith, Ian, 'The History of Space Photography: From the Beginnings to the Pinnacle of Astrophotography', www.thevintagenews.com, accessed 20 March 2016

Stephenson, Bruce, Marvin Bolt and Anna Felicity Friedman, *The Universe Unveiled: Instruments and Images through History* (Cambridge, 2000)

Time-Life Books, editors of, *Life Library of Photography: Photographing Nature* (New York, 1971)

Trefil, James, *Space Atlas: Mapping the Universe and Beyond* (Washington, DC, 2018)

Acknowledgements

We take great pleasure in acknowledging the contributions of many deserving individuals in our constellation of thanks. Among the most prominent stars is Alexandra Mazzitelli of the New-York Historical Society for her inspired research on images and permissions. Madeline Kennedy and Michele Rech of Williams College both assisted in many ways with meteoric efficiency.

The other bright lights to whom we are most grateful are the many generous academic and museum colleagues, private collectors and dealers who offered their knowledge and kind assistance. In alphabetical order they are: Brian Abbott, American Museum of Natural History; George Abrams; Susan Anderson; Thomas Baione, Library of the American Museum of Natural History; Mickey Cartin; Glenn Castellano, New-York Historical Society; Brenda Corbin; James Faber; Eleanor Gillers, New-York Historical Society; Owen Gingerich, Harvard-Smithsonian Center for Astrophysics; Alice Goldet; Stefano Grandesso; Wayne Hammond, Chapin Library, Williams College; Eleanor Harvey, Smithsonian American Art Museum; Judith Hernstadt; Jonathan Hill; Steven Holmes; Alexander B. V. Johnson; E. C. Krupp, Griffith Observatory; Françoise Launay, Observatoire de Paris; Lowell Libson; Nigel Lindsay-Fynn; Laurie Marty de Cambiaire; Kendra Meyer, American Museum of Natural History; Eva Oledzka, Bodleian Library, Oxford University; Nadine M. Orenstein, Metropolitan Museum of Art; Ursula Overbury; Pekka Parviainen; Naomi Pasachoff; Mai Reitmeyer, Library of American Museum of Natural History; Henrich Sieveking; Robert Simon; Freyda Spira and Perrin Stein, Metropolitan Museum of Art; Jennifer Tonkavich and Lindsey Tyne, Morgan Library and Museum; Jonny Yarker; Carlo Virgilio; Tom Widemann, Observatoire de Paris; Anne Woollett, J. Paul Getty Museum. We also thank the Williams College Science Center and Astronomy Department for their partial support of permissions fees.

At Reaktion, we would like to thank our stellar editor Vivian Constantinopoulos, editorial director, for support on all facets of the project; Amy Salter, editor; Aimee Selby, managing editor; and copy editor Jon K. Snow; and for the inspired design of the volume, Katya Duffy.

Photo Acknowledgements

George Abrams Collection (photo courtesy George Abrams Collection): 146; Alana Collection: 56; Albright Knox Art Gallery, Buffalo, New York - © Robert Indiana / Morgan Art Foundation / Artists Rights Society (ARS), New York: 226; Alte Pinakothek, Munich: 243; American Museum of Natural History, New York (images courtesy of American Museum of Natural History): 88, 124, 203; Amgueddfa Cymru-National Museum of Wales, Cardiff: 219; Peter Apian, *Astronomicum Caesareum*: 27 (photo Metropolitan Museum of Art, New York), 109 (photo John Carter Library Brown, Brown University, RI), 130 (photo Metropolitan Museum of Art, New York); Apostolic Palace, Vatican, Vatican City, Rome (photos Scala/Art Resource, New York): 66, 106; Atlas van Stolk, Schielandshuis, Rotterdam: 158; Australian Astronomical Observatory/David Malin: 236; Jakob Balde, *De Eclipsi Solari … libri duo* (photo courtesy Universität Mannheim and Deutschen Forschungsgemeinschaft): 69; Barber Institute of Fine Arts, The University of Birmingham / Bridgeman Images: 113; Johannes Bayer, *Uranometria*: 33, 34; Bayerische Staatsbibliothek, Munich: 64; Bayerisches Nationalmuseum, Munich (Basserman-Jordan Collection): 126, 127; Benediktiner-Kloster-und Pfarrkirche Sankt Georg und Sankt Martin, Weltenberg, Germany: 74; John Bevis, *Atlas Celeste [Uranographia Britannica]*: 38; Beyeler Foundation, Riehen, Switzerland – © ProLitteris, Zürich / Robert Bayer: 235; *Bible Readings for the Home Circle*: 203; Biblioteca Ambrosiana, Milan (© Veneranda Biblioteca Abrosiana-Milano / De Agostini Picture Library): 104; Biblioteca Angelica, Rome (Codex 123): 228; Biblioteca Nacional de España, Madrid: 31, 151; Biblioteca nazionale centrale, Florence: 51, 111 (photo courtesy of Canadian Royal Astronomical Society, Vancouver) 137; Bibliothèque Forney, Paris: 182; Bibliothèque nationale de France, Paris (Département des manuscrits): 54, 55, 99, 100, 107, 172; Bibliothèque de l'Observatoire de Paris: 70; Birr Castle Archives (photo courtesy of Birr Scientific & Heritage Foundation): 239; Tycho Brahe, *De nova stella* (photo Houghton Library, Harvard University, Cambridge, MA): 232; The British Library, London: 57 (Yates Thompson MS 36), 61 (MS Harley 937); The British Museum, London: 77, 78, 97, 195, 215; photos The British Museum, London (© The Trustees of the British Museum): 165, 166, 167, 197, 214, 218; Brooklyn Museum Costume Collection at the Metropolitan Museum of Art, New York: 262; *Buch der Natur* (photo Rosenwald Collection Rare Books and Special Collections, Library of Congress, Washington, DC): 23; © 2018 Calder Foundation, New York / Artists Rights Society (ARS), New York (photograph by Tom Barratt, courtesy Pace Gallery, New York): 46; Carlsberg Glyptotek, Copenhagen (photo courtesy Carlsberg Glyptotek): 281; The Cartin Collection: 67, 140, 141, 142, 143, 144, 145, 209, 210, 211, 212, 272, 273, 274, 275, 276 (courtesy the Cartin Collection); Casa Barbarella, Castelfranco: 26; Andreas Cellarius, *Harmonia Macrocosmica* (photo Linda Hall Library, Kansas City, MO): 36, 37; Central Library of Istanbul University: 150; *Le Charivari*, 1853 (photo Bibliothèque nationale de France, Paris): 172; City Museums and Art Gallery, Birmingham: 159; Collection of HM The Queen - Royal Collection Trust (© Her Majesty Queen Elizabeth II 2018): 169; Collection of Historical Scientific Instruments, Harvard University, Cambridge, MA: 40, 162; James Cook, 'Observations … : 267; Courtauld Institute Galleries, London (Princes Gate Collection): 194; Crawford Library, Royal Observatory, Edinburgh, Scotland

(photo courtesy NASA [National Aeronautics and Space Administration]: 278; Dallas Museum of Art, Dallas, TX (© Estate of the artist in support of Fundación Olga y Rufino Tamayo, image courtesy Dallas Museum of Art): 2; Danish Meteorological Institute, Copenhagen: 288; J. P. Loys de Chéseaux, *Traité de la Comète* (photo New York Public Library): 163; David Malin / Caltech, Photograph by Bill Miller: 294; David Malin / Jay M. Pasachoff / Caltech (courtesy of Robert Brucato): 247, 295; S. Deiries / ESO [European Southern Observatory]: 191; Derby Museum and Art Gallery (photo John Mclean/Derby Museums and Art Gallery): 39; Diözesanmuseum, Bamberg: 229; Fray Diego Durán, *Historia de las Indias de Nueva España*: 151; ESA (European Space Agency): 129, 302; © 2018 The M. C. Escher Company – The Netherlands: 234; ESO: 125; James Ferguson and Jeremiah Horrocks, *Astronomy Explained Upon Sir Isaac Newton's Principles* (photo Royal Ontario Museum Library & Archives): 75; Joseph Fraunhofer, *Bestimmung des Brechungs- und Farbenzerstreuungs-Vermögens verschiedener Glasarten*: 44; gallica. bnf.fr / Bibliothèque Nationale de France: 54, 55, 99, 100, 255; Brad Goldpaint/NASA: 193; Hally State Museum of Prehistory, Querfurt: 18; Bill Yidumduma Harney: 20; Heckscher Museum of Art, Huntington, New York / © Estate of George Grosc/Artists Rights Society (ARS), New York: 87; Collection of Judith Filenbaum Hernstadt: 222; Herschel Archives, Royal Astronomical Society, London: 42; Johannes Hevelius, *Cometographia* (photo New York Public Library): 156; Johannes Hevelius, *Machinae Coelestis* (photo Bayerische Staatsbibliothek, Munich): 53; Johannes Hevelius, *Selenographia*: 115; Hunan Provincial Museum, Changsha: 128; The Huntington Library, San Marino, CA – Art Collections (© 2014 Fredrik Nilsen – Estate of John and Paul Manship) courtesy of the Huntington Art Collections, San Marino, CA: 50; photo courtesy Huntington Library, San Marino, CA: 49; courtesy Les Images du Globe dans L'Espace Public / CERI [Centre d'Etudes et de Recherches Internationales]: 17; Institute for Astronomy, University of Hawaii, Honolulu: 240; courtesy Aleksandr Ivanov: 199; J. Paul Getty Museum, Los Angeles: 68; Steve Lee (University of Colorado), Jim Bell (Arizona State University), Mike Wolff (Space Science Institute), and NASA: 298, 299; Library of Congress, Washington, DC (Geography and Map Division): 76; LIGO [Laser Interferometer Gravitational-wave Observatory] (photo LIGO / A. Simonnet): 249; Cyprian Lvovický (Leowitz), *Eclipses luminarium*: 64; Konrad Lycosthenes, *Prodigiorum ac ostentorum chronicon* (photo Münchener DigitalisierungsZentrum Digitale Bibliothek, Bayerische Staatsbibliothek): 139, 277; Colección MALBA [Museo de Arte Latinoamericano, Buenos Aires]: 85, 86; Manchester City Art Galleries: 178; courtesy Matthew Marks Gallery, New York, and the artist (Vija Celmins) – © Vija Celmins: 263; Metropolitan Museum of Art, New York: 27, 101, 120, 245; Metropolitan Museum of Art, New York (The Elisha Whittelsey Collection): 45, 114; photos Metropolitan Museum of Art, New York: 22, 130, 147, 196, 205; courtesy Middlebury College, Middlebury, VT: 291; Musée Condé, Chantilly (MS 65): 206; Musée du Louvre, Paris: 12 (photo © RMN-Grand Palais), 176; Musée

National d'art modern – Centre de Création industrielle, Paris: 92; Museo Archeologico Nazionale, Naples: 19; Museo Civico, Viterbo: 110; Museo Guggenheim, Venice (Peggy Guggenheim Collection): 269; Museo Nazionale Romano, Palazzo Altemps, Rome: 4; Museo dell'Opera, Santa Croce, Florence: 65; Museo dell'Opera del Duomo, Florence: 5; Museo del Prado, Madrid (photo © Museo Nacional del Prado): 35, 242; Museo della Specola, Università di Bologna: 257; Museo Thyssen-Bornemisza, Madrid: 58; Museum of Fine Arts, Boston (© Museum of Fine Arts): 223; Museum of Jurassic Technology: 82, 286; Museum of Modern Art, New York: 190 (© Russell Crotty), 237 (© 2018 Jasper Johns / Artists Right Society [ARS], New York), 246; Museum of the Observatoire de Paris (photo J-M. Kollar): 72; NASA: 296, 297; NASA/Ames Research Center: 266; NASA / CXC [Chandra X-ray Center]/ SAO [Smithsonian Astrophysical Observatory]: 306 (X-ray photography); NASA, ESA, S. Beckwith (STScI [Space Telescope Science Institute]), and The Hubble Heritage Team (STScI / AURA): 238; NASA, ESA, and the Hubble Heritage Team (STScI / AURA [Association of Universities for Research in Astronomy]): 248; NASA, ESA, J Nichols (University of Leicester): 290; NASA / Johns Hopkins University Applied Physics Laboratory / Southwest Research Institute: 301; NASA / JPL [Jet Propulsion Laboratory]-Caltech: 300, 306 (infra-red photography); NASA / JPL-Caltech / MSSS [Malin Space Science Systems]: 303; NASA / JPL-Caltech / Space Science Institute: 251, 261; NASA / JPL-Caltech / SWRI [Southwest Research Institute] / Gerald Eichstadt: 254; NASA / JPL-Caltech / SWRI / MSSS / Betsy Asher Hall / Gervasio Robles: 252; NASA / JPL-Caltech / SWRI / MSSS / Gerald Eichstadt: 254; NASA / SDO [Solar Dynamics Observatory] / LMSAL [Lockheed Martin Solar and Astrophysics Laboratory]: 270; NASA / STScI: 304, 306 (optical photography); National Archaeological Museum, Athens: 3; National Gallery, London: 28, 200, 241; National Gallery of Art, Washington, DC: 6 (Samuel H. Kress Collection, 59, 102; National Library of Australia: 171; Ed Sweeney, Navicore, CC by 3.0: 192; New-York Historical Society, New York: 213; New York Public Library (Prints Division): 81, 170, 208 (© Fondazione Giorgio e Isa de Chirico / Artists Rights Society (ARS), New York); Roberta J. M. Olson and Alexander B. V. Johnson Collection: 121, 122, 161, 164, 175, 177, 180; Osservatorio, Palermo: 15; courtesy Pekka Parviainen: 289; Jay M. Pasachoff, with David Malin: 295; Jay M. and Naomi Pasachoff Collection, courtesy of Chapin Library, Williams College: 29, 30, 33, 34, 41, 43, 44, 63, 71, 95, 115, 131, 255, 256; Jay M. Pasachoff, Glenn Schneider, Dale Gary, Bin Chen, with the Big Bear Solar Observatory, New Jersey Institute of Technology: 271; Jay M. Pasachoff and the Williams College Eclipse Expedition: 48, 268; Jay Pasachoff and the Williams College Solar Eclipse Expedition / NSF [National Science Foundation] / National Geographic / NASA Massachusetts Space Grant / Clare Booth Luce Foundation: 73; Pennsylvania Academy of the Fine Arts, Philadelphia (John S. Phillips Fund and Exchange, courtesy of Gene Locks) – photo courtesy of the Pennsylvania Academy of the Fine Arts, Philadelphia and the artist (Jody Pinto): 227; Pinacoteca Vaticana, Vatican City, Rome: 52, 116, 201; Princeton

University Art Museum, Princeton, NJ: 265, 287; private collections: 13, 14, 79, 84 (formerly Alexander Gallery, New York), 93 (© Estate of Roy Lichtenstein), 105 (image courtesy ©bgC3), 173, 181, 217, 280 (photo courtesy of Lowell Libson and Jonny Yarker Ltd), 282, 288; Johannes Regiomontanus [Johannes Müller], *Epytoma in Almagestum Ptolemaei* (photo Library of Congress, Washington, DC): 7; Rijksmuseum, Amsterdam (Rijksprenetenkabinet): 157; Röhsska Museet, Göteborg (courtesy Röhsska Museet): 11; Royal Astronomical Society: 293; Royal Greenwich Museums, National Maritime Museum, London: 221; Rylands Collection, University of Manchester: 62; Johannes de Sacrobosco, *Sphaera Mundi* (photos University of Oklahoma History of Science Collections, University of Oklahoma Libraries, Norman, OK): 9, 108; San Francesco, Assisi: 207; San Lorenzo, Florence: 21, 103; San Pietro in Valle, Ferentillo: 231; Santa Croce, Florence (Baroncelli Chapel): 47; Santa Maria del Fiore, Rome: 136; Santa Maria Maggiore, Rome: 112; La Scala Opera House Museum, Milan – © Fondazione Giorgio e Isa de Chirico / Artists Rights Society (ARS), New York: 305; Hartmann Schedel, *Liber Chronicarum / Nuremberg Chronicle*: 24 (photo Cambridge University Library), 132 (photo Chapin Library, Williams College, Williamstown, MA); The Schoen Collection: 91; Science Museum, London: 117, 118 (photo Science and Society Picture Library); Scrovegni Chapel, Padua: 98, 135; Ernest Shackleton, *Aurora Australis* (photo Houghton Library, Harvard University, Cambridge, MA): 284; Smithsonian American Art Museum, Washington, DC: 285; Staatliche Museen, Berlin (Kupferstichkabinett): 25; Städische Galerie im Lenbachhaus, Munich: 179; State Pushkin Museum, Moscow (photo Pushkin Museum, Moscow/Bridgeman Images): 1; State Russian Museum, St Petersburg: 89; courtesy Peter Stättmayer (Munich Public Observatory) and ESO: 185; The Sterling and Francine Clark Art Institute, Williamstown, MA: 258, 259; courtesy J. A. Storer, Brandeis University: 224; Tate, London: 119, 168; courtesy Juraj Tóth: 202; Town Hall, Bayeux, France: 133; Universitätsbibliothek Heidelberg (Cod. Pal. germ. 149): 230; University of California: 184; University of Michigan, Ann Arbor, MI – photos courtesy the artist (Dorothea Rockburne) and Artists Rights Society (ARS), New York: 186, 187, 188, 189; Vatican Museums, Vatican City, Rome: 8, 10, 32 (Vincenzo Pinto / AFP / Getty Images); Victoria and Albert Museum, London: 90; Villa Boncompagni-Ludovisi, Rome: 250; Von Lintel Gallery, Los Angeles and New York (photo courtesy Von Lintel Gallery and the artist [Rosemarie Fiore]): 94; Vrouwekathedraal, Antwerp: 60; Wadsworth Atheneum Museum of Art, Hartford, CT: 16; The Warburg Institute, London (MS FMH 1290) – photos courtesy the Warburg Institute, London: 152, 153, 154, 155, 279; whereabouts unknown: 80 (photo courtesy Sotheby's); Whitney Museum of American Art, New York (gift of Sara-Jane Roszak – © Estate of Theodore Roszak / Artists Rights Society (ARS), New York): 225; Wilhelm-Hack Museum, Ludwigshafen am Rhein – © 2018 The Pollock-Krasner Foundation / Artists Rights Society (ARS), New York: 183; Wren Library, Trinity College Library, Cambridge: 134; Yale Center for British Art, New Haven, CT (Paul Mellon Collection): 174, 216; Yale University Art Gallery, New Haven, CT: 220; James Zang Collection, London – © Katie Paterson (photo courtesy James Cohan, New York): 96; Zentralbibliothek, Lucerne (MS S.23): 138, 198; Zentralbibliothek Zürich: 148, 149.

Index

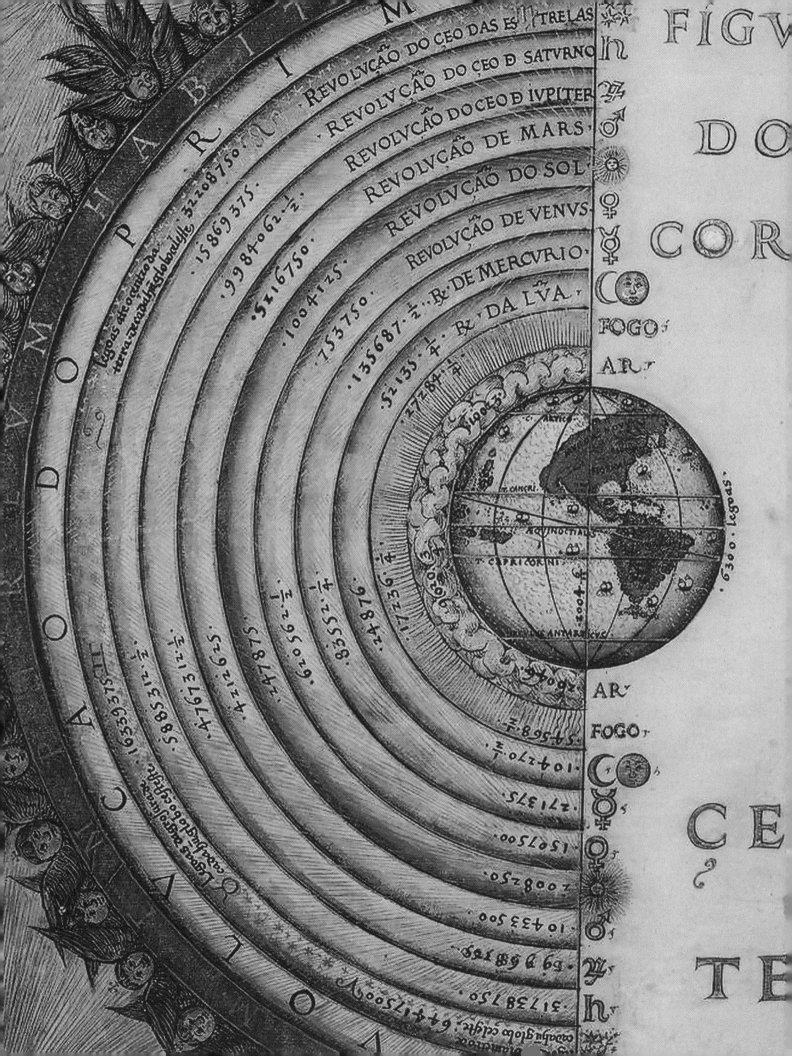